ART
AND
HUMAN VALUES

with a Foreword by Virgil C. Aldrich

Melvin Rader

Bertram Jessup

PRENTICE-HALL, INC., *Englewood Cliffs, New Jersey*

Library of Congress Cataloging in Publication Data

RADER, MELVIN MILLER, date
 Art and human values.

 Bibliography: p.
 Includes index.
 1. Aesthetics. 2. Worth. 3. Art—Philosophy.
 I. Jessup, Bertram Emil, date joint author.
 II. Title.
 BH201.R28 111.8′5 75–22486
 ISBN 0-13-046821-5

TO

Florence Jessup

and

Virginia Rader

10 9 8 7 6 5 4 3 2 1

PRENTICE-HALL INTERNATIONAL, INC., London
PRENTICE-HALL OF AUSTRALIA, PTY. LTD., Sydney
PRENTICE-HALL OF CANADA, LTD., Toronto
PRENTICE-HALL OF INDIA PRIVATE LIMITED, New Delhi
PRENTICE-HALL OF JAPAN, INC., Tokyo
PRENTICE-HALL OF SOUTHEAST ASIA (PTE.) LTD., Singapore

CONTENTS

iii

ACKNOWLEDGMENTS

If Bertram Jessup were alive, he would join with me in the following acknowledgments. We are grateful to Virgil C. Aldrich, Stefan Morawski, Lee Baxandall, Eugene Elliott, Grant Hildebrand, Victor Steinbrueck, Earl Bell, and Gretchen Riley for criticism and advice; to our students and colleagues, who helped to lay the groundwork of our theories during years of teaching and discussion; to the editors of journals for their kind permission to reproduce excerpts from our articles. Both Professor Jessup and I contributed to *The British Journal of Aesthetics* and *The Journal of Aesthetics and Art Criticism*. He also contributed articles on aesthetics to *The Journal of Philosophy*, *The Personalist*, *Philosophy and Phenomenological Research*, *Four Quarters*, and *Op. Cit.* Material from all these journals has been incorporated in the present book. Holt, Rinehart and Winston, Inc. have kindly granted permission to incorporate several brief excerpts from my book, *Ethics and the Human Community* (1964). We especially thank Professor Aldrich for contributing the Foreword and Professor Gerald L. LeCoat for his help in the preparation of the Appendix.

I am confident that Professor Jessup would have approved the dedication of the book to our wives, Florence Jessup and Virginia Rader. Florence shared with Bertram a lifelong interest in the arts. Virginia, a Master of Fine Arts, has contributed more to my understanding and appreciation of art and aesthetic value than any other person.

MELVIN RADER

FOREWORD

This book is strong on the counts of scope, scholarship, and sanity. It is a general theory of value. Were it not for the special stress throughout on aesthetic value, first by itself and then in relation to the other kinds, it would compete with R. B. Perry's classic *General Theory of Value,* whose interest theory of value has somewhat influenced our authors. However, the style and spirit of this new book, together with its spectacular panorama of quotations from other works, make it more humane than Perry's. It serves much better the purpose and need of the general reader, even if his concern is *not* primarily with aesthetic value but rather with global understanding of the condition of man.

With respect to scope—the first of the above three counts—some readers will complain that more attention should have been given to the recent linguistic approach. And this minority will consider the work therefore not *au courant* enough or as conceding too much to the traditional style of treatment. But there are scattered remarks throughout which connect the reader with the newer thing. The authors could not have done more than this without sacrificing the integrity of the classical spirit of the work as a whole.

As for the second count, scholarship, the great variety of primary source quotations and the references are calculated to assist the reader into comprehensive insights, rather than to feature esoteric materials for the sake of erudition. So, on this count, the work is not primarily for scholars in the academic sense. *They* will complain that it spotlights much that is already familiar stuff, overlooking the value it acquires

under the new organization it is given in these pages, which is to overlook the book's main purpose.

Under the third count, sanity, something can be said that further justifies the kind of scope and scholarship that concerns the authors. It has to do with "the book's main purpose" just mentioned. This is to promulgate an adequate philosophy of aesthetic and other human values, on a level of consideration that is right for any thoughtful reader concerned with the subject. I say this philosophy is sane because it is nonpartisan. Without scuttling the extreme and exclusive positions about art and aesthetic value, it takes the wind out of their sails by showing that the element of truth in them is done greater justice by a less exclusive stand—the recognition that there are several basic interests and kinds of value corresponding to the various general distinctions we naturally make—aesthetic, scientific, moral, religious, economic—in our thinking about what is good for human beings. The authors' view is that the harmoniously ordered whole in which these basic values are coordinated without loss of the distinctiveness of each is mankind's final good.

Virgil C. Aldrich

PREFACE

The present book was originally conceived by Bertram Jessup, and I was invited to collaborate after much had been written. Since his death on July 26, 1972, I have worked alone in finishing the manuscript. A great deal has been added or altered since his death, but the book as a whole strongly bears the impress of his thought.

Our theme, the nature of aesthetic value and its relation to other fundamental values, seemed to us the best approach to aesthetics for the general reader. We have written, not primarily for academic scholars and professional aestheticians, but for students and the public interested in the arts both in themselves and in relation to everyday life. Our approach to art and aesthetic value may be described as horizontal rather than vertical. The discussion is selectively extensive over and illustrative of the wide field of aesthetics rather than intensive and exhaustive of a section of it. We have explored the manifestations of aesthetic value in common life, in nature, and in art, and the relation between art and other spheres of human activity. We use "art" in the wide sense to include not only the plastic and graphic arts but music, literature, industrial design, architecture, and urban planning.

Although we have a great deal to say about art, we base our characterization on the interpretation of value. The purpose of our book is, first, to explicate the nature of aesthetic interest and value, and second, to discuss their relation to other human values and interests. Remembering that life unfolds as a single web of many strands, we isolate somewhat these strands to show more explicitly how art and aesthetic value stand in total human affairs.

The question we seek to answer is not "What can art *alone* do?" but rather "What can art *do best?*" Art can hallow and consecrate, strengthen right conduct, contribute to knowledge, improve efficiency, increase prosperity, accelerate or retard social reform. But none of these things is it peculiarly fitted to do—none does it do best. No other form of human activity can equal it as the expression of vivid values. Art tells us what science cannot tell us; it tells us of our hopes and fears, our loves and hates, our prizings and disprizings, not in the emotionally neutral languages of abstractions but in the vivid, stirring "language" of felt qualities.

This characterization avoids a one-sided emphasis on *form* and *quality* (the objective component of aesthetic value) or *feeling* (the subjective component). Many aestheticians have defined art in terms of feeling. These definitions are true in a measure but err in one-sidedness. It is equally one-sided to characterize art in terms of form and quality alone. For it is precisely its relation to creative intent and appreciative response that makes the work of art a living thing.

Some values, such as the beauty of pure artistic form, are peculiar to art, but others, such as moral, political, or cognitive values, are transmuted by artistic expression and embodiment into the stuff of art. The values of art never duplicate the corresponding values in life, because they are individualized and transformed by their expression in new variants and particularized media. The life-values are taken up, transformed and conserved on an imaginative plane. This new-minting of old or common values, not hermetic isolation from life, insures the autonomy of art.

Few books attempt such a far-ranging examination of aesthetic value in its various and broad connections with the condition of man. To the possible charge that we thereby sacrifice depth and penetration to breadth of inquiry, we reply that a broad orientation is needed to give life as a whole direction and purpose. Perhaps at no other time in history has this need been greater, since there is unparalleled uncertainty and confusion about human values, not least with respect to the arts. A multidimensional balancing and reassessment of goals are central to our argument.

There is risk of superficiality in this undertaking, but the risk seems worth taking. The challenge of attempting a broad critique of culture from a pro-aesthetic standpoint has been stimulating to us, the authors, and I hope it will be stimulating to our readers. Even from the limited objective of defining "aesthetic value," it is a useful exercise to try to sharpen this concept by examining boundary cases in which the aesthetic shades off into, or collides with, other values. These intersections and conflicts are dialectically interesting for the philosopher and dramatically interesting for the student or general reader, especially for the one who is interested in the relevance of aesthetics and the arts to the rest of life, or to his other studies.

Aesthetic Value

THE MEANING
OF VALUE

Interests and Values

Human life is a system of interests—for example, the interests in biological survival, physical and mental comfort, economic sufficiency, self-expression, companionship, and understanding of the natural and social worlds. Pursuit of these interests makes life interesting, and satisfaction of them makes life good. These attainments or satisfactions are values, such as health, security, freedom, friendship, and knowledge.

Different individuals pursue different interests. One individual is interested in or cares for another in the way of love or friendship for that person, or he is interested in collecting stamps of a certain country, or in hybridizing daffodils, or in understanding the life of Robert E. Lee, or in cross-breeding Brahmin cattle and Texas longhorns. Individuals are what they are because of the interests which they have and seek to realize. Their interests determine their occupations, their hobbies, and their characters. By their interests we know them and even name them. This man, we say, is a stamp collector, that one a hybridizer, that other one a student of the Civil War, or the lover or friend of so-and-so.

Specific, distinct interests thus serve to distinguish and separate

individuals. Your interests, what you care about, are you, make you what you individually are. And so mine. So everybody's. Interests also tend to divide and multiply the single individual. They divide his occupation from his hobbies, his play from his work, his public life from his private. A man may be a businessman, single-minded in pursuit of economic ends during the days of his work week, and a student, a poet, or a gardener evenings and Sundays, wholeheartedly devoted to interests other than economic. Such multiplication of interests we count good. It gives variety and fullness to life. To have many and deep interests is good.

Interests not only separate and divide; they also unite and integrate. They bring men together and they make them whole. Interests are at once individual and general, personal and social. The specific individual interest which one man has in hybridizing daffodils, for example, may be his special way of pursuing an interest which another pursues in quite a different way. And the immediate motive which leads a man to a certain activity may be almost anything. It may be economic, scientific, hygienic, social, or even religious. Let us suppose, for instance, that a man begins to hybridize daffodils because he believes it will be profitable. His initial interest is economic. In pursuing it he soon discovers that the culture of daffodils requires much careful observation, study, and experiment. He becomes absorbed in the *science* of hybridizing; he becomes intellectually excited, and with the economic value of profit there is thus integrated the intellectual value of knowledge and truth. In the pursuit of these values he looks up other hybridizers, exchanges observations and methods with them. He gives and gets knowledge, and profits from it. But in the course of things he will likely find too that common interests in the ways of daffodils bring people congenially together. And so he builds another interest and another value into his growing system, that of friendship. Likewise, the physical outdoor cultivation of daffodils may improve health, another value in the system. Again, the experiment of developing new species may bring imaginative and creative satisfaction. And so on almost without end. Any specific interest can begin anywhere and end everywhere to embrace all the values of complete human living. The separate individual thus finds in his dominant interest not so much a point of division and isolation as the focal point upon which all his strivings and satisfactions center, or, perhaps better, from which they radiate. Idiosyncratic as the interest in hybridizing daffodils may seem, its cultivation brings to fruition values common to us all.

However common, values are always particularized in the individual aims and activities of the person who pursues and attains them. Economic value is particularized for one person in raising cattle or in

growing flowers, for another in serving health or pursuing knowledge, for a third in selling groceries or digging oil wells, and so on in countless ways. Knowledge value comes for this man in the study of this special field or subject, for that one in something else; and friendship means my friends and my set to me and yours to you. And so on for all values.

But, as our imaginary example of the hybridizer shows, interests and values do not remain either detached or private. They become integrated, shared, and generalized. One value serves and is served by others, and with them forms a system of values, a total life. And every value, no matter how particular, is normally shared with other persons by way of cooperative pursuits and common satisfactions. We work and play with others, are devoted to the same subjects or causes, and often love the same friends. Also, finally, every particular value or interest is always an instance of a kind of value, a general interest. Although there are innumerable occupations, fields of inquiry, social attachments, customs, ways of thought and ideals, they all express general interests and embody general values, such as security, freedom, health, and knowledge.

Thus, when we seek a generalized understanding of human life, we do not speak of this person's work, or that person's health, or someone else's social attitudes. We speak rather of economic interest and economic goods, of intellectual interests and truth, of biological interests and physical well-being, and of moral interest and right behavior. What we are then talking about we may call basic interests and basic values, basic because they are what we find at the base of all specific strivings and satisfactions.

This book is about one of these basic human interests. It is about aesthetic interest and aesthetic value. More specifically, it is about the nature of the aesthetic interest and its place in total human living— that is, its relations to other basic interests which together with it make up the system of human wants and satisfactions, or values.

The aesthetic interest is something that fills a large part of everyone's daily life. It is an important and pervasive ingredient in common and total human good—of what makes life interesting. Though perhaps almost everyone today gives ready recognition to the presence and innocent desirability of the aesthetic in life, still many will not grant its basic importance and pervasiveness. To many its status seems different from that of other values. Values like safety, health, profit, friendship, and knowledge are taken for granted. Everybody knows them and has interest in them. They are familiar and plain. They are matters of constant concern. But with aesthetic value it can somehow seem different. Even if we speak of "beauty" the case is not clear.

Many people, even though they talk easily of beauty and of such related qualities as the pretty, lovely, and nice, still do not think of whatever answers to these terms as on a par in fact and in importance with health, profit, and fun. And to speak to them of generalized "aesthetic interest" is, it seems, to speak of something not strictly necessary to ordinary life, as marginal in value and not vital or basic, and certainly not to be demanded in the range in which life is most serious and practical.

Where, then, is this all-pervasive aesthetic value to be found? At first glance, the typical daily round may indeed not appear to contain it. In it there is the main practical occupation in work or business; there are the routines of domestic duties and personal care; and there are, of course, the free hours and days for social life, amusement, entertainment, and relaxation. Included in the free-time activities are such things as reading, going to the movies, gardening, and perhaps occasional glancing at pictures in magazines or on walls, and listening to music on the radio or television or in public concert.

The relaxation is, to be sure, agreeable, and the free activities are more or less fun or even seriously worthwhile in some sense which one does not exactly understand. But "aesthetic"—well, that must be something else, something not in the ordinary way of life of ordinary people. The word is not part of the daily talk, and it must, therefore, stand for a peculiar interest or thing which occupies only those people who make it their special concern. And that concern seems remote from what everyday people in their everyday life know and do and care about.

If for some reason the ordinary man tries to think further about it, he will probably associate the term "aesthetic" with certain objects and activities which are the exclusive interests of those who busy themselves with whatever one finds in art museums. That is, the term "aesthetic," he will think, applies to objects of "fine art" and to the practice and talk of those who produce and discuss them—the artist, the connoisseur, and the sophisticated gallery-goer. And he will not count himself among any of these.

Now our ordinary man will be altogether right in thinking that what goes on in the museum—at least for the responsive beholder—is aesthetic; but he will be quite wrong in believing that it goes on there only, that it begins and ends there. He will be most wrong in his belief that he himself, being, let us suppose, no artist or museum-goer, has nothing to do with the aesthetic. He could not be more wrong if he thought he had nothing to do with economics, medicine, or science. For the aesthetic, no less than these, is first and last an all-human concern and therefore everybody's. Everyone every day has

aesthetic experience, just as everyone every day has economic experience, or cognitive (knowledge) experience. Everyone knows in his own daily living that human existence goods—food, clothing, housing, and innumerable other necessities—have worth in that they satisfy creature needs and comforts and are bought and sold. And he knows that in work and in business he takes part in the economy that produces and provides these goods, or economic values. He is an economic producer as well as consumer. Likewise, everyone in his everyday, common-sense life has knowledge experience. He knows that fire burns, that water is wet, that sleep refreshes, and that nothing comes from nothing. And he knows countless other things. He lives by knowing, every day all the time.

But in this all-human realm of knowledge experience, the ordinary man, besides understanding that he has an active part in it, knows or can easily come to understand something further—namely, that the specialized pursuits of science and philosophy are simply extensions of the common-sense knowledge that is everybody's interest, that they grow out of it and always refer back to it. Everyone, in brief, has knowledge not only of things and affairs but also of knowledge itself, and when he is told that all knowledge, common-sense as well as scientific, has or is "cognitive value," the term may be new to him but the idea is not.

As it is with cognitive value, so with aesthetic value. It too belongs to a whole realm of common experience as well as to a specialized extension of that realm, and here too the latter grows out of and refers back to the former. Everyone has knowledge of aesthetic value in its daily occurrence by acquaintance—even if not by name.

And what is aesthetic value? In subsequent chapters we shall want to answer this question more precisely. For the present, though, it is enough to say that aesthetic value attaches, for example, to what men immediately or directly enjoy in simply looking at things in nature or at made objects; in listening to bird songs, or soughing trees, or to music; in feeling a piece of woolen or a smooth pebble; or in arranging an attractive table or a bed of flowers. We walk to work in the morning air with keen aliveness to the ground smells, the burgeoning or the turning leaves, and to the blue hills cut against the sky, because these are pleasant or exciting to look at. In the evening we go to a concert or to a movie, or we sit down with a good novel, or we sing or dance, simply because these things in themselves interest us or give us pleasure.

We have said that as it comes to us in such familiar examples from daily life, aesthetic experience wants no explanation or justification, needs no reasons. It is just there and obviously good, like breathing

fresh air and being comfortable. But in a way, of course, we have been giving reasons. We do so and so because we like to; we pause to look at this or that because we find it pleasant to look at; and we listen or read just because we find it interesting. However, such answers may not satisfy us if we become reflective about the whole matter. They may seem then to come to nothing more than a reaffirmation that there are such things—things that we usually take for granted, as we do particularly appetizing food or good-tasting drink.

But the question may then be asked: Why do we linger over these things—what is the good of them, really? And how do they differ from or relate to other things which we also value? To ask such questions is to go beyond the aesthetic experience itself and to make an effort to understand it. It is to this effort that this book is directed. It assumes that we are interested not only in having aesthetic experience but also in being interested in that interest. Aesthetics as a science or a philosophical inquiry can be so characterized; it is the outgrowth of an interest in the aesthetic interest. No further justification is needed. Having aesthetic experience is good. To understand it is also good. The first proof for either is that men find it so, that they want aesthetic experiences and that they want to understand why they want them, to see what value there is in having them.

The first, unlearned answer to this question, the question of why, then, is in fact one we have already suggested—namely, that we simply like to have them. By itself our everyday, spontaneous aesthetic experience is innocent; it makes no claims, pleads no causes, seeks no support, and offers no reasons. Being good in itself and fascinating in its immediate undergoing, it needs no ulterior justification. But our other interests do move in on it, call it to account, and provide it with reasons, sound or unsound. We learn that a good movie is relaxing, that a thoughtful novel or play enlarges our sympathies and our understanding of life and people, that a lofty mountain peak may bring a sense of spiritual elevation, and that a great poem may express profound truth. We learn that aesthetic experience involves much more than simple sensory enjoyment, that it may stir the whole mind and spirit of a complex human being, and that it is related in innumerable ways to other interests and experiences. All such far-ranging considerations and answers to the question: Why is aesthetic experience "really" good or important? are, in their measure and kind, efforts to understand or explain aesthetic value—as is also the unlearned "we just like it" answer, if insisted upon.

Our study, in its own effort to understand, may admit a general or partial, if not specific and complete, correctness in such various explanations and justifications of the aesthetic experience as those

given in the random reasons cited. It is correct in principle to ask what is the distinctive value of aesthetic experience, where and how the aesthetic fits in total human living, how aesthetic value goes together with other human values. That it does go together with all other human values is the main thesis of this book, and to show how it does is the major task in the chapters ahead.

The Concept of Value

Pivotal to our entire study is the concept of value. The term "value" is one of the basic words of human discourse, and like the meaning of other such words ("justice," "freedom," "truth," "reason," etc.), its meaning is complex and variable. It came into ordinary language by way of economics, being used to denote value in exchange, which is generally reckoned in terms of money or the price of a commodity. But its meaning has expanded to include many different kinds of value, such as moral, religious, economic, and aesthetic. Being so wide in scope, it is hard to pin down. Philosophers warn against its careless use:

> The term is almost hopelessly ambiguous and should be avoided except where the context makes its shade of meaning perfectly clear, or where vagueness is an advantage in covering a broad field, as when one speaks of "the general theory of value." [1]

The exception noted, that a vague term is useful in covering a broad field, is applicable to this book; but the ambiguity should be limited as far as is consistent with the breadth of our concern.

The sharp emergence of value as an independent concept can be traced back to Immanuel Kant. In all three of his great Critiques, he taught his readers to distinguish between valuation and factual explanation, and between problems of value and problems of existence. There is an ineradicable difference, he maintained, between saying that something ought to be the case (a statement of value) and saying that it is the case (a statement of fact). The realm of value overlaps with, but is not limited to, the realm of fact. A matter of fact is that which simply is, regardless of its value or lack of it. We determine that something is a matter of fact, not by finding out if someone prizes or disprizes it, or whether it is worthy of being prized or disprized, but by a logical process of verification, as in empirical science. An object of value, on the other hand, may be purely imaginary,

[1] A. Campbell Garnett, *The Moral Nature of Man* (New York: The Ronald Press Company, 1952), p. 130.

as when we enjoy a fictitious character in a novel or cherish a utopian ideal. In moral striving men are concerned with what ought to be, not simply with what was, is, or will be. In religious devotion men aspire to union of the me with the not-me, of the Self with the Other, in defiance of the alienations and conflicts of things as they are. In artistic creation or aesthetic appreciation men transcend the realm of fact, because imagination is entranced by possibility and not bound by existence. Even in science men discover value in fictions, because they understand facts better when they see how models and other mental scaffoldings approximate to or deviate from reality. Moral, religious, aesthetic, and cognitive values differ, but all are values; and it is a fallacy to confine any of them, because they *are* values, to the realm of fact. Admittedly, the dualism of fact and value can be overstated, because *felt* facts *are* values, and consideration of fact is often required to determine what is prizeworthy. But a person cannot logically infer a normative proposition from purely factual premises. To assume that a factual proposition, *x is the case,* must entail the normative proposition, *x is a value,* is to commit "the factualist fallacy."

Recognizing the distinction between statements of fact and statements of value, modern philosophers have noted that "value" is a generic noun that refers to all kinds of pro or con predicates as contrasted with matter-of-fact descriptions. They have assigned the study of value to a special branch of philosophy called *axiology* or the *general theory of value.* Special normative sciences, such as ethics, aesthetics, and economics, can be regarded as subdivisions of this general theory.

One of the familiar distinctions in the theory of value, as for example in the writings of Ralph Barton Perry, is between "interest" and the "object of interest." "Interest" is used in an inclusive sense to designate non-neutral attitudes—states of being *for* or *against,* such as prizing, liking, desiring, hoping, loving, or their opposites. These attitudes of favor or disfavor involve feeling, emotion, desire, or will —and in Perry's version, the accompanying bodily movements of seeking or shunning. "Objects of interest" are the things or qualities toward which these pro or anti attitudes are directed. They may be persons, institutions, concepts, ideals, aspects and attributes, relations and references, fusions and patterns, real entities or figments of the imagination—whatever can be perceived, conceived, introspected, or imagined as in any way likable or dislikable.

Value can be analyzed into three components, I–R–O, in which "I" is the interest of the subject, "O" is the object of the interest, and "R" is the relation between them. In the enjoyable experience of tasting clam nectar, for example, "I" is the enjoyment of the taster,

"O" is the nectar, and "R" is the stimulus-response pattern that binds
the two together. How should value be defined? Is it to be found in
the object of the interest? Or in the interest in the object? Or in
the relation between interest and object? In reviewing these questions
in this chapter, we are seeking to characterize value in general, but
we shall frequently cite beauty as an example.

 1. *Value as objective.* In his *Principia Ethica*, G. E. Moore asks
his readers to try the following experiment:

> Let us imagine one world exceedingly beautiful. Imagine it as
> beautiful as you can; put into it whatever on this earth you most
> admire—mountains, rivers, the sea, trees and sunsets, stars and
> moon. Imagine these all combined in the most exquisite propor-
> tion so that no one thing jars against another, but each contrib-
> utes to increase the beauty of the whole. And then imagine the
> ugliest world you can possibly conceive. Imagine it just one heap
> of filth, containing everything that is most disgusting to you for
> whatever reason, and the whole, as far as may be, without one
> redeeming feature. . . . [Now imagine that not] any human be-
> ing ever has or ever by any possibility can live in either, can see
> and enjoy the beauty of the one and hate the foulness of the
> other. . . . Supposing them quite apart from the contemplation
> of human beings; still is it irrational to hold that it is better that
> the beautiful world should exist than the one which is ugly? [2]

In answering the question, Moore contends that the beautiful world
is objectively better than the ugly one. Although he refers to worlds
without "any human being," we assume that he intends to exclude
all sentient beings whatever, whether god, man, or beast.

 The plausibility of his answer, that the beautiful world is better
than the ugly world even though no conscious being exists, depends
on an error that is difficult to avoid. We are asked to imagine that
there is no one to observe or conceive either world, and at the same
time, we are asked to imagine the superlative beauty of the one and
the abysmal ugliness of the other. As long as we are imagining, we
have not eliminated ourselves and our own predilections, and it is
virtually impossible to do so. To ask what values would exist when
there is no one to value them is as contradictory as to ask what ob-
jects would look like when there is no one to look. In a universe
with no glimmer of consciousness, there would be neither appearances
nor values.

 This is the conclusion of George Santayana in *The Sense of
Beauty*. He asks whether any value could exist in a totally mindless

2 *Principia Ethica* (London: Cambridge University Press, 1903), p. 83.

world. His answer is that "we can see in such a mechanical world no element of value whatever. In removing consciousness, we have removed the possibility of worth." [3] Beauty is a value, he says, and no value, either aesthetic or nonaesthetic, can exist in a world utterly devoid of awareness. Even in a world in which there are conscious beings, there would be no value if all interest were lacking.

> Every event would then be noted, its relations would be observed, its recurrence might even be expected; but all this would happen without a shadow of desire, of pleasure, or of regret. No event would be repulsive, no situation terrible. We might, in a word, have a world of idea without a world of will. In this case, as completely as if consciousness were absent altogether, all value and excellence would be gone. [4]

Although proof is impossible, we agree with Santayana. In a world in which there is no consciousness, or in which every conscious state is one of utter and complete indifference, all things would be neutral and valueless.

This conclusion applies not only to beauty in the natural world but also to beauty as an eternal essence in "a heaven above the heavens." In response to Plato's contention that beauty is a timeless form or archetype that transcends perishable things, we shall do no more than call attention to a counterthesis that is stated by Plato himself. In his dialogue *The Sophist*, "the stranger" replies to "the friends of the forms" that Being is power to act and be acted upon—it is action and passion. Apart from all life and motion, the stranger declares, eternal forms or essences are unmeaning fixtures. [5]

While locating the value in the object, Ralph Barton Perry escapes the kind of criticism that is applicable to Moore. To the question: What is value? he answers: Any object of any interest. Value, in the sense intended by Perry, can be defined as a relational property that exists if someone is interested in an object. So conceived, values are "objectively relative"—that is to say, they are properties of objects relative to our preferential attitudes and approach-or-withdrawal behavior. A great many of the properties that we ascribe to objects are of this relational character, as when we say that food is appetizing or a chair is comfortable.

Perry's definition, that value is any object of any interest, implies that value "attaches promiscuously to all objects of all interest." The

3 *The Sense of Beauty* (New York: Charles Scribner's Sons, 1896, and London: Constable and Company Ltd), p. 17.
4 Ibid., p. 18.
5 Plato, *Sophist*, #247–49.

poorest painting in the world, for example, possesses value if somebody happens to like it. This view commits Perry to an ultimate relativism:

> When . . . all cognitive differences have been eliminated or discounted, and two preferences still conflict, we are confronted with two undebatable facts both of which have to be accepted by both parties, the facts, namely, that whereas in the last analysis I prefer *b* to *a*, you prefer *a* to *b*. Such a conflict of preference, like conflict of interest, is a datum of value and an instance of its ultimate and irreducible relativity.[6]

We agree with Perry that *some* value, however minimal or irrational, is present whenever there is an interest in an object; but the interest may be mistaken or depraved, and the object far from choiceworthy. There may be a vast difference between what is prized and what is prizeworthy and between thoughtless prizing and thoughtful appraising. Unless these distinctions are recognized, the "interest theory" takes too little account of the worthiness or unworthiness of objects to be prized. By interest alone we cannot make a silk purse out of a sow's ear.

One way to defend the objectivity of beauty against a corrosive relativism is to identify it with the *power* in objects to produce a certain sort of aesthetic experience in fit mind-body organisms. W. D. Ross has written:

> The view to which I find myself driven, in the attempt to avoid the difficulties that beset both a purely objective and a purely subjective view, is one which identifies beauty with the *power* of producing a certain sort of experience which we are familiar with under such names as aesthetic enjoyment or aesthetic thrill.[7]

Some objects possess this power in a higher degree than others, and (to mention a point not emphasized by Ross) some persons are much better fitted to grasp and respond to this power than others. The "aesthetic transaction," to use a favorite term of John Dewey, implies the *mutual* fitness of object and subject.

2. *Value as subjective.* Those who contend that value is merely subjective identify it with some kind of feeling, satisfaction, or other psychological state. For example, David Hume denied that beauty is an objective quality and characterized it as a mental reaction:

> Euclid has fully explained all the qualities of the circle; but has not in any proposition said a word of its beauty. The reason is evident. The beauty is not a quality of the circle. . . . It is only

6 *The General Theory of Value* (Cambridge, Mass.: Harvard University Press, 1954), p. 255.

7 *The Right and the Good* (London: Oxford University Press, 1930), p. 127.

the effect which the figure produces upon the mind. . . . In vain would you look for [beauty] in the circle, or seek it, either by your senses or by mathematical reasoning, in all the properties of that figure. . . . Till . . . a spectator appear, there is nothing but a figure of such particular dimensions and proportions: from his sentiments alone arise its elegance and beauty.[8]

Since the time of Hume, many others have held that values are matters of feeling or desire. Morris Schlick writes that "the *essence* of value is completely exhausted" by "the feeling of pleasure." [9] DeWitt H. Parker declares that "values belong wholly to the inner world, to the world of mind." [10] Such characterizations have been common among subjective idealists and logical positivists.

If "value" were synonymous with ultimate "goodness" or "badness," this interpretation might be correct. Perhaps nothing is ultimately good except enjoyment or mental satisfaction, and the object may be good only as a stimulus or means to these inner qualities of experience. But "value," as commonly used, is not synonymous with good or bad in this sense. The term involves both an interest in an object and an object of interest, and we intend to cling to this usage.

To put exclusive emphasis on the subjective component in the value situation is as false and misleading as to put all the emphasis on the objective component. Interests are not blind and directionless and isolated—they find expression in objects and are directed toward objects and are publicly describable in terms of objective references. I enjoy this wine. I appreciate this music. I like this person. I admire this act. Interests without objects are unreal abstractions, and to talk about them as if they had a ghostly isolation from the real world of objects can lead to nothing but vagueness and confusion.

3. *Values as relational.* In the value situation, the subjective and the objective components exist in interlocking relation. As Samuel Alexander has said:

In every value there are two sides, the subject of valuation and the object of value, and the value resides in the relation between them. The object has value as possessed by the subject, and the subject has value as possessing the object. The combination of the subject and the thing which is valued is a fresh reality which is implied in the attribution of value to either member. Value as a "quality" belongs to this compound, and valuable things, truths, moral goods, works of beauty, are valuable derivatively from it.

[8] *An Enquiry Concerning the Principles of Morals* (London: Oxford University Press, 1902), pp. 291–92.

[9] *Problems of Value* (New York: Prentice-Hall, Inc., 1939), p. 105.

[10] *Human Values* (New York: Harper & Brothers, 1931), p. 20.

The same thing holds of the subject which values and is also valuable—the true thinker, the good man, the man of aesthetic sensibility.[11]

This interpretation of value is a clear statement of the doctrine that underlies this book. Subjective value is a property of subjects, and objective value is a property of objects; but neither, in isolation, is the entire value. The whole relational complex, I–R–O, is the only actual and complete value. The two opposing theories—subjectivism and objectivism—represent partial truths, and the whole truth combines the valid insights of both.

The relation between subject and object is one of interdependence —a change in either one brings about a change in the other. When a person takes a walk in the woods on a somber day, and the sun emerges from behind a cloud and floods the landscape with a golden glow, his mood suddenly brightens. On the other hand, when a man falls in love, an aura of enchantment enwraps the beloved and her surroundings. To the poet in love it seemed that

> Earth breathed in one great presence of the spring;
> Life turned the meanest of her implements,
> Before his eyes, to price above all gold;
> The house she dwelt in was a sainted shrine;
> Her chamber-window did surpass in glory
> The portals of the dawn; all Paradise
> Could, by the simple opening of a door,
> Let itself in upon him:—pathways, walks,
> Swarmed with enchantment. . . .[12]

Subject and object, mood and appearance interact in a complex pattern of internal relations.

That pattern can best be described as a configuration or gestalt.[13] In a gestalt, the parts belong together rather than being merely juxtaposed. A change in one part results in a change in the other parts; and the character of the parts is more or less determined by the character of the whole. A good example is a melody. To appreciate the melody, we must be aware not of single tones in isolation but of a temporal pattern of tones. Each tone is heard, and its value is determined, not as a detached sound, but as an integral part of that

11 *Space, Time, and Deity* (London: Macmillan & Company, 1920), 2:302.
12 William Wordsworth, "Vaudracour and Julia," lines 41–53. The poem is a thinly disguised narrative of the young poet's love for Annette Vallon.
13 See Risieri Frondizi, *What is Value?* (La Salle, Ill.: Open Court Publishing Company, 1971), esp. pp. 7–10, 159–65. Frondizi's analysis of value is closely akin to the interpretation in this book.

pattern. The total configuration, moreover, has a relative independence of its constituents: the melody transposed into a different key is immediately recognizable, even though not a single tone of the original arrangement recurs. On the other hand, if all the tones remain the same in pitch, but are presented in a different temporal order, the effect will be entirely different.

When the melody is heard and appreciated, the tones take on an affective coloration—they are not neutral qualities but *felt* qualities. The objective and subjective component coalesce. The beauty of the melody springs from this amalgamation of sounds and mood. In instances of nonaesthetic value, the coalescence of subjective and objective components may be less evident, but there is always a union of object of interest and interest in the object. Value emerges from this synthesis of objective and subjective factors. It is an emergent quality of the relational complex or gestalt, I–R–O.

If we use the noun "value" in this relational way, it is consistent with the verb "to value." The verb, in its positive connotation, means to prize something, to hold it dear or precious. Negatively it means to disprize. We cannot use the verb meaningfully unless there is both an act or attitude of prizing (the subjective component) and something prized or disprized (the objective component). It would be awkward to use the verb "value" in this relational sense and at the same time to use the noun "value" in a nonrelational way. Such awkwardness we have avoided by defining the noun "value" as a quality of a relational complex.

Kinds of Value

Another advantage in using the noun "value" as we have is that it can cover the whole range of the likable, indifferent, and dislikable. When the value is on the plus side, such as beauty, it can be called positive value; when on the negative side, such as ugliness, it can be called negative value; and when something is indifferent, exciting no interest whatever, it can be called valueless. Of course, the valueless or negatively valuable from one point of view may be positively valuable from another. For example, the gargoyle on a medieval cathedral may be repulsive in isolated perspective but enjoyable as part of the total ensemble. Or a can heaped with garbage may be offensive to smell but attractive to sight. Or villainy, which is morally minus, may be aesthetically plus—for the villain is often the most interesting character in a play. Even if he is a real-life villain, he may be fascinating to contemplate aesthetically.

In most of our discussion in the first part of this chapter, we used "interest" and "value" in a generic sense. We spoke of the aesthetic interest, the economic interest, the scientific interest, and so forth; or conversely, the value of the aesthetic experience, the value of economic well-being, or the value of scientific knowledge. But it is possible to use "value," "interest," and "object" in a specific way. We are then referring not to a generic type but to a particular instance. For example, when someone appreciates the unusual color arrangement in a Matisse painting, the appreciation is the specific interest, the color arrangement is the specific object, and the specific value is a quality of the whole complex of this object related to this interest. In most instances, the context will indicate just how we are using our terms, whether generically or specifically.

Another distinction is between actual and potential value. The value is actualized whenever there is an interest in the object, but if no interest has been excited, we may still speak of potential value, meaning that the object *would* arouse interest under certain conditions. It has potential value by virtue of its possibility of being valued. There are many objects in nature, for example, that have not as yet attracted enough notice to be appreciated, but they may have potential value in the sense that they are fit to excite interest. A neglected work of art may be worthy of being appreciated though no one is presently appreciating it. For this reason we can say that there are "values" that are not appreciated even though they ought to be. But the only adequate test of such potential value is its actualization. Just as the combustibility of gasoline is manifest only when it is burning, so the value-making capacity of an aesthetic object is manifest only when it actually evokes appreciation. In its full and strict meaning, value requires all three components—the subject, the object, and their interlocking relation.

A distinction must also be drawn between instrumental and intrinsic value. An instrumental value is a means to an end—for example, the ploughing of a field is a means to growing a crop; the crop, in turn, is a means to reaping a profit; the profit, finally, is a means to the satisfactions of a higher standard of living. Instrumental value might seem to be independent of interest—vitamins, for example, were a means to sustaining Rembrandt's health even when neither he nor anybody else was aware of them. But there must be an indirect relation to interest even in such instances. Something is instrumentally valuable only because it is a direct or indirect means to intrinsic value, and intrinsic value is that which is valuable in itself, as an end, or for its own sake.

Intrinsic value may be called a "consummation" or "consumma-

tory value," indicating that it is a fulfillment of an act or striving. The aesthetic value of a work of art is terminal in the sense that interest or striving is consummated in and through it. John Dewey, while agreeing that the joy of consummation is characteristic of art, declares that works of art are at the same time instrumental to renewed or fresh consummations. Otherwise they would not sustain interest long, they would not influence life so pervasively, and they would soon turn to the ashes of boredom. Hence Dewey speaks, in reference to art and aesthetic experience, of "the continuity of means and ends." [14]

In concluding this chapter, we are aware that "value" is often characterized in other ways, and that there have been innumerable disputes concerning its proper usage. These other characterizations may be entirely legitimate in a different context or from a different perspective. For our purpose, it is enough to stipulate the definitions we have given, but if the reader wishes to explore the subject further there is a large body of philosophical literature at his disposal.[15] To understand this book, it is necessary to bear in mind the definitions and distinctions as we have stated them.

Our intent is to proceed not in a spirit of dogmatism but in a spirit of inquiry. We shall take our data, the field of aesthetics, as it actually comes before us in all its lasting and changing variety of kinds, forms, purposes, preferences, and effects. In this spirit we will not prescribe to artists any more than to nature, nor legislate to critics, nor seek to dictate tastes and enjoyments. These things and these activities are what we accept as our data. All that we expect of them is that, like other facts which somehow regularly go together in other fields, they make some sort of sense, that they be collectively intelligible. Our guess or our hypothesis is that they do make sense in terms of a common basic concept which is definite enough to be enlightening and broad enough to bring together in understanding that great multiplicity and variety of activities, interests, and things which range from the simple enjoyments of sights and sounds in nature to the complex and cultivated experiences with great works of art—painting, music, literature, and so forth. This basic concept we have called "aesthetic value." The questions: What sort of meaning shall we give to this concept? and In what relations does aesthetic value stand to other values? are the continuing questions in the chapters that follow.

[14] *Experience and Nature*, rev. ed. (La Salle, Ill.: Open Court Publishing Company, 1929), Chap. 9.

[15] See the article and bibliography on "Value and Valuation" by William K. Frankena, in Paul Edwards, ed., *The Encyclopedia of Philosophy* (New York: The Macmillan Company and The Free Press, 1967), 8:229–32.

AESTHETIC OBJECT

The Aesthetic Object and Its Qualities

As Chapter 1 indicates, values are analyzable into objective and subjective components. Their union produces a gestalt or configuration. The qualities of the object and the interest of the subject combine to constitute value. If a person speaks of either the object or the interest *alone* as a "value," he is using the word in a derivative and incomplete sense. This is eminently true of aesthetic value, in which the subjective and objective elements mesh very closely together to constitute felt quality. Let us not lose sight of the relational nature of aesthetic value. As long as we remember that value is to be found only in the whole relational complex I-R-O, no misunderstanding can result from the distinction between object and interest. We shall concentrate in this chapter on the object, in Chapter 3 on the interest, and in Chapter 4 on the relation.

We can begin our discussion by pointing out typical examples of aesthetic objects, thus indicating in a rough way what we are talking about. Such pointing is illustrated by Stephen Pepper in the following passage:

In the aesthetic field, for example, it is generally acknowledged that the poems, pictures, statues, musical compositions of the great artists are aesthetic materials, and also many buildings such as medieval cathedrals, and fondly made tools like paddles and baskets and pottery of primitive peoples, and dance and ritual, and also certain perceptions of nature like the sea and starry nights and sunsets and pleasant pastures and groves and sometimes fear-inspiring scenes like storms and mountains, and waterfalls.[1]

As Pepper remarks, to deny that these are works of art or objects of beauty or sublimity is contrary to common sense, and any plausible definition of the aesthetic field must fit such examples.

But pointing out aesthetic objects does not take us very far. We can conclude from Pepper's examples and other similar listings that both human artifacts and natural objects may be aesthetic, and we can note the great variety of things that are so classified. We can remark that things such as waterfalls and sunsets, or the pictures and statues and musical compositions of great artists, are all vivid objects and fascinating to see or hear. We may be a little hesitant about including paddles and baskets and pottery, asking ourselves just how "fondly" they must be fashioned before they become aesthetic and cease to be merely utilitarian. Or we may note that rituals, among the things listed by Pepper, may be humdrum and not truly felt as aesthetic. We can question why certain things are *not* included, such as very sentimental pictures, or awkward mechanical contraptions, or landscapes so flat and monotonous that we hardly give them a second glance, wondering whether these objects are incorrigibly nonaesthetic, or whether in certain moods or from certain perspectives they take on aesthetic quality. As soon as we ask these questions, we are doing more than pointing—we are interpreting and theorizing. We do not even know what to point at until we have some idea of the difference between aesthetic and nonaesthetic objects.

It is not so difficult to tell the difference in pointing to objects in nature. Any natural thing or quality can be considered "aesthetic" if it delights the beholder by the bare fact of its being apprehended. "Let that be called *beauty*," said Saint Thomas Aquinas, "the very perception of which pleases." [2] No more simple and satisfactory definition of beauty has ever been suggested. It contains two ideas. First, beautiful things give pleasure. Second, not everything that gives pleas-

[1] Stephen C. Pepper, *The Basis of Criticism in the Arts* (Cambridge, Mass.: Harvard University Press, 1965), pp. 22–23.
[2] *Summa Theologica*, I-a II-ae, q. 27, trans. Wladyslaw Tatarkiewicz, *History of Aesthetics* (The Hague: Mouton, 1970), 2:258.

ure is beautiful, but only that which gives pleasure in immediate perception. We do not call a thing beautiful if it gives us pleasure for some other reason, for example, because it is useful or edifying. The sublime in nature is also considered aesthetic. Sublimity is contrasted with "beauty" in the narrow sense, but it is a subdivision of "beauty" in the very wide sense. So considered, it is a quality in objects "the very perception of which pleases" by awakening awe, reverence, lofty emotion, a sense of immense power or magnitude. In the narrow sense of beauty, a daisy is beautiful but the starry heavens are not; but in the wide, robust sense of beauty, few natural objects are as beautiful as the stars in all their splendor. There are other qualities in nature (such as gracefulness) that are aesthetic, but most of these can be considered subdivisions of beauty.

It is much more difficult to identify human artifacts as aesthetic or nonaesthetic. One reason is that there are many different kinds of things that are called works of art. There are things made by artists and placed on public display, such as statues and paintings in art museums, or similar works displayed in the privacy of a home or office. Then there are prints and copies of paintings and copies or casts of sculpture as distinguished from the originals. There are also etchings or lithographs rendered in multiple copies, each one of which is equally "original." There are novels, poems, and texts of plays extant in few or many copies; and there are literary works transmitted only by oral tradition, such as the Indian *Vedas* before the invention of written language, and folk songs preserved only in memory and occasional performance. There are scores and scripts that are no more than instructions for performers, and performances of plays, television scripts, musical compositions, and ballets that follow more or less faithfully the instructions. There are clowns, acrobats, dance improvisers, and persons engaged in "happenings" following no instructions at all. There are many buildings, machines, and tools designed for some useful purpose that may nevertheless evoke aesthetic appreciation. Similarly, there are performances, such as sports, military parades, and religious rituals, that are carried on for some end other than aesthetic. All of these, including those not so intended, may be the objects of aesthetic contemplation.

We shall not undertake to answer the extremely difficult epistemological question, that of the mode of existence of these innumerable objects and artifacts. But it is clear that they exist in various stages and modes, some in the mind, some in preliminary sketch, and some in physical actualization. Also, some are duplicates, others are not; some are originals, others are copies. Some works of art, like nonpro-

grammatic music and nonfigurative painting, refer to nothing beyond themselves; others symbolize or represent things in "real life," and these representations and symbolizations likewise evoke aesthetic interest.

When the objective component in aesthetic value is so varied, it may seem impossible to pin it down or sum it up in a definition. But it seems to us possible, if not to define, at least to reach valid conclusions. We can say that an outstanding characteristic of incontestably aesthetic objects, whether they be works of art or things in nature, is their qualitative force and vivacity. Take any arresting objects, such as migrant birds passing from darkness into darkness across the moon, and they become aesthetic the moment they are appreciated as sheer spectacle. Unless there is some quality to arrest attention, unless the object has character and distinction, unless it stands out as vivid and memorable, unless it has a peculiar lustre of its own that we can snatch from the common dust, there is likely to be little aesthetic value or none at all. The object of aesthetic value, we can conclude, is a thing or quality that is fascinating in direct apprehension. We are using the word "quality," let us not forget, in a very inclusive sense to denote any aspect, characteristic, or attribute of a thing, including its intrinsic and relational properties, its form and its constituents.

It might be objected that we are slipping back into the purely objective or nonrelational view that aesthetic value is in the object alone and that the subjective part is simply one of recognition. Our intention, however, is not to contradict the relational theory. In the first place, the object may be purely imaginary, the fine arts being the very homeland of creative imagination. And in the second place, few objects, if any, are incorrigibly nonaesthetic. Even a handful of grass, said Walt Whitman, can excite marvelling contemplation. Some of the devices of avant-garde artists, such as John Cage's evocation of strange, hitherto unnoticed sounds and silences, or the "minimal" artist's gouging out an interesting shape in mud, are intended to broaden people's ideas of what *is* "quality to arrest attention." We must recognize, nevertheless, that some objects are much more fit to be aesthetically appreciated than others. A very simple object, such as a single isolated dot, could scarcely attract or long hold aesthetic interest. Unless we are to discount the objective factor altogether, we must recognize that some objects, because of their inherent limitations, are aesthetically worthless or nearly so. Here, as elsewhere, we are simply insisting on the relational nature of aesthetic value—two sets of factors are always involved: those in the object and those in the percipient.

What is worthy of aesthetic appreciation may pass unnoticed until

there is someone who looks with fresh eyes. So enslaved are most people to the stereotypes of expectation that they are unable to see what is plainly before them. Custom lies upon them "with a weight, heavy as frost, and deep almost as life." As Victor Sklovskij, a Russian literary critic, writes:

> People living at the seashore grow so accustomed to the murmur of waves that they never hear it. By the same token, we scarcely ever hear the words which we utter. . . . We look at each other, but we do not see each other any more. Our perception of the world has withered away; what has remained is mere recognition.[3]

The function of the artist, according to Sklovskij, is to excite a sense of the strangeness and beauty of even the most common thing. This he does by seeing it afresh and lifting it to the "sphere of new perception." Similarly Wordsworth, in his famous Preface to the *Lyrical Ballads*, speaks of "a certain coloring of the imagination, whereby ordinary things should be presented to the mind in an unusual way." Coleridge noted Wordsworth's "gift of spreading the tone, the *atmosphere*, and with it the depth and height of the ideal world around forms, incidents, and situations, of which, for the common view, custom had bedimmed all the lustre, had dried up the sparkle and the dew drops." [4] Charles Peirce cites the example of our ordinary perceptions of color as contrasted with the perceptions of the gifted painter:

> When the ground is covered by snow on which the sun shines brightly except where shadows fall, if you ask any ordinary man what its color appears to be, he will tell you white, pure white, whiter in the sunlight, a little greyish in the shadow. But that is not what is before his eyes that he is describing: it is his theory of what ought to be seen. The artist will tell him that the shadows are not grey but a dull blue and the snow in the sunshine is a rich yellow.[5]

The impressionist movement, as represented by such painters as Monet, Pissarro, Sisley, and Bonnard, was an attempt to see and capture the splendors of color, the subtleties of light and shade, and the shimmering atmospheric veil that enwraps a scene under certain optical conditions.

3 Quoted by Victor Erlich, *Russian Formalism*, 2nd. ed. (New York: Humanities Press, 1965, and London: George Allen & Unwin Ltd), pp. 176–77. Reprinted with permission of Humanities Press, Inc.

4 Samuel Taylor Coleridge, *Biographia Literaria*, ed. J. Shawcross (Oxford at the Clarendon Press, 1907), 1:59. Similarly, the surrealists have characterized art as a "renascence of wonder" and "an act of renewal." For similar statements by T. S. Eliot, Jean Cocteau, and others, see Erlich, *Russian Formalism*, pp. 179–80.

5 *Collected Papers of Charles Sanders Peirce*, eds. Charles Hartshorne and Paul Weiss (Cambridge, Mass.: Harvard University Press, 1931–1935), sec. 5.42.

The impressionist movement provoked such derisory comments as the retort, "I never saw a purple cow." But given the necessary optical conditions, there *are* purple cows and the man who is blind to such fugitive impressions is the poorer for his blindness. If the spectator is to see objects as they really appear, he has to trust his eyes and ignore his expectations.

The painter, of course, may choose to stress quite other features of objects than these evanescent effects. Paul Cezanne began as an impressionist but developed an idiom and vision of his own. He noticed, as had the impressionists, that light both reveals and destroys form, sometimes robbing the object of its own color and solidity and bathing it in an iridescent atmosphere. To record these transient appearances did not interest him. In his most characteristic painting, he emphasized solid and massive forms, building up sturdy three-dimensional shapes by the structural use of color, and relating conceptualized objects to one another in both pattern and deep space. His favorite subject was the massive shape of Mont Sainte-Victoire, the creation of innumerable centuries of geological formation and attrition. He preferred to paint still objects, whether a mountain or an arrangement of fruit, impatiently bidding his posing wife, "Be an apple!" Characteristically, he remarked that nature can be resolved into the cylinder, the sphere, and the cone. His paintings are exercises in a kind of Platonic geometry which clarifies the enduring essences and structural harmonies of nature.

Both Monet and Cezanne make us see afresh, make us see what otherwise we would not see at all. The contrast between these two painters is instructive because they call attention to opposite qualities, but actually they do not contradict each other. Whatever they as artists or others as critics may say about their respective art practices, they do not gainsay each other. Art works of differing kinds do not say or imply, *this* is the way things *really* are, but rather, things are *also* this way. The artist, in effect, does not ask what is something *truly*, but asks rather, what *else* is it? Given honest perception, art collectively contains no contradictions, no denials, no corrections. It rounds and fills out the world of appreciations, and does not subtract from that world. The works of both Monet and Cezanne, and indeed of every true artist, can be cited as evidence that art leads to a heightened and extended awareness. "To follow the arts is to walk the earth with heightened awareness," as Brooks Atkinson has said.[6]

The features to which we respond aesthetically can be found not

[6] *The New York Times,* May 11, 1961.

only in the expanses of earth, sea, and sky, but in the man-made scenery of town and city, as portrayed, for example, in the paintings of Utrillo and Dubuffet. Or we may turn away from the physical environment altogether and explore "the labyrinthine ways" of the mind or the dramatic confrontations of human beings in their social milieu. In novel, play, and motion picture, our attention is directed to the nuances of character, the clash of wills, and the patterns of destiny. In Dostoevsky's novel *Crime and Punishment*—to cite a single example—the falling snow or the sunlight breaking through the clouds is scarcely noticed at all, and even urban scenery is the scantiest. Instead we have a blaze of light on the interior workings of a young man's conscience.

Visionary artists, such as William Blake or Odilon Redon, may be far less concerned with ordinary sensory data than with the world of the spirit or the upsurgings of the unconscious mind. And modern "abstract" painters, such as Mondrian and Kandinsky, or in more untrammeled style, Sam Francis and Jackson Pollock, have been fascinated by the emotionally evocative power of lines and shapes and colors, or the properties of design.

We have scarcely more than hinted at the range of even a single art such as painting. If, in addition, we include all the qualities embodied in dance, music, sculpture, and architecture and in all the literary and dramatic arts, the variations are inexhaustible. This whole gamut of aesthetic qualities—natural and artificial, introspective and extrospective, representational and presentational, real and visionary, intellectual and emotional—is infinite in scope and variety.

There is no obvious and simple classification of all these aesthetic data, but philosophers sometimes refer to primary, secondary, and tertiary qualities. This threefold classification is incomplete and must be supplemented by the myriad qualities of social life, introspective experience, and kinaesthetic and other somatic excitations. Despite this incompleteness, it may be illuminating to characterize aesthetically the three classes mentioned. We shall leave out of account the epistemological theories associated with this classification and mention only the phenomenal appearances.

The *primary qualities* are the more abstract and measurable properties of objects—number, extension, shape, weight, and motion. When abstracted and measured, they are more often the data of science than of art and aesthetic experience, constituting as they do the bare mathematical skeleton of the world. But as Edna St. Vincent Millay reminds us in her sonnet, "Euclid Alone has Looked on Beauty Bare," there is a kind of pure and rarefied beauty in these formal structures.

Without having in mind modern interpretations of primary qualities, Plato found absolute beauty and unalloyed pleasure in contemplating line, shape, and mass:

> I do not now intend by beauty of shape what most people would expect, such as that of living creatures or pictures, but . . . I mean straight lines and curves and the surfaces or solid forms produced out of these by lathes and rulers and squares. . . . For I mean that these are not beautiful relatively, like other things, but always and naturally and absolutely; and they have their proper pleasures, no way depending upon the itch of desire.[7]

This passage has been cited many times by the defenders of geometricized art, but few of us want to limit our tastes to things so rarefied and formal.

Primary qualities may be abstracted and emphasized as in diagrams made with ruler and compass, but they never occur in aesthetic perception all by themselves. Number without something to be numbered, extension without something to be extended, shape without something to be shaped, and motion without something to be moved, are unreal abstractions. Quite different is the motion of a dancer, the shape of a building, the length of a musical phrase, or the number of stressed syllables in a line of poetry. When thus conjoined with other features, the primary qualities contribute a necessary firmness of structure, providing the formal nexus to materials that might otherwise be too amorphous and chaotic to be called aesthetic objects.

The *secondary qualities*—sounds, colors, odors, tastes, and textures —are the more vivid but less measurable sensory properties. These lively qualities of natural objects—for instance, the musty reek of dead leaves, the feel of rain-drenched moss under bare feet, or the rustle and creaking of trees in a windstorm—are more often than not the most striking features aesthetically. Color, rather than bare abstracted shape, makes a sunset memorable:

> *Its edges foamed with amethyst and rose,*
> *Withers once more the old blue flower of day:*
> *There where the ether like a diamond glows*
> *Its petals fade away.*[8]

[7] Plato, *Philebus,* 51 B. Trans. E. F. Carritt, *Philosophies of Beauty from Socrates to Robert Bridges* (New York: Oxford University Press, 1931), p. 30. By permission of The Clarendon Press, Oxford.

[8] A. E. (George William Russell), "The Great Breath," *Collected Poems* (London: Macmillan & Company, 1931), p. 9. Quoted by permission of A. M. Heath and Company Ltd on behalf of the Estate of the late A. E.

Whether occurring in nature or art, secondary qualities are the main source of sensuous richness. Art becomes merely schematic and almost ceases to be art when it loses this vividness of sense qualities.

If the primary qualities run the danger of being too abstract and vacuously formal, the sensory qualities, with the exception of sound and color, run the danger of not being formal enough. The qualities of touch, taste, and odor, lacking any intrinsic principle of order such as pitch or hue, are difficult to articulate and compose in analyzable structures. For this reason, the attempt of Des Esseintes, the hero in H. K. Huysmans' novel *Against the Grain*, to construct "symphonies" of tastes and odors is rather ludicrous. Sounds, in contrast to odors and tastes, can be deployed in complex relations of pitch, timbre, intensity, and duration, and musical composition can be rendered precise by the use of scales or other notation. Likewise the dimensions of color—hue, saturation, and degree of light or dark—afford a natural basis for composition, and when combined with the primary qualities of line, shape, and mass, take on definite structure. But other sensory qualities, such as tactile impressions, are not to be excluded from the aesthetic sphere, and especially when combined with structural properties, may contribute greatly (as Bernard Berenson contends in his *Florentine Painters of the Renaissance*) to aesthetic value.

The *tertiary qualities*—such as the gaudy, robust, graceful and delicate—are properties of phenomenal objects. In philosophical use, a "phenomenal object" is an immediate object of perception as opposed to a thing existing independently of human experience. When we say that tertiary qualities, such as the somberness of Picasso's *Absinthe Drinker* or the lilt of Strauss' *Blue Danube* waltz, are phenomenal, we mean that they belong to things as they appear—not to things-in-themselves that are inferred to exist apart from appearances.

The aesthetic meaning of "tertiary qualities" seems to have originated in the use of the term by the British philosophers Bernard Bosanquet and Samuel Alexander. Bosanquet spoke of "beauty and delightfulness" and similar qualities as "tertiary." "A thing may be charming," he remarked, "quite as really and truly as it is red; but its charm . . . must be a mind-dependent attribute (for to be charmed is a mental act)," whereas redness can plausibly be regarded as "physical and mind-independent." [9] He was apparently the first person to use the term "tertiary qualities" to designate not only specific aesthetic qualities but also the generic values "goodness, truth, beauty."

[9] *The Distinction Between Mind and Its Objects* (Manchester at the University Press), 1913, pp. 22–23.

Commenting on this latter use, Alexander pointed out that beauty is the only one among the three values that "attaches directly to things; for truth attaches to propositions, and goodness to actions":

> . . . Beauty depends . . . on characters imputed to the work by the artist or spectator. Thus dead marble looks alive and full of character, or in a picture stable forms are seen, aesthetically, to be in motion, for instance, to be dancing. . . . The artist introduces himself into his art, giving the work characters which it only has so far as seen with the aesthetic eye.[10]

Alexander, like Bosanquet, pointed out that tertiary qualities, resulting from "the amalgamation of the object with the human appreciation of it," are more subjective than the primary and secondary qualities. "In the case of beauty," he remarked, "the connection between mind and object is much more intimate" than in the case of goodness and truth, because "the beautiful object is not merely considered along with its contemplating subject, but they are organic to each other. The object then seems to us to possess as it were a new quality, comparable to that of color. It is charming as well as red or sweet." [11] Later writers have referred to objects as eerie, somber, majestic, garish, strident, and so forth, extending the meaning of "tertiary qualities" to apply to all such characteristics. Indeed, all of us in ordinary speech refer to a fire as cheerful, or a song as gay, or a lake as calm, or a windstorm as turbulent.

A tertiary quality is a felt quality, but every other *aesthetic* quality is also felt. Whether red, for example, may exist as an objective quality independent of any perceiver, we need not presently decide; but if it does exist unperceived and unfelt, or if it is cognized without the least feeling, it is not actually aesthetic. Likewise in the case of lines, shapes, tones, textures, and space and time relations: if unfelt, they lie outside the aesthetic domain. A curvilinear line, for instance, has a different "feel" from a zigzag line—otherwise it would have no aesthetic expressivity. The same kind of remark applies to any other quality. An aesthetic quality is not an abstraction from the vital context of life—it is concrete and full-bodied and feeling-toned. Hence, when used in an aesthetic context, the word "quality" always means "*felt* quality."

"Tertiary qualities" often go by other names, such as "physiognomic properties," "emotional qualities," and "feeling import." Some of these names may be less misleading than "tertiary qualities." The

[10] Samuel Alexander, "Qualities," *Encyclopaedia Brittanica* (1944), 1:264.

[11] Samuel Alexander, *Space, Time and Deity* (London: Macmillan & Company, 1920), 2:239. Reprinted with permission from Macmillan London and Basingstoke.

word "tertiary" seems to imply that there are three distinct levels of quality, and that the tertiary qualities are what are left after we have subtracted the primary and secondary qualities. This way of thinking implies a too-sharp distinction and externalistic relation between the three kinds. When primary and secondary qualities are perceived as aesthetic, they too are felt qualities. There is no sharp distinction between them and the tertiary. Charles Hartshorne, with only a touch of exaggeration, has said:

> The "affective" tonality, the aesthetic or tertiary quality, usually supposed to be merely "associated with" a sensory quality is, in part at least, identical with the quality, one with its nature or essence. Thus, the "gaiety" of yellow (the peculiar highly specific gaiety) is the yellowness of the yellow.[12]

Even though the yellow is "gay" (a word used analogically and not literally), the gaiety is not the yellowness of yellow, "one with its nature or essence"—it is an affective tonality analytically distinguishable from but firmly attached to the yellow. Although we make a distinction between the tertiary quality and the primary or secondary quality, no such separation is made within the aesthetic experience itself.

Hence we must reject the sharp distinction drawn by Frank Sibley between the "aesthetic" and "nonaesthetic" qualities in works of art.[13] He contrasts the "aesthetic properties," such as the "dramatic," "graceful," "dainty," or "garish," with the "nonaesthetic properties," such as "red," "circular," "loud," or "high pitched." Aesthetic sensitivity, he says, is required to perceive the aesthetic properties, but not to perceive the nonaesthetic properties. The distinction, he declares, is perfectly obvious, and there is no need to defend it.

The plausibility of his contention depends on a shifting back and forth from an aesthetic to a nonaesthetic perspective. In the latter perspective, no aesthetic sensitivity is required to perceive the "nonaesthetic properties." For example, a workman who is concerned only with fitting a painted canvas into a packing case would need no aesthetic sensitivity to be aware of its colors and shapes. But to the beholder who looks at the painting with an aesthetic eye, the colors and shapes are just as aesthetic and vibrant with feeling as any other features of the painting. In fact, the dominant tertiary quality is indi-

12 *The Philosophy and Psychology of Sensation* (Chicago: University of Chicago Press, 1934), p. 7. In our comment on Hartshorne's statement we are indebted to Louis Arnaud Reid, "Feeling and Expression in the Arts," *Journal of Aesthetics and Art Criticism*, 25 (1966), 132–34.

13 "Aesthetic Concepts," in Joseph Margolis, ed., *Philosophy Looks at the Arts* (New York: Charles Scribner's Sons, 1962), pp. 63–87.

visible from the primary and secondary qualities, because it is an emergent or regional quality that permeates and infects all the others.

One reason for the aesthetic importance of tertiary qualities is that they are more pervasive and integrative than other qualities. In a work of art, the dominant tertiary quality is an all-pervasive influence in determining other contents. It runs through all details, gives meaning to each, and binds them all together. "The underlying unity of quali-tativeness," as Dewey declares, "regulates pertinence or relevancy and force of every distinction and relation." [14] It demarcates the work from others, gives it the stamp of individuality and creates a total unity of mood. A truly original work of art is the revelation of some new and perhaps nameless tertiary quality, and for the full realization of the quality we have to experience the whole work of art.

We have now summarily characterized the objective constituent in aesthetic value. If there is a single term for this constituent, it is "felt quality," meaning any feature that is distinctive enough to invite contemplation and vivid enough to excite feeling. We have tried to indicate something of the character and the range and variety of this qualitative content. Although we have been speaking of primary, sec-ondary, and tertiary qualities, we do not mean to limit the content to these categories. Anything at all that is "perspicuous and poignant" may be the object of aesthetic interest.[15]

Our way of characterizing this objective component in aesthetic value may give rise to misunderstanding. When the word "quality" is used, a person is more likely to think of a single constituent in an aesthetic complex than of the entire complex. He might, for ex-ample, speak of the quality of color in a painting without intending to refer to the composition as a whole. If "quality" were understood *only* in this limited sense, it would be misleading. Although we do not agree with extreme formalists who would limit aesthetic value to the all-enveloping form of the object, we do not wish to disparage the formal aspect. Unless there is an "underlying unity of qualitative-ness," to recall Dewey's phrase, the object is aesthetically poor or de-fective. The internal harmony of a work of art is of paramount im-portance aesthetically, but this pervasive order has its own qualitative character.

Content and form, although distinguishable, are inseparable. No content is wholly formless, and all form is the form of some content.

14 John Dewey, "Qualitative Thought," in *Philosophy and Civilization* (New York: Minton, Balch and Company, 1931), p. 99.

15 See J. N. Findlay, "The Perspicuous and the Poignant: Two Aesthetic Funda-mentals," in Harold Osborne, ed., *Aesthetics* (London: Oxford University Press, 1972).

In aesthetic experience, the unity of content and form is especially close. The content is the elements-in-relation, the form is the relations-among-the-elements, and the aesthetic object is the content-and-form inseparably joined. The phrase used by the painter Ben Shahn as the title of his book, *The Shape of Content* (Harvard University Press, 1957), epitomizes this inseparability. When we use the word "quality," therefore, to denote the objective component in aesthetic value, we do not intend to emphasize the content aspect at the expense of the form, nor the form aspect at the expense of the content. We intend to include both.

The Principles of Form

A work of art is indivisible; it cannot be broken up into units with independent meanings. Yet critics and aestheticians talk about distinguishable principles of form, such as rhythm and thematic variation, and any keen observer notices such formal aspects. There is no harm in distinguishing them as long as we bear in mind the involvement of every element and aspect in the total fabric of the work.

The principles of form are referred to by such terms as thematic repetition and variation, balance, rhythm, progress or evolution, emphasis and subordination, and conformity to type. In addition, there is the all-embracing principle of unity in variety—a principle metaphorically designated as "living form" or "organic unity." When embodied in a work of art, these principles belong among the objective components in the relational complex, I–R–O.

Thematic repetition and variation. The same pattern may be repeated in a wallpaper design; the same color may appear in separated areas of a painting; a tonic chord may be repeated in a musical composition; identical columns may appear in a building; or the same refrain may appear in a poem or song. Although exact repetition is sometimes very effective, its danger is monotony. Hence the need for variation, as in the repetition of a musical motif by some other voice or instrument, for example, when the melody inaugurated by the cello in Schubert's *Symphony in B Minor* is repeated by all the strings, or when the theme of the second movement of Rimsky-Korsakov's *Scheherezade* is rendered successively by bassoon, oboe, strings, and flute.

To repeat with a difference is one of the common devices in all the arts. In combining familiarity with strangeness, it avoids the monotony of mere repetition and the chaos of mere difference. In music, there may be repetition on different instruments, at different tempos,

with different keys, with different intervals, with different harmonies, or with variations in melodic pattern. In the visual and plastic arts, there may be variation in size, hue, intensity, lightness or darkness, line, shape, mass, texture, perspective, symbolism, or representational detail. It is possible to illustrate repetition and variation with examples drawn from literature, music, dance, sculpture, painting, moving pictures, architecture, and the industrial arts, but a single illustration from Shakespeare's *Hamlet* must suffice. The following sketchy analysis of parts of the first and second scenes is suggestive of the continuity in other parts of the play.

The opening scene is that of a change of guard on the ramparts of the castle of Elsinore. It is deep night and very cold. A misdirected challenge on the part of the oncoming guard suggests a state of extreme tension. One of the guards on post says to his replacement:

> *For this relief much thanks. 'Tis bitter cold*
> *And I am sick at heart.*

He is never seen or heard of again in the play, and he might be passed over at first reading as merely a fill-in or bit character in the background. But his words, "I am sick at heart," emotional material already supported by the night, the bitter coldness, and the loneliness of the watch, soon turn out to be the first striking of a major theme of the drama. In the next scene, the theme is taken up, varied, and enlarged. It is treated first in sheer spectacle through contrast, visual and auditory. The stage is dominated by the royal procession, the king and queen, councilors and attendants. There is color, pomp, gaiety, laughter and lively conversation, fanfare of trumpets. And against all this, at a distance behind, the lone, silent, somber figure of Hamlet in "inky cloak"—visual "heartsickness" the theme. The dialogue, when he is soon drawn in by the king and queen, repeats it and varies it; and finally when the court goes off and leaves him alone, the heartsickness is uttered directly in the soliloquy, "O that this too too solid flesh would melt."

The theme, of course, continues through the play. But this is enough to show its substance and direction. A bit of action compounded of night, cold, military routine, royal pomp, dejection, and conflict of emotion and will, all strung on a thread of "heartsickness," yields a marvelously intricate yet closely composed experience, in which there is both thematic continuity and progression toward the tragic denouement.

Balance. The meaning of balance may be illustrated by a playground seesaw. If the seesaw is to work, there must be balance either symmetrical or asymmetrical. Children of the same weight may balance each other by sitting in the same relative position; or the weight of

an adult may be balanced by the weight of two children; or a child who is heavier may balance a child who is lighter by moving closer to the center. Thus, there may be a balance of similarity or contrast, but in either case there must be some equality of weight.

In a work of art, balance likewise involves some kind of equality —of scale, emphasis, proportion, or interest. Lack of balance produces lopsidedness—for example, when one side of a painting lacks interest in comparison with the other. As in the example of the seesaw, the balance may be of likes or unlikes, and of any degree of likeness or unlikeness. The balance of similars is called symmetry, and of dissimilars, asymetrical balance or contrast. Often the two are combined. For example, in a painting the lines and masses might balance symmetrically while the colors might balance asymmetrically (a cold blue, for example, balancing a warm orange). The balance may be on a horizontal, vertical, or diagonal axis.

Symmetry is more applicable to the spatial arts, such as painting, sculpture, and architecture, than to the more dynamic temporal arts, such as music, dancing, moving pictures, and drama. But even in the spatial arts, perfect symmetry is likely to prove uninteresting, because it involves less variety than does contrast. Hence many architects, sculptors, and painters prefer asymmetrical balance. In music, there is frequently a symmetrical balance between the earlier and later parts of a composition—for example, in the length of the movements; and symmetry is employed, to some extent, in all the other temporal arts.

Contrast may be illustrated by innumerable examples—between light and dark, warm and cold, and bright and dull colors; straight and curved, and horizontal and vertical lines; heavy and light, and big and little masses; near and distant objects; blank and patterned surfaces; rough and smooth textures; high and low, and loud and soft notes; sound and silence; slow and fast movements; calm and excited moods; sad and gay emotions; good and bad, comic and tragic, male and female, and young and old characters; victorious and defeated forces in a novel or play. When each of the contrasting factors is given approximately equal emphasis, there is a balance of contrasts, and this is often more satisfying than a disproportionate emphasis upon one factor as opposed to another. But it is necessary to take account of the need for emphasis and subordination—a principle that may run counter to balance.

Rhythm. This is not a separate principle but a combination of balance and repetition. In the rhythm of waves, for example, the crests are balanced by the dips, and both crests and dips are repeated. But rhythm is so important that it deserves separate consideration. It may be achieved in numerous ways, for example, by size: large–small; by

length or duration: long–short; by tempo: swift–fast; by accent: loud–
soft; by pitch: high–low; by color: warm–cold, bright–dull, light–dark.
Whenever there is measured alternation, there is some kind of rhythm.

Rhythm is very important in the temporal arts, especially poetry,
dancing, and music. Eduard Hanslick, the famous musical aesthetician,
called it the "main artery of the musical organism." [16] But the explora-
tion of recurrent similarities and differences in spatial objects may have
a rhythmical character. The up and down thrust of a zigzag line, for
example, appears rhythmical to an observer who takes the time to run
his eye along it. Similarly, rhythm can be felt whenever one surveys
the measured alternation of light and dark, of contrasting hues, of
contrasting shapes, of large and small units, of filled and empty spaces,
of near and far objects, of horizontals and verticals, or of other effects.

Rhythms may be varied in innumerable ways. Instead of contrast-
ing pairs, there may be an alternation of more complex clusters. The
compound and complex rhythms of poetry, music, dancing, and even
the visual arts, may be highly involved. The rhythms may be regular—
when similar measures occur in sequence—or irregular—when dissimilar
measures occur. Rhythms may cross, conflict, or commingle.

To be interesting, rhythm must be somewhat complex and varied,
as in musical syncopation. No one can sustain interest in rhythms that
are as simple and monotonous as the ticking of a clock. The variations
in rhythm are frequently expressive of a changing mood or meaning.
A faster rhythm may express joy; a slower rhythm, sorrow. In Shelley's
"Stanzas Written in Dejection Near Naples," the poem begins with
a lilting rhythm:

> *The sun is warm, the sky is clear,*
> *The waves are dancing fast and bright.*

But the rhythm gradually changes, as the mood of dejection deepens,
to a slower pace, until the lines that envisage the poet's death by
drowning take on a solemn and majestic tempo:

> *Till death like sleep might steal on me,*
> *And I might feel in the warm air*
> *My cheek grow cold, and hear the sea*
> *Breathe o'er my dying brain its last monotony.*

Expressive variation in rhythm is one of the main sources of aesthetic
effect.

Progress or evolution. In rhythm, there is no necessary devel-

[16] *The Beautiful in Music* (New York: Liberal Arts Press, 1957), pp. 47–48. See
also Susanne Langer, *Feeling and Form* (New York: Charles Scribner's Sons, 1953),
pp. 126–27.

opment but only an alternation. Different is the way a novel, a play, a moving picture, or a musical composition as a whole unfolds, with a progress from beginning to end. Here there is no mere alternation but a growth and accumulation—a real evolution. The earlier parts contribute to the later; the later parts depend upon the earlier; so that there is a definite and irreversible movement from beginning to end. A story cannot be told backwards or a musical composition played backwards without ludicrous results.

Evolution obviously applies to the temporal arts, but there may also be movement and a felt sense of direction in the visual arts. In surveying a Gothic cathedral, the eye naturally starts at the bottom and sweeps upward until it reaches the topmost spire, rather than vice versa. In many of the paintings of El Greco, there is a similar upward lift; and in mural paintings, there may be a natural movement from one side to the other and from one picture to another, as the contemplator progresses through a related series of paintings.

Progress often takes the form of following a sequence of graduated qualities. As Stephen Pepper, in his *Principles of Art Appreciation*, points out, "a gradation consists in following a sequence of nearly related qualities. . . . Thus a sequence of grays from black to white would be a gradation, or a sequence of hues from red through orange to yellow." A similar progression "is possible with lengths and widths and degrees of curvature of lines, with sizes and volumes, with shapes such as gradations from circles into narrower and narrower ellipses, or from squares into narrower and narrower rectangles. In sound there is a gradation of pitches low to high, and of intensities from soft to loud. And so with all sense qualities." [17] Even identical objects can *appear* as gradations. For example, identical columns when seen in perspective diminish in apparent size. Or again, identical circles look more and more elliptical when spaced farther and farther away; or identical sounds appear softer and softer as we move away, or louder and louder as we approach. Whether the gradation is real or apparent, its contemplation involves a kind of progression. For example, when we run up the notes of a musical scale, we feel that we are "getting somewhere," and when we run through a gradation of colors, we have a similar sense of movement.

Emphasis and subordination. Certain qualities tend to be more emphatic than others: the loud rather than the soft, the bright rather than the dull, the big rather than the small, the swift rather than the slow, the discordant rather than the concordant, the tense rather than

[17] Stephen C. Pepper, *Principles of Art Appreciation* (New York: Harcourt Brace Jovanovich, Inc., 1949), p. 51.

the relaxed. When the qualities in a graduated series are so arranged that there is a progression toward a high point of emphasis and interest, we can speak of movement toward a climax. We are all familiar with climaxes in plays, novels, musical compositions, and moving pictures, but to a lesser extent we find climax in the visual arts when our attention passes through a graduated series to a peak of interest and intensity. Such a peak is usually in the center of a painting, and the gradations lead from the periphery into the center. For example, there may be color gradation from darker to lighter, beginning at the sides and reaching a climax in light, brilliant color at the central focus, as in Fra Angelico's "Madonna of Humility." [18] In the temporal arts, the climax often comes before the end, and the earlier upward movement is balanced by a swift downward movement, the resolution or denouement. Sometimes, as in Shakespeare's *Macbeth,* there are a number of climaxes, a succession of rises and falls—for example, in many symphonies, plays, novels, and dances. Emphasis may be achieved in other ways—by repetition, contrast, discord, focal position, size, color, tone, tempo, suspense, fullness of elaboration—without necessarily mounting to a climax.

Whenever there is emphasis there is subordination. To emphasize everything is to emphasize nothing; for example, no emphasis would be gained by italicizing every word in a book. Hence an artist must learn to modulate his emphasis—to practice restraint. He must work out a hierarchy of details, giving to each the relative degree of emphasis or subordination that is suitable. With the judicious use of subordination and emphasis, a work of art can contain a great wealth of detail without being cluttered. It is one of the principal means of reconciling unity with variety.

Type. One of the commonest ways of achieving organization is conformity to type. A type is any set of characteristics that serve to mark off a class of objects. When we look at the painting of a nude woman, for example, we have in mind the characteristics of the female human form. We recognize the type and see the details as fitting into a preconceived whole. The eyes, ears, nose, mouth, and hair fit together to constitute the head; and the head, arms, legs, stomach, breasts, and other features combine to form the larger pattern of the body. The nude figure, as a recognizable type, thus provides a compositional scheme to bring together and unify many details. In providing such schemes, representational subject matter has an important unifying function. But many artists prefer to deviate greatly from nat-

[18] This painting is reproduced in color (Plate I) and discussed with keen insight by Pepper in his *Principles of Art Appreciation,* pp. 52–56.

uralistic appearance for the sake of a more beautiful, or a more original and expressive, composition.

We have concepts of innumerable natural objects—animals, plants, mountains, streams, clouds, and so forth. To these we can add the man-made things—tables, chairs, articles of clothing, automobiles and airplanes, or any other human artifact. Each of these has a recognizable structure which can serve as a unifying factor in representational art. Usually a number of natural objects or artifacts are represented in a single work of art, and there is an overall subject that unites the various recognizable parts. Arrangement in terms of perspective, which is a type of spatial organization, is a scheme often used to order and unite the objects. In literature the overall scheme may be an incident or story. The Greek dramatists, for example, used the myths of gods and heroes to provide a familiar narrative structure. Types of character can also serve as schemata, as in Molière's depiction of hypocrisy, avarice, jealousy, hypochondria, religious bigotry, and other obsessions.

Not only are there human and natural types but such recurrent abstract forms as circles, squares, rectangles, triangles, cubes, spheres, and pyramids. These are quite as recognizable as the types of natural objects or human artifacts—and they may have a similar organizing function. One of the characteristics of the cubist movement in painting was stress upon such abstract forms. In much "nonfigurative" painting and sculpture and in a great deal of architecture, the forms of circles, triangles, spheres, arches, and so forth are the essential patterns. Many of these forms are elements in a larger comprehensive pattern, but this larger pattern, in turn, may be circular, triangular, pyramidal, or of some similar abstract type.

Finally, there are *artistic* types—such as the sonnet, the waltz, the sonata, the fugue, the minuet, the Corinthian column. Artistic types are especially frequent in poetry, music, and dancing. Styles in architecture, such as the Romanesque or the Dutch Colonial, are artistic types; and in the other arts, too, there are formal conventions that characterize the works of the various "schools" of artists. Such types are helpful in providing a ready-made compositional scheme. To the artist with sufficient genius, the type is not a rigid mold but a plastic receptacle which he can fill with new content. An example is the use of the sonnet by Shakespeare, Milton, Wordsworth, and Keats. Each of these poets achieved superb and highly individual effects with a relatively strict traditional type. In music, Bach provides illustrations:

> Bach was one of the most conventional composers who ever existed. He accepted forms and formulas ready-made from his predecessors, chiefly German and Italian, but French and English

also, and he was none the worse for it, because he succeeded, in spite of these self-imposed blinkers to his fancy, in making something greater out of precedent than it had ever been before.[19]

But a mediocre artist may employ type patterns to conceal the poverty of his imagination or as a short-cut in obtaining a slick effect. To conform to a traditional type when new materials, techniques, functions, and intentions require a different treatment is a mark of mediocrity. One of the banes of architecture is the tendency to be traditional when tradition is out of place.

To the contemplator of a work of art, recognition of type characteristics gives the pleasure of recognition, but this pleasure tends to be transient and superficial. In the last analysis, every work of art is individual and concrete, and unless the beholder goes beyond schemata to grasp the vivid original essence of the work, he has "missed the boat." But the knowledge of types may be an invaluable preparation for and aid to enjoyment.

Organic unity. This is the all-inclusive principle of form to which all the other principles contribute. The term "organic unity," used to emphasize the similarity between an organism and a work of art, is a metaphor derived from Aristotle and other classical aestheticians. An organism is a unitary being composed of interdependent parts constituted for subserving vital processes. Thus there is a total functional integration, the life of the whole, which is the end of the parts. Now a work of art is not, in this sense, alive, but it resembles a living organism with respect to adequacy, economy, and internal coherence.

There should be nothing lacking that is required to give wholeness and integrity to the work. The test of adequacy is whether the beholder is satisfied, not whether the work of art resembles a natural organism in its completeness. "If it pleases a futurist to paint a lady with only one eye, or a quarter of an eye," Jacques Maritain remarked, "nobody denies him such a right: all one is entitled to require—and here is the whole problem—is that the quarter eye is all the lady needs *in the given case.*" [20] The only valid test of adequacy is the test of imagination: Does the work seem to be completely executed—is it a satisfying whole rather than a mere fragment?

Another mark of organic unity is economy. The work should not be cluttered with distracting and unnecessary details. This means, not

[19] Erich Blom, *The Limitations of Music* (New York: The Macmillan Company, 1928), p. 114.
[20] *Art and Scholasticism and Other Essays* (New York: Charles Scribner's Sons, 1949), p. 22.

that details should be few, but that none should be superfluous. Many of Rembrandt's paintings are rich in details, but by the masterly use of unifying principles—especially emphasis and subordination—they achieve a remarkable integration. The ideal is to be more unified without being less inclusive. If we combine adequacy with economy, we have *enough* for unity but *not too much*.

An organic unity is not a mere arithmetical sum of separate and distinct parts but a configuration of interdependent parts. Consider this line from Wordsworth's poem "Michael":

> *And never lifted up a single stone.*

Although strikingly prosaic when detached from the poem, it is beautiful and expressive *in its context*. One mark of organic unity is that the parts *do* thus function in context, lending their value *to* the whole and deriving value *from* that whole. The total effect determines whether any detail should be added, omitted, or altered. Every inconsistent detail cries out for change and alteration; or if it is included, the whole must be reorganized so as to achieve a unified effect. This sort of unity in variety, with nothing lacking, nothing superfluous, and all the parts cohering, is organic unity.

It can be violated in innumerable ways: by subject matter inconsistent with the nature of the medium (such as the representation of a light and transient movement in heavy inflexible stone); by static paintings that try to tell stories; by machines with incongruous decorations; by moving pictures in which songs are artificially introduced; by novels in which the propagandistic element is "dragged in"; by operas in which the acting, music, and scenery are imperfectly integrated; by architecture in which the traditional style ill fits the modern materials and functions of the building; or by any work of art in which there are unrelated, inconsistent, insufficient, or redundant details.

Lest "organic unity" be interpreted too narrowly, we should consider two characteristics of organisms pointed out by Aristotle. First, he distinguished between the essential and the accidental. In the human organism, the functioning of the heart is essential, the length of the hair is accidental. The clipping of hair or fingernails is not serious, the loss of an arm or leg is serious, total damage to the brain is catastrophic. The analogy with a work of art is obvious, because some parts of the work are much more essential than others. The "Venus de Milo," for example, is beautiful in its broken state, but it would be more seriously damaged if its head in addition to its arms were missing. As Ruth Saw has remarked, "Part of the beauty of the statue is the way the head is held on the shoulders, and if neck and head

were missing, this might be completely lost." [21] Because a well-wrought work of art is a gestalt, in which the character of the whole permeates every part, even a torso may be extremely beautiful. But the impairment cannot go beyond a certain point without a fundamental loss.

In a small work, such as a sonnet, the requirement of organic wholeness is much more stringent than in a big work, such as a novel or an epic. *War and Peace* is a masterpiece, although much could be eliminated without mutilation. But there is danger in huge size, as the fate of the dinosaurs indicates. In the fossil record of the rocks, it is "always the gigantic individuals who appear at the end of each chapter." [22] Comparing a too-lengthy play with an imaginary animal a mile long, Aristotle implied that both real animal and good play must have organic limits.[23]

Second, Aristotle insisted that each organism has a "soul"—a word that he used in a special sense to designate its functional unity. Among the terms he employed to characterize the soul are "the determining principle of life," "the essential and enduring character of a living body," and "the form of a natural body endowed with the capacity of life." Although only a living being can have a soul, we can speak of a functional object as if it had.

> Suppose, for example, that an instrument such as an axe were a natural body. Its character of being an axe would be its "whatness, or essential thinghood," and therefore its "soul"; if this were taken away it would no longer be an axe except in name.[24]

The soul is its nature, which makes it possible for the axe to function as an axe. We can speak similarly of the parts of a living body. "If the eye were an independent organism," Aristotle remarks, "sight would be its soul, for it is in terms of sight that the essential whatness of the eye must be defined." [25] What is true of a bodily organ must be no less true of the whole organism—its soul must be defined in functional terms. The soul of a cat, for example, is the principle of life, or animating force, that enables it to function as a feline organism.

If, by analogy, this notion of soul is applied to a work of art, it would follow that its "soul" is its capacity to fulfill its function. We maintain that the function of a work of art is to express values.

[21] Ruth L. Saw, *Aesthetics: An Introduction* (Garden City, New York: Doubleday & Company, Inc., 1971), p. 84.

[22] H. G. Wells, *Mind at the End of Its Tether* (New York: Didier Publishers, 1946), p. 25.

[23] Aristotle, *Poetics*, vii.

[24] Aristotle, *Psychology* (*De Anima*), Book II, trans. Philip Wheelwright, *Aristotle* (New York: Odyssey Press, 1951), p. 126.

[25] Ibid., p. 127.

Hence the "soul" of the work of art is its value-expressiveness. This leads us to the next division of our chapter.

The Primacy of Expressiveness

The word "expression" has a dual meaning. It means both the *act* of expressing and the *content* that is expressed. In this section we are concerned with the expressive content rather than the expressing activity. To avoid confusion we shall use the term "expressiveness" for the content and reserve "expression" for the act.

Expressiveness is found in nature quite apart from any artistic act of expressing. This is a point that Rudolf Arnheim has strongly emphasized. He has pointed out that nature and the human environment are replete with expressive qualities, and that our perception of these qualities is original and primary:

> We perceive the slow, listless, "droopy" movements of one person as contrasted to the brisk, straight, vigorous movements of another. . . . Weariness and alertness are already contained in the physical behaviour itself; they are not distinguished in any essential way from the weariness of slowly floating tar or the energetic ringing of the telephone bell. . . . A steep rock, a willow tree, the colors of a sunset, the cracks in a wall, a tumbling leaf, a flowing fountain, and in fact a mere line or color or the dance of an abstract shape on the movie screen have as much expression as the human body, and serve the artist equally well.[26]

Arnheim's contention is that expressiveness is an inherent characteristic of perceptual patterns—it is not just "read into" the patterns by an act of empathic projection or by the association of ideas. If the artist draws upon this vast reservoir of expressive qualities, the qualities must be there in the first place.

Consider the situation in which you sit before a fireplace and watch the bright red flames in rapid movement. According to the traditional theory of the association of ideas, which is still widely held, the expressiveness of the fire is the result of your first perceiving the colors and darting shapes and then associating these perceptions with ideas and perceptions stored in memory.

> You perceive a number of visual data, shades of the color red, various degrees of brightness, shapes in rapid movement. But this is not all. The theory tells us that these stimulations of the brain-

26 *Art and Visual Perception* (Berkeley and Los Angeles: University of California Press, 1969), p. 433.

center of vision will have secondary effects. You know from ex-
perience that fire hurts and destroys. It may remind you of
violence. Perhaps you associate red with blood, which will re-
enforce the element of violence. The flames may seem to be mov-
ing like snakes. Also, your cultural environment has accustomed
you to thinking of red as a color of passion. In consequence of
all this, you not only see colors and shapes in motion, but you
are also struck by the expression of something frightening, vio-
lent, passionate.[27]

In criticizing this explanation, Arnheim denies that the perception of
the bare colors and shapes comes first and that the expressiveness is
a superadded and secondary response due to the association of ideas.
He insists that the expressiveness is in the visible pattern itself and
strikes our attention immediately. We see "the graceful play of aggressive
tongues, flexible, striving, lively color" vibrant with expressiveness. We
may *then* associate ideas with this phenomenal object, but it is already
expressive.

We think this is a sound interpretation, and it fits in perfectly
with our account of "felt qualities" in the initial section of this chapter.
And because "felt qualities" is another name for values, we have
been laying the foundation for a theory of aesthetic experience as
replete with values and of art as value-expressive. Aesthetic experience
is pre-analytical—that is to say, it is experience with its vividness and
feeling tone intact. Whitehead observes: "We enjoy the green foliage
of the spring greenly: we enjoy the sunset with an emotional pattern
including among its elements the colors and the contrasts of the vision.
It is this that makes Art possible: it is this that procures the glory
of perceived nature." [28] When we grasp this kind of experience in its
immediacy, before analysis has done its work of dividing and abstract-
ing, when we appreciate it in its integrity and for its intrinsic per-
ceptual worth, we can accurately call it "aesthetic."

What does the work of art contain that the natural aesthetic object
(the green foliage or the sunset) does not? First, it exhibits a more perfect
unity in variety. It has been shaped into an "organic unity," so that its
expressive "soul" is manifest with exceptional clarity. With most of
nature's offerings the artist must do more or less picking and choosing,
selecting and arranging and altering, until he achieves the harmony that
he seeks. The landscape painter, for example, may omit a tree here and
add one there to secure balance; intensify the light here and soften it

[27] Rudolf Arnheim, "The Priority of Expression," *Journal of Aesthetics and Art
Criticism*, 8 (December 1949), 106.
[28] Alfred North Whitehead, *Adventures of Ideas* (New York: The Macmillan
Company, 1933, and London: Cambridge University Press), p. 321.

there to focus attention; change the shape of a cloud, the contour of a hill, the curve of a river or a road, to perfect his design. There is little in nature that is ready-made for the harmony the artist seeks.

Second, the work of art is stamped by its intentional origin. It bears on its face the mark of its creator in its style, its expressiveness, its range of values. By its means the beholder is in touch with another spirit—human soul speaks to human soul through the intermediary of the "soul" of the work. "For soul is form," wrote Edmund Spenser, "and doth the body make." [29] It makes the matter of a human body into an organism, and it makes the "body" of a work of art into a "living form." It is this "life" and "vitality" of the work of art that binds man unto man.

To summarize: The objective component in aesthetic value is any quality whatever—natural or artifactual, introspective or extrospective, psychic or somatic, representational or presentational, real or imaginary, primary, secondary, or tertiary—that has enough vividness or character to make us value it for its own sake. Especially in works of art, every detail is individualized and invigorated by a context of internal relations, creating the unity and configurational quality of the whole. Although the form is an indivisible gestalt or configuration, it is possible to distinguish its formal principles—thematic repetition and variation, balance, rhythm, evolution, emphasis and subordination, and apperceptive type, each of which we have delineated. All of them combine to serve the master principle of "organic unity." The latter term implies that a work of art resembles a living organism in its adequacy, economy, and internal coherence. The functional unity of an organism is called by Aristotle its "soul," and this term, by analogy, may be extended to the work of art. Because the "soul" and its expressive constituents, whether found in nature or in art, strike the contemplator prior to the analytical and associational processes of thought, we can accurately speak of "the primacy of expressiveness." But in works of art something is added to nature: the "soul" is reconstituted and perfected by the artist, and it bears the marks of its intentional origin. It is the living bond between the artist and the beholder.

29 "Hymne in Honour of Beautie," line 133, in *The Complete Poetical Works of Edmund Spenser* (Boston: Houghton Mifflin Company, 1908), p. 748. (Spelling modernized.)

AESTHETIC INTEREST

The Distinctiveness of Aesthetic Interest

We have maintained that aesthetic value is a gestalt which includes the aesthetic object, the aesthetic interest, and their interrelation. In the preceding chapter we characterized the aesthetic object and in this chapter we shall examine the aesthetic interest.

Aesthetic experience is the apprehension of a certain kind of value, and this value must be clearly distinguished from practical, moral, cognitive, and other kinds of value. Because almost any object under certain circumstances can be regarded aesthetically, the distinction between aesthetic and other human values must be sought mainly in the interest and not in the object. That there *is* a difference between aesthetic and nonaesthetic interest is evident from even a cursory examination. Aesthetic vision is not observation of matters of fact or practical import—it is the kind of vision that makes us appreciate the feeling tones and vivid qualities of objects and that yields satisfaction in pure apprehension. It is a vision and a delight that "luxuriates in contemplation." [1]

An example employed by James L. Jarrett will clarify the dis-

[1] J. N. Findlay, "The Perspicuous and the Poignant," in Harold Osborne, ed., *Aesthetics in the Modern World* (London: Thames and Hudson, 1968), pp. 137–38.

tinctiveness of this mode of interest. He describes the differing reactions of four men—a botanist, a rancher, a fisherman, and a painter—to a mountain meadow which each in turn encounters. The botanist is surprised to find manzanita bushes at this altitude, and is impressed by the lushness of the clover. He concludes that there is either more rainfall or less sandy soil than he expected. The rancher notices that the meadow is good pasturage and calculates that it ought to take care of his cattle for at least a week. The fisherman, remembering instructions on how to reach his destination, is glad to see the meadow, a waypoint described by his informer, and hurries on with his fishing gear. The painter, simply entranced by the scene, surveys it in leisurely fashion and soliloquizes:

> "Say, that's nice! The way that stream bends right there—such a long, smooth curve. And the border of cream-barked trees over there to back up this mottled green texture." And he sits on a boulder to look for a while.[2]

Each man sees the meadow in a different way—for the botanist, it is a herbarium; for the rancher, an object of use; for the fisherman, a signpost; for the painter, a thing of beauty. How different and how selective is the observer's attitude in each instance! Those who deny the distinctiveness of the aesthetic mode of vision are slurring over the facts.

In characterizing aesthetic interest, we need to distinguish between an attentional and an elaborative aspect. Terms such as "disinterestedness" and "psychical distance" are used mainly to describe the attentional aspect. Terms such as "empathy" and "imagination" are used mainly to characterize the elaborative aspect. Most of the mistakes in delineating "the aesthetic attitude" consist in putting too much stress on one aspect to the exclusion of the other. Only a balanced recognition of both aspects is adequate to characterize the subjective component of aesthetic value.

The attentional aspect is a matter of what the aesthetic observer is or is not attending to. He is *not* attending to the external relations of the object and he *is* attending to its internal qualities and internal relations. Suppose a person is looking at a Persian rug. If his thought is, "How much would that cost?" his interest is economic. If he is preoccupied with the question, "How was that made?" his interest is cognitive. If he asks himself, "Would ownership of this rug enhance my social status?" his interest is in a kind of snob appeal. These and similar questions lead away from the rug into extraneous interests. But

2 *The Quest for Beauty* (Englewood Cliffs, N.J.: Prentice-Hall, Inc., 1957), p. 103.

if the spectator is undistracted by any such concern and is absorbed in the vision of the rug itself—if he appreciates its colors and patterns in the mere apprehension of them—then his interest is aesthetic. It can be characterized quite simply as an appreciation (not a mere noticing) of quality for its own sake.

In some aesthetic experiences, there is little more than the attentional aspect, but in other experiences, the elaborative aspect is fundamental. Most aestheticians have recognized such an aspect: for example, the harmonious and uninhibited play of our mental faculties (Kant, Schiller); or heightened awareness and clarity of vision (Bullough, Fry); or the interpretation of the object by a process of "seeing as" rather than "knowing that" (Wittgenstein, Aldrich); or the enrichment of the object by projective imagination (Lipps, Lee) or sympathetic imagination (Keats, Ruskin). We shall now review several theories that stress either or both of these aspects.

Disinterestedness and Mental Harmony

Immanuel Kant in *The Critique of Judgement* (1790) distinguished between pure and impure aesthetic experience, and characterized the former as untainted by any cognitive interest or practical or possessive impulse. In *pure* aesthetic experience, according to Kant, there is a design or form enjoyed simply for its own sake, and having no function beyond arousing the mind to enjoyable contemplation. What, for example, is the purely aesthetic value of a vase? Not its suitability for holding liquids, but its form happily constructed to make our faculties play—it is a thing so attractive to look at that it makes us want to keep on looking irrespective of any desire to use it. According to Kant, this aesthetic value is best realized not through a utilitarian object such as the vase but through abstract design, nonrepresentational and nonfunctional. Representation excites cognitive interest and function begets practical interest, both of which for Kant are nonaesthetic.

He distinguished between "free beauty," such as that of a Bach fugue, which we enjoy in distinterested hearing, and "dependent beauty," which we enjoy when we bring to bear our knowledge of function or representative type. The beauty of a sailboat (a functional object) or of the human form (a recognizable type) would be an example of the latter. In every good piece of architecture, as in many other works, the two sorts of beauty, that which satisfies our pure sense of form and that which satisfies our sense of type or function, coalesce in a single experience. Although there is here loss in purity (as compared with pure design), there is, one might argue, gain in richness and variety of appeal.

To understand Kant's doctrine we must distinguish between being interested, uninterested, and disinterested. "Interested" and "uninterested" are opposites, but "disinterested" and "interested" are not. To equate "disinterestedness" with "uninterestedness" is a radical misunderstanding. That even an aesthetician may be the victim of this misunderstanding is indicated by a remark of Elijah Jordan:

> Interest is, as Santayana has shown, nothing more than attention. So that if beauty is disinterestedness, then it would imply an experience which lacked any degree of attention, which is psychologically absurd.[3]

This criticism, which equates distinterestedness with inattention (the lack of interest), is very wide of the mark. Kant's point is not that a disinterested experience is lacking in attention but rather that the attention is concentrated upon the aesthetic object as a thing fascinating simply to contemplate.

Santayana, contrary to Jordan's assertion, did not show that "interest is nothing more than attention." Instead, he pointed out that the enjoyment of aesthetic objects may be coveted as much as any other pleasure. When the beauties are scarce and cannot be enjoyed except by a few, they may be the objects of intense rivalry and acquisitiveness. But Santayana recognized that, in the moment of aesthetic experience (which is the moment that Kant was characterizing), "we do not mix up the satisfactions of vanity and proprietorship with the delight in contemplation." [4] There is no great difference in meaning between Santayana's "delight in contemplation" and Kant's "disinterestedness."

Kant himself may have contributed to Jordan's confusion by his peculiar use of the word "interest," reserving it for extra-aesthetic concerns. This usage obscures the fact that to be disinterested is one way of being interested—the way of contemplation. It is to have a detached interest in the object as sheer spectacle. Although Kant distinguished this purely contemplative concern from interest in sensory gratification, moral betterment, scientific knowledge, and profit or utility, he never questioned the fact that a disinterested person may be enthralled by a work of art or a thing of natural beauty. Having distinguished rapt aesthetic contemplation from nonaesthetic interests, he admitted that they are frequently intermingled. He believed that the experience of sublimity, for example, has not only an aesthetic but a moral character. The art that he admired most, literature, exemplified "dependent" rather than "free" beauty.

3 *The Aesthetic Object* (Bloomington, Ind.: Principia Press, 1937), p. 15.
4 George Santayana, *The Sense of Beauty* (New York: Charles Scribner's Sons, 1896, and London: Constabe and Company Ltd), p. 38.

For a person gifted with aesthetic sensibility, a disinterested joy as Kant defined it may be very intense. Bernard Berenson speaks in one of his letters of the "dazzling sheen of ruby and mother-of-pearl tints" in a majolica plate by Maestro Giorgio. "I like to sit down where I can get the light on one of his plates," Berenson writes, "and then to look at it for hours." [5] In his autobiography, *Sketch for a Self-Portrait*, he speaks of many such "moments of utmost sensual and spiritual ecstasy." His joy was entirely disinterested but great nonetheless, because it absorbed the whole attention of a very sensitive man to the exclusion of everything else.

Berenson's approach to works of art was not always so single-minded. Gifted with great humanistic learning, he wrote books that immensely enrich our knowledge of the Italian painters of the Renaissance. He was an advisor to Lord Duveen and other wealthy collectors, and many masterpieces in homes and museums were bought upon his recommendation. His diverse interests in art—cognitive, economic, and aesthetic—were often focused on a single work of art. The example of Berenson proves that disinterestedness as Kant defined it may be harmoniously combined with a variety of interests.

One point to be clear about is that different interests may be simultaneous or mixed in occurrence but they remain different in kind. We may have both an aesthetic interest and an economic interest in a work which we own, but ownership of the work with its economic value does not determine its *aesthetic* value. Possession of a sum of money equal to the market value of the work of art would have the same economic value but not the same aesthetic value. The money might even be aesthetically worthless—as it probably would be if it were in the form of a negotiable bank note or an I.O.U. Similarly, we must clearly distinguish cognitive and aesthetic value. A person may know a great deal about a painting—its history, its technique, the traditions that influenced the painter, and so forth—but this knowledge must be distinguished from aesthetic enjoyment. The person might have all this knowledge without aesthetically enjoying the painting at all.

One might question Kant's theory by arguing that we may have disinterested attitudes toward nonaesthetic objects and that consequently disinterestedness does not serve to differentiate aesthetic attitudes from nonaesthetic. To be disinterested in something, we might say, means to have an attitude toward it unswayed by practical advantage. According to this definition, the scientist who is solely devoted

[5] From an unpublished letter by Bernard Berenson dated Berlin, October 6, 1890, quoted by Ralph Barton Perry, *Realms of Value* (Cambridge, Mass.: Harvard University Press, 1954), p. 329.

to truth without regard to personal gain or any other practical consideration would be disinterested. But Kant defined "interest" as concern for the *real existence* of an object, and he characterized "disinterestedness" as fascinated attention in the absence of such concern:

> The delight which we connect with the representation of the real existence of an object is called interest. . . . Now, where the question is whether something is beautiful, we do not want to know whether we, or any one else, are or even could be, concerned in the real existence of the thing, but rather what estimate we form of it on mere contemplation. . . . Every one must allow that a judgement on the beautiful which is tinged with the slightest interest, is very partial and not a pure judgement of taste.[6]

If we were to adopt the scientific attitude, however single-minded and "objective" we might be, we would not be disinterested in Kant's sense, because we would be seeking to determine what really exists. Repeating Kant's point, Croce declares that "the historical existence of Helen, Andromache and Aeneas makes no difference to the poetical quality of Virgil's poem." [7] Santayana in his later philosophy, especially in *The Realms of Being,* similarly contends that an object aesthetically regarded is a "pure essence"—that is to say, it is contemplated for its manifest qualities, and belief or disbelief in its reality does not arise.

Kant would also exclude moral, practical, or appetitive interest because these entail concern for the existence of its object. In willing the good or the expedient, we are interested in bringing into existence an object or an action from which some gain or good is expected; or if we are seeking to satisfy greed or appetite, we are concerned with possessing something existent or bringing something into existence that will satisfy the craving. According to Kant, the aesthetic attitude, in contrast, is concerned with the imaginative perfection of the vision and not the real existence of the object.

It might be objected that there is aesthetic concern for the existence of the object, because a work of art, such as the plate of Maestro Giorgio, is a real thing. If the aesthetic attitude toward the plate involves perceiving it, and if perceiving a thing entails the existence of that thing, then does not the attitude after all involve a belief in and a need for the existence of its object? Similarly, even if Berenson was not concerned with the reality or unreality of the sheen on the plate while he aesthetically contemplated it, still he presumably believed the plate to exist insofar as he saw it. So if the plate and

6 *The Critique of Judgement,* trans. James Creed Meredith (Oxford at the Clarendon Press, 1952), pp. 42–43.
7 Benedetto Croce, "Aesthetics," *Encyclopaedia Brittanica* (1944), 1:265.

not the sheen—or the plate as having this sheen—was the object of his aesthetic contemplation, does this not imply existence of the object?

In reply to this objection, we note that aesthetic objects are phenomenal rather than physical [8] and that many aesthetic objects are purely imaginary. In art, our imagination is free to dream; it is as free as the dream; and if we try to reduce the world of imagination to the world of physical reality, we fall into utter confusion. Even when the object is a "real thing," like a plate that one can hold in one's hands, or a painted canvas that hangs on a wall, it is not its real existence, or materiality, that is the object of aesthetic appreciation. In the spirit of Kant, we must distinguish between the material substrate and the aesthetic semblance. What Friedrich Schiller called *schein*—the semblance or sheer appearance as distinguished from the underlying reality—is the indispensable characteristic of all objects when viewed under their aesthetic aspect. As Schiller says:

> This does not, of course, imply that an object in which we discover aesthetic semblance must be devoid of reality; all that is required is that our judgment of it should take no account of that reality; for inasmuch as it does take account of it, it is not an aesthetic judgment.[9]

The object may be a figment or an actual thing, but what is relevant aesthetically is its sheer appearance—its manifest qualities simply as felt and envisaged.

Let us consider another objection. John Hospers, if he intends to criticize Kant, is mistaken when he interprets "disinterestedness" as impartiality and declares that this "quality of a good judge" has no discernible applicability to aesthetic perception:

> Disinterestedness is a quality of a good judge and occurs when he is impartial. The judge may be impersonally involved in the sense that he cares deeply about the disposition of a case (for example, who will get custody of the children in a divorce case), but in deciding the case, he must not be personally involved in the sense of letting his personal feelings and sympathies sway him or prejudice him one way or the other. Impartiality in moral and legal matters certainly characterizes what has been called "the moral point of view," but it is far from clear in what way we are

[8] For an excellent discussion of the perceptual (phenomenal) nature of aesthetic objects, see Sir Russell Bain, *The Nature of Experience* (London: Oxford University Press, 1959), Ch. III. Understanding of this chapter is enhanced by reading the first two chapters in that book.

[9] *On the Aesthetic Education of Man in a Series of Letters,* ed. and trans. Elizabeth M. Wilkinson and L. A. Willoughby (Oxford University Press, 1967), pp. 197, 199. By permission of The Clarendon Press.

supposed to be disinterested (that is, impartial) when we look
at a painting or listen to a concert. . . . "Impartial" is a term
geared to situations in which there is a conflict between opposing
parties in a dispute, but it does not appear to be a very useful
term when one is attempting to describe the aesthetic way of look-
ing at things.[10]

The "impartial judge" in Hosper's example is concerned with existen-
tial matters, such as the custody of children, and for this very reason
his impartiality should not be confused with "disinterestedness" in the
Kantian sense.

Suppose the judge were considering a *fictional* lawsuit. Would
his impartiality fit Kant's characterization of "disinterestedness"? The
answer is no. Even though the judge is unconcerned with the existence
of the particular instance (the imaginary lawsuit), he *is* concerned
with the just settlement of a suit of this kind. As a matter of general
principle, he is concerned with justice or right; and if the lawsuit
has any judicial point or relevance, it illuminates and exemplifies the
principle. Like the moralist, the judge is concerned with the *ought,*
and that concern is existential—for if something *ought to be* or *ought
to be done,* its existence is worthwhile, it ought to exist. According
to Kant, this kind of concern falls outside the aesthetic sphere.

He maintained that "disinterestedness" is necessary but not suf-
ficient to characterize the pure aesthetic judgment. Another indispen-
sable mark of the aesthetic is the harmonious play of our mental fac-
ulties including the resultant pleasure. The aesthetic object in its formal
properties stirs the faculties to a harmonious co-working. When form
is discovered in a work of art or a natural object, it is as though
the object were gratuitously pre-adapted to the form-loving propensi-
ties of the human mind, stimulating the imagination and understand-
ing to a harmonious excitation and interplay. The aesthetic pleasure
results from the harmony of the faculties in free and harmonious in-
terplay. The pleasure is transformed into beauty when the value is
unconsciously imputed to the object contemplated and not to the mind
contemplating.

The imagination produces the manifold of images and percep-
tions, and the understanding unifies the manifold without prejudice
to the imagination's free play. The freedom of the imagination is un-
trammeled; no extraneous interest, sensuous or moral, no concept, no
purpose, no necessity imposed from without, is allowed to interfere
with it. Whereas in ordinary cognition, the imagination is subordinate

10 "Problems of Aesthetics," in Paul Edwards, ed., *The Encyclopedia of Philos-
ophy* (New York: The Macmillan Company and The Free Press, 1967), 1:37.

to the understanding, in aesthetic experience the understanding is subordinate to the imagination. The imagination freely creates another nature out of the perceptual data that phenomenal nature presents to it. The result is the joy and freedom of the human spirit in the vivacious play of its powers.

It may again be illuminating to compare Kant and Santayana. In connecting beauty with pleasure, both philosophers affirmed its ultimate subjectivity, although it *appears* to be objective. Beauty is defined by Santayana as "pleasure regarded as the quality of a thing." [11] Similarly, Kant remarks that everybody speaks "as if beauty were a quality of the object . . . although it is only aesthetic, and involves merely a representation of the object to the subject." The form of the object stimulates the harmonious play of imagination and understanding; the effect is pleasure, without which there can be no beauty. Nevertheless, the beholder is unconscious of this subjective basis, "and speaks of beauty as if it were a property of things." [12] The characterizations of beauty by Kant and Santayana are similar.

Despite the subjectivistic elements in his theory, Kant recognizes a universal element in the intersubjectivity of aesthetic experience. There are at least two ways in which he moves from an individualistic psychological position to a social or communal standpoint. First, the disinterested character of aesthetic appreciation eliminates selfish and personal perspectives. What pleases me aesthetically pleases me impersonally, and hence it pleases me as a member of humanity, and not as a private individual. Second, the psychological conditions of aesthetic appreciation are said to exist in everyone. All normal human beings possess the faculties of imagination and understanding, and these are the faculties needed for aesthetic appreciation. In aesthetic judgment we intend "to speak with a universal voice," and our intention is justified by the fact that the aesthetic faculties are the same in all men. This does not mean that there is perfect agreement about matters of taste, but it does mean that aesthetic judgments are *normatively* universal. When we esteem a work of art as "really beautiful," we think that the judgment is more than a personal whimsy.

No one before or since Kant has more clearly distinguished aesthetic interest from practical, moral, cognitive, and appetitive interest. His idea of disinterestedness reappears in Schopenhauer and Bullough, not to mention many other writers. Although there has been a massive assault on this concept in recent aesthetics it deservedly commands a great deal of credence. The notion of a dynamic mental harmony

[11] George Santayana, *The Sense of Beauty*, p. 49.
[12] Kant, *The Critique of Judgement*, pp. 51, 52.

is no less influential. It has been developed by Schiller and Coleridge, and in recent times, by Dewey and I. A. Richards.[13] There is merit in this theory even though it needs to be carefully phrased.

There are other Kantian concepts that we regard as less tenable. Kant draws no clear distinction between value and valuation. Aesthetic value is immediately apprehended; aesthetic valuation is the result of intellectual processes of comparison and judgment of values. In characterizing aesthetic experience as judgmental, he admits the very element of cognition that he otherwise had excluded. Much more clearly than Kant, we must distinguish between valuation and value.

For Kant, as for such aestheticians as Hanslick and Bell, the pure aesthetic experience essentially and always consists in the apprehension of form. This is to deny that a single quality, such as a tint of color, can be the object of aesthetic interest, and it is to label impure the aesthetic value of representation, which taps a reservoir of aesthetic appreciation as vast as that tapped by design. Kant thought that beauty is the sole aim of disinterested and pure art. This basis for the theory of aesthetic value is too narrow and subjectivistic.

Kant speaks as if there are only two alternatives, subjectivism and objectivism. But value, as relational, is neither subjective nor objective exclusively—it is just as truly both, because it contains an objective and a subjective component. Aesthetic value emerges from a relation between subject and object, and it therefore partakes of some subjective conditions and some objective conditions. Kant would have been more accurate if he had clearly realized this fact.

His difficulty was that the historical time was not ripe for a clear, unequivocal relational type of theory. The sharp dichotomy, subjectivity *versus* objectivity, was too much in the minds of his contemporaries, because an unambiguously relational theory of value had not been formulated. Kant came close to formulating it in maintaining that the object we judge beautiful is one whose form causes a lively and harmonious play of our mental powers. This is akin to the slang phrase that says a beautiful girl is "easy to look at"—implying that there is a felt harmony between the appearance of the girl and the faculties of perception. But Kant's mind was too dominated by Hume and other subjectivists to purge his language of subjectivistic coloration. From a later historical perspective, we can detect his difficulty and advance to a consistently relational doctrine. We conclude that the dichotomy of subjectivity and objectivity is not exhaustive, and

[13] See discussion of "Synaesthesis" in C. K. Ogden, I. A. Richards, and James Wood, *The Foundations of Aesthetics* (New York: International Publishers Company, 1922).

that aesthetic value is a relational complex including the aesthetic interest, the aesthetic object, and their internal relatedness.

Aesthetic Distance

The phrase "psychical distance" was employed by Edward Bullough, a distinguished British psychologist, to denote "the marveling unconcern of the mere spectator" in the moment of aesthetic contemplation. Because the word "psychical" has a misleading connotation, connected with spiritualism and other paranormal phenomena, some recent aestheticians have preferred the term "aesthetic distance." It is this latter term that we shall employ.

"Aesthetic distance" is used, not literally in the sense of spatial or temporal remoteness, but metaphorically to denote the awareness of the spectator (or the device ensuring it) that the qualities and characteristics of the aesthetic object are not those involved in practical, urgent living. Because it is the consciousness that one is in the presence of an aesthetic object or work of art, it is the opposite of the illusion that the thing beheld is a "real life object" of practical import. By setting the object apart from "real," "practical," or "personal" concerns, distance makes possible a single-minded focusing on qualities for their own sake. It is the absorption in phenomenal data for their intrinsic perceptual worth.

Bullough maintained that aesthetic distance has both a negative, attentional and a positive, elaborative aspect. *Negatively* it means "cutting out of the practical sides of things and of our practical attitude toward them." [14] *Positively* it means "the elaboration of the experience on the new basis created by the inhibitory action" of the negative phase—in other words, the attainment of more forceful objectivity and greater clarity of perception when the mind is undistracted by non-aesthetic concerns and is able to concentrate its perceptive and imaginative powers. Practical interest in what is to be done or cognitive interest in what is to be believed is likely to distract us from the immediate intuitive grasp of felt quality.

To illustrate the contrast between practical and aesthetic interest, Bullough cites two ways of regarding a perilous fog at sea. One way is for the observer to be absorbed in the urgency of the situation —to be agitated with "feelings of peculiar anxiety, fears of invisible dangers, strains of watching and listening for distant and unlocalized signals." The appearances are attended to with the utmost concentra-

14 Edward Bullough, " 'Psychical Distance' as a Factor in Art and an Aesthetic Principle," *British Journal of Psychology*, 5 (1913), reproduced in Melvin Rader, ed., *A Modern Book of Esthetics* (New York: Holt, Rinehart and Winston, Inc., 1973), p. 370.

tion, but with the intent to look through or beyond them to the hidden dangers they may signify. For a man of aesthetic temperament, the scene may be regarded in a different way. He may be fascinated by the sheer spectacle as "a source of intense relish":

> Abstract from the experience of the sea fog, for the moment, its danger and practical unpleasantness . . . direct the attention to the features "objectively" constituting the phenomenon—the veil surrounding you with an opaqueness as of transparent milk, blurring the outline of things and distorting their shapes into weird grotesqueness . . . note the curious creamy smoothness of the water, hypocritically denying as it were any suggestion of danger; and, above all, the strange solitude and remoteness from the world, as it can be found only on the highest mountain tops; and the experience may acquire, in its uncanny mingling of repose and terror, a flavor of such concentrated poignancy and delight as to contrast sharply with the blind and distempered anxiety of its other aspects.[15]

As long as the "repose" is sufficient, the danger simply infuses a tone of sublimity into an experience savored for its own sake.

An amusing example is supplied by Lascelles Abercrombie in his account of a family visit to Morecambe Bay on the English coast. One morning there was a horse caught in quicksand. Abercrombie joined a group trying to rescue the animal and his little boy watched.

> Only the head, back and tail of the horse were above ground . . . the sand had set all round—till we began to dig, and then it at once became a sort of porridge. It was a long business and terribly exciting. We could feel at our backs the menace of the tide; it was only a gleam as yet on the skyline—but everyone knows how the Morecambe tide comes in. Exciting, certainly; but the excitement was one of intense and practical anxiety. We were all the time calculating the possibility that the poor beast might be still embedded when the water was up to its nostrils; and we were trying not to notice the anguish of terror in its eyes and the quivering palsy to which exhaustion had reduced its pitiable struggles.

Meanwhile the little boy hopped about "in pure candid untroubled enjoyment of the whole affair":

> "Will the horse be drownded?" he kept eagerly asking. There was nothing callous in that: what the horse felt about it had simply

15 Ibid., pp. 368–70. Compare Bullough's account with the following remark of Edmund Burke: "When danger or pain press too nearly, they are incapable of giving any delight, and are simply terrible; but at certain distances and with certain modifications they may be, and they are delightful, as we every day experience." *Enquiry into the Origin of Our Ideas on the Sublime and Beautiful* (1756), Chap. 7.

not occurred to him: the only judgment to which the spectacle had been referred was the simple and immediate judgment, was it a thrilling affair or not? Why, of course it was: the whole thing was most admirably arranged. And then came the final touch. The men were busily digging round; we were all hauling on a rope doubled endways round the horse's body; the owner was hauling on the horse's tail. But the tail and his hands were slippery with salt water; and just as we made a grand concerted effort,—the tail slipt through his hands and over he went, heels over head. Instantly there shrilled out a piercing keen peal of ecstatic delight; I have never heard laughter of a more unqualified rapture; and I have never, I think, been more shocked by the intrusion of the *pure aesthetic* view of things into the world of moral or practical values. Severe remonstration followed: the unseasonable nature of laughter was made clear. But the excuse was irresistible: "I thought he'd pulled the tail right out!" That would, indeed, have raised the affair to an exquisite perfection. It was not true; but the instantaneous impression of it was accepted without question and enjoyed to the utmost—simply as a thing given.[16]

Implicit in this passage is an interpretation of aesthetic interest. The sheer spectacle, even the illusory appearance, entranced the child, not because of any ulterior consideration but because it was fascinating simply as given.

To say that the aesthetic interest is absorption in the perceptual aspects of experience need not imply a *total* detachment. Bullough himself was no isolationist wishing to cut off the aesthetic experience sharply from the rest of life. On the contrary, he argued that the most desirable condition for both the artist and the spectator is "the utmost decrease of distance without its disappearance." This principle, which Bullough called "the antinomy of distance," is intended to strike a middle position between too much and too little distance. The variability of distance depends upon both the distancing power of the individual and the character of the object. Too much formalism in the object makes for overdistancing and too much naturalism for underdistancing, but in addition the propensities and powers of the individual to detach himself from "real-life" attitudes must be taken into account. "The antinomy of distance" means that the more our life interests are profoundly stirred, as long as distance is maintained, the better and more powerful will be the work of art. Arguing similarly, Kenneth Clark has said that a strong erotic appeal may greatly heighten the aesthetic value of a work of art, for no man can divest himself

[16] Lascelles Abercrombie, *An Essay Toward a Theory of Art* (London: Martin Secker, 1926), pp. 19–22.

of his essential humanity and he should not try.[17] Intensity may be beneficially gained by some loss of detachment.

The inhibitory action of the negative phase of distancing may reach an almost inhuman point. As an example, we may cite

> that early morning of despair in 1879 when, after an all night vigil, Monet had knelt beside his wife's body and against his will noted the changing colors of Camille's beautiful face as the light grew stronger and the death pallor—the gray and blue tonalities, the waxy yellow—deepened. Struck with horror by his obsession with visual experience "even in the midst of personal tragedy," he realized that he was a prisoner of "the fascination of light and color." [18]

Under these abnormal conditions, the aesthetic distance was obsessive, but under normal conditions of artistic creativity, it enabled Monet to sort out the aesthetically relevant factors from the irrelevant and to attain an extraordinary vividness and subtlety of vision. Similar concentration is required of the beholder if the work of art is not to trigger irrelevancies of thought and feeling.

"The antinomy of distance" does not mean that "there is only *one* correct distance for each person and each thing." [19] As a doctrine of a mean between extremes, it is similar to Aristotle's conception of moral virtue as a flexible mean between "too much" and "too little." Aristotle maintained that the right moral mean is not a fixed point between extremes but a sliding adjustable mean relative to the time, the place, the circumstances, the person who acts, and the persons affected.[20] So, similarly, with Bullough's attempt to find a mean between high and low distance. The theory takes account of the immense range of styles and aesthetic reactions, while warning that the extremes must be avoided. If we are "underdistanced," we shall be too subjective and practical; if we are "overdistanced," we shall be too cold and withdrawn. Between these limits we may move freely back and forth, choosing now an aesthetic experience that touches our own lives deeply, now an experience that has scarcely any personal or practical reference.

Bullough's theory is mainly an interpretation of the attentional aspect of aesthetic interest, but he is aware of an elaborative aspect. Unfortunately he says little about it. This deficiency is partly remedied

17 *The Nude* (New York: Pantheon Books, 1956), Chap. I.

18 Sarah Newmeyer, *Enjoying Modern Art,* © 1955 by Litton Educational Publishing, Inc., p. 83. Reprinted by permission of Van Nostrand Reinhold Company.

19 Louis Arnaud Reid, *A Study in Aesthetics* (New York: The Macmillan Company, 1931), p. 56.

20 *Ethics,* II, vi.

by Roger Fry in *Vision and Design*. Fry is aware of the negative, inhibitory aspect of distance: the aesthetic object is cut off from practical exigencies and freed from the pressures of ordinary human perspectives. But more explicitly than Bullough he delineates the positive side of the aesthetic experience. When, in consequence of the negative phase, attention is focused on the intrinsic qualities of the object, the imagination sees it in a different light, grasping it with a sharper clarity, a heightened sense of its form and expressiveness, and a greater purity and freedom of emotion. All men, responding sometimes practically and sometimes imaginatively, live a kind of double life: an "actual life" determined by practical needs and an "imaginative life" of disinterested contemplation. "Art is an expression of a stimulus of this imaginative life, which is separated from actual life by the absence of responsive action." [21] Fry makes clear that the relation between the negative and positive aspects is by no means accidental. The negative aspect liberates feeling and imagination so that they can devote their powers wholeheartedly to the enrichment of perception. What we behold then becomes a thing of vision invested with vividness and poignancy. This interpretation of aesthetic distance is needed to round out Bullough's theory.

George Dickie notes that Bullough neglects the positive aspect and "devotes all his attention to distance as an inhibitory force." [22] But Dickie himself neglects the positive aspect, writing as if the aesthetic beholder were merely receptive. This is a basic flaw in his persistent criticism of Bullough.

A number of the alleged examples of "underdistancing" or "overdistancing" are properly dismissed by Dickie as simply instances of inattention or misattention. He cites "Bullough's example of the jealous ('underdistanced') husband at a performance of *Othello* who is unable to keep his attention on the play because he keeps thinking of his own wife's suspicious behavior." [23] Dickie also dismisses the contention of Sheila Dawson, a defender of Bullough's theory, that if someone in the audience is mainly concerned with the technical details of the play's presentation, he is overdistancing. Why not simply say that he is attending to the technique of presentation rather than to the play as an aesthetic spectacle?

Dickie criticizes Bullough's example of a fog at sea as "a des-

21 Roger Fry, *Vision and Design* (London: Chatto and Windus Ltd , 1920), p. 20.

22 "Psychical Distance: In a Fog at Sea," *British Journal of Aesthetics*, 13 (Winter 1973), 19. This essay, with related material, appears also in Dickie, *Art and the Aesthetic: An Institutional Analysis* (Ithaca: Cornell University Press, 1974).

23 "The Myth of the Aesthetic Attitude," *American Philosophical Quarterly*, 1 (January 1964), 57.

perate and atypical case," suggesting that distancing might not be generalizable to nondesperate situations.

> Bullough has taken several atypical cases of aesthetic appreciation, has tried to show that these desperate cases necessarily involve the occurrence of a psychological blocking force, and then has concluded that such a force is necessary for every case of aesthetic appreciation. But if one reverses Bullough's procedure and begins with "easy" cases, with the experience of works which are devoid of strong emotional content, then the idea that *all* aesthetic experiences require insulation from practical impulses and thoughts simply does not arise.[24]

This is not a justifiable criticism. Bullough chose the example of the fog at sea and other "atypical" examples because they strikingly illustrate the difference between the practical and the aesthetic attitude. He did not imply that aesthetic distance always requires a special act that suspends action or anxiety. In typical instances the object simply fascinates the beholder so that he spontaneously contemplates it aesthetically. The little boy in Abercrombie's example did not deliberately contrive an act of distancing. Neither does the adult aesthetic spectator in nonperilous situations.

Dickie contends "that there is no necessary conflict between aesthetic appreciation and practical concerns." [25] Kant would agree that this is the case with respect to "dependent beauty," and Bullough would say that practical anxiety may even heighten the aesthetic enjoyment. In his example of the fog at sea, he speaks of the "uncanny mingling of repose and terror" as source of the "flavor of . . . concentrated poignancy and delight." But terror without any intermingling of repose would not contribute to the aesthetic attitude.

According to Dickie, there is no such thing as an aesthetic mode of attention, unless one means by it "paying close attention" to the aesthetic object. Attention is qualitatively the same in all instances whether aesthetic or nonaesthetic. We disagree. There is a difference between aesthetic attention and nonaesthetic attention. The critical difference in marking off the aesthetic sphere is between these kinds of attention, and not between attention and inattention. Paying close attention is not sufficient to characterize aesthetic interest. As Virgil Aldrich has remarked in a communication to the authors of this book, Boy Scouts are trained to be keen noticers of the properties of things and events but this training is not necessarily aesthetic. The Scouts

24 "Psychical Distance: In a Fog at Sea," p. 21.
25 Ibid., p. 26.

are more likely to be taught to look at things cognitively or practically than to savor things aesthetically.

Almost any comparison of aesthetic and practical attention will reveal a qualitative difference. A soldier watching an enemy approach might be paying the very closest attention to the figure threatening to kill him, but his attitude is obviously practical rather than aesthetic. He is wholly absorbed in finding cognitive clues as to the motions that his adversary is about to make, so that he may outwit and kill him rather than be killed. If he escapes with his life, he may at some *later* time go over the experience again "in imagination." He is then no longer confronted by danger or the necessity to act, and he may remember the perceptual and emotional aspects of the battle with something of an aesthetic relish. It is just this element of detachment that makes possible an aesthetic interest—the relishing of qualities for their own sake—that was lacking in the moment of peril. An aesthetic object elicits interest because of its inherent qualities; an object of practical import commands interest because it points beyond itself to desirable or undesirable consequences. This difference in import is reflected in the difference between the practical and aesthetic attitude. Because of this difference in attitude, other aspects are focused upon and thrown into high relief. The object, as phenomenal, is transmuted by the aesthetic attitude—it takes on a different coloration and meaning—and it is this transmuted phenomenal object, and only this object, that counts aesthetically.

Likewise there is a qualitative difference between aesthetic and cognitive attention. A scientist might carefully examine an electron-microscope photograph of Volvox—the "spinning, minute ball of green algal cells bearing flagella that beat in unison." [26] His interest might be limited to resolving the puzzle whether Volvox should be classified as a multicellular individual or a protozoan colony. An artist, on the other hand, might scrutinize the photograph without having the least inkling of or interest in this scientific puzzle. His interest would be an exclusively aesthetic delight in the lovely and intricate pattern revealed in the photograph. Each person, having a different attitude, would notice different aspects.

Dickie supplements his attentional thesis with a motivational account directed against the theory of disinterestedness. He cites the example of listening to music with and without an ulterior purpose:

Note that what initially appears to be a perceptual distinction—listening in a certain way (interestedly or disinterestedly)—turns

[26] Susanne Langer, *Mind: An Essay on Human Feeling* (Baltimore: Johns Hopkins Press, 1967), 1:348, with a picture of Volvox.

out to be a motivational or an intentional distinction—listening for or with a certain purpose. Suppose Jones listens to a piece of music for the purpose of being able to analyze and describe it on an examination the next day and Smith listens to the same music with no such ulterior purpose. There is certainly a difference between the motives and intentions of the two men: Jones has an ulterior purpose and Smith does not, but this does not mean Jones's *listening* differs from Smith's. It is possible that both men enjoy the music or that both be bored. The attention of either or both may flag and so on. It is important to note that a person's motive or intention is different from his action (Jones's listening to the music, for example). There is only one way to *listen* to (to attend to) music, although the listening may be more or less attentive and there may be a variety of motives, intentions, and reasons for doing so and a variety of ways of being distracted from the music.[27]

Without denying that there is a difference in motives, intentions, and reasons, we think that this difference presupposes a distinctive mode of experience and cannot serve as a substitute for this original demarcation. The ultimate ground for the aesthetic motivation is to be found in the nature of the aesthetic experience itself. If Smith is really having an aesthetic experience and is not simply being bored, he finds listening to the music rewarding in itself. If he should cease to find it intrinsically rewarding, he would cease to listen to it aesthetically. Hence he focuses upon those aspects of the music that have intrinsic perceptual worth. Jones is not necessarily concerned with the music as fascinating for its own sake. With an ulterior purpose in mind, he focuses on the analytically describable features that he can later write about on the examination. Even if he should be bored, he will continue to listen and analyze the music in order to pass his examination. There is an intrinsic difference between his experience and that of Smith, and not simply an extrinsic difference in intention or motivation.

That the nature of the experience and not the motivation is the critical differentiating factor is indicated by sudden, unexpected aesthetic enjoyment. When a person all of a sudden notices flowers in bloom or hears the strains of a violin sonata, he may immediately enjoy the sight or sound aesthetically. Although there is no previous intent or motivation, the experience is none the less aesthetic. What makes it aesthetic is the moody savoring of qualities for their own sake.

Bullough's doctrine of aesthetic distance, in contrast with Dickie's motivational theory, locates the differentia of the aesthetic in the ex-

27 "The Myth of the Aesthetic Attitude," p. 58.

perience and not in an extrinsic factor. His doctrine is not as orig-
inal or profound as Kant's theory, but it marks off "the aesthetic at-
titude" from the practical and the cognitive, and it reminds us of
the variability of aesthetic distance. Despite some errors and ambi-
guities, it contains a solid core of truth.

The Imaginative Mode of Awareness

In commenting on Ludwig Wittgenstein's theory of "seeing as,"
Virgil Aldrich characterizes it as "the imaginative mode of awareness." [28]
Its point of departure is an ambiguous figure, such as the "duck-rabbit"
which appears on page 198 of Wittgenstein's *Philosophical Investigations*.
The figure can be seen as a rabbit's head or as a duck's.

Another figure used by Wittgenstein can be seen as a black cross on
a white ground or a white cross on a black ground.

Similarly, Virgil Aldrich has used a diagram that can be perceived
as receding like a tunnel, or protruding like a truncated pyramid seen
from above, or flat like a small square suspended from its four corners
in a large square frame.[29]

28 Virgil C. Aldrich, "Pictorial Meaning, Picture-Thinking, and Wittgenstein's
Theory of Aspects," *Mind*, 67 (1958), 74. See also Aldrich, "Back to Aesthetic Experi-
ence," *Journal of Aesthetics and Art Criticism*, 24 (1966), and "Education for Aesthetic
Vision," *Journal of Aesthetic Education*, 2 (1968).
29 Aldrich, *Philosophy of Art* (Englewood Cliffs, N.J.: Prentice-Hall, Inc., 1963),
p. 20.

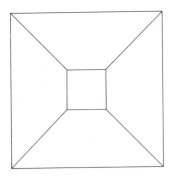

Salvador Dali's painting, *Paranoic Face,* can be seen as either some figures sitting before a mound and trees or as a strange face half buried in sand. Similar illustrations can be found in textbooks on gestalt psychology. In all these instances, appearances are radically transformed when a viewer switches from one perspective to another. He can remember a previous set of appearances when he sees a later set, but he cannot experience two or more alternative sets at the same time.

The point is not that these trick pictures necessarily have aesthetic merit; the point is that different aspects show up in different perspectives. If we apply this principle to aesthetics, the results are illuminating. An object may have an aesthetic aspect when seen from one point of view and a nonaesthetic aspect when seen from another. An example cited in Chapter 2 is the aesthetic appearance of a painting when seen with the eye of an art-lover, and the nonaesthetic appearance of the painting when seen by a carpenter intent on fitting it into a packing case. Like remarks apply to "hearing as." A critic judging the musical quality of a singer's voice would listen in a different manner and notice different properties than would a sound engineer testing the acoustical characteristics of an auditorium.

Wittgenstein mentions a number of ways in which a person might refer to the aesthetic qualities of music:

> "You have to hear this bar as an introduction"; "You must listen for this key"; "You must phrase it like *this*" (which can refer to hearing as well as to playing).[30]

A listener may be concentrating on a formal aspect, as when he hears a melodic pattern as the transformation of an earlier theme. Or he may be focusing on some quality of feeling, as when he hears the

[30] Ludwig Wittgenstein, *Philosophical Investigations,* trans. G. E. M. Anscombe (Oxford: Basil Blackwell Publisher and New York: The Macmillan Company, 1953), p. 202.

music as joyful or plaintive. Or he may be noting a stylistic characteristic, as when the patterns of Renaissance architecture recall features of an older Byzantine style. Or a programmatic musical composition may be heard as a kind of musical metaphor for things we meet in nonmusical experience. Arthur Honegger's *Pacific 231,* for example, can be heard as "the quiet breathing of the engine at rest, the straining at starting, the gradually increasing speed," culminating in "the lyrical pathetic state of a fast train, three hundred tons in weight, thundering through the silence of night at a mile a minute." [31]

Our way of looking at things affects the whole configuration of what we see. "One kind of aspect," as Wittgenstein remarks, "might be called 'aspects of organization.' When the aspect changes parts of the picture go together which before did not." [32] This observation applies not only to a puzzle-picture, in which you suddenly see a human shape where before you saw only branches, but to visual, literary, musical, and theatrical works of art. It even applies to a string of events. Think how differently happenings appear to a paranoid as contrasted with a normal person. But normal people, too, see things in differing configurations depending on the point of view.

Such aspects of organization are strikingly illustrated in the poems of Robert Browning. His "dramatic monologues," exemplified by poems such as "Fra Lippo Lippi" and "Abt Vogler," are perspectival vistas of things and events. The whole ethos and structure of life appear different from these contrasting perspectives. But the best example is Browning's masterpiece *The Ring and the Book.* On a June day in 1860, the poet discovered the source for this long poem in a stall in the Piazza di San Lorenzo, Florence. An Old Yellow Book contained the musty record of a murder trial at Rome in 1698. From this tangled narrative Browning constructed the highly differentiated sketches that comprise his poem. They present the evidence in a series of dramatic monologues in which the speakers review the events from different angles.

It is as if one were to visit a series of galleries, each of which presents studies of the same individuals, but by a different artist, and were thus to get a sequence of impressions, subject to the diversities of the artists in intellectual grasp, in spiritual insight, and in technique.[33]

[31] Arthur Honegger's description of his *Pacific 231* quoted by Wilson Coker, *Music and Meaning* (New York: The Free Press, 1972), p. 158.
[32] *Philosophical Investigations,* p. 208.
[33] Frederick Morgan Padelford, ed., Introduction to Robert Browning, *The Ring and the Book* (New York: Charles Scribner's Sons, 1917), p. xi.

Like light refracted by a many-colored dome, the "truth" lurks problematically behind the varied perspectives.

These examples indicate that "perceiving as," whether it be seeing, hearing, or otherwise apprehending, is not a passive mirroring but a mental participation in what is being perceived. As Wittgenstein remarks, the visual "flashing of an aspect on us seems half visual experience, half thought." [34] In the make-believe of children, for example, "a piece of fancy" is worked into the object of play.

> Here is a game played by children: they say that a chest . . . is a house; and thereupon it is interpreted as a house in every detail. . . . And does the child now *see* the chest as a house? "He quite forgets that it is a chest; for him it actually is a house." (There are definite tokens of this.) Then would it not also be correct to say he *sees* it as a house? [35]

E. H. Gombrich cites the example of a stick that qualifies as a horse because it serves as a focus for the child's fantasies as he gallops along.[36] The hobby horse, like a little girl's doll, lives in the imagination "as if" it were real. In between such obvious make-believe and ordinary perception, there are innumerable kinds and degrees of imaginative recreation.

A good example of an imaginative mode of awareness is to be found in Wordsworth's long autobiographical poem *The Prelude*. When Wordsworth was a child, so young that his hand could scarcely hold a bridle, his father's servant James took him for a riding lesson. By "some mischance" the little boy got separated from his instructor. Dismounting in fear and leading his horse "down the rough and stony moor," he came upon the remains of a mouldering gibbet where a murderer had been hanged and someone had carved the killer's name in the turf. The separation from the trusted servant and the sight of the gibbet and the strange name terrified the child. As he turned and climbed up the common, all that he saw took on the intensity of vision:

> > . . . *I fled*
> *Faltering and faint, and ignorant of the road:*
> *Then, reascending the bare common, saw*
> *A naked pool that lay beneath the hills,*
> *The beacon on the summit, and, more near,*
> *A girl, who bore a pitcher on her head,*

34 *Philosophical Investigations*, p. 197.
35 Ibid., p. 206.
36 *Meditations on a Hobby Horse and Other Essays on the Theory of Art* (London: Phaidon Publishers, 1963), title essay.

> *And seemed with difficult steps to force her way*
> *Against the blowing wind. It was, in truth,*
> *An ordinary sight; but I should need*
> *Colours and words that are unknown to man,*
> *To paint the visionary dreariness*
> *Which, while I looked all round for my lost guide,*
> *Invested moorland waste, and naked pool,*
> *The beacon crowning the lone eminence,*
> *The female and her garments vexed and tossed*
> *By the strong wind.*[37]

Wordsworth cites this experience as an example of the awakening of imagination in a child "not six years old." "It was, in truth," he says, "an ordinary sight," implying that another person might have seen the objects in the prosaic light of common day. A local historian, for example, might have inspected the gibbet and the name carved in the turf with a purely cognitive interest. Even the child would have seen things differently if fear alone had overwhelmed him. It was not fear but "visionary dreariness"—the all-pervasive tertiary quality—that finally held him spellbound.

We can discern in Wordsworth's narrative some of the distinctive features of aesthetic perception. First, it was object-centered. Not the child's feeling, strong though it was, but the various objects—the girl, the pool, the beacon, the moorland waste, and the visionary dreariness—form the center of vision. If the little boy had been simply preoccupied with his own emotion or bodily condition, or if his thoughts had wandered off into tangential reverie, he would not have been caught up in the aesthetic experience. Second, the out-there-ness of the visionary dreariness, with its all-enveloping unity of mood, was not the kind of objectivity that strips away emotional coloration and is subject to public verification. It was an *aesthetic* and not a scientific objectivity. Third, the child became a true spectator, his fear allayed, his action arrested, by the intensity and expressivity of the scene. Characteristic of aesthetic vision is the subordination of action to intrinsic perception. Fourth, the vision was imaginative—not imaginative, of course, in the sense in which the child William Blake saw a tree full of angels, but imaginative in the sense that "an ordinary sight" was invested with the eerie quality of an apparition.

Wordsworth remarked on the regional qualities that pervade and unify an entire scene:

> *Ye Presences of Nature in the sky*
> *And on the earth! Ye Visions of the hills!*

[37] William Wordsworth, *Prelude* (1850), XII, lines 246–61.

And Souls of lonely places! can I think
A vulgar hope was yours when ye employed
Such ministry, when ye through many a year
Haunted me thus among my boyish sports,
On caves and trees, upon the woods and hills,
Impressed upon all forms the characters
Of danger or desire; and thus did make
The surface of the universal earth
With triumph and delight, with hope and fear,
Work like a sea? [38]

In instances of this sort the configurational unity is not effected by the mind *after* sensation—the sensa enter into consciousness already synthesized by the alchemy of imagination.

The transforming effect may be little or great. When the lost child William beheld the pool, the crags, the gibbet, and the girl with a pitcher on her head, the objects took on an emotional coloration but retained their recognizable identity. In contrast, the objects in this passage from Ruskin are utterly transformed:

Not long ago, as I was leaving one of the towns of Switzerland, early in the morning, I saw in the clouds behind the houses an Alp which I did not know, a grander Alp than any I knew, nobler than the Schreckhorn or the Mönch; terminated, as it seemed, on one side by a precipice of almost unimaginable height; on the other, sloping away for leagues in one field of lustrous ice, clear and fair and blue, flashing here and there into silver under the morning sun. For a moment I received a sensation of as much sublimity as any natural object could possibly excite; the next moment, I saw that my unknown Alp was the glass roof of one of the workshops of the town rising above its nearer houses and rendered aerial and indistinct by some pure blue wood smoke which rose from intervening chimneys. [39]

Even when, as in this instance, the objects are perceived incorrectly, the aesthetic effect is none the less present. Both Ruskin and his favorite painter Turner were endowed with marvelous imagination, but apart from verbal description, Ruskin's vision was evanescent and Turner's was fixated in works of art. Virgil Aldrich maintains that the role of the artist is thus to make aspects enduring. [40] Perhaps Plato had something like this in mind when he said in the *Symposium*: "All

38 Ibid., I, lines 464–75.
39 John Ruskin, *Modern Painters*, Part IV, Chap. X, #8, in *The Works of John Ruskin*, E. T. Cook and A. Wedderburn, eds. (London: George Allen, 1904), 5:176.
40 "Pictorial Meaning, Picture-Thinking, and Wittgenstein's Theory of Aspects," pp. 73–74, 76.

creation or passage of non-being into being is poetry or making, and the processes of all art are creative. . . ." [41]

As Kant pointed out, aspect perception is frequently based on type expectation. Each one of us, for example, carries in his mind a "model image" of the human form. Past impressions of particular human beings, by virtue of their intrinsic similarity, have a tendency to be merged into a generalized image or apperceptive type. "The mind . . . can in actual fact," declares Kant, "though the process is unconscious, superimpose as it were one image upon another, and from this coincidence of a number of the same kind, arrive at a mean contour which serves as a common standard for all." [42] Thus is formed in the mind a kind of composite photograph which serves as the "normal idea" of the human form. But the normal is only the average. Hence, for the sake of greater beauty or expressiveness, there must be a departure from the normal. This reconstitution of the type requires imaginative power on the part of the beholder, still more on the part of the artist.

The process of forming model images is not limited to representational types, such as the model of a human being or a horse or a lion. As we pointed out in Chapter 2, the artist or spectator has in mind recurrent abstract forms, such as circles and rectangles, and artistic types, such as the sonnet, the minuet, and the Gothic arch. Such types represent ready-made compositional schemes which both artists and laymen have in mind. They must use these models flexibly lest they be a deterrent rather than a help. But the capacity to perceive something *as something* requires that we already have that something in mind. When Robinson Crusoe noticed a depression in the sand, for example, he saw it as a human footprint only because he had a prior concept of a foot, a print, and a human being. "Hence the flashing of an aspect on us seems half visual experience, half thought." [43] This way of perceiving things may occur either within the context of the aesthetic attitude or in the service of some extra-aesthetic preoccupation, such as scientific research or practical concern. But imagination has its fullest scope in an aesthetic rather than a practical or cognitive context.

The examples we have cited from Wordsworth and Ruskin clarify the distinction between "seeing as" and "knowing that." In the

[41] *Symposium,* trans. Benjamin Jowett, #205. "Non-being" is Plato's term for the world of flux, and "being," the term for eternal essences.

[42] *The Critique of Judgement,* pp. 77–78. A similar discussion of apperceptive types may be found in Santayana, *The Sense of Beauty,* pp. 112–26; E. H. Gombrich, *Art and Illusion,* 2nd ed. (New York: Pantheon Books, 1961), especially Chaps. II and V; and Kendall L. Walton, "Categories of Art," *Philosophical Review,* 79 (1970).

[43] Wittgenstein, *Philosophical Investigations,* p. 197.

Wordsworth passage, the "rough and stony" character of the moor is confirmable by all observers, but the "visionary dreariness" is not. Similarly, in the Ruskin example, the glass roof of the workshop is publicly confirmable, but the sublimity of the imagined Alp is not. When the public object (the rough and stony ground or the glass roof) alters in aspect, it has not *actually* changed. Similarly the duck-rabbit may be seen first as a duck, then as a rabbit, but the figure itself remains the same. There is a difference between the aspect as seen and the unchanging figure as known.

Art *envisages* things, not as they *are,* but as they *appear.* Science *knows* things, not as they *appear,* but as they *are.* Ruskin was aware of this distinction:

> Science deals exclusively with things as they are in themselves; and art exclusively with things as they affect the human sense and human soul. Her work is to portray the appearances of things, and to deepen the natural impressions which they produce upon living creatures. The work of science is to substitute facts for appearances, and demonstrations for impressions.

So far we agree with Ruskin, but he adds that both art and science "are equally concerned with truth; the one with truth of aspect, the other with truth of essence." [44] Because we would deny that both "are equally concerned with truth" in the sense of verifiable matter of fact, we would phrase the comparison differently. Art is the language of appreciations: science is the language of descriptions. Art is the expression of values: science is the depiction of facts. Artists *see* things in valuational perspective; scientists *know* things by socially verified observation. In aesthetic experience, human beings are not simply "perceiving as," they are "valuing as"—and this is a different process than scientific confirmation. But we agree with Ruskin that the artist is concerned with aspects, the scientist with things as they are.

Distance and Participation

In the imaginative mode of perception, the mind is active and participative rather than passive and withdrawn. Hence John Dewey has contended that "disinterestedness" (Kant) and "psychical distance" (Bullough) are too negative to characterize aesthetic experience. As Dewey has said, "There is no severance of self, no holding it aloof, but fullness of participation." The word "contemplation," he thinks, also suffers from the suggestion of passivity but may be less misleading:

44 *Stones of Venice,* in *The Works of John Ruskin,* 11:47–48.

Taken at its best, that is to say, with a liberal interpretation, contemplation designates that aspect of perception in which elements of seeking and of thinking are subordinated (although not absent) to the perfecting of the process of perception itself. . . . Not absence of desire and thought but their thorough incorporation into perceptual experience characterizes aesthetic experience, in its distinction from experiences that are especially "intellectual" and "practical." . . . The aesthetic percipient is free from desire in the presence of a sunset, a cathedral, or a bouquet of flowers in the sense that his desires are fulfilled in the perception itself. He does not want the object for the sake of something else.[45]

Dewey here states all that is most essential for the characterization of aesthetic interest. To appreciate a thing primarily for its perceptual qualities rather than for its extrinsic meanings, ends, and uses is basic to the aesthetic attitude, and contemplation is accessory to this appreciation.

The "fullness of participation" of which Dewey spoke is illustrated by John Keats' identification with the objects around him. "When I am in a room with People," he wrote in a letter to a friend, "if I ever am free from speculating on creations of my own brain, then not myself goes home to myself: but the identity of every one in the room begins to so press upon me that I am in a very little time annihilated—not only among Men; it would be the same in a nursery of children."[46] Keats imaginatively identified himself not only with people but with any kind of living creature and even inanimate things. "If a sparrow come before my Window," he said, "I take part in its existence and pick about the Gravel."[47] He said he could even project himself into a moving billiard ball, and intuit, as though its qualities were his own, the "roundness, smoothness and volubility and the rapidity of its motion."[48]

This identification and fellow-feeling with the object is similar to empathy—namely, the projection of one's feelings into objects. But there is a subtle difference. Both Vernon Lee (a typical advocate of the empathy theory) and Keats speak of the power to enter into emotional harmony with an object and thus to derive aesthetic satisfaction, but Lee stresses the subjective and Keats the objective side of this merging. Keats writes of an active identification with and imagina-

[45] *Art as Experience* (New York: Minton, Balch and Company, 1934), pp. 253–54. Quoted by permission of G. P. Putnam's Sons.

[46] Letter to Richard Woodhouse, October 27, 1817.

[47] Letter to Benjamin Bailey, November 22, 1817.

[48] Notes by Richard Woodhouse on a letter from Keats. Hyder E. Rollins, ed., *The Keats Circle* (Cambridge, Mass.: Harvard University Press, 1965), 1:59.

tive participation in the object; Lee speaks of "the attribution of our vital modes, of our movement, conation, intention, will and character to assemblages of lines and sounds. . . ." [49] But they agree that the beholder's ability to feel at one with the object is a basic way of realizing aesthetic value. In the following quotation from Balzac the two modes of imagination, the sympathetic and the projective, merge into one:

> On hearing the people of the street, I was able to wed myself to their life; I felt their rags on my back; I walked with my feet in their torn shoes; their desires, their needs, everything passed into my soul, and my soul passed into theirs. . . .[50]

The twofold awareness of self and object disappears—there is no separation between the perceiver and the perception.

It may be thought that we have contradicted ourselves. We seem to have embraced theories of disinterestedness or distance, and also theories of participation and empathy. The former kind of theory emphasizes detachment from life; the latter emphasizes immersion in the life stream. To embrace both, it may be charged, is to fall into contradiction. This charge is based on misunderstanding. The two kinds of theory, unless pushed to extremes, are not in conflict. Among the first group of theorists, Bullough strikes a middle position by devising a principle, "the antinomy of distance," which will explain the variety of artistic styles while adopting a flexible mean between high and low distance. There is nothing inherently antagonistic in his position to that of Dewey. Kant, it is true, emphasizes disinterestedness, but again there is no contradiction unless the idea is pushed to an extreme. Although Dewey is often represented as an extremist at the opposite pole, this is to misinterpret him. Andrew Paul Ushenko, a fellow philosopher, has written:

> I once expressed to Dewey my opinion that his emphasis on continuity between life and art does not do justice to the fact that an aesthetic experience is disinterested, i.e., indifferent to matters of practical concern. Dewey answered that the conception of "an aesthetic experience," as defined in *Art as Experience,* is intended to recognize both the basic continuity between life and art and the distinctive quality of being completed in itself that makes a work of art stand apart from the field of practical transaction.[51]

[49] Vernon Lee and C. Anstruther-Thompson, *Beauty and Ugliness* (London: John Lane, 1912), p. 363.

[50] Honoré de Balzac, quoted by DeWitt H. Parker, *The Analysis of Art* (New Haven: Yale University Press, 1916), p. 16.

[51] Andrew Paul Ushenko, *Dynamics of Art* (Bloomington: Indiana University Press, 1953), pp. 11–12.

This statement, which a study of Dewey's book will confirm, recognizes the valid insight in theories of disinterestedness and distance.

The two kinds of theory, that of distance and that of participation, are complementary rather than contradictory. It is hard to see clearly and steadily and comprehend fully what is very close to us. We must achieve some degree of detachment or distance in order to grasp the object in its full qualitative richness. In witnessing *Hamlet* or *King Lear,* for example, we cannot grasp the interplay between the various motifs, or appreciate the dramatic playing off of characters against each other, if we identify ourselves too closely with any character or become too emotionally involved in any theme. As Morris Weitz has said, "aesthetic experience is richer than our ordinary experiences, because it gives us the opportunity to see life as a kind of whole, in which we are not called upon to choose sides and look at it from our chosen side." [52]

Friedrich Schiller wrote:

> As long as man . . . is merely a passive recipient of the world of sense, i.e., does no more than feel, he is still completely One with that world; and just because he is himself nothing but world, there exists for him no world. Only when, at the aesthetic stage, he puts it outside himself, or contemplates it, does his personality differentiate itself from it, and a world becomes manifest to him because he has ceased to be One with it.[53]

Professor Elizabeth M. Wilkinson notes the similarity between Wordsworth's famous phrase, "emotion recollected in tranquillity," and Schiller's advice to the poet that he should write, not in the grip of immediate emotion, but "in the tranquillity of distancing recollection." This remark of Schiller, she suggests, may well have been the source, via Coleridge, of Wordsworth's phrase.[54] The complete sentence in Wordsworth's Preface to the *Lyrical Ballads* is worth quoting:

> I have said that poetry is the spontaneous overflow of powerful feelings; it takes its origin from emotion recollected in tranquillity: the emotion is contemplated till, by a species of reaction, the tranquillity gradually disappears, and an emotion, kindred to that which was before the subject of contemplation, is gradually produced, and does itself actually exist in the mind.

[52] *Philosophy of the Arts* (Cambridge, Mass.: Harvard University Press, 1950), p. 186.

[53] *On the Aesthetic Education of Man in a Series of Letters,* ed. and trans. Elizabeth M. Wilkinson and L. A. Willoughby (Oxford University Press, 1967) , p. 183. (Twenty-Fifth Letter, #1.) By permission of The Clarendon Press.

[54] Introduction to Edward Bullough, *Aesthetics: Lectures and Essays* (London: Bowes and Bowes, 1957), p. xxv.

This sentence illustrates the very point that we are making—namely, that the tranquillity of **distancing recollection** is the systole of detached contemplation that precedes the diastole of the full-bodied aesthetic emotion gradually realized in the mind. Otherness and oneness, distance and union, detachment and participation, are complementary moments in the systole-diastole of aesthetic experience. This is true not only for the artist but for everyone.

One great merit in Dewey's interpretation is that he avoided an ivory tower aestheticism. He fully recognized that aesthetic value permeates everyday experience and is not restricted to the art gallery or the concert hall. This is the point of view that runs throughout this book. It is false to speak of art and aesthetic experience as if they were separate from life—remote, mysterious, unapproachable. Actually, there is scarcely anything more common than art and aesthetic interest. We hear and see art wherever we go: in the designs of our homes, inside and out, in the clothes we wear, in stories, movies, pictures, songs, and dances. We exhibit aesthetic taste whenever we decide that certain articles of clothing look well together; or that flowers should be arranged in a certain way in a vase; or that a chair would look better if moved to a different spot. Every time we enjoy a sunset, admire the shape of a knife or a cup, or like a snatch of music, we have an aesthetic experience. "The habit of art," Whitehead has said, "is the habit of enjoying vivid values." [55] We all have this habit to some extent and it is a good habit to cultivate. It is an inexhaustible source of pleasure, and it makes us more keen and broad and sensitive. So when we speak of aesthetic interest we do not mean something rare and esoteric. There is nothing more natural, nothing more primordial, than the appreciation of presented qualities as such —and this is just what aesthetic interest is.

If this interest is to be so broadly characterized, it must in its optimum form engage the whole mind and not a sequestered fragment of it. Sense and imagination are involved, but so are feeling, desire, and intellect. Some writers, such as Tolstoy and Ducasse, have emphasized the feeling or emotional side; others, such as Nietzsche and Freud, have emphasized wish and desire. That aesthetic experience is emotional can scarcely be doubted, but that it involves wish is almost as evident. In the words of Francis Bacon, it submits "the shows of things to the desires of the mind." [56] The part that intellect plays is less obvious, although philosophers from Aristotle to Mari-

55 Alfred North Whitehead, *Science and the Modern World* (New York: The Macmillan Company, 1925), p. 287.

56 *The Advancement of Learning* (1605), II, xiii.

tain have stressed it. Without the selecting, integrating, formulating, and interpreting exercise of thought and without recognizing the intellectual content of many works of art, much would be lacking that characterizes a cultivated taste. Aesthetic experience at its best brings into play feeling and desire and understanding, all fused with each other and with sensuous or imaginative form. A great work of art appeals to the whole man and not merely a part of him.

Whatever be the psychological factors in aesthetic interest —whether affective or volitional or intellectual—they are directed to the appreciation of qualities, and not toward the excitation of action or the grasp of bare facts. We roll these qualities on our imaginative tongue, so to speak, and extract their full flavor. This we do, not because of any ulterior gain or motive, but because the flavor is intrinsically fascinating. Hence we must distinguish between good-to-do, good-to-believe, and good-to-behold, and mark off the kind of interest that each excites. In many of the affairs of life the three kinds of interest overlap or intermingle, but they are three and not just two or one. It takes more than one to form a union.

We have now completed our analysis of the subjective component in aesthetic value. This component is frequently called the aesthetic attitude, but to emphasize its relation to aesthetic value, we prefer to call it the aesthetic interest. It combines both an attentional and an elaborative aspect. The beholder *dis*attends to the purely external relations of the object and attends to its internal qualities and its internal relations. He then elaborates the experience on the basis created by this focusing of attention. The elaboration is a moody and imaginative mode of vision for the enrichment of the intrinsic perceptual value of the object.

In consequence of the focusing of attention, we have experiences which are disinterested and self-sufficient in immediate consciousness. We do not then regard things inquiringly with curiosity as to their causes, consequences, and meanings. We take things not as problems or agencies, practical or intellectual, but as self-contained occurrences. And we feel not primarily in the way of acquisitive satisfaction or dissatisfaction; but rather, we feel things as things, qualities as qualities, as interesting and satisfying in present experience. We linger; we savor and enjoy. This enjoyment is heightened by the imaginative and participative character of aesthetic experience in its richer moments. Just as Kant and Bullough are very helpful in interpreting the attentional aspect, so Dewey and Wittgenstein are highly suggestive in interpreting this elaborative phase.

RELATION OF OBJECT
AND INTEREST

How Aesthetic Object and Aesthetic Interest Interlock

Although we have been leading up to the concept of aesthetic value, we have not placed the capstone on our interpretation. This we shall do now. Having characterized the qualitative nature of the object in Chapter 2 and the appreciative nature of the interest in Chapter 3, we must now discuss the interrelation between object and interest. Then and only then we shall have characterized aesthetic value in terms of all three of its components—the object, the interest, and the relation between them.

In the ordinary case of a nonaesthetic value, the object and interest are relatively independent. The object remains almost constant in the presence or the absence of the interest in it, and the interest remains much the same if it is detached from the object and transferred to another. Just the opposite is true of aesthetic value. The quality of the aesthetic object is not separable from the interest in it, and the interest is appreciation of *this* object and no other.

In instances of value farthest removed from the aesthetic sphere, there is either no interest in the qualitative individuality of person or thing, or the interest verges on indifference, being external and

gross, not intimate and discriminating. It may be spread over many objects, for example, when a demographer is interested in births and deaths solely with a view to the statistics that he is compiling. In commercial dealings, the commodity may receive no more than bare recognition; it is enough to identify a product by its trade name, and any one of a number of duplicates on the shelf will serve the parties to the transaction. The salesman may direct no more than a cursory glance at the customer and the customer at him, because they are not concerned with one another as individuals; the attention is in behalf of ulterior considerations, such as profit to the seller or utility to the buyer. Many relations between human beings are no less abstract and impersonal, as when police deal with lawbreakers, politicians with voters, and administrators with employees. People do not have the time and cannot afford to be concerned with what is unique and "peculiar" in each other or in the objects which they manipulate and consume. Consequently they treat one another as things, and things as items to pigeonhole. Object and interest, thus de-individualized, have no close or natural affinity, and because they are joined superficially, they part company easily.

Many nonaesthetic or pseudo-aesthetic objects are ungrounded or insufficiently grounded in the data of perception. Apparently ungrounded are the free-floating moods—the vague, relatively undirected feelings of anxiety, depression, or euphoria. Anthony Kenny has questioned whether any such moods or feelings are, strictly speaking, objectless:

> We are often unaccountably depressed on days when for no reason everything seems black; but pointless depression is not objectless depression, and the objects of depression are the things which seem black.[1]

After citing this remark, Alan Tormey goes on to say that the objects in puzzling instances of this sort "are undetected, unrecognized, indeterminate, or diffuse."[2]

But the question of whether the feelings are really objectless or merely seem so is not germane to our point here. In order that there be an aesthetic experience, there must be a *felt* object that *is* detected and recognized, just as there must be a *known* object or state of affairs in the case of a cognitive experience. The tie between feeling and object must be definite—or else the experience falls outside the aesthetic realm. One may get up in the morning, for example, "on

[1] *Action, Emotion and Will* (London: Routledge & Kegan Paul Ltd, 1963), pp. 60–61.
[2] *The Concept of Expression* (Princeton, N.J.: Princeton University Press, 1971), pp. 34–35.

the wrong side of the bed" with a seemingly objectless grouchiness. But then one may soon find objects to grouch about—a shoe to kick, a door to slam, a husband or wife to scold. Or conversely, one may arise in a sunny mood and soon find something to be sunny about —the song of birds outside the window, the taste of fresh peaches, the answering smile of one's companion. The feeling becomes focused and takes on clear objective reference. Only *then* can it be called aesthetic.

Insufficiently grounded in the data of perception are sentimental emotions, which are reactions not justified by the facts as they appear. "One special mountain of great natural charm," confesses an author, "has lost for me all its impressiveness, because a light-hearted companion once compared its autumn coloring with that of 'corned beef hash.'" [3] In this instance, the actual appearance of the mountain counts for very little; it merely triggers a past unpleasant association which takes possession of the mind. The reaction is sentimental because there is an incongruity between the distaste associated with hash and the manifest charm of the mountain. In other instances, the reaction may be disproportionate rather than incongruous—the emotion spills forth in excess of any present stimulation. A keepsake, for example, may be worthless in itself but cherished for reasons of nostalgia, as in the example cited by Santayana:

> Thus the mementos of a lost friend do not become beautiful by virtue of the sentimental associations which may make them precious. The value is confined to the images of the memory; they are too clear to let any of that value escape and diffuse itself over the rest of our consciousness, and beautify the objects which we actually behold. We say explictly: I value this trifle for its associations. And so long as this division continues, the worth of the things is not for us aesthetic. [4]

In all the examples cited, the relation between the object and interest is external and tenuous, because the distinctive qualities of the object play little part in determining the subjective attitude. The prime mark of such nonaesthetic value is this very looseness of connection between the interest and the quality. The mark of aesthetic value is precisely the opposite: there is a close interdependence between the appreciation and the qualities appreciated. The object itself and the feeling about that object are inseparable and mutually determinative.

3 Henry Rutgers Marshall, *Aesthetic Principles* (New York: The Macmillan Company, 1895), p. 18.
4 George Santayana, *The Sense of Beauty* (New York: Charles Scribner's Sons, 1896, and London: Constable and Company Ltd), p. 194.

There are currently two influential theories that help to account for the close connection of subjective and objective factors in the aesthetic experience. The first can be called the theory of fusion, the second the theory of formal resemblance. The fusion theory partially explains the synthesis of objective and subjective constituents within the aesthetic object. The theory of formal resemblance, in addition to buttressing the fusion theory, helps to explain the affinity felt by the beholder for the object.

The Theory of Fusion

The theory is foreshadowed in ancient writers such as Plotinus; it is expressed by the great Romantics, such as Coleridge and Wordsworth; and it has been elaborated by recent authors, such as Dewey and Pepper. According to this doctrine, the mood of the beholder and the qualities of the object coalesce. The tensions and relaxations that we feel when we listen to music appear as *its* tenseness and relaxedness; our strong and cheery interest in a bright color appears as *its* strength and cheerfulness. The sensory and formal elements in the object and the desires and feelings of the perceiver become fused, to be distinguished only by analysis.

As sensation blends with sensation to create a new sensory quality (for instance, when notes combine to form a chord), so feeling or desire blends with sensation to create a felt quality. The diverse strands—objective and subjective—merge into this new distinct quality, the product of a kind of moody vision. There is nothing rare or exceptional in this fusion. Some lines from a sonnet of Wordsworth will provide examples:

> *It is a beautous evening, calm and free,*
> *The holy time is quiet as a Nun*
> *Breathless with adoration; the broad sun*
> *Is sinking down in its tranquillity;*
> *The gentleness of heaven broods o'er the Sea.*

The evening, the holy time, the sun, the heaven, the sea are saturated with feelings. The mood of the beholder is commingled with the sensory features of the object. Such experience is characteristic of life in its immediacy before analysis has done its work of dividing and abstracting.

We cannot correctly interpret the process of fusion unless we recognize that the aesthetic object is a joint construction of the outer world and the creative imagination. There is a synthesis in which something is contributed by the source of stimulation and something

by the self in the act of being stimulated. In the language of Wordsworth, there is

> A balance, an ennobling interchange
> Of action from without and from within;
> The excellence, pure function, and best power
> Both of the object seen, and eye that sees.[5]

Or in the more philosophical language of John Dewey:

> The painting as a picture is *itself* a *total effect* brought about by the interaction of external and organic causes. The external causal factor is vibrations of light from pigments on canvas variously reflected and refracted. . . . The *picture* is the integral outcome of their interaction with what the mind through the organism contributes.[6]

The aesthetic work of art is not the pigments on canvas, the carved stone or moulded clay, the physical sounds of the instruments, the printer's marks on a page—it is the product of the creative interplay between the artist who uses the physical medium to transmit and the observer who uses his imagination to vivify the data thus transmitted. Because the observer and the artist are separate persons, we can never be quite sure that the intentional object created by the artist ("the work" as he intends and perceives it) is substantially the same as the intentional aesthetic object of the observer. But the material substrate, the "real thing" made by the artist, exercises a powerful check and control over the imagination of the observer, so that his recreation of the work of art is not a piece of errant fancy.

How much lies in the material substrate and how much is contributed by the perceiving self is a controversial question. Some philosophers, such as Samuel Alexander, would say that colors are really in physical objects; others, such as Arthur Lovejoy, would say that they are present only as electro-magnetic vibrations which require the response of an organism to be actualized as colors. Whatever interpretation be adopted, aestheticians would go on to distinguish between the *perceived* colors and the *imagined* deep space of a painting—the far distances of El Greco's *Toledo,* for example, being imaginary in a way in which the colors are not. All aestheticians, whatever they may think of the color or space in a picture, would admit that *in-*

5 William Wordsworth, *Prelude* (1850), XIII, lines 375–78.

6 *Art as Experience* (New York: Minton, Balch and Company, 1934) . pp. 250–51. Quoted by permission of G. P. Putnam's Sons. For a similar analysis spelled out in great detail, see Roman Ingarden, "Artistic Values and Aesthetic Values," *British Journal of Aesthetics,* 4 (1964), and *The Literary Work of Art* (Evanston: Northwestern University Press, 1974). See also Mikel Dufrenne, *The Phenomenology of Aesthetic Experience* (Evanston: Northwestern University Press, 1973), Pt. I.

terests are not physical, and yet as tertiary qualities they are incarnate in the object:

> The world glows with interest; our hearts go out to it with appetite to encounter it, to live in it, to get to grips with it. A great novel is how we would like our lives to be, not petty or dull, but full of great issues, turning even death to a noble sound. . . . A great picture is how we would like the world to look to us—brighter, full of affective color. Great music is how we should like our emotions to run on, full of strenuous purpose and deep aims.[7]

When the mind contributes its glow to the aesthetic object, something enters into the synthesis that comes from the appreciative self and not from the physical vehicle.

The fact that appreciative moods are inherent in sensory forms and qualities makes both artistic expression and aesthetic appreciation possible. The artist is especially sensitive to the presence of tertiary qualities, and he has learned how to select, create, and manipulate these qualities so as to express the well-nigh inexpressible. Subjective states, in their uniqueness and inaccessibility, constitute the most private part of a man's being—they are not open to public inspection and are scarcely amenable to scientific description. The inmost core of a person's nature, which is through-and-through qualitative and interest-directed, would remain hidden and incommunicable were it not for art. But in painting, drama, music, and the other arts, the division between the outer and the inner world is overpassed. Through the work of art, which is "the outer image of inward things," the "ineffable" becomes manifest.

The theory of fusion should not be allowed to obliterate the distinction between the phenomenal object and the act of appreciating it. Even after the fusion of the subjective and objective contributions have created the tertiary qualities, they can still be apprehended by the beholder as inherent in the *phenomenal* object. The radiance of a sun-drenched landscape may be recognized by a person who does not feel radiant. The majestic sadness of Chopin's *Sonata in B-Flat Major for Pianoforte* may be noted by an unsad listener. The spectator or auditor does not simply project his own feelings into the object—he discovers the expressive quality in the object itself, and he may or may not be in a kindred mood. As Ralph Barton Perry has remarked, unless the distinction between the interest and the object is to some extent preserved, "it is impossible to avoid the circular state-

[7] Christopher Caudwell, *Illusion and Reality* (New York: International Publishers, 1947), p. 262.

ment that it is the aesthetic enjoyment which is aesthetically enjoyed."[8]

The fusion theory is an account of the genesis of aesthetically expressive objects rather than a direct discussion of the relation between the aesthetic object and the aesthetic interest. But it suggests that the object and the interest are closely related because the former is the reflection of the latter. We see ourselves, either as we are or as we aspire to be, in the tertiary qualities of the object. There is no adequate way in which we can *directly* apprehend our inner life: the awareness of spirit is parasitic upon its outward display. Like Narcissus, we encounter ourselves in the object and are fascinated by our own image. It is not surprising that there is a close tie between the interest-expressive object and the interested subject.

The Theory of Formal Resemblance

The essence of the theory is that the aesthetic object and the beholder are in "isomorphic" relation—that is to say, what goes on in the mind of the contemplator is of identical or like *form* with the structural character of the object. In ancient philosophers the theory is found in germ. The Pythagoreans first discovered the numerical ratios in the vibrations of voice or instrument which determine the concordant intervals of the musical scale, and they boldly conjectured that harmony both in the universe at large and the human soul is based on a kindred equilibrium and "attunement." They supposed that the whole cosmos is a kind of divine music box: the stars, at harmonious intervals from one another, move at speeds related to the mathematical ratios of the scale, and in stirring the ether emit a heavenly music which human ears, unfortunately, cannot hear. All through nature runs this principle of mathematical harmony, beauty everywhere being expressive of an order that has affinities with the soul and the cosmos. Because "like knows like," there is a felt correspondence between the harmonious play of our mental faculties and the harmonious vibrations of musical tones which echo, in turn, the "music" of the circling spheres. There are traces of this doctrine in Plato's *Timaeus,* Plotinus' *Enneads,* St. Augustine's *De Musica,* not to mention the works of later thinkers, such as Ficino and Shaftesbury.

There have been recent attempts to work out a theory of the isomorphic relation between the mind and its object—notably in the writings of Rudolf Arnheim and Susanne Langer. According to Professor Langer's interpretation, the original emotion felt by the artist

[8] *Realms of Value* (Cambridge, Mass.: Harvard University Press, 1954), pp. 332–33.

is not transmitted to the spectator or auditor, but a formal pattern analogous to the emotion is created as a "symbol" of the inner state. In Ravel's *Bolero,* for example, emotional agitation is musically rendered by such means as staccato notes, strong accents, quavers and trills, wide jumps in pitch, rapid accelerandos and crescendos, fortissimos and percussive effects, all related to one another in a pattern of increasing emphasis. This pattern expresses mounting agitation without duplicating it. The slow movement of Beethoven's *Eroica* symphony, in contrast, is a poignant expression of grief. Yet Langer is aware that it does not arouse *real* grief in the listener. The movement, which exhibits features like the slow movements of the mind–body when one is feeling sad, is the articulated image of sadness, even though we may listen to it with pleasure. Thus the expressive form of the work of art is an abstracted pattern that conveys, not the actual feeling, but the import or essence of the feeling.[9]

Rudolf Arnheim supplies us with an example from another art, that of the dance.

> In the representation of sadness the movement was slow and confined to a narrow range. It was mostly curved and showed little tension. The direction was indefinite, changing, wavering, and the body seemed to yield passively to the force of gravitation rather than being propelled by its own initiative. It will be admitted that the psychical mood of sadness has a similar pattern. In a depressed person the mental processes are slow and rarely go beyond matters closely related to immediate experiences and interest of the moment. In all his thinking and striving are softness and a lack of energy. There is little determination, and activity is often controlled by outside forces.[10]

The essence of the theory is that structural characteristics of artistic form are related to similar structural characteristics of human feeling and behavior.

This theory has been criticized by the British aesthetician Harold Osborne. He maintains that our emotions seldom have complicated patterns, and that even if such patterns do exist, they can rarely be observed and compared with the patterns of aesthetic objects:

> So far as I can observe, my feeling of sadness or elation is as nearly structureless as anything I know. While it lasts it is here and everywhere, like an atmosphere or an odour, or a diffused toning of colour, lending a special flavour of melancholy or joy

[9] See the books of Susanne Langer, especially *Feeling and Form* (New York: Charles Scribner's Sons, 1953).

[10] *Art and Visual Perception* (Berkeley, Los Angeles, London: University of California Press, 1971), p. 428.

to anything that comes into my mind. It has duration, but it has no internal structure. And the word "rhythm" seems inappropriate to describe the fluctuations and interplay of the various moods in experience. I can find nothing useful in postulating that the higher-level emergent configuration properties of works of art resemble the patterns or rhythms of feeling. It is a statement hard to refute but incapable of proof.[11]

We do not find this criticism persuasive. If sadness is thought of as a momentary state, it is structureless; but if it is conceived as Arnheim and Langer conceive it, as a temporal and dynamic pattern of experience, it has a definite and discoverable structure.

In our judgment the theories of fusion and isomorphic resemblance contain a partial although not a full explanation of the emotional expressiveness of aesthetic objects. They also help to explain the close tie between the aesthetic interest and the aesthetic object. The interest finds in the object not something alien but something profoundly akin, and this is the explanation of the internal relation between the two.

What is Good Taste?

The concept of aesthetic value as a relational complex, I–R–O, helps us to resolve the conflict between objectivism and subjectivism. Some writers have put all the emphasis on the subjective pole of the relation and others on the objective pole. Both extremes are mistaken. Because the value is relational, it is to be found not solely in the interest or solely in the object, but in the worthiness of each to contribute to the aesthetic experience. The object is fit to excite an appreciative attitude in the beholder, and the beholder is fit to appreciate the object. The aesthetic goodness is the result of a felt harmony between the appreciator and the thing appreciated, each being fit or worthy for the other. An excellent work of art is more worthy of being appreciated than trash, and a gifted art-lover is better fitted to appreciate it than an insensitive spectator. When the experience is poor, the fault may be either in the work or the beholder or both. The work may be insipid, chaotic, trite, sentimental, or otherwise defective. The beholder may be inattentive, biased, uncultivated, insensitive, or fatigued. When a person does not like a work of art, he should consider whether the deficiency is in the object or in himself. If the latter is the case, he should not condemn the work of art, but, if possible, improve his taste. This he may do solely through the use of his own critical faculties or with the help and guidance of a critic.

11 "The Quality of Feeling in Art," *British Journal of Aesthetics*, 3 (1963), 45–46.

This brings us to the question: What is good taste? The answer we shall propose is not original. It is intended to set forth what is commonly meant by "good taste."

It has often been said that good taste is rooted in but not guaranteed by native sensory equipment—good eyes, good ears, an alert mind, etc. Good taste is not innate or ready-made. For good taste, besides being a keen taste, is an educated taste; it is informed, experienced, and cultivated. In its operations it is discriminating, broad, tolerant, and unconfused. In its articulations it is sincere. It is a taste that is refined but at the same time robust, not so overrefined that it loses its gusto and becomes finicky. Its interest in the orchid must not dull it to the primrose and the dandelion.

Conversely, "bad taste" in common usage means, besides a taste that is insensitive because of impaired sense faculties or dullness of mind or emotions, a taste that is ignorant, uninformed, inexperienced, narrow, intolerant, confused, or oversophisticated. But one deficiency does not entail all the others. A person of narrow taste may, for example, be informed, experienced, and sensitive to whatever he reacts to within the range of his interests. But still, to call a taste "narrow" is to subtract something from it qualitatively.

A few illustrations will serve to enforce these characterizations. Good taste is discriminating. A person of good taste will not react, for example, in a single lump of indiscriminate feeling to John Bunyan's *Grace Abounding* because he meets there an uncongenial theological doctrine; he will rather note that fact as an unpalatable ingredient and then go on to feel pleasantly the charm of innumerable little incidents told by the way and enjoy the admirable honesty and excellence of the simple English prose style.

A person of good taste is tolerant in his responses. He is not quick to feel displeasure in the presence of a work of art or kind of art with which he is unfamiliar, of which he does not have experience and about which he does not have understanding. He will not feel antipathy out of hand to an avant-garde design because it answers to nothing in his previous experience. He will not break into derisive guffaws at a native south African dance because it is not European ballet. Nothing is more stifling than continually insisting that all works of art should conform to an already established norm. Art can never be reduced to a recipe, and genius refuses to be fenced in. The greatest figures in the history of art have almost invariably been rebels against established taste, and it is only after their works have lost their virtue as catalytic agents that they become "classics." Something new and unprecedented, such as the "barbaric yawp" of Walt Whitman, strikes most people initially as outrageous. To cite a

more contemporary example, the combination of loud "rock music," psychedelic "light show" including "strobe" effects, and free, inner-directed dancing, might seem the epitome of "bad taste"; but Robert Joffrey, the ballet director, recognized the vitality of these "hippy" art forms and incorporated them into one of the finest ballets. In view of such examples, we should be leary of condemning works of art that do not fit into the standards of *conventional* "good taste."

Good taste is broad. It is a various taste. Many kinds of objects engage its interest and command its approval. It will warm not only to modern art but to classical too. It will like not only classical music but swing and jazz also. It will enjoy the novel as good reading but not to the exclusion of poetry. It is not provincial. Artistic merits being equal, it will find pleasure in a Japanese landscape as much as in a typical homeland scene. It is not one-sided. It will not exalt purely formal beauties above those of content, nor those of thought above those of sensuous surface.

But every person has his limitations; no one can like everything that is worthy of being enjoyed. Human temperaments are bound to vary, and different works will appeal to different temperaments. To the bored opera-goer, who has been told that opera is excellent but is incapable of feeling it, the "knowledge" that he is listening to fine opera is cold comfort. For him the opera *as art* does not exist. If he can truly appreciate a simple folk song, it is aesthetically better for him than the grand opera. He may eventually learn to enjoy opera and other difficult musical forms, but in the meantime, there is no justification for trying to fool himself and others into thinking that he enjoys what he does not enjoy. As Henry James declared:

> Nothing, of course, will ever take the place of the good old fashion of "liking" a work of art or not liking it: the most improved criticism will not abolish that primitive, that ultimate test.[12]

It is a test of honesty both for the critic and the public. The well-known fact that taste can be cultivated implies that it can be broadened and improved. But the last thing we should seek to cultivate is a *cult* of good taste.

Aesthetic taste, to be honest and good, must be really aesthetic. A taste is not good aesthetic taste if it is not aesthetic taste at all. If an object of art is valued for its snob appeal, the taste is not aesthetic. If a poem is liked because it is scientifically true or morally uplifting, it is not valued poetically. If a building impresses because of its cost, it is not valued architecturally. If a painting is favorably

12 *The Art of Fiction* (New York: Oxford University Press, 1948), p. 15.

received because of its religious or irreligious content, it is not valued as art. And if a work is found interesting because it throws light on a page of history, it is a cognitive and not an aesthetic interest that is satisfied. And so on.

The nonaesthetic interest may, of course, be perfectly worthy, and by itself does not result in bad aesthetic taste. But when *aesthetic* worth is imputed to the total object on the basis of a separately considered, nonaesthetic ingredient in it, then confusion of value and in that sense "bad taste" does occur. When, for example, a thing of great cost is deemed *ipso facto* a thing of high aesthetic value, the corruption of taste which in one of its meanings is called "vulgar taste" sets in.

The argument against confusion of values does not imply that the presence of values other than aesthetic in the aesthetic object is necessarily corruptive of good taste. There is often good reason to combine aesthetic and nonaesthetic value. Aesthetic characteristics, moreover, are built out of other characteristics, aesthetic values out of other values. These other characteristics and other values are then the aesthetic materials, and there is no limit to the materials, physical, ideational, or emotional, which may serve. Stone, concrete, iron, wood, or plastics may be made into statues; sensations, ideas, conflicts, attitudes, and beliefs may be made into poems. But the statue is not the stone or the wood, and the poem is not the idea or attitude. Concrete by itself may be considered dull, marble beautiful; a belief by itself may be judged true or false, and an attitude as such may be approved or disapproved. Confusion and resulting failure of taste occur not when the material is taken into account but when it is made to account for everything and the transmutation wrought by art is unrecognized.

Aesthetic taste to be good must be adequately perceptive. This means simply that what is responded to must be really there in the work and that what is really there must be responded to. To be adequately perceptive is to be fully and relevantly perceptive. The work of art must be seen or heard in whole and not merely in part. Correct response is total response. Inadequate response may also be described as failure to respond to the work as object and to use it rather as a trigger to set off memories, feelings, and sentiments which are related to the object only by psychological privacies or eccentricities of the beholder. In that case the taste is directed not upon the object but upon the recalled and outside incidents and interests of the beholder's life. If, for example, in reading Shakespeare's

All the world's a stage
And all the men and women merely players,

the reader feels confirmed in his conviction that life is showy and superficial, and if he stops there in the satisfied feeling of being confirmed by Shakespeare, then he has not arrived at an adequate perception of Shakespeare's play, nor even of the lines themselves. He is responding to the thought rather than through the thought to the character who is made to utter it and is thereby perceptually defined. He has failed to see that Shakespeare does not make the assertion, but *uses* it—that is, makes something *of* it. The reader's preception has failed and his taste has been misdirected. A misdirected taste is a bad taste.

"Good taste," to be a meaningful concept, must mean more than my taste and your taste and any taste. It must represent a normality of response based on normality of capacity to respond. A good taste is one that is able to see what sharp eyes can see, to hear what good ears can hear, to take in what a good mind can encompass, and to feel what an emotionally sensitive person can feel. Good taste is the actual full possession and exercising of these capacities. Thus, for example, Dr. Samuel Johnson's hardness of hearing is correctly inferred to account in part at least not only for his lack of enjoyment of music but also for his critically unfavorable appraisals of certain poems in which tonal excellence is fundamental.

What is a Good Work of Art?

If we turn from a consideration of good taste to the consideration of good works of art, we again offer a sample of common-sense criteria without entering into the intricacies of advanced critical theory.

1. *Beauty.* "Beauty" is frequently used in casual conversation, as in remarking "What a beautiful day!" When applied to works of art, it may indicate nothing more specific than an attitude of approval or enjoyment. To say that a work is beautiful tells us very little about it or the motives for its creation. Even if beauty is characteristic of the work, it is a unique beauty, as we can see if we compare the beauty of works by El Greco and Rembrandt, or of Chaucer and Shelley, or of Mozart and Stravinsky. Hence the concept is too vague to function effectively as a tool for explaining artistic phenomena or directing aesthetic choice. It is mainly useful in indicating that the aesthetic object pleases, for as St. Thomas said, "The beautiful is something pleasant to apprehend." [13]

The judgment that a work of art is beautiful may be, in a par-

[13] St. Thomas Aquinas, *Summa Theologica,* trans. English Dominican Fathers (London: Burns, Oates and Washbourne, Ltd), Pt. II, first part, ques. 27, art. 1.

ticular instance, irrelevant or misapplied. The spectator may ask of
the work, "How beautiful is this?" when the artist was not interested
in beauty. It is true that an artist may create beauty when he is
intent upon something else, and that the spectator may be interested
only in this incidental effect. All expressive art may require some
foundation of formal beauty if it is not to fall flat, but its value
is not reducible to beauty alone, and the person who looks always
and only for beauty will miss much of the distinctive value. The ex-
pressive content of many works is bitter, gloomy, heart-rending, even
horrible and ugly. Art has explored the depths of life as thoroughly
as it has explored the heights.

2. *Originality.* Uniqueness or originality is an important char-
acteristic of a genuine or good work of art. The language of appre-
ciation and criticism is replete with terms whch recognize the quality.
An excellent work of art is "inimitable." To ascribe to an artist
"originality" in conception or style is basic praise. Conversely, to be
derivative is in a work of art to be less than great. It is always better
to be *the* Shakespeare than to be Shakespearean; better to be *the*
Tolstoy that to be, like Sholokov, "the most Tolstoyan of Soviet
novelists." [14]

Uniqueness, originality, is a prime character of art. But the
uniqueness that is possible to a work of art and in terms of which
we praise it is a relative, not an absolute or total, uniqueness. This
is seen in the fact that once we have established the uniqueness of
an artist we do not hesitate to compare others with *him*. We say that
there is something in the sonnets of Keats at his best which is
Shakespearean, or that there is something of Michelangelo in Rubens.
And if we read or look with attentive and trained discrimination, we
will not be at a total loss to say what the something or the somewhat is.

The assertion has been made of many great composers, whether
classic (Ockheghen, Bach, Handel, Mozart) or modern (Ives, Stra-
vinsky, Bartok) that they have "stolen" or "borrowed" themes from
other composers. Shakespeare derived his plots from Seneca, Plutarch,
Holinshed, or the *Gesta Romanorum*, and much of his dramatic tech-
nique from Kyd and Marlowe. Turner is said to have lifted many
of his compositions from Claude Lorrain. Picasso, Braque, and Gris
in their cubist period, or Henry Moore and Barbara Hepworth in
much of their sculpture, closely resemble each other. The idea that
each artist stands alone, or that every work of art is entirely unique,
is not borne out by the history of art. We are not questioning the

[14] E. J. Simmons, *An Outline of Modern Russian Literature* (Ithaca: Cornell
University Press, 1943), p. 52.

value of originality, but we are saying that it has its taproots, its vital connections with what has already been created.

Uniqueness, if pursued too far, produces novelty—a quality of negative aesthetic weight. The book of the month, or the play of the season, or the stunt painting has it, but not the work of the centuries. The work that takes its place enduringly has something more than uniqueness, something equally primary. It has the character that makes it a particular embodiment, no matter how new and strange, of art as a continuing and shared reality.

3. *Formal integration.* The qualities in works of art are elements in relation or relations among the elements; they are never properly grasped in disconnection. When the integration is complete, the duality of form and content disappears. The parts attain their keenest lyrical beauty by reason of their relation to the whole; and the whole attains its vivid expressiveness because it is articulated in and through the parts. Such "organic unity"—with nothing essential lacking, nothing redundant, and all the parts contributing to, and being governed by, the total configuration—is the supreme mark of good art viewed from the standpoint of form.

It is possible that the vividness of the individual qualities may detract from the formal excellence of the work. One might think that the more arresting each detail, the better will be the work of art in the total ensemble in its qualities. But as Plato remarked:

> Suppose that we were painting a statue, and some one came up to us and said, Why do you not put the most beautiful colours on the most beautiful parts of the body—the eyes ought to be purple, but you have made them black—to him we might fairly answer, Sir, you would not surely have us beautify the eyes to such a degree that they are no longer eyes; consider rather whether, by giving this and the other features their due proportion, we make the whole beautiful.[15]

In judging how the details should be treated, we must bear in mind the intent of the work. Let us suppose a painter is aiming at beauty of design, in the sense of a beautiful organization of colors, lines, shapes, and volumes. Attention to striking subject matter would distract from attention to design. Hence the subject matter, in this instance, should be made relatively inconspicuous, and figurative detail either subordinated or cut out altogether.

If there is enough skill, impressive representational subject matter can be perfectly harmonized with the form. In the works of great

15 *Republic*, trans. Benjamin Jowett (London: Oxford University Press, 1892), #420.

masters such as Giotto and Rembrandt—to mention only painters—
there is a superb harmonization of all aspects of the work: the sensuous
materials, the subject matter, and the design enhance one another
rather than compete. Provided that the unity and expressiveness of
the whole are served, deeply expressive subject matter is aesthetically
all to the good. Art can thus combine significant *content,* including
representational matter movingly portrayed, with significant *form.* In-
deed, in the wide sense of "form," the subject matter is a constituent
within the form. In this broad meaning—and it is the meaning that
we here intend—form is the integration of *all* the elements and aspects
that comprise the work of art.

Form has often been characterized as unity in variety. If there
is too little unity in comparison with the variety, or too little variety
in comparison with the unity, the form is comparatively unimpressive.
Superb art is more unified without being less inclusive, and more in-
clusive without being less unified. Plenty is synthesized into harmony.
Hence, as Aristotle recognized, a certain magnitude, bringing with it
amplitude and variety, as long as the whole is coherent and perspicuous
throughout, is necessary for the greatest art.

More inwardly conceived, form is a kind of dynamic psychological
equilibrium. It has been characterized by Coleridge in a well-known
passage:

> [The imagination] reveals itself in the balance or reconciliation
> of opposite or discordant qualities; of sameness, with difference;
> of the general, with the concrete; the idea, with the image; the
> individual, with the representative; the sense of novelty and
> freshness, with old and familiar objects; a more than usual state
> of emotion, with more than usual order. . . .[16]

Similar is the contention of Schiller and Kant that the unity and
manifoldness of the aesthetic object is inwardly reflected in the unim-
peded exercise and mutual facilitation of our basic human faculties. This
free play, balance, and harmonization of diverse, or even discordant,
impulses and faculties has been called "synaesthesis," and I. A. Richards
has proposed to make it the main criterion of aesthetic excellence.[17]
But his theory is stated too exclusively in response language rather than
object language. As we have so often said, object and response are
indissolubly united in aesthetic value.

4. *Memorable experience.* We need, in addition to formal

[16] Samuel Taylor Coleridge, *Biographia Literaria,* J. Shawcross, ed. (Oxford at
the Clarendon Press, 1907), Chap. XIV.

[17] *The Principles of Literary Criticism* (New York: Harcourt, Brace and Com-
pany, 1926), Chaps. 2, 10–15, 18, 27.

standards, a wider and freer criterion of good art. John Dewey has suggested such a wider standard in "an experience that is *an* experience" —that is to say, an experience that is rich, satisfying, creative, memorable. Stephen Pepper, in characterizing this standard, has said:

> The stress is on the experience, the unique quality of the experience, and it is this that is quantified to give the contextualistic aesthetic standard. *The more vivid the experience and the more intense and rich its quality, the greater its aesthetic value.* . . . Dewey frequently chooses the word "seizure" to designate the highest aesthetic experience. It is an experience in which a total situation is absorbed in a vivid fused satisfying quality.[18]

Among the ways suggested to attain the optimum vividness of quality are the freshness and sharpness of details to avoid dullness and banality, the discreet use of conflict to stimulate alertness, and the interrelating and convergence of qualities to achieve a total vivid seizure.

It might be objected that the standard of memorable experience applies only to the beholder's response, and not to the work of art. This objection overlooks the relational character of aesthetic values. As Dewey and Pepper recognize, the vivid values that evoke a memorable experience in the perceiver are qualities in the object. The standard can be stated in terms of either object language or response language. Really there are not two separate standards, one objective and grounded in the work and the other subjective and grounded in the response, but rather one single standard, that of the vivid fused satisfying quality which characterizes the object as much as it characterizes the subject, because it is a product of the conjunction of the two.

The criterion of memorable experience is akin to the standard of "greatness" enunciated by Longinus, who defended elevation and intensity of content as against correctness of form.[19] Similarly, Walter Pater, at the end of his "Essay on Style," declared that the distinction between "good art" and "great art" depends not on form but on subject matter.[20] Rejecting this dichotomy of form and content, Lascelles Abercrombie has said that "the greatness of poetry is the greatness of the scope of its unifying harmony." For example, "the art of interpretation," such as the poetry of Chaucer, is greater than "the art

18 Stephen C. Pepper, *The Basis of Criticism in the Arts* (Cambridge, Mass.: Harvard University Press, 1965), pp. 57, 65. Italics in the original.

19 See Longinus, *On Great Writing*, trans., with an introduction, by G. M. A. Grube (New York: The Liberal Arts Press, 1957).

20 "Essay on Style," *Appreciations* (London: Macmillan & Company, 1897), pp. 35–36.

of refuge," such as the poetry of Spenser, "for the harmony it effects cannot but be a fuller and richer version of life." [21] The great artist contrives a rich texture of intensities and complexities which combine into a total form of impressive range and power. It is exemplified by a great symphony, a majestic architectural structure, or a monumental painting or statue; and it is not dependent solely on representational subject matter. The greatness is the result of the teamwork of all the qualities, representational and presentational, which contextually interpenetrate and give the impression of mystery, complexity, and depth.

Difficult Art

All these marks of excellence may be present in works of art, and yet the works, because of their complexity, intensity, breadth, or strangeness, may not be appreciated. The spectator or listener may have to return to the work again and again and analyze it in great detail before he can grasp its intricate structure. Even after prolonged effort, the complexity of the form may elude him. Also, some works of art are so intense that they put heavy demands upon the observer. The high tension of great tragedy, for example, calls for an intense response—strong emotion and extreme concentration. The sublime, in many of its aspects, requires an exalted mood and abundant spiritual energy; when a person is fatigued, or in a light, playful frame of mind, he may be unmoved by sublimity. Some works of art demand a freedom from prejudice and a tolerant outlook. The comedy of Ben Jonson or the satire of Rabelais, for example, may offend the prudish. Conservatives may be repelled by left-wing art, such as that of Daumier or Orozco; orthodox people may not be able to enjoy heterodox religious art. Some works are so strange, so different from the usual, that they require a great readjustment before they can be appreciated. We tend to like what we already know—the familiar is easy to like; the unfamiliar requires much more effort to enjoy. A person may need special training or experience, such as familiarity with the musical idiom of Arnold Schoenberg or Milton Babbitt, in order to enjoy the work of art. The factors that we have been mentioning—complexity, intensity, breadth, and strangeness—are not the only sources of difficulty in appreciating art, but they are among the most important.[22]

Difficult art may repel at first, but if the object is worthy and the beholder can cultivate a taste for it, it will likely be a richer

[21] *The Theory of Poetry* (New York: Harcourt, Brace and Company, 1926), p. 240.
[22] See also Bernard Bosanquet, *Three Lectures on Aesthetic* (London: Macmillan & Company, 1931), final lecture.

source of aesthetic satisfaction than an object that is easy to appreciate. Many excellent works of art do not immediately make themselves felt—they require familiarity and cultivation. This fact is well to bear in mind when we judge works of art, because it will keep us from making hasty and superficial judgments.

The distinction between easy and difficult works of art points up the main idea of this chapter, that aesthetic value is neither in the object alone nor in the subject alone but in the relation between the two. Aesthetic value in full measure can be actualized only when the object is worthy to be appreciated and the beholder is worthy to appreciate it. The depth of appreciation must meet and match the depth of expressiveness in the object. As long as interest and object do not interlock, there is aesthetic value only in potentiality. The actualized value exists if and only if (1) the necessary conditions for its existence are present in the object, and (2) the requisite capabilities to appreciate the object are present and operative in the beholder. Until both of these conditions are fulfilled, the natural object or artifact remains a bare skeleton, neutral and dumb. Relativism, which puts exclusive emphasis upon the subjective factors, and absolutism, which puts exclusive emphasis on the objective factors, are equally misleading and one-sided. The valid alternative is a subject-object relationship that accords due weight to both subjective and objective components.

Summary and Conclusion

We have characterized aesthetic value as a gestalt consisting of three components—the object, the interest, and their interrelation. Having devoted most of Chapters 1 through 4 to an elucidation of this concept, we shall now gather together the threads of our discussion.

The *aesthetic object* is any thing or quality, whether imaginary or real, that has enough vividness and poignancy to make us appreciate it simply as given. Nothing is excluded that can excite aesthetic interest, even though it be a blade of grass; but some objects are much better fitted to arouse and sustain aesthetic interest than others. The distinction between content and form is a relative one, the content being the elements in relation and the form being the relationship among the elements. The elements comprise all kinds of qualities— natural and artifactual, introspective and extrospective, representational and presentational, primary, secondary, and tertiary—all qualities whatsoever that are fascinating to sense, imagine, or apprehend for their own sake. The formal principles that bind together these qualities include thematic repetition and variation, balance, rhythm, evolution,

and emphasis and subordination. All serve the master principle of organic unity—the adequacy, integrity, and internal coherence that make a work of art resemble a living organism.

The *aesthetic interest* involves both an attentional and an elaborative aspect. The observer disattends to ulterior motives, purposes, and connections, whether these be practical, moral, or cognitive, to focus on the qualitative tang of the object. But in addition, he enlivens and enriches the object by responding with feeling and imagination. In some instances, this emotional and imaginative elaboration is minimal, but in other instances, such as in the aesthetic apprehension of a great work of art, the full evocative power of understanding, feeling, and relevant imagination may be called into play. This elaborative aspect is too often overlooked by the critics of "the aesthetic attitude," as if writers such as Kant and Bullough had nothing more in mind than "paying close attention." Because the attention and enrichment vary from person to person and from one object to another, aesthetic interest may be of either high or low degree. It may be no more than a ripple on the surface of experience, or it may be a great wave of invigoration.

The *interrelation* of aesthetic object and aesthetic interest is intimate and indissoluble. Whereas in nonaesthetic value the relation between interest and object is relatively loose and external, in aesthetic value the relation is close and internal. We have mentioned certain theories of fusion and formal resemblance that help to explain this intimacy of connection. Also we have indicated standards of good taste and criteria of good works, both of which must be fulfilled for the optimum realization of aesthetic value. This interdependence of subjective and objective factors is basic to our entire argument.

Values as they occur in art and aesthetic experience are concrete and individuated, but in addition, we can speak of aesthetic value in a wider and more generic sense. We can think of art and aesthetic experience as a way of life, and we can ask what good is that way. Just as we can ask what is the good of science, or what is the good of religion, so we can ask what is the good of the aesthetic way. To bring the question to a focus, we can consider what would be lost if art and aesthetic experience should entirely disappear from human life. The loss, we believe, would be catastrophic, for aesthetic value is very pervasive and primordial. Only when we gain some sense of that loss can we understand the "good" of art and aesthetic experience.

We can speak not only of the value *of* art, in the sense of the generic good of this way of life, but also of values *in* art—namely, the value qualities embodied and expressed in particular works of art. For art is, in its very nature, the expression and embodiment of vivid

values, and hence values are incarnate in the works created by the artist and appreciated by the public. This we cannot say of science, which is more correctly characterized as the description of facts. This contrast between art and science will be clarified in later chapters. We shall also have much to say about the "good of art" in a sense that is parallel with the "good of science." In addition, we shall discuss the relation of aesthetic to nonaesthetic values, such as economic and moral. But before we encounter these large issues in Part Two, we shall discuss aesthetic value in common life, in fine art, and in nature.

AESTHETIC VALUE

IN COMMON LIFE

The Universality of Aesthetic Interest

Aesthetic interest and aesthetic value occur most familiarly not in isolation at the level of the fine arts confined in special places, such as museums, but in common life and in the midst of everyday affairs. Art, before it is taken to the museum, has its life in the cave, the home, the marketplace, the hunting ground, the place of worship, and on and in the grave. It is originally and lastingly part of all life. Even when it occurs, as it eventually has and often does, as an independent object or activity, it occurs first and continuingly and most widely in the broad common life and not as a withdrawn and specialized pursuit of a few for a few. In its earliest known manifestations and in its broadest continuing expression among all people today the aesthetic interest is not separated from other interests, but mingles with them, supervenes on them, serves them in various ways, or lives side by side with them in equal importance to the whole life.

When we consider the origin of art and aesthetic experience, we should remember how ancient and shrouded in mystery is the life of early man. On the basis of new fossil discoveries, Drs. L. S. B. and Richard Leakey, the British anthropologists, have pushed back the time

estimate of the dawn of the human race to 1,800,000 years. We can only speculate whether anything that could be called art existed so long ago and if so in what form. But in periods for which we have reliable evidence, the aesthetic interest is demonstrably present, either independent of or auxiliary to other interests, such as the practical and the religious. Some archaeological objects in which we today find aesthetic qualities of shape, design, and texture seem clearly to have been objects of use—tools, weapons, conveyances, and utensils. Others seem clearly to have been objects of magic, worship, or of religious meaning of some kind—amulets, talismans, propitiatory symbols, figures of gods and other divine agencies, and paraphernalia of shamans or witch doctors. But still others seem hard to explain except as aesthetic in origin. All three kinds of artifacts have been uncovered in abundance. In the caves of Paleolithic and Cro-Magnon man, there are found flint arrowheads, bone needles, and pebble cups, all of which are obviously objects of use for domestic life or for the hunt or war. There are also found drawings, paintings, statuettes, and ornamentations which may have served in part or altogether religious beliefs and practices. In addition there are found such things as necklaces made of perforated shells and plaques in an "ornamental-fanciful" style, suggesting a probable interest in embellishment or adornment for its own sake. But whether there was a conscious aesthetic motive or not, it is true in any case that earliest known man could and did draw, carve, chisel, and model; that he was able to satisfy an interest, whether independent or subservient, in qualities of form, design, and color; and that the things he fashioned come to us with aesthetic appeal through 25,000 or more intervening years.

The ancient cave paintings at Altamira and Lascaux (10,000 to 25,000 years old) are especially impressive. As Andreas Lommel, Director of the Museum of Ethnology in Munich, has written:

> It may come as a surprise that early men—the hunters of the Early Stone Age—must have been thoughtful individuals, and not at all the "primitive savages" that they were once thought to have been. They were backward only in the sense that they stood at the beginning of human development. . . . No one disputes the fact that the rock paintings are great and unique works of art, yet some people still seem reluctant to admit that those who produced these works must also have been men of unique intellectual accomplishment, in a word, great artists who are comparable with the dominating figures of historical times.[1]

[1] *Landmarks of the World's Art: Prehistoric and Primitive Man* (New York: McGraw-Hill Book Company, 1966), p. 17.

The later art of the New Stone Age, stretching from about 10,000 B.C. to the fringes of historical time, turned away from vivid animal representation in the cave paintings to geometrical design applied to pottery and other utensils. Although perhaps not as impressive as the Old Stone Age art, these designs represent the emergence of sophisticated geometric art. Considering the archaeological evidence supplied by these two types of art, naturalistic and geometric, we wonder if the concept of "progress" has applicability beyond limited spheres. With perhaps a touch of exaggeration, the ethnologist quoted above has remarked, "Though primitive cultures may be inferior to the mature cultures in their level of material culture and of economic and technical development, this is not true of their art." [2]

The aesthetic in these prehistoric ages is not rare but universal. Wherever in the world archaeology has turned up the artifacts of the dim past, the aesthetic interest and will is evident in its findings. Thus, for example, of the unearthed and studied prehistoric stone sculpture of the American Pacific Northwest it is observed that "the technical proficiency and the strong, often astounding aesthetic qualities of this sculpture establish it . . . as one of the great arts of the American Indian"—that is, of the pre–white-contact Indian. And, though most of these objects are utilitarian, "superbly shaped and carved stone tools, implements," mauls, clubs, handles of pestles, etc., "the presence . . . of so many decorated utilitarian objects suggests the existence of an art-for-art's sake and a connoisseurship." [3]

If we turn from archaeology, the inferential study through cultural remains of the life and history of prehistoric man, to anthropology, the direct observational study of existent and recent primitive peoples, we find the same kind of evidence. The observed fact of a universal concern for aesthetic values is expressed in the following summary by Franz Boas:

> No people known to us, however hard their lives may be, spend all their time, all their energies in the acquisition of food and shelter, nor do those who live under more favorable conditions and who are free to devote to other pursuits the time not needed for securing their sustenance occupy themselves with purely industrial work or idle away the days in indolence. Even the poorest tribes have produced work that gives to them aesthetic pleasure, and those whom a bountiful nature or a greater wealth of inventions has granted freedom from care, devote much of their energy to the creation of works of beauty. [4]

2 Ibid., p. 10.
3 Paul S. Wingert, Introduction to the catalogue of the Exhibition, *Prehistoric Stone Sculpture of the Pacific Northwest* (Portland: Oregon Art Museum, 1952), p. 26.
4 *Primitive Art* (Cambridge, Mass.: Harvard University Press, 1927), p. 9.

"In one way or another," concludes this eminent anthropologist, on the basis of his wide and diverse studies of primitive culture, "aesthetic pleasure is felt by all members of mankind." Another scholar in the same field, agreeing with still a third, voices with equal conviction the same conclusion. "I will postulate," he writes, "the aesthetic impulse as one of the irreducible components of the human mind, as a potent agency from the very beginnings of human existence . . . I hold with Jochelson that 'the aesthetic taste is as strong and spontaneous a longing of primitive man as are beliefs' " [5]

The aesthetic interest is, then, for primitive man, as it was for prehistoric man and as it remains for man today, an affair of life going on with other affairs, and not an occasional or culturally deferred activity depending upon special conditions, favoring circumstances, or the peculiar interests of rare individuals. It is a basic impulse of all life in all people.

That it continues to remain universal in occurrence and appeal is not hard to prove, even though modern specialized and largely compartmentalized civilization tends to put the aesthetic at its upper reaches of "fine art" into a realm of its own. The proof lies in ourselves individually at almost every hour of our daily life.

Our immediate life is a stream of direct experiences consisting of sensations, perceptions, actions, memories, and anticipation. Each of these components of our experience has a double role. On the one hand, each functions practically in a sense of "practical" broad enough to include the intellectual and theoretical. Sensation is a sign of something further to be expected; memory is a guide to present response and belief; action is a drive to carry through a task; and anticipation foresees an event to be welcomed, or a threat to be prepared for. Much but not all our interest is thus practical in primary impulse, and yet rarely is it completely so. The sensation received or the thing perceived, besides being a pointer to the future, or a sign of something more not yet discovered, or a datum which sets a problem to be solved, is also a quality or a complex of qualities which can and sometimes does invite absorbed attention to itself. And when we attend to qualities for their own sake, even partially or fleetingly, then our experience, whatever it may otherwise be, has an aesthetic ingredient. And when we attend more largely or steadily, then our experience takes on a definite aesthetic tone, comes alive qualitatively. Occasionally, at least, we all interrupt or put aside the practical, the work or the problem, and then we turn completely to the aesthetic, there being nothing else to turn to. We stop to look at the thin moon with its one attendant star, or dwell in the recaptured sensation of sea water breaking

[5] Robert H. Lowie, *Primitive Religion* (New York: Boni and Liveright, 1924), p. 260.

thrillingly over our heads, or we linger with present satisfaction over the completed task laid out before us as a thing done or arrived at.

No one in his normal living is without such aesthetic experiences, both as ingredients and as wholes. The farmer ploughing takes more than practical satisfaction in the straightness and fresh loaminess of the new-turned furrow. The housewife looks at her well-tidied room in its immediately perceived neatness and sees more than a useful and convenient disposition of furniture. Even a man's all-business attention to his occupational work in trade or profession may at times become detached and turn almost into an aesthetic devotion. Charles Lamb gives us an example, whimsically rendered, but nonetheless relevant. He is writing of the clerks in the old South-Sea House, among them the accountants. Of these warders of profits, practical functionaries certainly, Lamb says from the inside, being one of them, ". . . to a genuine accountant the difference of proceeds is a nothing. The fractional farthing is as dear to his heart as the thousands which stand before it." That is, a *genuine* accountant is one to whom figures and exact balances, regardless of in which direction, are objects "dear to the heart" in achievement and contemplation.

If this example be thought too literary and perhaps too fanciful, we may turn to a nearer and more literal report of how the aesthetic works into or lies behind the seemingly altogether practical —in this instance the intellectual problem-solving interest. It is from Kurt Koffka speaking on "Problems in the Psychology of Art." [6] The occupation of the psychologist, he says, is to study behavior—for example, the behavior of "white rats running through a maze." The psychologist's preparations are painstaking, his observations as minutely exact as possible. And all that the psychologist here does may, it seems, be explained and described in terms of his objectives and exclusive interest in the animal's behavior. "But," declares Koffka, "I am convinced that very few psychologists will do only this and nothing else. Most of them—some more, some less—will be aware of a rather thrilling spectacle, the sight of a living being trying to attain a certain place as quickly as possible, *a phenomenon with its own qualities* (italics added), qualities which are not captured in the record of the animal's accomplishments."

It is instructive to note further, in anticipation of our later attention to relations between the aesthetic and other interests, that this interest in the "aesthetic quality" (Koffka, professional psychologist though he be, so names it) of the rat-maze spectacle is found to be not merely extraneous to or innocently subsequent upon the comple-

[6] "Problems in the Psychology of Art," in *Art: A Bryn Mawr Symposium* (Bryn Mawr: Bryn Mawr College, 1940), pp. 180–81.

tion of the psychological experiment, but auxiliary to it. The two interests are intimately bound together in reciprocal relation, even though the scientific interest initiates the investigation and is dominant in the total activity. Such acts of aesthetic awareness, says this writer, "have led to concepts as important for the understanding of the rat's behavior as any of the measurements. . . ." And the psychologist "who can enjoy the spectacle of the running through a maze as he enjoys the spectacle of a dance or the glory of a beautiful face," [7] is actually strengthened in his scientific motivation.

The foregoing examples of the occurrence of aesthetic interest in a wide variety of activities which are not primarily aesthetic suggest a further observation: The psychological fact that the aesthetic interest may occur anywhere rests on the physical fact that aesthetic quality exists everywhere. Both are universal in their possible occurrence. Aesthetic quality is always with us or waiting around us, because aesthetic quality as the objective component in aesthetic value is simply quality itself—the sound, the feel, the look, the perceived character of a thing, a situation, or an action. No object, simple or complex, and no state of affairs lacks quality. It must have the quality which it has to be what it is. And when, for no ulterior motive, we become aware of and interested in the quality of an object then it becomes, even if only for a moment, an aesthetic object, like the farmer's furrow, the housewife's tidied room, the accountant's exact balances, and the scientist's rat-maze spectacle.

The universal presence of quality as an objective fact in everyone's environment at all times does not, of course, guarantee for everyone a rich aesthetic experience. It merely provides universal opportunities for such experience at the level of common human living. Most of us, perhaps most of the time, do not seize the opportunity. The aesthetic awareness is often absent altogether or so feeble, thin, hasty, or minimal as hardly to constitute an aesthetic experience at all. We notice a tree in our path only to walk around it, not to look at it and trace the leafy pattern of its boughs, its bark texture, or the groundswell at its roots. Most often our recognition of things is merely a token recognition, just enough to set off a practical reaction or an intellectual inquiry. When we react in this way we take things not as things, and qualities not as qualities, but as signs, directives, or evidence. And beyond that, most of what always lies around us we don't notice at all.

There is, of course, nothing wrong in the fact that our daily recognitions and nonrecognitions are largely practical and intellectual pursuits. They become deplorable only in excess—that is, if carried

7 Ibid., p. 181.

into habits which needlessly exclude or impoverish aesthetic aware-
ness. Aesthetic experience is thus rightly limited by the necessities and
urgencies of our practical life, but wrongly limited by habits of prac-
tical perception when we carry these habits beyond the practical needs.
In any case, it remains true that everything in our perceptual environ-
ment is available for aesthetic experience. Whether or not it actually
comes into aesthetic consciousness depends upon us, whether we can
or will permit it.

A corollary to these observations is that there are few if any
objects which are "properly" or intrinsically aesthetic in an exclusive
sense. Things cannot be divided into those which are aesthetic in hav-
ing an objective aesthetic quality and those which are nonaesthetic
in failing to have this quality. (This is not the same as saying that
all qualities excite aesthetic interest, nor is it saying that no objects
are properly works of *art* or have *artistic* quality.) Willing and in-
trinsically rewarding attention to any quality as directly presented
makes it "aesthetic" quality and the thing which has it an aesthetic
object. When, accordingly, we do reject something in the natural or
human environment as aesthetically unacceptable, as drab, dull, or even
painful, we may still recognize it as aesthetic, but in negative mode,
probably so determined by our cultivated *artistic* sense, which demands
the fullest possible satisfaction and rejects as "unaesthetic" whatever
fails to provide it.

The universal occurrence of aesthetic quality in experience
through willing attention and interest has been the point of emphasis
in this section. The archaeologist, the anthropologist, and the his-
torian, we have seen, produce ample evidence and record of this in-
terest to support the conclusion that it prevails at all known times
and with all known peoples. But, as we have seen too, we have ample
evidence also in our own daily living. Not only do all men find aes-
thetic value in the common enjoyment of nature and the simple plea-
sures of sensation and perception, they also create aesthetic value in
the things which they make and dispose of in their daily lives. And
in this creative activity, no matter how homely or modest, they can
be said rightly to make art; for it is there where art begins and has
its widest occurrence—with everybody.

Sources of the Aesthetic

In order to distinguish and describe in some detail the occur-
rence of the aesthetic in common human life, we may mark certain
large divisions within which aesthetic experience occurs. We note three

such divisions: first, the enjoyment of nature; second, the making and appreciating of whatever is added beyond practical and intellectual need to the things and affairs of daily living; third, the production and appreciation of works of "fine art." It is mainly with the second of these that we have been and will continue to be concerned in this chapter. But because nature too is a source of the aesthetic in common life, we pause to note its universal availability and inexhaustible variety as a source of aesthetic satisfaction. Whether he has named his experience "aesthetic" or not, every human being has responded countless times to the beauties or charms of nature. He has sensed the "pleasure in the pathless wood," or observed that "waters on a starry night are beautiful and fair," or felt his heart leap up when he beheld a rainbow in the sky. The pages of poetry from all times and places are filled with the poetic appeal of nature, which finds an answering response in the experience of all. No one outside a ghetto needs to be persuaded that nature can be enjoyed. But we shall postpone until Chapter 7 a discussion of aesthetic value in nature. Our purpose here is simply to notice it as a division which will help us to mark off that area of the aesthetic in common life which we want to examine further in the remainder of this chapter. To indicate that the aesthetic represents more than a pleasant or interested awareness of the natural world, we distinguish for separate attention the man-made aesthetic from the natural aesthetic, or in a very broad sense "art" from nature.

We say "in a broad sense" because in "art" we distinguish again between what is ordinarily called "art"—that is, "fine art"—and that activity and its products which we have described as the creatively aesthetic in the everyday life of all men. Although the latter is not usually called by the name, it is generically real art and has genuine aesthetic value. And to give it the name is to call attention to the fact there is a continuity between it and fine art. We shall therefore continue to speak of it as "art in common life."

The phrase "art in common life" is meant, then, to denote not only the division between art and nature already drawn but also the further division between art in the specialized sense of "fine art" and art in everyday life. Unlike works of fine art, which, on the whole, are taken today to appeal to the aesthetic as a detached interest, common-life art is not detached in occurrence or enjoyment, but is characteristically woven into the other activities of life.

Common-life art partly includes folk art and popular art, but it is not coextensive with them. For folk art may itself become on occasion detached and practiced and enjoyed apart from other interests, and then it becomes by intention "fine art" produced by other

than professional artists—that is, by the folk. Folk ballads and folk dancing are familiar examples. Popular art is in the main art which is professionally and often commercially produced and which has a wide and easy appeal, such as the "hits" on phonograph records or in television shows. The lines between none of these divisions are exact or absolute, and qualitative differences are not the defining ones. Folk art, popular art, fine art, and art in common life may in any specific instance be aesthetically excellent, mediocre, or bad.

The term "common life" in the phrase "common-life art" is also used with a broad meaning. It means, for one thing, what all men do in the course of common human living, such as eating, sleeping, dressing, working, playing. In the present context, it means further what any men do other than produce and enjoy fine art, specifically so intended. For example, it is part of common-life activity to earn a livelihood, though it is by no means common to earn it by being a highly specialized brain surgeon, a glass-blower, or a scholar in Mongolian law. But for our purpose these, like more ordinary occupations, are all common-life activities because they are expressive of basic interests other than the aesthetic.

In view of our insistence that the aesthetic interest is basic in all human living, it may seem contradictory that we now oppose it to all other human interests. But the opposition is methodological only. For purposes of inquiry into some other basic interest, say economic or cognitive, a similar division could be methodically drawn between it and all the rest. We could then distinguish between the cognitive interest and common-life interests so as to include in the latter the aesthetic along with the economic, the religious, the moral, and so on. In any case, there is no intent here to extrude the aesthetic from common life, or to suggest that it is in any degree artificial, or extraneous to "real" life. Quite the contrary. We first isolate it only to recognize it better and thus to show more clearly that it is everywhere present and that other interests do not go without it.

If we mark the areas where the aesthetic plainly occurs in independence of the beauties of nature, on the one hand, and of the fine arts, on the other, we can then say that the area of common-life art covers everything in between and that it is here that we want to exhibit the pervasive occurrence of art in integration with all other interests. Without either honorific or belittling intent, common-life art may then be said to lie "below" the level of fine art and "above" the direct enjoyment of nature.

There are two familiar ways in which art appears in common life beyond nature and below fine art. The first is the way of ornament and grace given to our everyday objects and activities beyond the demands of need and use; the second is that of unadorned excellence

attained in purely functional objects and activities. We will describe and examine each of these ways in the sections that follow.

Ornament and Grace of Form
as Sources of the Aesthetic in Common Life

We may begin with an observation from Tolstoy. "All human life," he writes, "is filled with works of art of every kind—from cradle-song, jest, mimicry, the ornamentation of houses, dress, and utensils, to church services, buildings, monuments, and triumphal processions. It is all artistic activity." [8] We may extend this observation and this list by a little further reflection and by calling to mind a few familiar examples of our own. What, we may ask, do we do in daily living besides working and eating and sleeping and dressing? And what besides thinking on the means of doing these things most efficiently? Well, in general, we may answer, we try to make the daily routine of use and necessity attractive and agreeable, by surrounding ourselves with pleasing objects as well as needful ones, and by striving to give our things of use appealing forms and qualities. And we may note further that when we do so we bring our aesthetic demand into our work-a-day life, we do not let it wait for our playtime or recreation or leisure. And when we do seek it in our practical life, even though we may never think of it as such, we evince our aesthetic interest and put art into our life.

Examples are everywhere. We manufacture useful articles or commodities not merely to serve well, but also to look "nice." In industry and business, art in this primary sense goes into almost every thing that is made and, indirectly at least, into every transaction that is carried on. In marketing, for example, the very fact that the attractive packaging of articles of use and sale, say a can of beans or a pack of cigarettes, is commercially profitable attests the further fact that the aesthetic demand is important and that its satisfaction is good business. The shrewd manufacturer or merchant knows this well. Most times when a merchant sells and a customer buys something of everyday practical use—food, clothing, or utensil—an aesthetic object as well as a utilitarian one has changed hands. Most times it is perhaps not mentioned, but nonetheless it is there. Aesthetic appeal is sales appeal. Our choices in everyday purchasing are just as truly aesthetic as practical choices. We do not walk into a shop when the need arises and simply ask for a suit or a dress of a certain price and certain weight, and one that is durable. In addition we spend time in deliberating

8 Leo Tolstoy, *What is Art?* and *Essays on Art* (London: Oxford University Press, 1962), p. 125. (First printing, 1905.)

and deciding on the color, the weave, the pattern, the cut—that is, on the looks and the feel as well as the wear and the price. Sometimes, indeed, the aesthetic appeal comes first—the feeling rather than the calculation. A contemporary painter states it thus:

> The man of the people is born with this feeling for beauty. The stone mason who prefers a blue sash to a red one commits an act of choice. His first judgment concerning modern manufacture is of an aesthetic type. He will say "a nice bicycle," "a nice car," before finding out if it goes.[9]

This need and demand for aesthetic appearance may show itself in almost everything we do and make and acquire. Almost anything, object or activity, private or public, domestic or civic, must please in appearance as well as serve in use to satisfy fully. It would be hard indeed to think of any utilitarian object, big or small, important or trivial, from cooking pots and corkscrews to airlines and office buildings, in which some extrafunctional element of aesthetic appeal is regularly and entirely absent. And this element is one of the familiar sources of the aesthetic in common life.

Excellence as a Source of the Aesthetic in Common Life

But grace, ornament, and refinement of form for its own sake are not the only expression of the aesthetic in everyday life. Another fundamental source or mode of the aesthetic in common life is excellence—pure or unadorned excellence of any sort. For functional excellence, besides being practically valued and praised, tends strongly to be felt as beautiful—that is, as satisfying in itself, in contemplation. And when excellence is embodied in a physical practical object, that object, while not ceasing to be practical, may become an aesthetic object, an object of aesthetic experience—in effect, an object of art, a thing of more than practical admiration, and a delight to see. Countless utilitarian objects, the designs of which are determined by the severest principles of use and efficiency, are thus raised to aesthetic quality in appreciation through sheer realization of purpose in material and form. Examples are legion. We all know the aesthetic delight in well-loomed woolens, in plain serviceable colors, in a sturdy well-turned pair of shoes,[10] or in a fine-tempered, keen-edged cutting tool. The lowly and common hickory axe-handle, it has often been

[9] Ferdinand Leger, "Painting and Reality," in Myfanwy Evans, ed., *The Painter's Object* (London: Gerald Howe Ltd, 1937), p. 19.
[10] See John Galsworthy's short story, "Quality."

felt, is a thing of genuine aesthetic pleasingness in its eminently suitable material and in its functionally unimprovable curve.

A relatively minor but nonetheless pertinent example of the emergence into awareness, with the help of time, of pure art from utility is that of the then-ordinary drug jar of the Renaissance. Concerning this once common object of use it has been written:

> The Albarello or drug jar made as a simple object of utility for the storing of drugs has often achieved a value far beyond that which its function suggests. . . . Many of these humble earthen productions have survived the centuries and now grace the vitrines of museums and cabinets of the greatest collectors, although in the first instance, they were merely planned as workmanlike performances which would fulfill adequately . . . the simple purpose asked. Majolica, an earthenware glazed with stanniferous, or tin, glaze was a most practical answer to a need. It was resistant and it was cleanly.[11]

Chinese snuff boxes, Oriental prayer rugs and saddle rugs, and South Sea tapa cloths are further instances of things originating partly at least in utility and now widely prized for their aesthetic qualities alone.

But impressive examples of the conjunction of utility value and aesthetic value in excellence can easily be found in certain major fields of fine art itself. These fields, practically conceived, are language communication and building; or, aesthetically conceived, literature and architecture. Both are of course often turned directly to aesthetic intent, as in poetry and drama and in decorative monument and pavilion. But both too are first of all utilitarian arts. Practical building and prose communication are equally and primarily works of use. But both by sheer attainment of excellence in fulfilling their practical functions often become works of art as well. Language designed for communication of practical or theoretical matters, when used with the skill of a master, becomes eminently successful. By that fact alone it attains the character of literature—that is, of art. "All beauty," said Walter Pater, "is in the long run only fineness of truth, or what we call expression. . . ." And, ". . . the excellences of literary form in regard to science are reducible to various kinds of painstaking; this good quality being involved in all 'skilled' work whatever, in the drafting of an act of parliament, as in sewing. . . ."[12]

Any skilled or painstaking work, Pater is saying, whatever its specific purpose or function, is art, in activity and result. In language communication, whether intended as literary or not, skilled work is

11 William M. Milliken, "Majolica Drug Jars," in *Art and Medicine, Bulletin of the Medical Library Association,* 32 (July 1944), 293.
12 "Essay on Style," *Appreciations* (London: Macmillan & Company, 1897).

accuracy in saying what is to be said; and this accuracy of expression, whether of thought or feeling, results in literary excellence or aesthetic character. It is this principle which can explain why we often find aesthetic enjoyment in such primarily intellectual discourses as the works of some of the great philosophers and scientists writing soberly and unemotionally about their subjects, and why we regard such works as literature as well as works of science and philosophy. And it explains why in a university the writings of a philosopher or a scientist may be appropriately read not only in the department of philosophy or science but also in courses in literature.

Examples of greatly successful practical communications which, because of that success, have an undoubted place in literature, lie richly at hand in innumerable classics. Hume's treatises in philosophy, Gibbon's historical *Decline and Fall of the Roman Empire*, Lord Chesterfield's letters of practical advice to his son, Darwin's diary describing the flora, fauna, and geological formations in the Southern hemisphere, are among them. Papers and addresses of state from presidents, prime ministers, and ambassadors; military records and reports; agricultural instructions; private letters of domestic happenings—in sum, anything whatsoever, even when its purpose is primarily informative, can produce literature simply in being well-written or spoken.

In building it is the same as in writing or speaking. In architecture as in literature, other factors than attainment of success in practical aim do, of course, contribute to the aesthetic quality which that art affords; but at the same time practical excellence is often sufficient in itself to raise the craft of building to a very level of fine art. Furthermore, it has been maintained, without that basic excellence of function realized, no amount or variety of other aesthetic addition will raise it to that level. And this has been held not only of building but of all other works too in which there is a primary purpose of use. If it be a thing to use, it must be a good thing of use before we can accept it as also aesthetically good. The uncomfortable chair will not be saved aesthetically by scrolls and carvings or marquetry, and the unbalanced spoon cannot be raised above its awkwardness by the cunning fineness of its embossings. It may have been meant as a whimsy of exaggeration, especially if ladies' hats are in question, but nevertheless the point is made in the downright words of a poet, when he says, "No hat is a beautiful hat which does not fit you and which the wind can easily blow off your head." [13]

But whatever we demand of hats, in architecture it is certainly

[13] Carl Sandburg, *Early Moon* (New York: Harcourt, Brace and Company, 1930), p. 18.

true that no house is a good house which cannot be lived in com-
fortably and no factory is a good factory in which the purpose of
manufacture cannot be efficiently carried out. Here too the principle
of excellence is found to operate. The modern idea of functional ar-
chitecture makes it a fundamental principle that in building, "form
follows function." And this principle is held to be equally an aesthetic
and a practical principle. Far from needing to be sacrificed to the
practical, the aesthetic is an outcome of it. This is the modern archi-
tectural expression of the general principle that practical excellence
results in aesthetic excellence. By some of its most insistent exponents,
the theory has been carried to the extreme of denying any other source
of aesthetic quality in building than that of practical success in de-
sign and engineering—specifically, of denying the validity of ornament
in that art. Thus, it is reported that "at the beginning of the century,
Adolf Loos, the Viennese architect, had proclaimed that ornament was
a crime." [14]

How strictly this principle is to be understood and accepted is,
however, very much a debatable question, and much doubt has been
raised against it. Thus Santayana, in a discussion of the contribution
of the sense of "practical fitness" to the "sense of beauty," declared
that "this principle is, indeed, not a fundamental, but an auxiliary
one; the expression of utility modifies effect, but does not constitute
it. There would be a kind of superstitious haste in the notion that
what is convenient and economical is necessarily and by miracle beau-
tiful." [15] Are we, we may ask, despite Santayana's warning, to believe
that aesthetic quality inevitably follows upon practical excellence, so
that a practically good thing cannot be ugly? Or are we to understand
more reservedly that the practical need not be ugly, but can always
just as well be made beautiful? Or is it, against both these alternatives,
possible that in some cases the aesthetic must give way to the practical
entirely, that some perfectly well-made practical things are unfortunately
but necessarily ugly?

Too many complicating factors and vague meanings are involved
to permit a ready answer to such questions. Both the key terms in
the sought-for conjunction are very unsettled and shifting. Whether or
not a given utility object is practically good is almost always a ques-
tion that is both vague and relative. For instance, the question: What
is a good and therefore (wishfully) an aesthetically pleasing roof? can-
not be answered except in relation to many considerations, such as
climate, durability, and purpose of the structure.

14 Lewis Mumford, "The Skyline," *The New Yorker*, September 28, 1957, p. 114.
15 George Santayana, *The Sense of Beauty* (New York: Charles Scribner's Sons,
1896, and London: Constable and Company Ltd), p. 215.

Again, a machine or a factory may be practically good in turning out a product in sufficient quantity for a satisfying profit. But the course of inventive progress shows that almost any machine or other utilitarian object can be made practically better or replaced entirely by a different one. (The ordinary household pin seems to be a rare if not unique exception.) Then, too, whether a given thing is or is not practically good, and if so in what degree, depends very much on the relation to it of the individual whose practical interests are in question. A poorly lighted and badly ventilated factory may be practically "good enough" for the factory owner who is content with the profits that are coming in, but it may be practically very bad for the workers to whom future health and present physical comfort is as real a practical concern as present earnings.

And even if it be argued, as it frequently is to good purpose, that such an owner is short-sighted in terms of his own self-interest in failing to provide the best conditions for the efficiency of the workers on whom his profits depend, it may still be answered that in some cases, the short-sightedness is practically appropriate. The enterprise may be a calculated short-range affair, aiming at quick and big profits, after which it will shut down. Or it may be calculated that capital investments required for improvements are not financially justified in probable increased profits. What then? Is not the humanly deleterious and aesthetically ugly factory practically better than a sightly and comfortable one would be? And likewise of tenements. Where, from the landlord's point of view, is the practical gain in replacing a tenement which yields large returns on a relatively small investment, by a modern apartment building or housing unit which may well yield a much smaller percentage return on a larger outlay. Is the tenement practically good? The landlord's answer may conceivably be an emphatic *yes*, even though the tenant's may be an equally emphatic and wretched *no*.

Of course, it may be pointed out in such cases that, from the standpoint of the factory owner or the landlord, we are talking of economic good, while from the standpoint of the worker and the tenant, we are referring to "human" good. But both of these are "functions," and the question is not resolved by the formula that form follows function. The vital question in specific cases is, which function? It may be further suggested that in cases of conflict of values, the human is to be given precedence, that human value is what is meant by "utility value" when we seek to establish a relation between it and aesthetic value. This may well be the answer, but in that case we shall have new questions, questions concerning the relations of the economic

and the aesthetic. We shall not, however, raise them here but will come to them in a later chapter.

The ignoring of differences in individual wants in matters of housing has been charged against the "form follows function" school of thought in architecture. Functional architecture, dedicated to the faith that if close attention is paid to practical needs, the aesthetic will come unsought, has been charged with cutting human wants too short. The "open plan" in domestic architecture, for example, gives primacy to ease of access and requirements of sociability, but it disregards other factors in human need. Picture windows, flexible and common living spaces, and extension visually and otherwise of indoor area into the garden and beyond are the result. The criticism is not that these are not good and satisfying to some people, but only that they do not suit everybody. Some seek and have as individuals a right to seclusion and privacy and want confined rooms and fixed walls. They too have a natural human need, and the architecture which satisfies it may also give rise to the aesthetic through function realized. This criticism, of course, leaves the principle untouched, but it does warn rightly against tying it too tightly to a limited set of practical needs.

In any case, we will assert the principle of excellence only reservedly, as we did at the beginning, and say that practical excellence *tends* to be felt as beautiful in contemplation, not that it must be felt or unfailingly is so felt by all and in the same way. With this reservation, we can affirm the prime examples which architecture affords. In excellence of purpose realized, a bridge may become something good to look at as well as a sure and convenient means of getting from one shore of water to the other. And a factory rigorously built to requirements of use may become an impressive structure of intrinsically interesting interrelated masses and planes as well as an efficient place to work. Successful building, like successful speaking and writing, can give aesthetic satisfaction in the characteristic which bespeaks its success. And excellence in these and many other practical works is one main source of the aesthetic in common life.

Contributions of Practical Excellence to Aesthetic Quality

Without further questioning of the fact, we may still ask how precisely does practical excellence produce aesthetic quality and evoke aesthetic appreciation? It does so in at least three ways. They may be stated in terms of appreciation:

1. Appreciation of function realized in the product.
2. Appreciation of resulting qualities or form.
3. Appreciation of technique or skill in the performance.

All three may be present in the experience of a given object or activity, and they may also be present, singly or together, with the practical employment of an object.

1. To appreciate function realized (as distinct from ornamental embellishment) means to be aware of and impressed with the niceties of its functioning, with seeing that it works "beautifully," is fit for its task. Those who actually use the thing, handle the tool, or operate the machine probably appreciate this kind of excellence most or best, but it may also be appreciated in detached observation. In any case, everyone uses and operates many things, and the experience of the character of functional excellence is therefore known to all. The steam-shovel man perhaps knows most directly and with intimate feeling the fitness of his ponderous, iron-mouthed machine to its task, but we who stand and watch can see it and sense it too. And then, besides, if we do not operate steamshovels or production tools, we do use spoons, typewriters, and can-openers; and we carry watches and drive automobiles. In all these and countless other everyday things we have ample acquaintance with function that is both realized and aesthetically appreciated.

2. Appreciation of quality or form resulting from function realized is also common experience. It may occur even when there is little or no functional understanding of the object in question. We may admire the display of tools and instruments in a hardware store window solely for their forms, their materials, and their imagined feels, enjoying them as we might abstract sculpture. We may have no skills to employ them and no knowledge even of their names and yet find them absorbing to look at. Countless things outside our own practical ken, from ships to scooters and from scalpels to ancient scimitars, can in this way fall within our aesthetic range. Many present-day artists have turned major creative attention to this source of the aesthetic in the modes of assemblage, dislocation, and techniques of minimal and pop art. Contemporary sculpture and painting, and even the dance, have found inspiration in the machine and have incorporated its forms and movements into aesthetic "statements." [16] And recent aesthetic exploration outside the conventional fine arts altogether has found a new

[16] See, for example, David Smith's "Euterpe Terpsichore," a fabricated bronze merging in form the human and the mechanical, the cog and the limb, in the Willard Gallery, New York; or in painting, Peter Blume's "Parade," (1930) in the Museum of Modern Art, New York, which makes dominant compositional use of machine plane and mass.

area of interest in the directly perceived machine and tool purely as form, structure, and texture. Museum collections and photographs presenting this interest range from household utensils and appliances to dynamos and plants of heavy industry.[17] In such objects "fine art" and "fine craft" merge. When the thing of use is perceptually excellent, the application to it of the term "art" in the phrase "useful art" is not felt to be an accident of nomenclature, but is taken as a fit designation of the aesthetic quality which it then shares with the work of fine art—namely, style or form.

Evidence of aesthetic quality resulting from good workmanship in producing a useful object is given also by the anthropologist in his study of primitive crafts. The following is an example:

> Objectively the excellence of workmanship results in regularity of form and evenness of surface which are characteristic of most uncontaminated primitive manufactures, so much so that most objects of everyday use must be considered as works of art. The handles of implements, stone blades, receptacles, clothing, permanent houses, canoes are finished off in such a way that their forms have artistic value. Expert workmanship in the treatment of the surface may lead not only to evenness but also to the development of patterns. In adzing [as in hewing out a canoe], the form of the object to be smoothed will determine the most advantageous direction of the lines in which the adze has to be carried.[18]

This observation on works of primitive cultures supports what we know in our own. The product of skilled and honest work is at once an object of practical excellence and of perceptual (i.e., aesthetic) excellence. It works well and its looks good. The purely useful, even the starkly useful, whether a savage war club or a "civilized" dive-bomber, can be a work of art in the common-life sense.

3. In appreciation of technique or skill, the third in our list of the ways practical excellence is a source of aesthetic quality, lies the enjoyment of the actual performance or operation which produces the well-wrought things of use. Though it is an important mode of experiencing the aesthetic in the excellent, it requires no long explanation. It is well-known and easily recognized. The skilled man at work, whether in the simplest craft or in the most difficult and exacting profession or art, commands admiration. Cook, bootblack, bricklayer,

17 For instance, the collection of the Walker Art Center, Minneapolis, and its publication, *Everyday Art Quarterly*. For the aesthetic interest in the industrial machine, see Philip Johnson, *Machine Art* (New York: The Museum of Modern Art, 1934).
18 Franz Boas, *Primitive Art*, p. 30.

sculptor, boat-builder, and surgeon—the skills of all and each may be appreciated as such and enjoyed as a spectacle. And there is in principle no difference in kind between the admiration we feel toward the skills of the crafts and trades, even the humblest, and those which are exalted as "properly" aesthetic, those of the virtuoso in painting, dancing, or music. It is all skilled working, and it is a self-sufficient source of enjoyment. That skill really is self-sufficient in merited attention is well recognized in the fine arts, especially in music and dance, where the skill is often detached and exhibited as virtuosity for its own sake. Thus, for example, an étude is a musical composition especially designed to afford a performer a means of showing his command of some special point of musical execution, of exhibiting his artistry.

But virtuosity is also shown and valued in some of the humbler occupations, and situations are arranged for exhibiting them. Skills here too are often detached from actual employment and are presented for admiration and entertainment. The skill of the glass-blower, a regular feature of the old-time circus sideshow, is a good example. The folk have always, the world over, made festivals of their occupational skills. Log-rolling, bronco-busting, and even hog-calling are among the well-known work skills which, in the American scene, have long delighted and still continue to delight in independent exhibition. Athletic performances, too, certainly have their origins in the highly esteemed skills of once vital and altogether practical occupations—in the prowess of the warrior, the swift foot of the courier, and the sharp eye, true arm, and long leap of the hunter. All such performances may be detached from their original work, and interest is taken in the sheer showing of them. The work aim of riding a bucking bronco is to "break"—that is, to tame him, but in the rodeo the aim is simply to ride him successfully according to the rules and in good form. The self-sufficiency of the performance is reflected in the fact that the "good" rodeo bronco is the one that is incorrigibly bad, that can't be tamed. And in the spectacle of an athletic meet today, such as an intercollegiate rowing match, there is, in the mature and knowledgeable spectator, a keen enjoyment and admiration of skill, an enjoyment which is at least in part aesthetic. The interest is not merely in the winning or the achievement, but more importantly in the exhibition of "good form."

In athletic spectacles it is clear that what is being admired is the show of skill, not the use of it. Here, indeed, work is no longer to be done, and the activity, which may once have had a practical function, survives in form only. Such skill may of course be put to new work, such as that of winning games for the school, an athletic

scholarship for the player, and perhaps legislative and alumni largesse for his college. In this way a new practical value will be given to a skilled activity whose original use is no longer needed. But the fact of the survival of the skill beyond the original function may remain dominant in attention, and the attention may then be entirely or mostly aesthetic.

In seeming contradiction to what we have been saying, it has often been asserted that the acme of art is to conceal art. Kant, for example, argued that the art of pure beauty seems unlabored, spontaneous, "like nature." Virtuoso art, he contended, is inferior for the very reason that it calls attention to technique. For instance, it has been said in criticism of the Russian ballet that it impresses too much by way of virtuosity and gymnastic stunts. The greatest art, in contrast, transcends its technique, the means used being hidden in the perfection of form and expression. We must admit that there is truth in these contentions. Virtuosity, especially in the fine arts, detracts when it becomes obtrusive—any work that impresses us mainly as a stunt or showoff trick has questionable value. Perhaps this is simply to say that *artistically* the work is not as skillful as it should be, because the skill is not subordinated to the artistic end. Great skill consists in a mastery that becomes second nature and consequently *is* unobtrusive. To the discerning beholder it is recognized as all the more superb, and this recognition contributes to the aesthetic pleasure.

The Majority Report

We have described how the aesthetic interest is widely and variously expressed in forms that are part of normal everyday living. The conclusion is inescapable that art in its widest sense is pervasive in human living because the aesthetic is one of the root interests of human nature as we find it everywhere. Art is not a late and luxury development in civilization, unknown when life is rude and primitive and dispensable when the other needs of life become pressing. And with the individual it is not merely a leisure-time interest, but one which goes with him every hour wherever he turns and whatever he does.

There is an increasing realization in recent years that the "art for art's sake" theory represents a "minority report." As a lecturer at Harvard University has said:

The notions we hold concerning the place of Art in the scheme of life, which notions we have inherited from the enthusiasts of the sixteenth century, who adopted them from the period of clas-

sical decline, may be true, but it is well to remember that we who hold them are, historically speaking, in a very small minority. With the exceptions noted, all people of all times and all places, from the highly civilized Artists of Egypt, Assyria, India, China, Japan, Mexico, Peru, and the European Middle Ages, to the primitive and savage peoples of both historic and prehistoric times, have united in answering this question about Art in a manner very different from our own.[19]

Among the majority of "all people," the word "art," if it is used at all, does not mean fine art—it means skill. "The Balinese have a saying: 'We have no art, we do everything the best way we can.'" The writer who quotes this saying adds: "The fact that we have a concept of art stands in the way of art's permeating every aspect of our lives; seeing art on a universal level."[20] This universal meaning of art—the making or doing of things in "the best way we can"—is embedded in the history of our language. "The fishermen can't employ their art," writes Addison, "with so much success in so troubled a sea."[21] The same kind of broad meaning attaches to the word "artist." John Milton, for example, referred in *Paradise Lost* to

> . . . *The Moon, whose Orb*
> *Through Optic Glass the Tuscan Artist views*
> *At Ev'ning from the top of Fesolé. . . . (I, 288–90)*

The "artist" here mentioned was the famed Galileo, scientist-philosopher to the grand duke of Tuscany, who made and put to good use one of the first telescopes. To cite another example, Defoe in *Robinson Crusoe* described a ship in a sudden storm wandering erratically "because there were no *artists* on board" (our italics)—that is no men skilled in navigation.[22] "Art" and "artist," in the restricted aesthetic sense, do not appear in English dictionaries until well into the nineteenth century.

The excesses of aestheticism have recently produced a reaction and swing back to a wider conception of art. Typical is the remark of John Cage that "the obligation—the morality, if you wish—of all the arts today is to intensify, alter perceptual awareness and, hence, consciousness. Awareness and consciousness of what? Of the real material world. Of the things we see and hear and taste and touch."[23]

[19] Graham Carey, *The Majority Report on Art* (Newport, R.I.: John Stevens, 1937), p. 1.

[20] Preston McClanahan, "To Prove the Fact of Existence," *Arts Magazine*, 45 (Summer 1971), 37.

[21] Cited by *Webster's International Dictionary* (1897).

[22] The citations from Milton and Defoe appear in Carey, *Majority Report on Art*, pp. 3–4.

[23] Interview with John Cage, *The New York Times*, Sunday, March 16, 1968, p. D9.

This is akin to the sensual mysticism of D. H. Lawrence, with its aspiration to awaken "the unborn body of life hidden within the body of this half death which we call life." [24] It is akin also to various movements outside the arts, such as the politics of "engagement" and de-alienation, the breaking down of old inhibitions against nakedness and eroticism, the rapid and dangerous use of "mind-expanding" drugs, and the popularity of "encounter groups" and gestalt therapy.

What are the signs of a similar movement in the arts? They include the following:

- Use of "found objects" and materials taken from common life, such as driftwood, scraps of paper, junk, and (in music) street noises.
- Fascination with the childlike, the primitive, and the utterly simple.
- Employment of chance, improvisation, and "free form" in an approach to the randomness of life.
- Acceptance of the ugly, the obscene, the sacrilegious, the commonplace, and even the trivial as subject matter in art.
- Increased reliance on the kinaesthetic and contact senses, such as touch.
- Exposure of the body from without (nakedness) and awakening of the body from within.
- Readiness of artists to employ technological tools such as lasers and computers and to collaborate with technicians and engineers.
- Elimination of the audience as separate from performers, as in folk dances and "happenings."
- "Do-it-yourself" movements which bridge the gap between the professional artist and the ordinary creator.

The cumulative effect of these trends and innovations is to enlarge the scope of consciousness and break down the separation of art and common life.

The negative consequences for aesthetic theory may be summed up in the form of various denials and rejections: denial of aesthetic standards of ideal harmony and formal beauty; denial of isolation, distance, disinterestedness, and aesthetic aloofness; rejection of the notion that art is unique, and a scoffing at the "museum mentality" designed to safeguard that uniqueness; and rejection of any substantive distinction between the "fine" and the popular arts. Combined with these negations are some strong affirmations, such as an insistence on the continuity between art and life. These trends in the arts and aesthetics, Arnold Berleant concludes, "suggest the need for new concepts, for a theoretical vision which is able to encompass the broader

[24] D. H. Lawrence, "Glad Ghosts," *Dial*, 81 (July 1926), 2.

extension of the arts, their fuller integration into the other activities of men, and their greater generality and inclusiveness." [25]

We applaud the new sensitive awareness of the things of common life and the readiness of artists and aestheticians to embrace this enlarged consciousness. There is much élitism and snobbery in the artistic domain, and these we deplore. In some ways, however, we are old stick-in-the-muds, cherishing the formal beauty of art in the past and admiring high and rare attainments in the present. As we have made clear in Chapter 3, we are not prepared to discard the concept of aesthetic distance as worthless. Nor are we ready to erase the distinction between art and non-art, or between fine and popular art. It is not enough to make art common—art should be common in an uncommon way. The ideal is to share artistic excellence and not mediocrity. We must admit that there are some moons we should not cry for—the ones forever beyond our reach. If excellence is bound to be rare, we should give up the hope of its wide diffusion. But many of us oldtimers are deeply loath to forsake the ideal of a *high* democratic culture as expressed, for example, by Walt Whitman in *Democratic Vistas.*

Art should neither be debased to a merely utilitarian role nor separated from the main business of humanity. We should live as whole men, not with our muscles or brains alone, but with our eyes, our ears, our entire mind and body, with the full range of our creative capacities. Thus to live we must respond to the world in a skilled, active, artistic way, our senses aroused, our tastes cultivated, our imaginations at work. Art, as Ruskin and Morris maintained, must lend its grace to the most familiar objects and scenes: daily attire, common utensils, homes and gardens, streets and neighborhoods, places of work and play. Artists must join with engineers, city planners, and civic-minded leaders in bringing cleanliness, order, and comeliness into our urban environment. The artistic phase must enter much more pervasively into industry—with less emphasis upon mere volume of productivity and more emphasis upon fine workmanship and good design. A revival of creation, in the form of various amateur pursuits, has already begun, and it must be energetically promoted by schools, discussion groups, neighborhood art centers, and all sorts of music and art circles. In all these ways, art and aesthetic value can enrich the common life, but not, we hope, through a blurring of distinctions and a process of debasement.

In the past, human associations have been determined chiefly by

[25] "Aesthetics and the Contemporary Arts," *Journal of Aesthetics and Art Criticism*, 29 (1970), 165.

economic necessity, geographic proximity, and blood ties. In the future, technology may free men from bread-and-butter cares and supply them with leisure, easy communication, and rapid transit. They can then flock together upon the basis of friendship and mutual interests —scientific, recreational, artistic, etc. A new kind of decentralization, functional rather than merely geographic, can thus be achieved, and common men can be supplied with the means of living aesthetically expressive lives. The Great Schism between science and humanism can be terminated, and the artist can regain the sense of community.

In this chapter we have described in considerable detail how the aesthetic interest is widely and variously expressed in forms that are part of normal everyday living. The conclusion is inescapable that art in its widest sense is pervasive in human living because the aesthetic is one of the root interests of human nature as we find it everywhere. Art is not a late and luxury development in civilization, unknown when life is rude and primitive, and dispensable when the other needs of life become pressing. It is there from the beginning and it is there always. And with the individual it is not merely a leisure-time interest, but one which goes with him every hour wherever he turns and whatever he does. Without it life is not whole. And we go now from our consideration of art in common life and of the aesthetic interest in fundamental human nature to a study of aesthetic value in the "fine arts" with no false notion of approaching something perhaps very grand but quite foreign to the concerns and conditions of ordinary life. We come to it rather with the sound expectation that in fine art we shall find a further and freer pursuit, specialized but not insulated, of an interest altogether natural and common. We shall expect to find the artist a man talking to men in terms of a common human need.

Chapter 6

AESTHETIC VALUE
IN FINE ART

Art as a Specialized Interest

In the preceding chapter we dwelt on the fact that aesthetic experience is pervasive in everyday living. It embraces the appreciation of natural objects as well as of human artifacts, and it permeates the borderlands of art in such things as manners, ceremonials, and rituals. By aesthetic experience we mean awareness and enjoyment of quality, form, and grace beyond the demands of our other interests—the practical, the moral, the cognitive, and so forth. We found that the aesthetic interest expresses itself in mutual support of and multiple relations to these other interests, and we concluded that it may be regarded as equally basic with them in total human living. Taking "art" to mean generically the creation of aesthetic value in any way whatsoever, we observed that all men seek and enjoy it in the shapes and colors and in the grace which they give to the daily objects and acts of use and need—to chairs, blankets, automobiles, and skyscrapers, and to eating, dressing, and gardening. And though in distinguishing aesthetic from nonaesthetic interests, we said that in the

120

aesthetic we are not concerned with things in their uses and detached meanings, nor in their profits and their advantages, we gave examples to show that even here the aesthetic may emerge, as in the psychologist's rat-maze spectacle, in the moralist's view of a state of affairs, and in the appreciation of excellence of function or purpose realized. The latter possibilities rest on the fact that nonaesthetic meanings and uses, once given, may themselves be contemplated as well as pursued, and thus evoke aesthetic interest and take on aesthetic character. A machine or a tool may become an object of sculptural interest, a moral situation may be attended to as an image of dramatic human relationships, and a reasoned philosophical conviction may appear as a trait of an aesthetically interesting character. And so on.

But in a developed society, such as ours, art does not remain a merely random element in the common stream of life. Like other fundamental interests, art becomes a specialized pursuit, aiming to serve a common need. The result is the professional artist and *fine* artworks which express in a higher degree and with conscious purpose and trained skill the beauty of harmony and appearance which is otherwise sought more or less by the way in practical living. The artist is one of our specialists. In giving us fine art he provides us more expertly than we ourselves can provide one of our daily human needs. He does not in last analysis create the need, but serves it in an especially competent way.

Fine art is widely familiar. It is music, sculpture, painting, literature, dancing, the moving picture, and many other commonly experienced forms of nonutilitarian goods. It also includes architecture as far as that art transcends merely utilitarian calculations.

Fine art is in its one line of interest a culmination of what already goes on in life at all lower levels. It is a culmination in the same sense that all specialized and expert works in a society carry to refinement and to fuller realization already existing practices and purposes. It follows that though in fine art the art interest becomes an object of independent pursuit, it is not thereby cut off from life. Being merely the special cultivation of one of the root interests in life, it is similar, in its reason for being, to the specialized pursuit of knowledge in pure science or philosophy and the professional occupation with production and trade in manufacture and business or the specialized cultivation of other root interests. Art, like business and other occupations, no matter how specialized, grows out of all-human activities, serves all-human demands, and provides public goods. The artist should not be regarded as one who has found *the* good

way of life and leads it with his own satisfaction exclusively in mind, but rather as one who has found his special *function* in his society and who is happy in fulfilling that function. In fine art, the art interest gains in excellence of expression and intensity of appreciation, and in fine art the place and importance of art generally in life is best revealed and most clearly understood.

It does not follow, of course, that any given example of fine art will be better by the fact of being fine art than any given example of common or non-fine art. There are certainly very bad paintings and poems and pieces of music, and there are no less certainly very good (i.e., aesthetically good) rugs, automobiles, and cutting knives. But in intention, fine art is *excellent* art. Indeed, fine art may be not badly defined as the pursuit of aesthetic excellence for its own sake, and the artist as a specialist in works of excellence. In fine art, we may say, we have presentations of what life or experience in its immediacy is like when it is really good or memorable—which it seldom is without subtraction.

Fine art intensifies the quality and the beauty of things because it offers them in relative independence or purity. In the mixed experience in which art or beauty in common life occurs, the aesthetic interest and the aesthetic quality are often obscured and easily overlooked or neglected in the midst of practical pursuits. The aesthetic interest in good-looking blankets, for instance, though actually distinct from the practical interest in sound sleep, may be easily confounded with the latter. So also the aesthetic admiration of a bridge may be neglected or only dimly felt in the pressing practical desire to get over the bridge to the far shore. When such blurring of the sense of beauty becomes frequent, or such neglect of it habitual, we are in the way of impoverishing or drying up one of the root human interests. It is the concern of art as a special interest to see that aesthetic impoverishment of human life does not occur. Fine art offers us conspicuous examples of how things in their immediate appearances and in their intrinsic nature may be interesting. We do well with art if we carry this power which it gives us back in some measure to life itself. With this advice in mind, it has been wisely said that life should imitate art, not art life.

Because of the independence of its works, its devotion to excellence, and its sharpening of appreciation of things as we directly see and feel them, fine art affords the best example for understanding the importance of the aesthetic interest in human life. Consequently, the question: What is art? may be best or most fully answered by answering the question: What is fine art? Let us now endeavor to answer this question in greater detail than we have done so far.

What is Art?

In order to stress both the continuity and the differences between the aesthetic in common life and the aesthetic as a specialized interest of the artist, we have in the previous pages regularly used the expressions "art in common life" and "fine art"—the term "art" in each phrase indicating the continuity and the qualifying words the differences in the two. But because the point has now been made, and because in what is to come the contexts will make it clear when it is important to distinguish, whether we are speaking of the one or the other, or of both under the common idea of aesthetic value, we shall for the most part dispense with the phrases "art in common life" and "fine art" and speak simply of "art." In what immediately follows we shall principally mean art in the specialized sense of "fine art," the sense in which the term in its conventional contemporary usage refers to the activities and works of painting, sculpture, imaginative literature, music, dance, and so on, and to the thing or characteristic meant in the appreciation of these.

Contrary to the view of some linguistic philosophers, we do not believe that the task of the aesthetician is to investigate how people ordinarily talk about art or aesthetic experience. It is quite possible and even rather likely that ordinary notions are logically confused or based upon superficial knowledge or erroneous impressions. Mistakes, whatever they are, should not hide behind the protective screen of customary usage. We propose to rely upon our own aesthetic insight and to appeal to *your* insight and not to be unduly bound to what people ordinarily say.

To enumerate the *kinds* of things which are usually meant by the term is another method of trying at the outset to tell what "fine art" is. We made use of this method when we listed painting, sculpture, literature, etc. as examples of the fine arts; and we could easily have illustrated by pointing to a paradigm example of each kind (for example, a sonnet of Shakespeare, as an example of poetry; a quartet of Mozart, of music; a landscape of Constable, of painting, etc.). This method also has its difficulties. Usage of the term "fine art" to name types of art has through the centuries shifted considerably and sometimes capriciously. At one time there was no single conception of the fine arts at all, and those divisions which we now include under the single term were variously seen as activities in the sciences and the crafts. Music was classified with mathematics, poetry with grammar and rhetoric, and painting with the manual crafts of bricklaying, masonry, etc. At another time the fine arts meant only the visual arts, while subsequently they included poetry and music, and also eloquence, optics,

and mechanics. Architecture shifted in and out of the total group. It was once a fine art, then it was not, and now again it is.[1]

It does not help much to appeal to modern or current usage either, because agreement here is far from complete and such as there is leaves many questions unanswered. Schools of fine art in universities usually include the "major" arts of painting, sculpture, and architecture, and also some of the "minor" arts, such as ceramics, weaving, and landscape architecture. The question arises: What is the basis of distinction between the two groups? Are both "major" and "minor" arts "fine arts"? Or are only the "major" arts "fine"? Also, more liberal interpretations within the university reach out into other fields and departments to include literature, music, drama, and dancing. And, though still for the most part outside of universities, a place for the moving picture as a form of fine art is demanded with increasing insistence.

Mere usage, alone, then, either historical or current, will not suffice to answer the question: What is fine art? Nor is it possible, except very arbitrarily, to select within the current usage criteria which can be offered as a revised and disciplined usage. Nevertheless, we must attempt to formulate at least a tentative definition following the empirical method that we have indicated.

The breadth or narrowness of the definition should depend on the purpose of the definer. If his purpose is to separate the "pure essence" of art from all impurities, the definition will be correspondingly strict and narrow. If the purpose is to forge a strong nexus between art and society, the definition will be broad and inclusive. In the National Foundation on the Arts and Humanities Act of 1965, for example, the Congress of the United States defined the arts as including, but not limited to, "music (instrumental and vocal), dance, drama, folk art, creative writing, architecture and allied fields, painting, sculpture, photography, graphic and craft arts, industrial design, costume and fashion design, motion pictures, television, radio, tape and sound recording, and the arts related to the presentation, performance, execution, and exhibition of such major art forms." Here the broad public policy led to an inclusive listing of the arts.

No all-purpose definition of art or the arts is possible.[2] Our purpose in this book is to characterize art and aesthetic value and to explore their relations to other fundamental human values. This purpose is best served by a broad and interdisciplinary approach that is

[1] See Oskar Kristeller, "The Modern System of the Arts," *Journal of the History of Ideas,* Vol. 12 (1951) and Vol. 13 (1952).

[2] See Thomas Munro, *The Arts and Their Interrelations* (Indianapolis: Bobbs-Merrill Company, 1949), p. 543 and *passim.*

definitely linked to the concept of value. Hence we include art in common life and the aesthetic values of nature within the scope of our concern, and we shall define fine art in no narrow and constrictive way. We are not trying to find an exclusive essence that marks off fine art from all other human activities. The various strands of human life are too intermingled and changeable to permit a neat demarcation. Hence it is foolish to try to draw a sharp and immutable dividing line between art and non-art or between fine art and the art of common life.

Although uncertain about borderline instances, we can be fairly certain about the core of art. We said at the beginning of this chapter that "art" means generically the creation of aesthetic value in any way whatsoever. In the art of common life, this creation more often than not creeps in unintentionally as the by-product of skill or good workmanship; in fine art, it is the deliberate aim and intent of "specialists" in artistic creation. Lest the definition of art as the creation of aesthetic value seem no more than a tautology, we should recall the characteristics of aesthetic value as we have stated them. First, the objective component is any quality that has enough vividness and pungency to make us contemplate it for its own sake. Second, the subjective component is appreciation of this quality as good or interesting simply to apprehend. Third, the objective and subjective components are indissolubly connected, aesthetic value being a property of the object-subject gestalt. In characterizing art as the creation of aesthetic value, we need to be on our guard lest we overemphasize either the objective or the subjective side, bearing in mind the third mark, the relational character of aesthetic value. We shall now try to make clear some of the implications of this view of art, hoping thereby to define "art" more precisely.

Art as the Expression of Values

Suppose we begin with an artist at work. The following passage occurs in a letter written by Vincent Van Gogh to his brother:

> I should like to paint the portrait of an artist friend, a man who dreams great dreams, who works as the nightingale sings, because it is in his nature. He'll be a fair man. I want to put into my picture my appreciation, the love that I have for him. So I paint him as he is, as faithfully as I can. But the picture is not finished yet. To finish it I am now going to be the arbitrary colorist. I exaggerate the fairness of the hair: I come even to orange tones, chromes, and pale lemon-yellow. Beyond the head, instead of

painting the ordinary wall of the mean room, I paint infinity, a
plain background of the richest, intensest blue that I can con-
trive, and by this simple combination of the bright head against
the rich blue background I get a mysterious effect, like a star in
the depths of an azure sky.[3]

This brief passage illustrates the three marks of aesthetic value that
we have mentioned: (1) the objective complex of qualities, (2) the
subjective mood, (3) the essential relatedness of subject and object.
We shall now discuss each of these marks in defining art as a creative
process.

1. *Art as qualitative.* From the standpoint of the objective com-
ponent, art is a process of elaborating, enhancing, and synthesizing
qualities. In the passage quoted above, Van Gogh speaks particularly
of the evocation and intermingling of qualitative nuances through the
play of colors. In order to present with optimum vividness the quality
of the blonde head, Van Gogh becomes an "arbitrary colorist," exag-
gerating the fairness of the hair, and turning to orange shades, chrome
yellow, and light lemon color. To accentuate by contrast, he paints
behind the blonde head a background of "rich blue," the richest,
strongest blue that he can contrive. Each color has its nuance and
all are keyed together to enhance one another and to form a total
design. By these means Van Gogh achieves an overall quality that in-
tegrates the entire picture—a "mysterious effect" like that of a star in
the azure sky.

Art can be defined in terms of this kind of qualitative process.
The artist may work, as in the case of Van Gogh, with colored shapes,
or he may work with lines, masses, movements, tones, textures, word
connotations, or other elements, but whatever be the realm of qual-
ities, he can find within it an almost infinite range of possibilities.
His problem is to focus upon some aspect as motif and to work out
an ensemble of related qualities, each quality being selected and ex-
perimentally transmuted according to the requiredness of the whole
structure which gradually emerges. Comparing the artist and the sci-
entist, John Dewey has said:

The artist has his problems and thinks as he works. But his
thought is more immediately embodied in the object. Because of
the comparative remoteness of his end, the scientific worker oper-
ates with symbols, words and mathematical signs. The artist does
his thinking in the very qualitative media he works in, and the

[3] Irving Stone, *Dear Theo: The Autobiography of Vincent Van Gogh* (Boston:
Houghton Mifflin Company, 1937), p. 441.

terms lie so close to the object that he is producing that they merge directly into it.[4]

Every competent artist respects and is sensitive to his medium, gets the feel of it, learns its peculiar sensuous qualities and expressive powers—and its limitations. He knows that what can be shown or sounded or "said" in one medium cannot be presented or conveyed in a different one. The sculptor, for instance, thinks and feels and works sculpturally and not musically as does the composer, or verbally as does the poet. And even more specifically, he thinks, feels, and works in wood, stone, concrete, or plastic, and so on, in whatever material is chosen or is at hand to be shaped. Thus too in the graphic arts, the differences between the fine line work of etching and the rich shading of charcoal are due primarily to the understanding and use of the characteristically different media. There is a similar contrast between the effects that are suitable to water colors and the effects that are possible in oil painting. The water colors of Winslow Homer, for example, exhibit a kind of surface fluidity, in marked contrast to the heavy textured effects that Van Gogh achieves with thick pigments of oil. So in music, every instrument has a special character of its own that a fine composer learns to appreciate. Chopin, for example, is a superb composer for the piano: his effects are properly pianistic, because he has become so intensely at one with the piano, so sensitive to its peculiar expressiveness, that his imagination freely conceives within the terms and limits of this instrument. Very different from the piano, with its clipped tones and great harmonic resources, is the violin, with its lesser capacity for harmony and percussive effect, but its great expressiveness in stress, vibrato, tone color, and ability to sustain notes. If a transcription from the violin to another instrument is highly successful, as in Bach's harpsichord transcription of a Vivaldi violin concerto, it is because the composition has been imaginatively recreated to fit the new medium, or because the tone color has been minimized and the abstract architectonic form emphasized in both compositions.

The problem for the composer of orchestral music is to combine the sonorities of many instruments. Aaron Copland has pointed out the singular achievement of Berlioz in this respect:

> It is generally agreed that it was the orchestral genius of Hector Berlioz that was responsible for the invention of the modern orchestra as we think of it. Up to his time composers used instruments in order to make them sound like themselves; the mixing

――――――
[4] *Art as Experience* (New York: Minton, Balch and Company, 1934), p. 16. Quoted by permission of G. P. Putnam's Sons.

of colors so as to produce a new result was his achievement. Berlioz took advantage of the ambiguity of timbre that each instrument has in varying degrees, and thereby introduced the element of orchestral magic as a contemporary composer would understand it. The brilliance of his orchestration comes partly by his ability to *blend* instruments—not merely to keep them out of one another's way.[5]

Whether the problem is one of blending or one of realizing the full expressive potentialities of a single instrument, a good musician is professionally adept in solving problems in the media he employs. Similar remarks are applicable to the sculptor, the architect, the choreographer, the dramatist, the poet, or the artist in any medium whatever.

But qualitative problem solving is by no means limited to the use of media. There are the more intangible qualities of form and expression, and these also confront the artist with formidable problems. To return to Van Gogh's letter to his brother, the painter wishes to portray the nature of his artist friend, "a man who dreams great dreams" and "who works as the nightingale sings." He desires to express temperament and character by visual appearances—not so much by representation of a facial expression or any literal physiognomic feature as by the lyrical quality of color combinations and figurative design. Thus to capture and portray the life spirit of another human being requires a special kind of genius, and even a painter as gifted as Van Gogh may fail, or succeed only after repeated attempts. In another letter he writes:

> When I have a model who is quiet and steady and with whom I am acquainted, then I draw repeatedly till there is one drawing that is different from the rest, which does not look like an ordinary study, but more typical and with more feeling. . . . When I once get *the feeling of my subject,* and get to know it, I usually draw it in three or more variations—be it a figure or landscape— only I always refer to Nature for every one of them and then I do my best not to put in *any detail,* as the dream quality would then be lost.[6]

As we have said, the qualities which the arts embody are infinite in scope and variety, being as inexhaustible as nature and the human imagination. They range from the qualities of the medium and the formal properties of the design to all the vivid qualities of the outer world and the nuances of our inner life. Perhaps there is no quality

[5] *Music and Imagination* (New York: Mentor Books, 1959), pp. 44–45. Copyright 1952 by the President and Fellows of Harvard College.

[6] *Letters to an Artist: Vincent Van Gogh to Anton Ridder van Rappard* (New York: The Viking Press, Inc., 1936), pp. 106–7. (Italics in the original.)

under the sun that cannot be presented, represented, or connoted in one or more of the arts. But as Pepper, who has defined art in terms of the enhancement of qualities, has so strongly insisted, aesthetic qualities are not bare objective data but *felt* qualities. In a sense, the artist is concerned with outward things, but they are things-as-felt (as glowing with "interest"), with the feelings entering constitutively into the objects. Qualities utterly neutral and stripped of all feelings may be of concern to the scientist, but they are of no concern to the artist.[7]

2. *Art as expressive of feelings.* If we choose to emphasize our inner response to things, we can define art as the expression of mood or feeling. To illustrate, let us turn back to the letter of Van Gogh to his brother and note this subjective element. He says that he wants to put into his picture his "appreciation," his "love" for his artist friend. Hence he does not wish his painting to serve as a precise description of his friend's height, weight, the exact color of hair and eyes, or any other factual details. Faithful reproduction, as he points out, is only a preliminary exercise. He wishes to convey the mood of appreciation that he feels toward his friend. Art is the "language" of appreciation rather than the "language" of description.

One of the first aestheticians to characterize art in terms of subjectivity was Eugene Véron, whose book *L'Esthétique* (published in 1878) greatly influenced Leo Tolstoy's *What is Art?* Véron defined art as the expression of the emotional life of the artist:

> Art consists essentially in the predominance of subjectivity over objectivity; it is the chief distinction between it and science. The man intended for science is he whose imagination has no modifying influence over the results of his direct observation. The artist, on the other hand, is one whose imagination, impressionability—in a word, whose personality is so lively and excitable that it spontaneously transforms everything, dyeing them in its own colors, and unconsciously exaggerating them in accordance with its own preferences.[8]

Véron defined art as the expression of emotions, in this respect differing from Tolstoy, who insisted that art should be defined as the communication of emotions; but both agreed that art is, so to speak, the language of feeling rather than of intellect.

In the same tradition, Curt J. Ducasse has defined art as "the objectification of feeling," meaning the expression in objective form

7 See Stephen C. Pepper, *Concept and Quality* (La Salle, Ill.: Open Court Publishing Company, 1968), pp. 31–33.

8 *Aesthetics*, trans. W. H. Armstrong (London: Chapman & Hall, 1879), p. 389. Reproduced in Melvin Rader, *A Modern Book of Esthetics*, 4th ed. (New York: Holt, Rinehart and Winston, Inc., 1973).

of some feeling experienced by the artist. "Creation provides the artist," he writes, "with a mirror of the feeling aspect of his soul, through which its movements, until then obscure, reach clarity for him. . . . Another function of art . . . is to serve human beings as a means of acquaintance with one another's horizons of feeling." [9] The word "feeling" as Ducasse employs it has a wide connotation. He includes not only emotions but "longings, impulses, dispositions, aspirations, inclinations, and aversions," as well as "sensory impressions" and "images of imagination"—"all of these, however, as felt directly, rather than as intellectually analysed." [10]

This way of speaking about art is importantly true in a one-sided way. It is true that art, as compared with science, is a way of expressing subjective mood and feeling in a form communicable to others. But to put exclusive emphasis upon feeling is one-sided or even misleading. "Feeling" is so irreducibly associated with subjective states that it seems impossible to conceive of it as "objectified"—that is to say, as somehow made into an object. To speak of art as the enhancement of qualities is also true but one-sided in the opposite direction. "Quality" denotes an objective property, phenomenally if not noumenally, and unless we speak of *"felt* quality," it is too limited. It is only when we link together quality and feeling, the objective and the subjective poles, that we have the basis for an adequate and well-balanced definition of art. But to link the two together is to adopt the concept of value. For "value," as we have explained, is a two-sided notion, objective and subjective; hence it includes the truth of the qualitative approach and also the truth of the affective approach.

3. *Art as value-expressive.* Because of this greater inclusiveness, art is more accurately defined as the expression or embodiment of values than as either the expression of feelings or the enhancement of qualities. Our phrasing conveys, as "the expression of feelings" or "the enhancement of qualities" does not, the most characteristic fact about art—that there is no cleavage between subjectivity and objectivity. As Louis Arnaud Reid has declared:

> It is as natural to speak of *values* being embodied in the forms of the objects, as it is unnatural to speak of *feelings* being embodied in the objects. . . . Values, although dependent on the subjective factor, are quite ordinarily placed in the objective world, and are inseparable from objects, as feelings are not. Moreover, if we try to say that feelings, not values, are aesthetically embodied, it will not work, since the feeling, by definition, is distinct from

[9] Curt J. Ducasse, *Art, the Critics, and You* (New York: Liberal Arts Press, 1955), p. 68. (First edition 1944, copyright by Oskar Piest.)
[10] Ibid., p. 133.

the object, and should be describable by itself (or at least known by itself), whereas what is aesthetically embodied is never accurately describable or known except in the actual aesthetic experience itself. It is value . . . which is embodied, value which is made as (say) the sounding music actually progresses. The value is known in the sounding progressing notes as heard, and is inseparable and indescribable, though clearly known in the experience of the sounding notes.[11]

Reid is here insisting upon a point that we strongly emphasized in Chapter 4, that value is a subject-object determination, and that in the case of aesthetic value, the relatedness of subject and object, of quality and feeling, is intrinsic and indissoluble.

If we again refer to our earlier quotation from Van Gogh, we are struck by how interdependent are the qualitative and the affective elements in the creative process. By means of feelings, Van Gogh grasps the qualities of the friend he wishes to portray, and by feelings, too, he intuits the expressive qualities of the pigments and the design. As Nelson Goodman has said, "In aesthetic experience the *emotions function cognitively*. The work of art is apprehended through the feelings as well as through the senses. Emotional numbness disables here as definitely if not as completely as blindness or deafness. . . . Emotion in aesthetic experience is a means of discerning what properties a work has and expresses." [12] This is as true for the artist as he labors to compose the work of art as it is for the beholder of the work after it has been completed.

To sum up, feelings, in art, are modes of awareness and appreciation of the qualitative features of objects, and aesthetic values are qualities-as-felt. As we have insisted all along, it is only when feeling and quality are thus united that we can speak of aesthetic value. This relational view is fundamental to our whole argument.

It is possible or even useful for some purposes to abstract quality or feeling from its relational setting and to consider it separately. If we wish to emphasize the objective pole of the relation, we can say that the function of art is clear and vivid realization of quality. Or if we wish to emphasize the subjective pole, we can say that the function of art is the expression and cultivation of feeling. But these functions are not really separate and independent—they are two sides of the same process. The function of art is to make articulate the whole

11 From an unpublished manuscript on "Art, Truth, and Reality." See also Louis Arnaud Reid, *Meaning in the Arts* (London: George Allen & Unwin, Ltd, 1969), pp. 192–94.
 12 *Languages of Art* (Indianapolis and New York: Bobbs-Merrill Company, 1968), p. 248.

gamut of human values, and this function embraces and unites the other two.

We seem to have contradicted our initial definition that art is the creation of aesthetic value. If art is the articulation of the whole gamut of values, it appears to be much broader than our initial definition would imply. This objection is based on a too-limited conception of aesthetic value. There is an isolationist conception that we reject and a contextualist conception that we accept. The isolationist conception defines both the subjective and the objective component of aesthetic value in a narrow, exclusive way. It insists that the subjective component is a peculiar "aesthetic emotion," and that the objective component is "pure form" nowhere to be found outside the aesthetic sphere. We reject all such special object and special attitude theories and favor a wide-open theory.

There is nothing so special about art as the purists suppose. Intrinsic attention to qualities, with the "aesthetic emotion" that accompanies it, is not peculiar to art or to rare aesthetic experiences—it is an everyday occurrence in our perception of nature and the human environment. A common instance would be the enjoyment of a sense quality for its striking intrinsic character. The fresh odor of the woods after a rain, the glitter of winter frost on a windowpane, the grace of a deer as it leaps up a mountain path, may arrest attention and evoke an aesthetic response. Similarly, an interest in form is a life interest, manifest even in the child who enjoys fitting blocks together. The interest in the patterns and structures and connections and relationships of things operates in life prior to and apart from its operation in art. (This is borne out by the findings of gestalt psychology.) The purists who would fence art off from life cut the ground out from under their own feet—because the enjoyment of intrinsic perception and the interest in form, which they point to as peculiar to art appreciation, are among the most common and elementary of all life interests. When we say that art is the creation of aesthetic value, therefore, we do not mean that there is an elusive emotion or an exclusive qualitative essence which art and art alone exhibits. Art creates aesthetic value, not by hermetic isolation from life, but by making life values fascinating to contemplate.

Aesthetic value in works of art is the bloom that appears when *any* value is artistically expressed—it is the mark of success in expression. A value may be initially religious or moral or practical or cognitive—it may be a value of any kind—but it becomes aesthetic when it is detached, refined, accentuated, vivified, and embodied in a perceptible medium for the sake of intrinsic perception. Admittedly, the artistic transmutation may be imperfect, and in consequence the work

may be marred by didacticism or other nonaesthetic residue. But when the transmutation *is* complete, the flowers of art are the more vigorous and resplendent for having their roots in the rich earth of life. The broad human function of art is to create aesthetic value by the artistic expression and embodiment of life values.

How deep this function goes, how essential it is to the nature of man, is clear when we grasp what is most fundamental in the human psyche. The familiar answer to the question: What is man? is the reply of Aristotle: "Man is the rational animal." But, as Ducasse has remarked, "All that can rationally be claimed is that man is the animal who is rational when there is no temptation to be otherwise—which is seldom indeed." [13] The great romantics in a past age and the existentialists in our own time have revolted against the Aristotelian conception of man and have emphasized the volitional, passional, and imaginative dimensions of human life. Nietzsche, who was a forerunner of the existentialists, suggests another sort of definition than Aristotle's. "Man," he declares, "is the animal with red cheeks." [14] When a man blushes, his cheeks are red because he is ashamed of himself; and to be ashamed is to recognize a gap between what one is and what one ought to be. Shame, therefore, implies ideals, norms, values. In effect, Nietzsche is saying that man is the only kind of animal with a developed capacity to prize and disprize. Man, in other words, is the valuing animal.

In consonance with this definition, Nietzsche maintained that art expresses human nature as valuational. "What does all art do?" he asked. "Does it not praise? Does it not glorify? Does it not select? Does it not bring things into prominence? In all this it strengthens or weakens certain valuations." [15] Art, he believed, is the great means of mastering life because it is the supreme instrument for the enhancement and transformation of values.

Many people have defined art as imitation, or intuition, or the play of imagination, or the creation of beauty, or the expression of emotion, or the sublimation of wish, or the construction of form or design; but relatively few have defined art as the expression and embodiment of values. All of the above definitions, when intelligently expounded, throw light on the meaning of art, but it seems to us that the conception of art as value-expressive is the most illuminating. The main diversities and oppositions in aesthetic theory find their reconciliation in the concept of art as the expression of values.

13 *Art, The Critics, and You*, p. 27.
14 Friedrich Nietzsche, *Thus Spake Zarathustra*. Quoted by Ducasse, ibid., p. 27.
15 *The Twilight of the Gods* (New York: The Macmillan Company, 1924, and London: Macmillan Services Ltd), p. 79.

A number of writers in addition to Nietzsche have suggested this sort of definition without exploring its implications very far. Hugo Münsterberg, in a book on education written at the beginning of this century, remarked that "the scientist works toward laws where the artist seeks values, the scientist explains where the artist appreciates." [16] Alfred North Whitehead, whose philosophy has a strongly aesthetic tinge, has said that in art "the concrete facts are so arranged as to elicit attention to particular values which are realizable through them. . . . The habit of art is the habit of enjoying vivid values." [17] Another philosopher, Charles W. Morris, has defined art as the sign language of values. "In works of art," he has declared, "men and women have embodied their experiences of value, and these experiences are communicable to those who perceive the molded medium." [18] But none of these writers has carried his insight very far. At considerably greater length, Louis Arnaud Reid has explored the meaning of art as "the embodiment of values."

Expression and Embodiment

Both Morris and Reid, in the quotations that we have cited, speak of the *embodiment*, rather than the *expression*, of values. Reid gives several reasons for preferring the term "embodiment":

> First, "embodiment" suggests the thing directly before us, while "expression" has the unfortunate tendency, already criticized, to direct our thoughts otherwards to feelings or ideas which are expressed. Secondly, "expression" suggests, at least in some of its uses, events which had some sort of complete existence before they were expressed and became known in expression, whereas the artistic meaning which is embodied has no complete existence till it is born in embodiment. Thirdly, "embodiment" stresses the importance of the actual presence of what we are *sensibly* aware of, and attending to—the sounding music, the plastic forms, the dramatic action.[19]

John Hospers and Alan Tormey similarly complain that "expression," when applied to art, is a term with misleading connotations. [20]

To these objections we would reply that no single word—whether

[16] *The Principles of Art Education* (New York: Prang Educational Company, 1905), p. 28.

[17] *Science and the Modern World* (New York: The Macmillan Company, 1925), p. 287.

[18] "Science, Art and Technology," *Kenyon Review*, 1 (1939).

[19] Louis Arnaud Reid, *Meaning in the Arts*, pp. 77–78.

[20] John Hospers, "The Concept of Artistic Expression," *Proceedings of the Aristotelian Society*, 1954–1955; and Alan Tormey, *The Concept of Expression* (Princeton, N.J.: Princeton University Press, 1971), Chaps. 4–5.

it be "expression," "embodiment," "objectification," "creation," "symbolization," or any other—can convey precisely what is involved in artistic production. Any such word needs to be limited and construed in a way that fits aesthetic discourse. Without such interpretation, "embodiment" may lead to focusing upon the material "body" of the work to the relative neglect of thought, feeling, and form. This would be as unfortunate as the opposite tendency. As Reid himself declares, "we must make clear . . . that the embodiment which is aesthetic and creative is different from any other sort." [21]

It is true that some idealistic aestheticians have overemphasized the "spiritual" aspect of artistic expression. But a good word need not be abandoned because it is sometimes misinterpreted. To guard against misunderstanding, we have stressed over and over again that in art there is no cleavage between *what* is expressed and *how* it is expressed. In a work of art, everything is shaped and affected by everything else: form and content, feeling and quality, spirit and matter, "message" and medium are mutually determinative. The values expressed in a work of art, even if originally drawn from "real life," are transmuted in the act of artistic embodiment. We think that expression, as thus interpreted, is virtually identical with what Reid means by "creative embodiment." But the conjunction "expression and embodiment" is more adequate when applied to art than either "expression" or "embodiment" alone. Lest there be a residue of meaning in "embodiment" that is not conveyed by "expression" it is better to use both terms. We do not claim that the expressive characteristics of art are its only characteristics, nor do we claim that "expression" and "embodiment" together convey all that we mean by art. But we do insist that expression and embodiment are not distinct and separate operations. Art is the expression of values transformed by embodiment. Or, alternatively, art is the embodiment of the expressive—of values and not bare facts.

As long as we cling to the word "feeling" rather than "value," it is difficult to avoid language that is misleading. We may say that art is expressed feeling or that it is embodied feeling, but our meaning is likely to be misconstrued. Either phrase or both phrases used conjunctively may seem to imply that there is a pre-existent feeling in the mind of the artist and that this very same feeling is expressed or embodied in the work of art. This implication is present in the famous definition of Tolstoy:

> To evoke in oneself a feeling one has once experienced and having evoked it in oneself then by means of movements, lines, colors,

21 *Meaning in the Arts*, p. 75.

sounds, or forms expressed in words, so to transmit that feeling that others experience the same feeling—this is the activity of art.[22]

The implication is false that a pre-existent feeling is communicated via artistic media to a recipient. Actually the original feeling, if present at all in the mind of the artist, is transmuted by the process of embodiment and thereby becomes a different and unique feeling. The embodied feeling springs into existence from the creative synthesis of the original feeling and the qualities of the medium. The expressed or embodied feeling emerges only in this process of expression. Hence each work has its own feeling, and in art there are no free-floating or detached feelings.

We prefer to use the word "value" rather than "feeling," because value, as we have defined it, is a subject-object determination and not a detached feeling. Art is the creation of aesthetic value, and every work of art is creative of unique value. A reader or a listener or viewer has a *new* value experience in each work of art. The process of artistic transmutation is not like a rolling snowball; it is not just an adding on of new parts. Instead, the quality and internal structure of the inciting experience alters as the work progresses. This alteration does not imply that nothing is carried over from life and expressed in the work of art. Much is preserved in altered form—much that represents and reminds us of life feelings and life experiences. The final artistic stage transforms the initial life content but does not cancel it. The content is gathered up, preserved, transmuted, and transcended in the later stages of the artistic process, just as the qualities of childhood are subtly transformed and yet conserved in adolescence and maturity.

Self-Expression and Self-Transcendence in Artistic Production

Art is a skilled and intentional activity. The principal character, Stephen, in James Joyce's novel, *A Portrait of the Artist as a Young Man,* asks the question, "If a man hacking in fury at a block of wood make there an image of a cow, is that image a work of art?" The correct answer is that the image is not a work of art—it is an accident, albeit an unlikely one. A similar answer must be given to the question whether the product of a purely natural process is a work of art. In reply to the suggestion of Morris Weitz that something "made by no one" may be a work of art, Erich Kahler has asserted:

[22] Leo Tolstoy, *What is Art?* (London: Oxford University Press, 1924), p. 173.

A piece of driftwood or a sea shell, be it ever so characteristically deceptive or charming, may remind us of art, but is never itself a piece of art, because it is not made by man through a consciously controlled impulse or effort. This is basic to all art. Kahler does not deny that unconscious processes may be at work, as in the composition of Coleridge's *Kubla Khan,* but even in such instances there was "a most subtly discerning mind deep below the surface of consciousness . . . directing the structure of the poem."[23] To this degree, fine art is a skilled and intentional activity, although the kind of skill involved is more radically creative than craft-skill.

As we have pointed out in Chapter 3, the original meaning of art is skill or good workmanship. A well-made pot as truly as a well-made painting is, in this sense, a work of art. Neither an unskilled performance, such as the spreading of iridescent colors by dumping oil on water, nor an unconscious natural process, such as the shaping of a rock by water erosion, is art. Even a found object—for example, a piece of driftwood or the sea shell mentioned by Kahler—is a work of art only so far as it is tastefully mounted, lighted, or otherwise displayed. It would then have a touch of art without being art through and through.

Dewey points out that we react to an object differently when we find out that it has not been produced by human skill:

> Suppose, for the sake of illustration, that a finely wrought object, one whose texture and proportions are highly pleasing in perception, has been believed to be a product of some primitive people. Then there is discovered evidence that proves it to be an accidental natural product. As an external thing, it is now precisely what it was before. Yet at once it ceases to be a work of art and becomes a natural "curiosity." It now belongs in a museum of natural history, not in a museum of art. And the extraordinary thing is that the difference that is thus made is not one of just intellectual classification. A difference is made in appreciative perception and in a direct way.[24]

Whether for the artist or the beholder, art is inherently an intentional mode of expression.

Almost every writer on the subject of artistic expression has distinguished between expressing emotion and betraying emotion—that is, exhibiting symptoms of it. For example, the involuntary behavior of one who feels ashamed—the flushing up, turning away, lowering one's eyes, or restlessly moving from side to side—is not art. When it is said

23 *Out of the Labyrinth* (New York: George Braziller, 1967), p. 98. Reprinted with the permission of the publisher. Copyright © 1967 by Erich Kahler.
24 John Dewey, *Art as Experience,* p. 48.

that the artist is one who expresses his feelings, this does not mean that he breaks down and cries uncontrolledly, or that he "blows his stack" and curses, or that he involuntarily turns pale and stammers.

Much has been written about the art of the actor who outwardly engages in this kind of behavior. Most writers on the subject recall Denis Diderot's famous paradox: to move the audience the actor must remain unmoved. William Archer, among others, has replied that the actor must himself feel the emotion that he is outwardly expressing. [25] Hamlet, in his advice to the players, is more on the side of Diderot than of Archer:

> In the very torrent, tempest, and, as I may say, the whirlwind of passion, you must acquire and beget a temperance that may give it smoothness.[26]

The player who is overcome with emotion is simply a poor actor. The *idea* or *image* of the emotion and its symptoms, not the emotion in its original raw form, is in the mind of the actor and controls its expression. As Collingwood has remarked, it is not the "ability to weep real tears that mark out a good actress; it is her ability to make it clear to herself and her audience what the tears are about." [27]

In its early and classic formulations, artistic expression was interpreted as *self*-expression. The statement of Eugene Véron is typical:

> A work is beautiful when it bears strong marks of the individuality of its author, of the permanent personality of the artist. . . . In a word, it is from the worth of the artist that that of his work is derived. It is the manifestation of the faculties and qualities he possesses which attracts and fascinates us.[28]

Aestheticians and artists seized upon the idea that all art is self-expressive. "Who touches this touches a man," wrote Walt Whitman of his own poetry, the "man" being himself. Benedetto Croce, perhaps the most influential advocate of the expression theory in this century, epitomized the theory in his doctrine that all art is "lyrical." He quoted with approval the remark of Amiel, the Swiss poet and critic, that "every landscape is a state of the soul." This is indisputable, remarked Croce, "not because the landscape is landscape, but because the landscape is art." [29] With his subjectivistic interpretation of art, he implied that "the soul" is that of the artist or the sympathetic beholder.

[25] See Denis Diderot, *The Paradox of Acting,* and William Archer, *Masks or Faces?* (New York: Hill and Wang, 1957).

[26] Shakespeare, *Hamlet,* Act III, Scene 2.

[27] R. G. Collingwood, *The Principles of Art* (New York: Oxford University Press, 1958), p. 122. By permission of The Clarendon Press, Oxford.

[28] Eugene Véron, *Aesthetics,* p. 107.

[29] Benedetto Croce, *The Breviary of Aesthetic* (Houston: The Rice Institute, 1915), p. 249.

The conception of art as self-expression is misleading and one-sided. Art is a mode of self-transcendence. The artist can be as objective with respect to values as the scientist with respect to facts. He may be interested in expressing, not his own scheme of values, but what he objectively finds to be the values in the human environment. The world of human experience—the world as phenomenally objective—is replete with intrinsically expressive qualities, and the artist draws upon this infinite repertoire of expressive forms in depicting the value-expressiveness of all life and all phenomenal existence. This is the theory that is sketched in the more profound interpretations of expression, as, for example, in Rudolf Arnheim's *Art and Visual Experience*. Characterizing the expressiveness of a dance or a painting, Arnheim declares:

> Particularly the content of the work of art does not consist in states of mind that the dancer may pretend to be experiencing in himself or that our imagination may bestow on a painted Mary Magdalen or Sebastian. The substance of the work consists in what appears in the visible pattern itself. Evidently, then, expression is not limited to living organisms that we assume to possess consciousness. A steep rock, a willow tree, the colors of a sunset, the cracks in a wall, a tumbling leaf, a flowing fountain, and in fact a mere line or color or the dance of an abstract shape on a movie screen have as much expression as the human body, and serve the artist equally well. . . . The fact that nonhuman objects have genuine physiognomic properties has been concealed by the popular assumption that they are merely dressed up with human expression by an illusory "pathetic fallacy," by empathy, anthropomorphism, primitive animism. But if expression is an inherent characteristic of perceptual patterns, its manifestations in the human figure are but a special case of a more general phenomenon.[30]

There are many passages in the books of Susanne Langer of similar import. We agree with Arnheim and Langer that things in the phenomenal world exhibit expressive qualities, and that the artist draws upon these qualities in expressing more than his subjective states.

We can distinguish between a lyrical and a histrionic imagination. The imagination of Shakespeare is histrionic in creating a whole world of characters no one of which is a self-portrayal. We can speculate that Shakespeare is more like Hamlet than like Richard III or Falstaff or Cleopatra, but he is not identifiable with any of his characters. The imagination of Shelley, in contrast, is subjective and lyrical. Even when he is writing about impersonal things, such as the West Wind, he injects his own personal feelings into the subject matter:

[30] *Art and Visual Perception* (Berkeley and Los Angeles: University of California Press, 1969), p. 433.

Make me thy lyre, even as the forest is:
What if my leaves are falling like its own!
The tumult of thy mighty harmonies
Will take from both a deep, autumnal tone,
Sweet though in sadness. Be thou, Spirit fierce,
My spirit! Be thou me, impetuous one! [31]

This contrast between subjective and objective expression runs through all the arts. It applies even to drama, the histrionic art *par excellence* —Strindberg, for example, being more subjective than Ibsen. It applies also to the nonrepresentational arts. The pure musician or nonfigurative painter may penetrate to the universal pattern or harmonizing principle in his material. Mondrian, for example, is more objective, Kandinsky is more subjective. Bach is more objective, Schumann more subjective. Art of "high distance," as Bullough points out, is more detached and objective; art of "low distance" is more personal and subjective.

In denying that art can be reduced to self-expression, we do not wish to deny that it is self-expressive. Even the most "objective" of artists exhibits a personal style. The artist is a self, of course, but his self is related, intentional, outgoing—he is destined to be interested in the other-than-self, and to realize himself in and through this interest. In his expression of other-than-self he reveals a unique self that we admire in his art.

If by "expression" is meant the intentional making of expressive objects, it is impossible to deny that art is a kind of expression. An inexpressive work is a total failure—it is not even "art." This point would be conceded by the critics of the expression theory. Monroe Beardsley, who may be cited as a typical critic, freely admits that a work of art exhibits expressive properties, or as he prefers to call them, "human regional qualities." He is as aware as anyone that a tune may be "gay" or a painted landscape may be "placid." What Beardsley objects to is the interpretation of an artist's works as expressive of their creator's mind and spirit. He thinks that this intentional mode of interpretation, if it is not sheer unverifiable speculation about what goes on in the artist's mind, is only an elaborate and circuitous way of referring to simple facts about works of art. Why not simply say that the landscape is placid or the music is gay? Beardsley thinks that nothing more is required:

[31] *Ode to the West Wind.*

The Expression Theory has called our attention to an important fact about music—namely, that it has human regional qualities. But in performing this service it has rendered itself obsolete. We now have no further use for it. Indeed we are much better off without it. "The music is joyous" is plain and can be defended. "The music expresses joy" adds nothing except unnecessary and unanswerable questions.[32]

The assumption here is that when critics or aestheticians talk about "expression," they ought to call attention to expressive qualities of works of art rather than to relations between art works and their creators. In a famous essay on "the intentional fallacy," Beardsley and Wimsatt have evinced an austere concern for the work of art isolated from the creative activity of the artist. [33]

The best answer to Wimsatt and Beardsley is to be found in Guy Sircello's *Mind and Art*. Because it is impossible to summarize this book in a few words, we shall mention only one example cited by Sircello:

We might say of Poussin's *The Rape of the Sabine Women* (either version, but especially the one in the Metropolitan Museum of Art in New York City) that it is calm and aloof. Yet it is quite clear that the depicted scene is *not* calm and that no one in it, with the possible exception of Romulus, who is directing the attack, is aloof. It is rather, as we say, that *Poussin* calmly observes the scene and paints it in an aloof, detached way.[34]

It is not necessary to know anything independently about Poussin to know how he painted the picture. The spectator knows by simply looking at the painting that Poussin "has painted the scene in an aloof, detached way. The cold light, the statuesque poses, the painstaking linearity are all visible in the work." [35] The description of Poussin's expressive act is at once and necessarily a description of the painting, and vice versa. "Thus one may, without change of meaning, say either . . . that Poussin paints his violent scene in an aloof, detached way or that the Sabine picture is an aloof, detached painting." [36] Here,

32 Monroe Beardsley, *Aesthetics* (New York: Harcourt, Brace and Company, 1958), p. 331.
33 See W. K. Wimsatt and Monroe Beardsley, "The Intentional Fallacy," *Sewanee Review*, Vol. 45 (1946). Often reprinted.
34 *Mind and Art: An Essay on the Varieties of Expression* (Princeton, N.J.: Princeton University Press, 1972), p. 20. Reprinted with permission.
35 Ibid., p. 27.
36 Ibid., p. 30.

as in innumerable other instances, there is an intrinsic connection between the expressive act of the artist and the expressive qualities of the work of art. The artistic intention is internal to the painting, and the embodied intention determines the beholder's response. This is an important point that Beardsley and other critics of the concept of expression have missed or all too easily dismissed.

The example of Poussin's painting helps to clarify exactly what is expressed in art. The expressive content in this instance includes not only the negative values depicted in the painting—the horror of rape and violent cruelty—but also the painter's vision of these negative values—the calmness, aloofness, objectivity, the strong sense of lucidity and order in Poussin's treatment of the material. Generalizing from this example and many others that might be cited, we maintain that art is an expression, not directly of life values, but of *the artist's vision of values.* Art is the expression of values, but it expresses the values by transmitting the artist's vision.

"Express" is derived from the Latin *expressus,* which is the past participle of *exprimere,* to press out—for example, to press out juice from grapes. Expression implies a movement outward as a result of pressure. In art that movement comes from the pressure of the vision. Artists feel an inner pressure that mere imitators do not feel. The imitator puts himself under the direction and control of the outer object; the artist is inwardly moved and has something to express. To express artistically means to put a mental content into objective form. The mental content is the vision of values, and the objective form is the embodiment. The content is not entirely preformed and immutable—it is elaborated and transmuted in the act of embodiment.

The artist may find the values at every level of human experience. At the most subjective level, he may intuit his own private states of mind and body, his thoughts, feelings, desires, pleasures and pains, his kinaesthetic and organic sensations. Or, less subjectively, he may be aware of himself-living-in-the-world—his personal engagements and encounters with people or things. Or, transcending all attention to himself, he may be intent upon value-expressive features of the phenomenal world—the intrinsic expressiveness of sensory configurations, of nature's ongoings, of human and animal behavior. Or he may turn to the expressive qualities of the artistic medium, exploring the properties and relations of sound, as in music, or of color, shape, and texture, as in painting or sculpture. Whatever be the sphere of his interest, the objects of his fascination are felt qualities. By means of his art, he selects, accentuates, distorts, combines, and synthesizes these intrinsically expressive qualities, creating a new and doubly expressive vision finally embodied in the work of art.

The Freedom of Art

We have said that art is a mode of both self-expression and self-transcendence, and that it creates aesthetic value, not by isolating itself from life but by the artistic expression of human values—the values of the not-self as well as of the self, the values of unreality as well as the values of reality. Human existence has many registers, and it is not given to anyone to play all of them. But it is the man of art, more than the mystic, more than the moralist, more than the scientist or technician or practical man, who is free to play the whole range. He is not necessarily limited, as these others are, by a concern for something real, or something taken to be real. He can roam as freely through the realm of imagination as through the realm of actuality. His is the domain of vivid values, and values both are and are not "real."

Art has a free choice of subject and theme. It may choose as its matter error as well as truth, vice as well as virtue, distortion as well as faithful depiction, and invention as well as fact. A work of art may represent anything or nothing—that is, nothing that answers to the things defined by other categories of experience, such as truth, morality, etc. A work of art is different from what it represents and also different from other ways of experiencing what it represents. Art is not, in first intention, truth, morality, or piety. Conversely, neither is it untruth, immorality, or impiety. It follows that such all-too-common, allegedly sufficient judgments of art as "how real!" or "how true!" or "how reverent!" are poor aesthetic judgments—poor at least in the sense of starting at the wrong end and resting there. The primary aesthetic judgment should be "how interesting!" or "how expressive!" In that judgment we voice the freedom which art can give.

Expression in art is a difficult thing to become clear about, because the temptation is to identify it with expression in science and other literal discourse; in other words, to limit art to statements of truth and exact report. Such misconception leads commonly, for example, to strained attempts to "tell the meaning" of poetry and even of music. Now poetry and music and other arts too do make *use* of literal meaning, sometimes very extensively, as when poetry describes a scene or an action, and when music imitates natural sounds. But when literal meaning is thus employed in art it is always subordinate or subservient to *aesthetic* meaning (at least it is if the art is good), and it is aesthetic meaning which art peculiarly expresses. Literal meaning, like mere sensuous quality, is the material rather than the product. The material is, of course, important. Literal meanings in art are important. The choice of material in art, whether it be inert physi-

cal material like clay and pigment, or ideational and moral material like thoughts, dreams, and social attitudes, is a major determinant of the character of the work. And the material available to art includes not only all the sensuous matter in the world but also all the experienced ideas, facts, behavior, and aspirations of man and his world. But these in themselves, we repeat, even though faithfully reported and extensively used by art, are not the meaning of art, not what art, as such, expresses.

What then does art express? What does it mean? As we have said, art expresses quality and feeling—not quality in cold isolation nor feeling detached from content, but feeling at one with the qualities felt. Art is not expression merely of what the facts are in the world and human experience, but very much more; it is the expression of how the individual artist feels, and if his feelings are normal, how we too feel about facts and experience—how we feel about mountains, love, patriotism, sorrow, joy, adventure, death, a bowl of fruit, an assortment of bottles, an old woman's face. To be art the feeling expressed must be objectified, transmuted into beauty, detached from practical or intellectual concerns. The feeling is revealed as *interesting*, and as such it is made *beautiful*. The feeling is made into an object, into a felt quality, into a value. Or, starting with the other pole, the artist may begin with a quality and then attach feeling to it. Only when the subjective and objective poles are united and the value is embodied in a work of art, is the process complete.

Aesthetic expression of feeling is not mere report of feeling. Report of feeling, like report of any other fact, is information, not art. In practical life, expressions of feeling are reports or signs: reports of how things are going in the organism, or signs that something is wanted. The cry of anguish, the shout for help, the peal of joyous laughter, and the smile of friendship—these are all expressions of strong feelings which as occurrences or as reported events are not art. They are materials for art. They may become art. Art may take these feelings, make them objects, give them an existence and a value which they never have and never can have as subjective occurrences. In subjective occurrence the feeling may be an incitement to action, a fugitive surge of joy or sadness, a dull and heavy weight of frustration, but not, as long as it remains subjective, a work of art. Ultimately, the impulse to unite feeling with quality arises because mere subjective feeling is always unsatisfactory. If it is of joy and gladness, the pity is its evanescence; if it is weariness and sorrow, the pity is its pain. Art overcomes both joy and pain. In art, feeling, no matter how fleeting or painful in life, gets a place in the world, permanent and satisfactory. Art liberates us from "the tyranny of feeling," especially

the "hypernormal" feeling, of joy which is so great as to become a burden and numbing despair. In the "Ode to a Nightingale" by Keats we find an excellent example of how art is felt to give liberation from "joy which is so great as to become a burden."

> My heart aches, and a drowsy numbness pains
> My sense, as though of hemlock I had drunk,
> Or emptied some dull opiate to the drains
> One minute past, and Lethe-wards had sunk:
> 'Tis not through envy of thy happy lot,
> But being too happy in thine happiness,—
> That thou, light-winged Dryad of the trees,
> In some melodious plot
> Of beechen green, and shadows numberless,
> Singest of summer in full-throated ease.

Keats achieves liberation from mere fleeting personal feeling through imaginative identification with the nightingale. The same poet has this kind of liberation in mind when he writes, "A thing of beauty is a joy for ever . . . it will never pass into nothingness." [37]

Conversely, but in the same manner and to the same end, art deals with the feeling of sadness, with the "numbing despair," which in practical life is sheerly destructive. "Our sweetest songs," writes the poet Shelley, "are those which tell of saddest thought." [38] And we may add, our greatest drama is that which tells of deepest struggle and defeat—of tragedy. The literature of music and the history of painting give much additional evidence of this value in art. Let us take a second example from poetry, a single line from the poet Byron. The poet writes: "My days are in the yellow leaf. . . ." [39] In it he feels and reports the fact, "I am growing old, and death approaches." But instead of merely carrying the unwelcome discovery in subjective feeling, he instates it in the world of things intrinsically interesting; and in the measure that he, and the reader of the line as well, becomes absorbed in the objective expression, advancing age and the ultimate frustration of death itself will be bereft of dread.

In the aesthetic expression of evil we do not deny evil, but turn it to interest, and thus become free. The principle is well expressed by another poet, John Donne, when he writes:

> Grief brought to numbers cannot be so fierce,
> For, he tames it, that fetters it to verse. [40]

37 Keats, "Endymion," opening lines.
38 Shelley, "To a Skylark."
39 Byron, "On This Day I Complete My Thirty-Sixth Year."
40 "The Triple Fool."

We may generalize: Our very defeats in "real life" become our triumphs in the life of art. Aesthetically, we become masters of our troubles, our frustrations, our defeats—by becoming interested in them, by making them into works of art instead of merely suffering them. Art is no thing of play or passive pleasure; it is, rather, serious and important, it demands our most earnest efforts and gives us many of our most precious values. Art is in the everyday sense nonpractical; but in precisely that its importance lies. Pure art is useless, but not worthless. Its worth is of the highest. It is important because it is humanizing and liberating. Art through objectification of human feeling in detached interest is a way of freedom. To be human is to be free. It is a mark of excellence and greatness in man to have detached interest—for the individual to be concerned not with himself alone. In art he can find that greatness, for art is one of the major ways of self-transcendence, which takes its place alongside morality, truth, and religion as one of the great liberating interests. Art, we repeat, is in this sense one of the fundamental meanings of human life. In art, as in truth, morality, and in that humility of ignorance which we may call religion, man becomes free.

To sum up: We have distinguished between a broader and a narrower meaning of art. In its broad meaning, art is the creation of aesthetic value, whether as a by-product of other activity or by deliberate intent. Common-life art is frequently the by-product of good workmanship, and aesthetic value creeps in as a result of doing an ordinary job well. Fine art, or art in the narrower sense, is specialized pursuit of aesthetic excellence for its own sake. Although it is "narrower" than art in the broad sense, it is not narrow or restricted in the range of its subject matter. If we consider all the arts in their total range, any value at all, or even any matter of fact if its quality is felt, may receive artistic expression. It is impossible to limit art to the expression of any kind of value or felt fact, but there is always a regulative principle, or artistic imperative—namely, the creation of aesthetic value. Art creates aesthetic value by expressing the artist's vision of all manner of values. As wine is to grapes, so art is to life: it draws its material from life, but it gives in return something that its material did not contain. This something is the unique aesthetic value that arises from the artistic expression and embodiment of felt facts and life values in a suitable medium. Some things are much better fitted than others to sustain and enrich intrinsic perception, and successful works of art—especially works that tap the deep primordial sources of human interest—are supreme among these things. Fine art is the intentional creation of actions and artifacts that are well-fitted to stimulate and sustain intrinsically valuable perception.

Chapter 7

AESTHETIC VALUE
IN NATURE

Art as Imitation of Nature

One of the persistent ideas in the history of aesthetics is that art represents nature. In the present context, we mean by "nature" the totality of all things that are not human artifacts—things such as rocks, clouds, animals, human beings. The doctrine that we wish initially to consider is that art depicts these nonfabricated things, whether they be the particulars of ordinary experience or the universal forms or patterns that are said to characterize "the nature of things." This doctrine is the ancient theory of imitation.

In its extreme formulation, the imitation theory is the contention that the artist literally copies natural objects. Few artists or critics would agree with the copy theory, but most would accept some non-literal version of the doctrine of representation. Even such formalist critics as Clive Bell and Roger Fry have maintained that art reflects the structural harmonies of nature. Bell contended (in *Art*, London, 1913) that the most abstract painting reveals "the essential reality" in things, "the universal in the particular," "the all-pervading rhythm" —vague terms but indicative of some kind of correspondence between nature and art. Similarly, Fry, in a rather typical passage, praised Cé-

zanne for seeking to penetrate to the structural "reality" beyond surface phenomena:

> He gave himself up entirely to this desperate search for the reality behind the veil of appearances. . . . It is precisely this which gives to all his utterances in form tremendous, almost prophetic significance.[1]

Likewise Piet Mondrian, although a nonfigurative painter, insisted that he was seeking the reality behind nature's superficial aspects. " 'Art' is not the expression of the appearance of reality as we see it," he said, "but . . . it is the expression of true reality and true life." [2] In elucidation of his position, he spoke of the natural "laws of equilibrium" which abstract art demonstrates in a direct way. In exemplifying such laws, the abstractionists of modern art are closer to nature as revealed by modern science than to nature as revealed in ordinary perception.

If interpreted literally, the theory that art is an imitation of nature is rather easy to refute, but the best representatives of the theory are not literalists. It may appear that Plato is an exception, because he often speaks of "imitative art" and remarks, in the *Republic,* that children and simple-minded people may be deceived by the illusion thus created:

> A painter will paint a cobbler, carpenter, or any other kind of artist, though he knows nothing of their arts; and, if he is a good artist, he may deceive children or simple persons, when he shows them his picture of a carpenter from a distance, and they will fancy that they are looking at a real carpenter.[3]

In judging such derisive references to imitation, we should remember that Plato lived during a period when Greek artists had turned away from the austere religious art of the past toward the naturalistic art of the Hellenistic age. According to popular stories preserved by Pliny, painters vied with each other in seeking illusionistic effects. Zeuxis is said to have imitated a boy carrying grapes so realistically that the birds flew down to peck at them. Thereupon Zeuxis confessed failure because if he had painted the boy as deceptively as the grapes, the birds would have been afraid to approach so closely. Parrhasius, not to be outdone, painted a curtain across his own picture so convincingly that even Zeuxis was deceived and tried to lift it. For Plato,

[1] Roger Fry, *Cézanne* (New York: The Macmillan Company, 1927, and London: The Hogarth Press Ltd), pp. 37–38.

[2] "Plastic Art and Pure Plastic Art," in Robert L. Herbert, ed., *Modern Artists on Art* (Englewood Cliffs, N.J.: Prentice-Hall, Inc., 1964), p. 127.

[3] *Republic,* Book X (#598). Jowett's translation.

with his theory of the supreme reality of the eternal archetypes, such illusionistic art was the very extreme of decadence.

Using the class of beds as an example, he speaks in Book X of the *Republic* of several levels of appearance or reality and a kind of making that corresponds to each level. There is first of all the form or essence of Bed, a kind of archetype which exists in the nature of things, and which we can say was made by God. This form Plato regarded as supremely real. Second, there is the particular bed which is made by a carpenter. Third, there is the appearance of the bed as depicted in a painting. The carpenter, we can say, imitates the Form of Bed, but the painter merely imitates the imitation. In these passages Plato is stating an imitation theory, though he has a low opinion of artists as imitators of particulars.

Taking all the dialogues into consideration, we can see that he speaks of art in many voices, and that at times his position is not far removed from that of Plotinus, who said that "the arts do not simply imitate the visible thing but go back to the principles of its nature." [4] For example, Plato distinguishes in the *Timaeus* (#28) between those artificers who fasten their gaze upon the unchanging forms and archetypes and those whose gaze is limited to the changing things of the perceptual world. The former, he says, produce artifacts that are beautiful, the latter do not. Plato is not thinking simply of fine arts in our modern sense, because the Greeks did not distinguish the arts from the crafts. But his remarks are extensible to such arts as painting, sculpture, and poetry.

Even in the *Republic*, which is the classical source of the imitation theory, Plato hints that the artist may be inspired directly by the essences of things, and thus be moved to create an art more formal and true. He tells us that a statue is none the worse for being more beautiful than any man, because the sculptor may be portraying the "ideal of a perfectly beautiful man" and not an imperfect human being (#472). In another passage, he declares that the artists favored by the state should "be those who are gifted to discern the true nature of the beautiful and the graceful," not merely in outward things but in the soul, and that "the man who has the spirit of harmony will be most in love with the loveliest" of the virtues (#401–2). In concluding his discussion of imitation, he declares that "the real artist, who knew what he was imitating, would be interested in realities and not in imitations" (#599). The context of this remark indicates that he was thinking mainly of the "art" of statesmanship, which he re-

[4] *Enneads*, V, viii, 1. Quoted by E. F. Carritt, *The Theory of Beauty*, 3rd ed. (London: Methuen and Company, 1928), p. 46.

garded as the highest of all the arts, but in other dialogues there appears to be no such limitation in his meaning. In Chapter 2, we have already cited a passage in the *Philebus* in which Plato speaks of the "pure pleasure" to be derived from abstract, formalistic art, and in the *Ion, Phaedrus,* and *Symposium* he speaks of the "musical soul" or artist as inspired by a vision of the forms. Plato did not intend to say that all art holds a mirror up to nature, or that art is best when it conforms to appearances.

The *Poetics* of Aristotle provides us with a clearer example of a nonliteral theory of imitation. From the standpoint of modern art, his theory is somewhat restricted in scope—for he was thinking of the imitation of human beings and not the imitation of plants, animals, or inorganic objects. For him the reality imitated by the fine arts is human life and human nature—thoughts or acts expressive of spirit. This emphasis upon the inner spirit helps to explain his remark in the *Politics* that music is, in a sense, the most imitative of the arts. In rhythms and melodies, he explains, we have the most realistic representations of human dispositions, such as the rise and fall of psychic tensions. "There seems to be a sort of kinship," he says, "of harmonies and rhythms to our souls."

His doctrine as expressed in the *Poetics* is far from being a defense of imitation in any literal sense. He declares that poetry seems to have sprung from two causes: the mimetic impulse and the instinct for harmony and rhythm. Thus a formal principle is recognized at the outset; and there is a strong emphasis upon form throughout his entire discussion, as, for example, in extolling the well-knit plot. Similarly, in his occasional remarks about painting or sculpture, he maintains that art imitates nature's structure more than nature's surface. "The most beautiful colors, laid on confusedly," he says, "will not give as much pleasure as the chalk outline of a portrait." A work of art imitates its original, moreover, not as it is in itself, but as it *appears* to the human observer. This contention is illustrated in his statement that the poet "ought to prefer probable impossibilities to possible improbabilities"—that is to say, he should aim at convincing semblance rather than verisimilitude. If truth is stranger than fiction, so much the worse for truth. Poetry imitates the universal and not merely the particular; it expresses the real, rid of contradictions, irrelevancies, the disturbances of chance; it represents "such and such a man" or the common designs of destiny. In imitating the universal, it also "imitates" the ideal—life purified and organized, not petty or dull, but full of great issues. The bare facts are transformed to emphasize values: tragedy imitates men as "better" and comedy as "worse"

than they really are. In these views of Aristotle, there is little to support a copy theory of art.

Similarly complex is the doctrine of imitation set forth by Leonardo da Vinci. In some of his statements, he appears to be saying that the artist should make his work as like nature as possible. "The mirror, above all, should be your master," he declared in his *Treatise on Painting*. "That painting is most praiseworthy which conforms most to the object portrayed. I put this forward to embarrass those painters who would improve on the works of nature." This remark was inspired by his profound veneration of nature, and was not intended to advise the painter to attempt verisimilitude. In his notebooks, he made clear that the artistic mirroring of nature is a selective and intellectual process. "The painter who draws by practice and judgment of the eye without the use of reason," he said, "is like the mirror which reproduces within itself all the objects which are set opposite to it without knowledge of the same."

Leonardo's scientific predilections merged with his artistic interests. The true "miracle" of nature, he thought, was its "wondrous and awesome necessity," and he regarded visual art as the most important tool for understanding this cosmic order. The artist must act as the interpreter of nature—of the formation of cliffs, the growth of foliage, the flow of water, the principles of perspective, the anatomical structure of men and animals, and so on—disclosing in his painting what he has learned. As he grew older, Leonardo became more visionary —more aware, as he said, that "nature is full of an infinity of operations which have never been part of experience." In characterizing his achievement, the art historian Hellmut Wohl has cited Matisse's dictum *"L'exactitude n'est pas la vérité."* This insight, that exactitude is not the truth, Leonardo learned through the comprehensive study of natural forms, finding identical patterns in things as seemingly disparate as woman's hair and falling water. "Having carried the empirical study of nature further than any other man of his generation," declares Wohl, "he acknowledged at the end of his life that the truth is not synonymous with the data of exact observation, but lies behind them." [5]

Whether the departure from verisimilitude is great or small, art begins where literal imitation ends. This is most evident from the "nonrepresentational arts," such as music and architecture. In music, the attempt to imitate external nature is necessarily limited in scope. Here

[5] *Leonardo da Vinci* (New York: McGraw-Hill Book Company, 1967), p. 32. Used with permission of McGraw-Hill Book Company.

and there we have examples of imitative effects, such as the birdcalls
in Beethoven's *Pastoral Symphony* and the bleating of sheep in Strauss'
Don Quixote. But few sounds in nature are complex enough to be
musically interesting. Although insects, frogs, toads, and lizards are "mu-
sicians" to a degree, birds are the only creatures except human be-
ings that display musical virtuosity:

> The basic difference between human music and bird music
> is the incomparably greater time span of the former. . . . No bird
> can master a definite pattern lasting more than a few seconds.
> After that it either pauses and then repeats the pattern, or it moves
> on to a different pattern, the succession of patterns conforming
> to no definite overall pattern. . . . Granted the brevity of the pat-
> terns . . . birdsong is recognizably musical by all basic human
> standards. It has nice bits of melody, charming rhythms, even bits
> of harmony (for birds, unlike us, can sing contrasting notes simul-
> taneously); it has obvious examples of theme with variations,
> neat examples of accelerando and rallentando, crescendo and di-
> minuendo, interval inversion, even change of key and tempo con-
> trasts, as, for instance, when the same pattern, e.g., a trill, is given
> at half or double speed.[6]

Although bird music sounds lovely in the woods, and may supply mo-
tifs for a composer, as in Respighi's *The Birds*, yet how simple and
limited human music would be if it merely imitated the songs of birds!

More frequent in music than imitation of sounds is the attempt
to recreate the moods and impressions resulting from observation of
nature. In Debussy's *Reflections on the Water*, for example, the music
suggests something of the iridescence and flickering quality of reflec-
tions on a pool, the tone colors and nuances of the music being used
to hint rather than describe. Sibelius' *Finlandia* similarly reflects, with-
out definite programmatic intent, the composer's attitudes toward na-
ture. The lack of descriptive content in such compositions makes us
realize that music is primarily the construction of the human mind,
bearing only an occasional or remote connection with particular ob-
jects. Hence most compositions are sufficiently designated by abstract
titles, such as *Sonata 6 in F Minor*.

Nevertheless, there is some point in saying, as Aristotle does, that
music imitates human moods and dispositions, the flow of passions,
and the nuances of character. When "imitation" or "representation"
is thus used to designate the power to portray man's inner life, it

[6] Charles Hartshorne, "The Aesthetics of Birdsong," *Journal of Aesthetics and
Art Criticism*, 26 (1968), 312. See also Gilbert Highet, "The Unconscious Artists," in
Talents and Geniuses (New York: Oxford University Press, 1957) for bird art other
than song.

becomes clear that reality can be reflected in all sorts of ways and that literal "copying" of sensible objects is only one approach. Perhaps it is best to limit the word "representation," or the older term "imitation," to the depiction of recognizable objects, such as a tree or a human figure, and to use "expression" or "connotation" to denote the reflection of inner mood. Still, it is well to remember that much can be connoted without being represented. In almost any work of art there is an aura of suggestiveness whether or not there is an overt representation, and half of the magic of the arts depends upon elusive suggestion.

Apart from sculptural decoration, architecture is almost completely nonrepresentational except in the sense of being, like music, expressive of human emotions. The fitting of a building to its site, however, exemplifies another kind of relation to nature. For example, Frank Lloyd Wright's two residences, Taliesin in Wisconsin and Taliesin West in Arizona, illustrate his remark that "the good building is one that makes the landscape more beautiful than it was before."[7] As a writer in a popular magazine has said, "the difference between the landscapes of Wisconsin and Arizona is sensational, and the houses reflect that difference with such extreme sensitivity that the impact on the beholder is a very powerful one." Although one of the main emphases in modern architecture is the accommodation of the building to its natural setting, good architecture has always been well-adapted to its site. The Spanish haciendas, with their interior patios and flat-tiled roofs, suit their warm environment, just as the houses of northern Europe, with their steep-pitched roofs and solid stone walls, fit a snowy climate. Nature is met more than halfway in the tendency of modern architecture to open up buildings to light and fresh air, to afford easy access to porches and patios, to grow plants inside the home as well as in the garden, to install great windows that open out upon the natural setting, and to use skylights that disclose the moon and the stars, the moving clouds, and the flight of birds. "It is the function of architecture," Schopenhauer wrote, "to reveal the nature of light, just as it reveals that of things so opposite to it as gravity and rigidity."[8] The light streaming into the building is intercepted, confined, filtered, and reflected in countless ways, revealing its nature and qualities. Disclosure of "the conflict between rigidity and gravity," as in the relation between beam and supports, is, as Schopenhauer said, another exhibition of elemental natural forces. He might

[7] *Architectural Forum*, 117 (1962), 122–23.

[8] Arthur Schopenhauer, *The World as Will and Idea*, trans. R. B. Haldane and J. Kemp (London: Kegan Paul, Trench, Trübner, & Co., 1883), Vol. 1, #43.

well have added that the nature of materials, such as wood and stone, is revealed by their undisguised appearance and characteristice use, whether in a residence or any other type of construction.

There are two primordial human needs that architecture is called upon to serve—the need for egress and the need for ingress. The first need is to go forth and meet and mingle with nature, and this need is satisfied in ways that we have indicated. The second need is to withdraw from nature and the bustling world and to enclose oneself as in a cave. Architecture satisfies this need by providing more shelter and privacy than nature affords—havens of retreat and defenses against the inclement elements. Sometimes the first need and sometimes the second is dominant—the one calling for the "open plan" and easy access to the natural setting, the other calling for places in the building where occupants can retire and rest and enjoy quietude and peace and comfortable seclusion. Contemporary architects appear to be more successful in satisfying the first need rather than the second, but both must be satisfied if buildings are to be "functional" in the profounder sense of that term—namely, in the adaptation to the deepest human needs. In short, we must both enjoy nature's bounty and make up for nature's deficiencies.

If we turn from music and architecture to the "representational arts," such as literature and figurative painting or sculpture, we come closer to "imitation" in its usual meaning, but here too the copy theory is far from adequate.

> Which is the more faithful portrait of a man—the one by Holbein or the one by Manet or the one by Sharaku or the one by Dürer or the one by Cézanne or the one by Picasso? Each different way of painting represents a different way of seeing; each makes its selection, its emphasis; each uses its own vocabulary of conventionalization.[9]

The appearance of an object, whether it be a human being or a mountain, is partly conceptual, a product of seeing and knowing. Artists brood over what they observe until their imaginations are kindled and the objects become vivid and expressive. The following account by an ancient Chinese painter of how he learned to paint "Hua Mountain" charmingly describes the process of artistic representation:

> Though painting represents forms, it is dominated by the idea [of the object represented]. If the idea is neglected, mere repre-

[9] Nelson Goodman, "The Way the World Is," *Review of Metaphysics*, 14 (1960), 52.

sentation cannot avail. Nevertheless, this idea is embodied in forms and cannot be expressed without them. He who can successfully represent forms will find that the idea will fill out those forms. But he who cannot represent them, will find that not form but all is lost. He who sets out to paint something wants his picture to resemble that thing, and how can it, if he does not even "know his subject by sight"? Did the old masters achieve their success by groping about in the dark? These fellows who spend all their time copying and tracing, most of them know the subjects they choose only by other people's drawings of them, and go no further. Each copy marks a wider removal from the truth. The forms are gradually lost, and the "idea" is not likely to survive them.

In short, till I knew the shape of the Hua Mountain, how could I paint a picture of it? But after I had visited it and drawn it from nature, the "idea" was still immature. Subsequently I brooded upon it in the quiet of my house, on my walks abroad, in bed and at meals, at concerts, in intervals of conversation and literary composition. One day when I was resting I heard drums and flutes passing the door. I leapt up like a madman and cried, "I have got it!" Then I tore up my old sketches and painted it again. This time my only guide was Hua Mountain itself. I thought nothing at all about the schools and styles which ordinarily obsess the painter.[10]

Wang Li, the old Chinese painter, was keenly aware that the artist does not create by passively imitating either nature or previous works of art. It was necessary for him to visit the mountain and to study its structure and appearance as carefully as possible; but he discovered the "real mountain" only after the "idea" and the "forms" had gradually crystallized in his subconscious imagination and then erupted into consciousness. The moment of sudden revelation when he leapt to his feet with the cry, "I have got it!" was possible only because of a long period of creative brooding. When there appears to be effortless creation, the hand has already been disciplined and the subconscious mind has already been peopled by bright images. Without the mind and its funded memories the hand is a servile copying instrument.

Originality, not only in the arts but in the sciences, springs into being when the environment is ripe, when the mind is richly stocked, and when there has been hard preparatory work and a period of subconscious rumination. Then there may occur a sudden welling up from

10 Wang Li, "Introduction to My Pictures of Hua Mountain," in Arthur Waley, *An Introduction to the Study of Chinese Painting* (New York: Charles Scribner's Sons, 1923, and London: E. Benn), p. 245.

the subconscious—an eruption that has been called "the Eureka process." The term derives from the story of how Archimedes, the great Greek mathematician and physicist, discovered the way to measure the volume and specific density of a golden crown of extremely intricate design. He had been asked by Hiero, the tyrant of Syracuse, to determine whether the crown was solid gold. For a long time he was baffled by how to proceed, but it suddenly occurred to him that the volume of a solid is equal to the volume of water displaced when the object is immersed, and that therefore the volume of the crown could be measured quite easily by calculating the volume of the displaced liquid. Then, by correlating this volume with the weight of the metal, he would be able to calculate its density, and thereby to judge whether it had been lightened with an amalgam. We are told that he thought about the problem a long time, and finally when he was relaxedly taking a bath, the solution all of a sudden struck him. So delighted was he that he jumped out of his bath and ran naked through the streets, shouting "Eureka, Eureka!" ("I have found it!"). This behavior is strikingly like that of Wang Li, leaping up like a madman and crying, "I have got it!" It illustrates the fact, for which there is an abundance of evidence, that there is a similar process of discovery in both science and art.[11]

What Wang Li discovered was the "real mountain" behind the superficial appearances. The search for "reality" in much modern art has taken the painter or sculptor deeper and deeper into abstraction. This "retreat from likeness" is the result of many and complex causes, but among these causes is the urge to depict, not the surface of nature, but its internal dynamics and structure. Some defenders of nonfigurative art have gone so far as to denounce all representation whatever. This seems to us an unjustifiable attempt at censorship and a needless abnegation of the full resources of art. The modernist critic or artist who belittles all representational concerns underrates their power to inflame the mind with a sense of values. There is no reason why art should not express the full gamut of values, including those derived from the love of natural forms. A painter like Picasso, who is master of both representative and nonrepresentative design, has far more resources to draw upon than a Joseph Albers or a Mondrian. And a representational painter such as Winslow Homer or Georgia O'Keefe is not to be despised.

Some account should be taken of the *use* of imitation—a work

11 See Arthur Koestler, *Insight and Outlook* (New York: The Macmillan Company, 1949), and R. W. Gerard, "The Biological Basis of Imagination," in Brewster Ghiselin, *The Creative Process* (University of Chicago Press, 1954).

of art may be imitative in details without being imitative in the whole. There are many realistic details in the paintings of Salvador Dali or the stories of Alice in Wonderland, but the total effect is unreal or surreal rather than real. Even in a realistic work, such a painting by Holbein, there is a creative form and individuality in the whole. The language of art consists of presentations, connotations, and representations, and all can be used freely and creatively to serve the purposes of the artist. In art, things are not merely shown—they are ordered, patterned, combined, synthesized, and interpreted to achieve a totality of effect quite different from the parts taken severally. Both fantasies and imitations are details of the vocabulary, and either can be used by the artist without tying him down to a copy of nature.

The work of art, even when representational, is a joint product of moody vision and external stimulation. Feeling is embodied in the object and the object articulates and enriches the feeling. But the process, while creating felt qualities, does not obliterate the distinction between subject and object. As we have already noted in Chapter 4, a person may be unsad even when he listens comprehendingly to sad music. The work of art has the capacity to convey the abstracted essence of sadness, its "image" or "taste," without making the listener actually experience the emotion. The same duality occurs when we contemplate things in nature. Thomas DeQuincey recalls how, in childhood, the chilly awareness of his sister's death was heightened by the radiance of a summer day: ". . . the glory is around us, the darkness is within us; and the two coming into collision, each exalts the other into stronger relief." [12] Similarly Coleridge, in his *Ode to Dejection*, contrasts his mood of profound dejection with the "serene and balmy" evening. At the same time that he is weighed down with a numbing grief, he marvels at the beauty of the moving and fleecy clouds, the sparkling stars, and crescent moon:

> *I see them all so excellently fair,*
> *I see, not feel, how beautiful they are!*

Aesthetically, both things in nature and works of art exhibit anthropomorphic qualities of mood and feeling, even though we in our subjectivity may experience a contrasting mood.

This confirms the contention of Rudolf Arnheim that ordinary objects—not the abstract objects of physical science but the concrete and phenomenal objects of direct experience—are expressive. We gaze at a fire and see "the graceful play of aggressive tongues, flexible striv-

12 "The Afflictions of Childhood," *Autobiographic Sketches*, 1845. Similar reflections occur in his *Confessions of an English Opium Eater*.

ing, lively color . . . The profile of a mountain is soft or threateningly harsh; a blanket thrown over a chair is twisted, sad, tired." [13] One reason that the artist can borrow motifs from nature is that natural objects are replete with expressive qualities. His object is not to impute feeling tones to neutral objects but to select, combine, and heighten materials that are already expressive.

The objects of the artist's vision are half-perceived and half-created. Art is a *second* creation after the initial creativity of moody perception. As Martin Buber has said of the painter:

> His seeing is already a painting, for what he sees is not merely what his physical sight receives: it is something, two-dimensionally intensified, that vision produces. And this producing does not come later, but is present in the seeing. Even his hearing, his smelling are already painting, for they enrich for him the graphic character of the thing; they give him not only sensations but also stimulations.[14]

The theory of art as imitation fails on two counts: first, it underestimates the creativity in the artist's initial vision of nature; and second, it discounts or entirely neglects the recreation of the vision in making the work of art. [15]

Man's Aesthetic Harmony with Nature

Man's relation to the world is ambivalent—he is in it and of it, and yet he stands apart. He is both engaged and disengaged—estranged and yet bound by natural piety. Although a human being is as much a part of the world as the earthworm, he is aware of his specific difference and jealous of his independence. He may feel the pulse of things as his very own—or he may feel a "stranger" in a world that is indifferent and "absurd." In the arts, one may emphasize the distance between oneself and the environment, creating images of transcendence, as in the other-worldly mosaics of Byzantium. He may distrust his senses and withdraw into himself, persuaded that the outer world is illusory and that truth dwells within the inner person, causing that person's art to turn introspective—as in the autobiography

13 *Art and Visual Perception* (Berkeley and Los Angeles: University of California Press, 1969), p. 430.

14 "Productivity and Existence." *Pointing the Way* (London: Routledge & Kegan Paul Ltd, 1957), pp. 8–9.

15 See Melvin Rader, "The Factualist Fallacy in Aesthetics," *Journal of Aesthetics and Art Criticism*, 28 (1970), 435–39.

of St. Augustine or the aloof figures of Buddha. He may seek escape
into a realm of fantasy, as in the idyllic scenes of Watteau and Fra-
gonard or in much of the poetry of Spenser's *Fairie Queen*. Or he
may cross over the abyss that separates man from man and man from
the surrounding universe, as in the great landscape art of China. In
the immense panoramas of the Chinese scroll paintings, the activities
of human beings are merged with the abundance of nature, and the
unity of mankind and the rest of creation attains its highest affirma-
tion. We suspect that human beings cannot be permanently satisfied
by withdrawal into self, or escape into fantasy, or fixation on static
and transcendent forms—they will return to the idea of an all-envel-
oping harmony and will find new ways of expressing it. To realize
their own natures to the full and make themselves at home in the
world—this will be their goal. This does not mean that the sense of
nature's manyness is wholly suspended—it may mean, rather, a sense of
multiplicity in oneness, the orchestration of diversity. Although con-
sciously retaining his separate identity, an individual may feel him-
self part of an infinite network of affinities.

Art draws man closer to nature and it draws nature closer to
man. Oscar Wilde has wittily characterized one side of this process—
"nature's imitation of art":

> Things are because we see them, and what we see, and how we
> see it, depends on the Arts that have influenced us. . . . At pres-
> ent, people see fogs, not because there are fogs, but because poets
> and painters have taught them the mysterious loveliness of such
> effects. . . . Now, it must be admitted, fogs are carried to excess. . . .
> And so, let us be humane, and invite Art to turn her wonderful
> eyes elsewhere. She had done so already, indeed. That white quiv-
> ering sunlight that one sees now in France, with its strange
> blotches of mauve, and its restless violet shadows, is her latest
> fancy, and on the whole, Nature reproduces it quite admirably.
> When she used to give us Corots and Daubignys, she gives us now
> exquisite Monets and entrancing Pissarros.[16]

There is truth in Wilde's paradox: nature, as grasped by man, *does*
imitate art. When the art public learned to appreciate Whistler's
paintings of fogs and Monet's paintings of sun-drenched fields, they
found in nature new qualities that no one but the artist had seen
before.

If we take account of the facts of perception, this is not as sur-

16 "The Decay of Lying," *Intentions* (1891), in *The First Collected Edition of
the Works of Oscar Wilde* (London: Dawsons, 1969), 8:42–43.

prising as it might seem. William James, in his *Psychology,* pointed out that even ordinary perception is profoundly affected by our interests and values:

Consciousness is always interested more in one part of its object than in another, and welcomes and rejects, or chooses, all the while it thinks. . . . But we do far more than emphasize things, and unite some, and keep others apart. We actually *ignore* most of the things before us. . . . Out of what is in itself an undistinguishable, swarming *continuum,* devoid of distinction or emphasis, our senses make for us, by attending to this motion and ignoring that, a world full of contrasts, of sharp accents, or abrupt changes, or picturesque light and shade. . . . Attention, . . . out of all the sensations yielded, picks out certain ones as worthy of its notice and suppresses all the rest. We notice only those sensations which are signs to us of *things* which happen practically or aesthetically to interest us, to which we therefore give substantive names, and which we exalt to this exclusive status of independence and dignity. . . . The mind chooses to suit itself, and decides what particular sensation shall be held more real and valid than all the rest.[17]

When a very hungry man is walking through a forest, for example, the wild huckleberries that would ordinarily escape notice leap forth and capture his attention. Here, as in most other instances, it is a practical concern that determines what shall fall within the circle of awareness. But scientific and aesthetic interests are similarly selective, each in a different way and for a different purpose. "The artist notoriously selects his items, rejecting all tones, colors, shapes, which do not harmonize with each other and with the main purpose of his work."[18] By means of his art, he is able to induce in others a kind of moody vision which, carried over into the perception of nature, discloses things and qualities that had never been noticed before.

Wilde cites the example of impressionist painting, and it is a good example. But the revolution in the perception of light and color, in the enjoyment of sky and sunshine and open air, is the work of numerous artists in various media. A close study of the poetry of the nineteenth century, including such works as Tennyson's "Lady of Shalott" and Francis Thompson's "Ode to the Setting Sun," will reveal a movement in literature parallel to the impressionist movement in painting. In architecture, the Crystal Palace in London (1851) and the Galerie des Machines in the Paris Exhibition (1889) represent a

[17] *Psychology* (New York: Harper & Row, 1961), pp. 37–38, 39. (Originally published in 1892.)

[18] Ibid., p. 173.

similar reaching out for light and air. Keats, writing before this change had come about, felt that he had to escape from the city to enjoy the expanses of the heavens:

> To one who has been long in city pent,
> 'Tis very sweet to look into the fair
> And open face of heaven.[19]

In Keats' lifetime many buildings were like sodden imitations of medieval strongholds, dark and imprisoning. As a result of innovations since his death, we can now sit in our homes or in public buildings and gaze at great expanses of the sky. The arts also entice us out of doors through the use of patios and garden sculpture. Henry Moore, whose imagination has been greatly influenced by the shapes of rocks and other natural objects, prefers to exhibit his statues in parks or fields. "A large piece of stone or wood," he has said, "placed almost anywhere at random in a field, orchard or garden, immediately looks right and inspiring." [20] Isadora Duncan, choosing to dance in a natural setting naked or lightly clad, may have been responding to the same kind of impulse—the need to expose oneself to sunlight and open air. The practice of sunbathing, which is now common but was unknown in the nineteenth century, is a symptom of the revolution that has taken place. In this instance as in so many others, life has imitated art.

Perhaps the most striking example of a change wrought by aesthetic imagination is in the attitude toward mountain scenery. It is difficult for us now to realize that mountains were once almost universally regarded as ugly or uninteresting. The silence of Erasmus, who crossed the Alps by the Mont Cenis Pass in 1506 when he was about forty years old, implies a remarkable indifference:

> Although the journey was made through some of the grandest and most stupendous of Nature's wonders, there is not one word in any of the great man's letters to show that he was even conscious of their presence, and, though he was engaged in writing constantly during the whole period, he could find nothing better to write about than his approaching old age, of which he had been reminded by discovering some gray hairs on his temples.[21]

More frequent perhaps than indifference was a strong negative reaction. Marjorie Hope Nicolson, in a study of the aesthetics of moun-

19 John Keats, Untitled Sonnet (opening lines).

20 "Notes on Sculpture," in Brewster Ghiselin, ed., *The Creative Process* (Berkeley and Los Angeles: University of California Press, 1954), p. 71.

21 J. J. Mangan, *Life, Character, and Influence of Desiderius Erasmus of Rotterdam* (New York: The Macmillan Company, 1927), 1:218.

tain scenery, reports that human beings for centuries regarded moun-
tains as "Shames and Ills," as "Warts, Wens, Blisters" upon the face
of Nature. "For hundreds of years most men who climbed mountains
had climbed them fearfully, grimly, resenting the necessity, only on
rare occasions suggesting the slightest aesthetic gratification." [22] Even the
greatest of writers, Virgil and Horace, Dante, Shakespeare, and Mil-
ton, had none or very little of our modern sense of the beauty and
grandeur of lofty mountains.

There could be no more striking reversal of this attitude than
in the poetry of the romantics, especially Wordsworth, Shelley, and
Byron. Familiar as the following passage is, we quote it because it
represents Wordsworth's reaction to the kind of Alpine scenery that
left Erasmus totally unmoved:

> *The immeasurable height*
> *Of woods decaying, never to be decayed,*
> *The stationary blasts of waterfalls,*
> *And in the narrow rent at every turn*
> *Winds thwarting winds, bewildered and forlorn,*
> *The torrents shooting from the clear blue sky,*
> *The rocks that muttered close upon our ears,*
> *Black drizzling crags that spake by the way-side*
> *As if a voice were in them, the sick sight*
> *And giddy prospect of the raving stream,*
> *The unfettered clouds and regions of the Heavens,*
> *Tumult and peace, the darkness and the light—*
> *Were all like workings of one mind, the features*
> *Of the same face, blossoms upon one tree;*
> *Characters of the great Apocalypse,*
> *The types and symbols of Eternity,*
> *Of first, and last, and midst, and without end.*[23]

Wordsworth, preferring his native Cumberland, found in English moun-
tains a sublimity that was less awesome and more tranquil than that
of the Alps. From early childhood to late maturity, he was "compassed
about by mountain solitudes" and experienced a range of aesthetic
values that would have been incomprehensible to the poets of a pre-
vious age.

This great transformation began in a small way more than a cen-
tury before the Romantic period and it has continued down to the

[22] *Mountain Gloom and Mountain Glory* (Ithaca: Cornell University Press, 1959),
p. 2. These generalizations apply to Western civilization. In China and Japan the
appreciation of mountain scenery is ancient.
[23] William Wordsworth, *The Prelude*, VI, 624–40.

present. "The picnic of the eighteenth century had been an intellectual amusement of the aristocracy—a symbolic paying of homage to the supposed virtues of Rousseau's Noble Savage—and it was held on the manicured lawns of formal gardens." [24] The Romantics changed all that, and John Ruskin, born in the flowering period of the Romantic movement, carried over their love of wild nature into the Victorian era. Devoting many pages of his *Modern Painters* to the praise of mountain landscapes, especially Turner's paintings of the Alps, he noted that "the leading masters, while they do not reject the beauty of the low grounds, reserve their highest powers to paint Alpine peaks or Italian promontories." [25]

In a study of the influence of Ruskin upon American art and aesthetics, *John Ruskin and Aesthetic Thought in America,* Roger Stein has shown that the love of mountain beauty took deep root in the United States and greatly stimulated landscape art. At present there is a reaction against representational painting, whether landscape or human portraiture, but the love of mountains has survived in such poetry as that of Theodore Roethke. [26] The camera, as well as poetry and painting, has contributed immeasurably to the knowledge and enjoyment of wilderness areas. After the Civil War, the photographer-as-explorer, represented by such daring men as Timothy O'Sullivan (1840–1882) and William Henry Jackson (1843–1942), recorded the incredible vistas of the Far West. Their epic work has been continued by such masters as Andreas Feininger, Bradford Washburn, Ansel Adams, and Eliot Porter.

> Each has attempted to define what the earth is like. Among them they have peeled away, layer by layer, the dry wrapper of habitual seeing, and have presented new discoveries concerning the structure, the beauty, and the meaning of our habitat.[27]

All of these men—poets, prose-writers, painters, photographers—have radically altered our perception.

The same kind of revolution, but without the aid of the camera, occurred in China and Japan, reaching its peak centuries before it began in the West. There are no more grandly designed landscapes

24 From *The Photographer and the American Landscape,* edited by John Szarkowski, p. 3. Copyright © 1963 The Museum of Modern Art, New York. All rights reserved. Reprinted by permission of The Museum of Modern Art.

25 *Modern Painters* (New York, 1856), 3:263. Quoted by Nicolson, *Mountain Gloom and Mountain Glory,* p. 6.

26 See Harvey Manning, *The Wild Cascades* (San Francisco: Sierra Club, 1967). The magnificent photographs are accompanied by poems of Roethke.

27 John Szarkowski, *The Photographer and The American Landscape,* p. 5.

than the Chinese scroll paintings, and no more exquisite pictures of mountain scenery than the Japanese paintings and prints. These were accompanied by poetry which, though impossible to translate adequately, is charming even to Western readers. Perhaps the Japanese have excelled in depicting the microcosm rather than the macrocosm, the single iris or bamboo stalk rather than the overpowering mountain range.

Just as nature may be painted in panoramic scope or intimate detail, so natural objects may be photographed in great or small scale. Few photographs are so memorable as Ansel Adams' picture of the Snake River wending its course against the majestic backdrop of the Grand Tetons, or Bradford Washburn's picture of an Alaskan glacier sweeping out of mountain fastnesses into an enormous valley. But a small or ordinary object depicted by a sensitive photographer may be no less memorable: a frog half-immersed in water beside a lily pad (Edward Steichen), a scintillating cobweb in the rain (Paul Strand), a rock eroded by the pounding of waves (Edward Weston), a quivering reflection of reeds at the water's edge (Harry Callahan), a gnarled trunk of an old sycamore tree (William R. Current). Things such as these, by isolation and reassociation, assume a new strangeness and importance. There is something almost religious in the way a seemingly trivial thing takes on lasting significance when we lay aside our preconceptions and see afresh. "To create a little flower is the labor of ages," said Blake, [28] expressing an insight that is both scientific and mystical.

The camera, in the hands of a master such as Henri Cartier-Bresson, is an incomparable instrument for isolating the fugitive moment. Our unassisted eye is too slow and too generalized to pick out the spot-instant where time and space cross in a sudden expressive transaction. Photographing this happy juncture is not just a matter of luck; it requires "a velvet hand, a hawk's eye" that knows the split-second when to press the shutter. This ability to capture the object in its most lyrical moment distinguishes the artist-photographer from the amateur or mere craftsman. Although the ordinary man is less expert, photography has become one of the most widely practiced of the arts.

Technology has added startling new dimensions to this medium. It is now possible to photograph what the earth looks like from distances as close as a hovering plane or as far away as the moon. With

[28] William Blake, "The Marriage of Heaven and Hell" in Geoffrey Keynes, ed., *Poetry and Prose of William Blake* (New York: Random House, 1927), p. 194.

the aid of the telescope, the camera records the shape of inconceivably distant galaxies and nebulae; with the help of the X-ray and microscope, it penetrates the deepest recesses of nature; in the form of cinema, it adds the illimitable dimensions of time to the vast reaches of space. These augmented powers are as important aesthetically as they are scientifically, but they would require a treatise for us to explore.

The arts—especially painting, architecture, literature, photography, and landscape gardening—are mighty instruments in the humanization of nature and the naturalization of man. Along with the sciences and technologies, they are the chief means by which man makes himself at home in the world. The position of religion is more ambiguous, because it frequently serves the purposes of escape and transcendence rather than adaptation to things as they are. But we shall reserve to later chapters the discussion of the relation of art to science, technology, and religion.

Nature Distinguished from Art as a Source of Aesthetic Value

Nature as the source of aesthetic value can also be approached independently of art. Its importance in this respect varies with the temperament of the onlooker. Benedetto Croce, for example, considers it vastly inferior to art.

> The always imperfect adaptability, the fugitive nature, the mutability of "natural beauties" . . . justify the inferior place accorded to them, compared with beauties produced by art. Let us leave it to the rhetoricians or the intoxicated to affirm that a beautiful tree, a beautiful river, a sublime mountain, or even a beautiful horse or a beautiful human figure, are superior to the chisel-stroke of Michelangelo or the verse of Dante; but let us say, with greater propriety, that "nature" is stupid compared with art, and that she is "mute," if man does not make her speak.[29]

George Santayana, in contrast with Croce, prefers the beauty of the open fields to the beauty of the salon:

> The fine arts have to be studied like any other department of nature; and that study, with much fatigue and waste of spirit, will yield some pleasures and a larger view of the world; it will refine a man's taste and enrich it with all sorts of side-lights, qualifica-

29 *The Essence of Aesthetic* (London: William Heinemann Ltd, 1921), p. 47.

tions, and ironies; but I think a lover of beauty will soon turn his back on concert-halls and museums, and take to the fields.[30]

The average man is more inclined to side with Santayana than with Croce. He is likely to enjoy a sunset more than a landscape painting; he is fonder of an outing at the beach than a visit to an art gallery or a concert hall. He may even feel that the arts are namby-pamby and look with contempt upon aesthetes chattering about the avant garde. But the love of art includes more than chitchat about the latest innovation: it is possible for tough minds and robust spirits to be enamoured of the arts. We would be foolish to debate whether nature or art is aesthetically preferable—each has its incomparable values, and neither is properly considered a rival of the other. They are complementary rather than mutually exclusive.

The aesthetic reaction to nature is many-faceted, and mere cataloging of the varieties would be tedious. Instead we shall cite a few interesting respects in which the aesthetic appreciation of nature differs from the enjoyment of art.

Nature impinges more sharply and directly upon the senses than do works of art. The impulse to establish direct contact with things, which prompts children to run barefoot and adults to reach out and touch the softness of moss or the prickliness of heather, can be satisfied by nature better than by art. When we plunge into the ocean surf or ski down a mountain slope, there is a freshness, an immediacy, and a vividness in our sensations that no artifact can supply. Even when nature is less stimulating, our experiences are often livelier than their artistic counterparts. For example, an impressionist painting, with all its brightness, cannot rival the intensity of light and color of a rainbow or a sunset. The stars on a very clear night are more fiery in their splendor than any stellar photograph. A walk in the woods on a fine spring day may set all our senses pulsating as no work of art can do. Seldom, under such circumstances, do we experience qualities isolated or received through a single sense: instead there is a variety of sensation that no artist can create. The scents, the sounds, the hues and shapes, the tactile and kinaesthetic impressions work upon our senses from many directions, and even though no single stimulus may excite us much, the conjunction of many stimuli may be very stirring.

Things in nature are less bounded and isolated and internally coherent than are works of art. We are imaginatively drawn into the charmed circle of the art object and there insulated from the sur-

30 "The Mutability of Aesthetic Categories," *Philosophical Review*, 34 (1925), 288.

rounding world: the parts interdepend and enhance one another in an internal self-sufficient web. The work of art may literally have a frame around it, or if not it has definite edges, or a beginning, middle, and end. In contrast, there are no frames, no clear-cut edges, no definite ends or beginnings in nature—things are strung along and loose and amorphous. Because there is no predetermined focus, the eyes of the spectator wander hither and yon, and there is none of the fixedness and exclusiveness and enclosedness of art: nature stretches away to infinity and every natural thing has an indefinite context. Whereas the qualities of a work of art are generally viewed from a fixed frame and from a preferred position, the qualities in nature are alterable by mentally enlarging or narrowing the context, or by turning one's head, or by moving toward or away from the object, or to the left or the right. There are more surprises, more free play, more scope for fancy, more of a sense of openness and adventure, more of a challenge to draw things together and relate them in new ways, than in the contemplation of art. The spectator is himself within nature, a form among its forms, so that he can turn completely about in a circle and feel everywhere enveloped and involved. This total envelopment can produce a sense of incorporation quite different from the psychical distance that aestheticians have stressed.

"The formative process is the supreme process," said Goethe, "indeed the only one, alike in nature and art." [31] But there is a difference; form in nature is many-leveled and multi-dimensional, while form in art lies on the surface, and in that sense is only "skin deep." In nature there are forms within forms within forms within forms: or, to put the same facts in reverse, there are electrons, atoms, molecules, and aggregations of molecules, and in the biological sphere, elementary organisms, plants, animals, and ecological communities, forming mounting series of wider and wider integration. With the instruments of science, such as the microscope and the X-ray, we discover that there are countless layers in nature, each one exquisite in its formal structure. As Roman Vishniac, photographer of the minute in nature, has said:

> Everything made by human hands looks terrible under magnification—crude, rough, and unsymmetrical. But in nature every bit of life is lovely. And the more magnification we use, the more details are brought out, perfectly formed, like endless sets of boxes within boxes.[32]

[31] Quoted by Lancelot Law Whyte, *Aspects of Form* (Bloomington: Indiana University Press, 1966), p. 233.

[32] Quoted by Andreas Feininger, *Forms of Nature and Life* (New York: The Viking Press, Inc., 1966), p. 10.

Louis Arnaud Reid speaks similarly of the contrast between art and nature:

> "The body" of a piece of sculpture is its perceived shape; and if we break it up we are left with lumps of dead matter. But dissect the flower or the tree, and you get layer upon layer of connected structure, and layer upon layer of appearing beauty, each yielding the effect of active immanent expressiveness, and each intricately connected with the beauties that have gone before. We can dig down to the very matter itself and still there is beauty. The only limitation to this process is that beyond a certain point we cannot perceive, but can only conceive, and, perhaps imagine.[33]

This multidimensional character is one reason that nature strikes us as inexhaustible, being infinite in the wealth and variety of its forms.

At the level of ordinary perception, however, nature is less formal than is art. In art appreciation we almost always respond to the whole form or configuration, whereas in nature appreciation we often enjoy the single quality. When Plotinus argued against the formalist contention that "only a compound can be beautiful, never anything devoid of parts," he found his best examples in nature and not in art. If beauty were limited to compounds, he remarked, then

> all the loveliness of color and even the light of the sun, being devoid of parts and so not beautiful by symmetry, must be ruled out of the realm of beauty. And how comes gold to be a beautiful thing? And lightning by night, and the stars, why are these so fair? [34]

Plotinus went on to say that a single note in music may be beautiful, but he failed to note that this beauty is artistically very elementary. In the sounds of nature, on the other hand, it is frequently the single quality rather than the form that haunts us. The caw-caw of a hawk, the croak of a frog, the roar of a cataract, the clap of thunder—these and other sounds in nature can be quite piercing in their timbre and intensity though they are almost devoid of form. Even the quieter sounds, such as the murmur of bees, lack any appreciable structure. Natural forms as grasped by ordinary perception, moreover, are less perfect than the forms created by a master artist. This is one reason a painter has to recompose the details in a natural scene before he can achieve the form that satisfies him. But this defect of nature has its compensation: we can take pleasure, as we have already noted, in

[33] *A Study in Aesthetics* (New York: The Macmillan Company, 1931), p. 393.
[34] *Enneads,* trans. Stephen Mackenna (London: The Medici Society, 1917–1930), 1:78.

the loose structure and sheer pluralism of the natural landscape. Art itself has recently tended toward freer form and more random organization, thus diminishing the difference between it and nature. There is something to be gained in an escape from the constricting effect of form, even though the mystique of the chance collocation can easily be carried too far.

The adaptation of form to function can be found both in nature and in art, but again there is a difference. In the products of man we discern the traces of human intent, whether in the utilitarian function of industrial artifacts or in the expressive function of works of art. We have the feeling that we are discovering and sharing in the mental processes of their makers. Perhaps the swing in some recent aesthetics from "intention" to "object" has been a necessary corrective, but it has substituted for the excesses of intentionalism and expressionism some excesses of its own. Despite all that has been written by Wimsatt and Beardsley about the importance of distinguishing between the work of art and both the artist's intentions and the spectator's responses, [35] the felt communication of meaning from artist to spectator is one of the important sources of artistic effect. We can find no such communication in nature except in the behavior of the higher animals, as when a dog wags its tail at its master. But among plants and animals and inorganic things we do find superb examples of the adaptation of form to function. In the tensile strength of a soap bubble or the stability of a crystal, there are lessons that have impressed Buckminster Fuller and other functionalist architects. The adaptation of the shape of rocks to the forces of erosion has inspired Henry Moore. "Pebbles show Nature's way of working stone," he has remarked. "Some of the pebbles I pick up have holes right through them. . . . A piece of stone can have a hole through it and not be weakened—if the hole is of studied size, shape and direction. On the principle of the arch it can remain just as strong." [36] In his own use of holes in sculpture and other rock-like features, Moore has emulated, if not imitated, the ways of inorganic nature. Similarly artists and critics have been impressed by the functional characteristics of organic forms. When Horatio Greenough, as an early advocate of functionalist architecture, wished to cite examples of functional beauty, he turned to the eagle, the lion, the hare, the greyhound, and the human body. The strong emphasis in the philosophy of art, from Plato

[35] See W. K. Wimsatt and Monroe C. Beardsley, "The Intentional Fallacy," *Sewanee Review,* 45 (1946), 468–88, and "The Affective Fallacy," *Sewanee Review,* 57 (1948), 31–55.

[36] "Notes on Sculpture," p. 70

and Aristotle to our contemporary aestheticians, upon "living" or "organic" form is a tribute to the functional forms of nature, but in animate nature the form is *really* living or organic, whereas in painting or sculpture or poetry it is only virtually so.

The difference between the virtual character of works of art and the real character of things in nature is worth remarking. Susanne Langer has maintained that every work of art is, like a rainbow, "a virtual object." The comparison is not apt because a rainbow, in its own way, is quite real; it is only the human observer who misinterprets it. But Langer's point is like that of Schiller, that a work of art is an "appearance" (*Schein*), something that we merely contemplate without regard to its existence or nonexistence. It is enough that it is an apparition—we demand no literal reality. The same point is made by Croce in calling the work of art "imaginary." Still other aestheticians, such as the German psychologist Karl Lange, have insisted that art is make-believe, or, to employ his favorite term, "conscious self-deception." A painting or statue, a poem or drama or novel, like a child's doll, lives in the imagination "as if" it were real. Even an abstract work of art, such as a piece of "pure music," involves "the illusion of feeling"—that is to say, it palpitates with human emotion and is imbued with a kind of life. Nature is different—apart from human misinterpretation, natural objects are not illusory at all. A rock is a rock, a tree is a tree, and they do not pretend to be otherwise. We know natural objects for what they are in their palpable and incontestable givenness. This contrast between nature and art explains why some deeply serious minds, feeling that life is real and earnest, shy away from art and yet find deep satisfaction in nature.

It would be a mistake to interpret this contrast as an absolute distinction. In the eyes of Peter Bell, the literalist depicted by Wordsworth, a yellow primrose is a yellow primrose "and nothing more." The aura of imagination which Peter missed transforms the primrose into an apparition, and this kind of transmutation of natural objects is not infrequent. On the other hand, it is possible to interpret the work of art as nonapparitional. Maurice Denis, in his "Définition du Neo-Traditionisme" (1890), begins with the injunction: "Remember that a picture—before it is a war horse, a nude woman, or some anecdote—is essentially a flat surface covered with colors arranged in a certain order." [37] To a limited extent, this kind of literalism has come back into style. Some contemporary artists regard themselves as "the makers of objects," not the makers of apparitions, and stress the literal

[37] *Theories 1890–1910* (Paris: Bibliothèque de l'Occident, 1913), p. 1.

reality of the things they make. On the other hand, apparitions, visions, and surreal experiences, as in the films of Bergman and Fellini, are popular with a large segment of the art world. A person's preferences, whether toward the literal or the visionary, depend in part upon the kind of aesthetics to which he clings. This much at least we would insist on—that the object must be regarded in terms of *values* rather than merely in terms of facts lest we fall victim to the factualist fallacy. To be aesthetically relevant, our attitude must be *appreciative* and not just *cognitive,* and this is the case whether the object is natural or man-made.

Nature appreciation differs from art appreciation in relation to beauty and ugliness. In the aesthetic enjoyment of nature, beauty (in the wide sense of the word that includes sublimity) is almost invariably the focus of attention. If the object is ugly, as in the case of some diseased plant or animal, we look elsewhere, or if we continue to look at the object out of curiosity, our attitude is no longer aesthetic. In the appreciation of works of art, on the other hand, value-expressiveness excites our interest, and the values expressed may be quite other than beauty. Ugliness, in fact, may serve the purpose of expression and be altogether justified artistically. When James Joyce in *Ulysses* expressed disgust at the sight of a cold, unwashed shaving brush ("the clammy slather of the lather in which the brush was stuck"), we accept the wording for its expressive power though we find no beauty in it. Similarly, a painter such as Grünewald, Goya, or Bacon may express what he abhors, and we may accept his work because it yields insight into human values, negative though they be. Aesthetic interest, being rapt and intransitive, is more often focused on the fascinating than the repugnant, for if the object is simply disgusting it will probably not keep our attention rapt for long. But we may be willing to look evil in the face for the sake of insight.

We have said enough to indicate some of the subtle and complex relations between nature and art—relations of likeness and relations of contrast. In both art and nature, men can find an inexhaustible source of aesthetic value. The great difference between them is that art is a human product and nature is not. This means that each has a range of values and meanings that is incommensurable with the other. Nature appreciation cannot be a substitute for art appreciation or vice versa, and both art and nature are essential to the satisfaction of our aesthetic needs. Any defense of the artistic representation of nature should first recognize the independence of art. Art can contribute to the world only by being itself. As a sterile duplicate of nature or the human world, it can contribute nothing.

To trace the way in which art is both involved and independent is the main task of Part Two. To this undertaking we now turn with considerable trepidation. We would be lacking in understanding if we were to overlook the difficulties and lacking in modesty if we were to underestimate the hazards. We think of our venture as exploratory—no more than a reconnoiter in a wide and treacherous terrain.

Art and Other Spheres
of Value

Chapter 8

ART

AND RELIGION

Transition to Part Two:
The Need for Balance and Wholeness

In Part One we examined the nature of aesthetic value and its
manifestations in common life, art, and nature. In Part Two we shall
discuss the relation between art and other human interests and be-
tween aesthetic value and other fundamental values.

If we ask what, in a fairly typical way, we find ourselves doing
in the course of human life, we may put our answer in terms of
interest activities as follows:

1. *Biological activity.* As organisms, we exercise our vital
functions, doing what is necessary in order to be and stay alive, to
keep going. We breathe, we eat, we sleep, we take refuge from weather
and danger, we engage in sexual union, and we beget and nurture
children in order to survive as a species.

2. *Religious activity.* Although it is all but hopeless to try
briefly to characterize "religious activity" in a way that will be gen-
erally acceptable, it must be included, however vaguely and variously
understood, in our list of root interests. Something answering to the
name "religious" has at all times and in all places been an important

concern in man's life. For our purpose, perhaps the best attempt to characterize it is that of William James. He says, "At bottom the whole concern of . . . religion is with the manner of our acceptance of the universe." The manner of acceptance, James finds, may vary immensely and endlessly between the extremes of "dull submission" and "enthusiastic assent." But he finds a "common nucleus" underneath "all the discrepancies of the creeds" in an uneasiness and its solution. "The uneasiness . . . is a sense that there is *something wrong about us* as we naturally stand. The solution is a sense that *we are saved from the wrongness* by making proper connection with the higher powers." [1] This characterization is akin to the concept of alienation and its overcoming.

3. *Moral activity.* In acting morally, we take an interest in what other people want and do. Morality is both practical and self-justifying. It behooves us to be moral and it satisfies us directly to be so. We learn practically that we must consider others if we wish others to consider us. But prudential considerations aside, we are still not content to live unto ourselves alone, mentally or emotionally. We just do feel for others, or feel ourselves with others. We are moral by nature and fundamental need.

4. *Knowledge activity.* We know our world. We perceive things and we seek to understand the regularities of their occurrence, their laws. To know our world is first of all to come to terms with it, to know how to live with it. But also, we just want to know, to understand what we are and what our world is, how it behaves, and what, if anything, it means and is all about. Our pursuit of knowledge is in part disinterested. But disinterested or practical, our desire for knowledge is fundamental.

5. *Economic activity.* We strive to secure and enlarge our subsistence and other desired goods. We work and we plan. With foresight we lay up for future need and want. We acquire and defend our property, and we strive to satisfy our economic wants. We win a living. We get and we spend.

6. *Political activity.* The objective of politics is or should be not simply this or that particular good but the good for man. Political activity is an all-human activity directed by the State toward the organization and fulfillment of social goals. In the words of the French Revolution, its goals are liberty, equality, fraternity.

7. *Aesthetic activity.* We have already characterized aesthetic activity in Part One, and it will be our continuing concern in Part

[1] *The Varieties of Religious Experience* (New York: Longmans, Green and Co., 1928), pp. 41, 508.

Two. As the expression and embodiment of values, it is the fundamental subject matter of this book.

This scheme of life activities or basic human behaviors—the biological, religious, moral, cognitive, economic, political, and aesthetic—is incomplete and it is certainly sketchy and spare. It might seem to omit technology, but we include it as applied science, economic productivity, and in general, as the means and skill to attain human objectives.

Each division in this scheme represents a whole field or several fields to which many books and endless study can be and have been devoted. Still, it serves as a chart which marks off in rough emphasis the coordinate place of the aesthetic interest in the total system of activities that constitute human life.

It should be remembered that the divisions in this scheme of life are abstractions, or separations of strands which regularly appear in actual life, though in varying proportions, in a single composite texture. All types of behavior are found together in human living. We separate them only to recognize more clearly and to emphasize more strongly their interrelations and interdependence. The specialized response or activity is never the whole individual. There can be no such person as a purely scientific man, a purely economic man, or a purely aesthetic man—which, if strictly meant, is quite obvious, but also there can be no man in whom one or more of these interests is seriously lacking. We are not speaking of a logical impossibility, nor even of an empirical or factual impossibility. Individuals abstracted or contracted in these ways are certainly conceivable, and in varying degrees and combinations are not only probable but actual. Furthermore, limitation and specialization of interest is, in fact, a condition of effective living. Limitation of interest may itself be good or bad. The right kind of limitation for concentration on a central interest. The central interest will not then exclude the others, but serve rather as a hub which will support them. In any case, the man who has no central interest is not the model for a good life.

The point of our observation is thus not compulsively logical nor descriptively factual, and it is not to be understood too narrowly. The point is, rather, normative, and liberally so. This means simply that when we do find an individual whose life seems exclusively or disproportionately absorbed in one interest we regard him as abnormal and we characterize him by some term which connotes unbalance and disapproval. Thus a person who can think nothing, do nothing, or allow nothing that does not narrowly serve doctrinaire religion is called a fanatic or a bigot. And even if we call him by more objective and

tempered names, such as zealot, enthusiast, or pietist, we often add to our intended meaning an imputation of excess. Likewise, a man who is all business all of the time we call unimaginative, illiberal, and a rank materialist or a money-grubber. Being all economic man, he is not even biologically wise. He will end, we predict, prematurely with a heart attack, or if he grinds through to retirement, he will retire to inanity and boredom. And the man who is all for art and the aesthetic life, hovering every moment over his precious sensibilities, we say, is an aesthete. And we mean no praise in calling him that. His life, we believe, is attenuated and "refined" to a point of mere preciosity, which declines into decadence and is lacking in fullness and robustness.[2] So too of each of the other interests pursued too narrowly. The severe and uncompromising moralist becomes a puritan, the heavy intellectualist is a dry and cold pedant, the mere technician is a spiritual dwarf, and the overimpassioned reformer turns into a crank. If we are right in such disapprovals, it means that no single interest of life can be safely and sanely pursued in isolation. Isolation makes for excess and impoverishment. Normal life is varied in interests because interests are interrelated.

We do not mean that all men should be all things, that there should be no expert craftsmen or specialized technicians; no merchants, tradesmen, or manufacturers busied occupationally with the production and distribution of goods; no professional scientists and philosophers giving their days and nights to pursuit of knowledge; no dedicated artists devoting their lives to the creation of painting, sculpture, music, and literature. We mean only that complete human value cannot be realized collectively except in terms of all the separate values which in the complex economy of a developed society are served by these various specialists, and that complete human value for the individual cannot be realized without his sharing in all these values.

This conclusion follows naturally from the fact that the interests and values of human life, although each may be distinguished and defined as different in kind from every other, do not occur in communal or individual life in isolation or independence. Pursuit of a given interest is never wholly or only what we name it. It is that only in the dominant aim of the total action, but it is always much else in its complete behavioral and intentional texture. Likewise values. They never come pure. They do not exist nomadically, either in preestablished harmony or in simple conflict as competing goods, the striving for which constitutes one way of life or another. Interests and

[2] An interesting fictional portrait of such a man is given in the novel, *A Rebours,* by J. K. Huysmans, translated under the title *Against the Grain* (New York: Dover Publications, 1969).

values are, rather, always interrelated not only in the sense that life includes them all but also in the sense that each permeates and is permeated by all the rest. They form a system of checks and balances. Every value is responsible to all values. No value is absolutely free in the sense that it can be pursued, attained, or understood unconditionally. When interest meets interest, and values intersect and collide, each must recognize and accommodate itself to the others. Unless somehow counterbalanced, the achievement of a single interest is good; but only the harmonious integration of all major interests can fulfill the requirements of an ideal economy of values.

In discussing the place of art in this economy, we need to keep in mind a point that we made at the end of Chapter 4. Value has a more intrinsic and constitutive relation to art than to science, politics, or other fields of interest. We can truly speak of the value *of* each of these fields, just as we can truly speak of the value of art. But we can also speak of the values *in* art—namely, the values expressed and embodied in works of art. The main function of art is just this expression and embodiment. Despite overlapping between the fields, no other form of culture can equal it as the language of vivid values—here then as we have repeatedly said, is its characteristic function and defining excellence.

Art draws its subject matter not only from nature and common life but from all human interests and activities. What Goethe said to Eckermann can be generalized to all nonaesthetic fields of value: "Religion stands in precisely the same relation to art as any other of life's higher interests. It is to be considered purely as material, having equal rights with all the other materials life affords." [3] The values found in all areas of human interest are transmuted by artistic expression and embodiment into the stuff of art. Hegel's term, *Aufhebung*, is useful at this point. It can mean "cancel" but it can also mean "preserve" and "lift up." When applied to art in this triple meaning, it indicates that ordinary qualities and life values are lifted up, transfigured by artistic expression and creative embodiment, and conserved on an imaginative plane. It is this transmutation, as we have already said, that insures the autonomy of art.

With this prefatory statement, we turn in Part Two to a detailed consideration of the interrelations between art and aesthetic value, on the one hand, and other fundamental human interests and values, on the other. Because in this book we are more concerned

[3] Quoted by Elizabeth M. Wilkinson and L. A. Willoughby, eds., in Friedrich Schiller, *On the Aesthetic Education of Man in a Series of Letters* (Oxford at the Clarendon Press, 1967), p. xxiv fn. By permission of The Clarendon Press, Oxford.

with culture than its biological foundations, we shall say no more about biological activity except so far as it overlaps with other interest activities, and we shall follow the specific divisions represented by religion, morality, science, and the social activities of economics and politics. We shall turn first to the relation between art and religion.

The Affinity of Religion and Art

The aesthetic and religious spheres exhibit a natural kinship. In ancient Greece, China, India, medieval Europe, pre-Columbian Mexico, and other distant times and places, the two are almost indistinguishable. Even in our modern secularized civilization, much of art retains a strongly religious tone. Examples are Hermann Hesse's *Siddhartha*, Jacob Epstein's statue of Christ, Benjamin Britten's *Requiem Mass*, Henri Matisse's chapel at Vence, and Le Corbusier's chapel at Ronchamp.

The affinity between religious and aesthetic value is not confined to art: the love of nature frequently has a mystical tinge, as in this quotation from Thomas Traherne:

> You never enjoy the world aright, till the Sea itself floweth in your vein, till you are clothed with the heavens, and crowned with the stars: and perceive yourself to be the sole heir of the whole world, and more than so, because men are in it who are every one sole heirs as well as you. Till you can sing and rejoice and delight in God, as misers do in gold, and Kings in scepters, you never enjoy the world.[4]

As one may judge by perusing the *Oxford Book of Mystical Verse*, the sense of sacredness and the sense of the beauty of nature are inseparable in much of the literature of mysticism.

Jane Harrison has declared: "It is at the outset one and the same impulse that sends a man to church and the theater."[5] She and Gilbert Murray, like Nietzsche in an earlier generation, have traced the tragedies of Aeschylus, Sophocles, and Euripedes back to their roots in magic and religion. Evolving out of religious rituals, the Greek plays were integral parts of religious festivals and the events they depicted were regarded by the public with holy awe. Nondramatic art, such as the frieze of the Parthenon, emerged from the same ritualistic and religious background. The two great figures that enriched the

[4] Bertram Dobell, ed. In *Centuries of Meditations* (London: published by the editor, 1908), p. 20.

[5] Jane Ellen Harrison, *Ancient Art and Ritual* (New York: Henry Holt and Company, 1913), pp. 9–10.

Greek religion were the poet and the sculptor, the one who elaborated the stories of mythology and the other who gave the gods and heroes an objective form. While citing these facts about ancient Greece, Jane Harrison rounds out her argument by many references to similar art origins in other times and cultures. Her contention that there is a close kinship between religion and art in the early life of mankind has been confirmed by historians of culture such as Ernst Cassirer and by anthropologists such as Sir James Frazer.

Both art and religion are among the most primitive expressions of human life. R. G. Collingwood has said that art is the natural speech of children and savages. In his *Speculum Mentis* (1924), he considers religion almost as rudimentary. Art, he says, is imagination, and religion is imagination believed in. For example, the *seeing* of ghosts and fairies is art; the *believing* in ghosts and fairies is religion —the second is almost as rudimentary as the first, and at a primitive stage it is difficult to distinguish the two. Logically the first must precede the second, but chronologically there appears to be no priority of one to the other. In primitive societies, philosophy and science scarcely exist at all, while religion and art are highly developed.

An example from fiction will illustrate their primitiveness. As Huckleberry Finn and Jim, the runaway slave, float on their raft down the Mississippi River, they look up at the moon and the stars and speculate about origins:

> It's lovely to live on a raft. We had the sky up there, all speckled with stars, and we used to lay on our backs and look up at them, and discuss about whether they were made or only just happened. Jim he allowed they was made, but I allowed they happened; I judged it would have took too long to *make* so many. Jim said the moon could a *laid* them; well, that looked kind of reasonable, so I didn't say nothing against it, because I've seen a frog lay most as many, so of course it could be done. We used to watch the stars that fell, too, and see them streak down. Jim allowed they'd got spoiled and was hove out of the nest.

These reflections, "of imagination all compact," illustrate myth-making at its naive level. For the adult and civilized man it is difficult to recapture this unsophisticated frame of mind, but from it both religion and art originally sprang.

The visionary quality of aesthetic and religious experience points to a common source in the deep unconscious abyss of the human psyche. Probing into the visionary depths of life, Plato links together the "madness" of the lover, the artist, and the religious seer. In the *Ion,* he distinguishes poetry as divinely inspired madness from science

as a sober description of fact, craft as a deliberate and expert skill, and philosophy as reason lighting up the nature of things. In the *Symposium,* he depicts the "musical soul" or artist as maddened and intoxicated by beauty, ascending by stages from the love of bodily forms to the love of spiritual realities. In the *Phaedrus,* he contrasts the healthy madness of the prophet, the ritualist, the lover, and the artist, with the pathological madness of the sexual pervert and the medically insane. This coupling together of the imaginative creations of the artist with the visionary experiences of the lover, the seer, and the madman has been a recurrent theme from the time of Plato until the present. For example, Shakespeare in *Midsummer Night's Dream* (VI, i, 1–28) links together "the lunatic, the lover and the poet," and Shelley, in "To A Skylark," implores the bird, symbol of "unpremeditated art," to impart to him, as poet, the "harmonious madness" of its song. The modern investigations of Freud and Jung and of analysts such as Maud Bodkin and Joseph Campbell have disclosed a vast psychic underworld to which both art and religion are bound. In Plato there is the implication that the artist is untrustworthy and that the philosopher alone beholds beauty pure and unalloyed, but these later writers conceive the artist and the seer as parting company from the scientist and the rationalistic philosopher and joining primitive man among the timeless band of visionaries.

As examples of "the visionary mode of artistic creation," Jung cites Dante's *Divine Comedy,* the second part of Goethe's *Faust,* Nietzsche's "Dionysian exuberance," Wagner's *Nibelungen-ring,* and the poetry of Blake, pointing out the similarity between such dreamlike creations and religious or prophetic visions:

> The creator of this kind of art is not the only one who is in touch with the night-side of life; prophets and seers are nourished by it too. . . . However dark and unconscious this night-world may be, it is not wholly unfamiliar. Man has known it from time immemorial, and for primitives it is a self-evident part of their cosmos. It is only we who have repudiated it because of our fear of superstition and metaphysics, building up in its place an apparently safer and more manageable world of consciousness in which natural law operates like human law in society. The poet now and then catches sight of the figures that people the night-world—spirits, demons, and gods; he feels the secret quickening of human fate by a suprahuman design. . . . In short, he catches a glimpse of the psychic world that terrifies the primitive and is at the same time his greatest hope.[6]

[6] Carl G. Jung, "Psychology and Literature," in *The Spirit in Man, Art, and Literature,* trans. R. F. C. Hull (New York: Pantheon Books, 1966), pp. 95–96.

From this vantage point it is possible to understand why the language of dream and myth and art is so often identical. In all three, thoughts and feelings are expressed in sensory images, the world outside being a symbol of the world inside:

> Symbolic language is a language in which inner experiences, feelings and thoughts are expressed as if they were sensory experiences, events in the outer world. It is a language which has a different logic from the conventional one we speak in the daytime, a logic in which not time and space are the ruling categories but intensity and association. . . . It is a language with its own grammar and syntax, as it were, a language one must understand if one is to understand the meaning of myths, fairy tales and dreams.[7]

This symbolic language, which we all "speak" when we are asleep, is the only universal language that mankind has ever possessed. As writers such as Joseph Campbell, in his *The Hero With A Thousand Faces* (1949), have shown, it is a language that appears in the oldest of myths and in the dreams and poetry of our contemporaries. It is the same language in ancient India and China and Babylon, in modern New York, Paris, and Moscow, among primitive tribes and among modern urban dwellers. Underneath all the changing modes of civilization, there is something timeless and universal, an instinctive core or human genotype. [8] The rather fantastic interpretations of this night life by Freud and Jung and other psychoanalysts should not obscure the fact that depth-psychology, in probing the latent meaning of dream, myth, and artistic creation, brings us in touch with the deeper layers of our personalities and the profound, albeit inchoate, wisdom of the human race. These visions are frequently religious in tone.

As master of expression, the artist can communicate these deep religious intuitions with incomparable vividness. Hence it is no accident that religion has found its fullest expression in art, and that so much of the world's great art is religious. The sense of sacredness cannot be expressed in the language of science, nor in the prosaic language of ordinary speech. Without art, religion is inarticulate, but without religion, art would lack some of its most potent themes. As Santayana has said, each may be at its best at their point of union, art losing its frivolity and religion surrendering its literalness and dogmatism.

[7] Erich Fromm, *The Forgotten Language* (New York: Holt, Rinehart, and Winston, Inc., 1951), p. 7.

[8] For a profound interpretation of the "genotype" and its influence on art, see Christopher Caudwell, *Illusion and Reality* (New York: International Publishers, 1937).

The Aesthetic and the Religious Impulse

Albert Hofstadter, who has deeply pondered the meaning of freedom, has maintained that both religion and art spring from the impulse to be free. He distinguishes, as many others have done, between negative and positive freedom. Negative freedom is the absence of restraints and inhibitions. Positive freedom is the presence of self-determination. "It is clear," he says, "that negative freedom exists for the sake of positive freedom." [9] Restrictions must be broken through and removed to permit self-determination and growth.

Looking deeper into the meaning of positive freedom, he characterizes it as the harmony of self with not-self. The impulse to achieve this harmony is the master drive of human life:

> Every form of significant action which man carries out in the whole life-process consists in the endeavor somehow to break through the limitations and inhibitions of his environment—of the Other that surrounds him, the world in which he exists—in order to attain to a kinship, harmony, union with that in the Other which permits it.

The way for a man to become free is to shed his stultifying isolation and participate as a whole man in a wider and deeper whole.

This concept of positive freedom implies a close link between freedom and community, as the etymology of the English "freedom" and the German *Freiheit* suggests:

> One can find the details in any available handbook for English or German, e.g. Partridge for English and the *Duden Etymologie* for German.[10] We learn there that *free* and *friend* are identical in origin. The verb *to free* derives from Old English *frēogan*, and the noun *friend* derives from the Old English *frēond*, itself shaped from the present participle of the verb *frēon*, which is a contraction of the verb *frēogan*, the same as that from which *to free* is derived. And what is of decisive significance is that *frēogan* means: to love. . . . Originally then, and as I believe basically in an ontological sense, freedom is what we have when we are with our own, when the others about us are own to us and we are own to them.[11]

[9] "The Aesthetic Impulse," *Journal of Aesthetics and Art Criticism,* 32 (Winter 1973), 175. Unless otherwise indicated, all quotations from Hofstadter appear in this article.

[10] See Eric Partridge, *Origins* (New York: The Macmillan Company, 1958) and *Duden Etymologie,* ed. Paul Grebe (Mannheim: Bibliographisches Institut, Dudenverlag, 1963).

[11] Albert Hofstadter, "Kant's Aesthetic Revolution," a paper presented to the Pacific Division of the American Society for Aesthetics, Asilomar Conference Grounds, California, April 12, 1974.

Here is the key, Hofstadter believes, to the interpretation of art and religion and much more besides.

"Man's fundamental impulse is toward freedom," he says, "to be with other as own"; "every satisfaction has its basis in some such union or reconciliation." It "not only lies at the root of everything aesthetic, but also of the whole of human reality." Science is the endeavor to gain a cognitive grasp of reality and thus to forge a link of understanding between the self as knower and the not-self as known. Morality is the endeavor to achieve a community in which no one is treated as a mere means and everyone is treated as an end-in-himself. Art is the endeavor to transcend the duality of subject and object by the subjectification of nature and objectification of spirit. Religion is the endeavor "to live with the Divine as own with own, as children with Father, sheep with shepherd, lovers with beloved," or however the religious imagination may symbolize "being with ultimate reality as own." And love as a root instinct and a pervasive force is the endeavor to realize "the fullness of being with the other person in the intimacy of inner as well as outer being."

From this perspective Hofstadter interprets revolt and destruction as the negative moment of freedom—the agonizing attempt to break through and demolish the barriers that limit human freedom. In religion it is manifest in the revolt against a stifling orthodoxy; in art it is manifest in rebellion against traditional styles and modes of expression. The negative moment is predominant in our deeply troubled age. No religion of traditional faith, no art of normal beauty, can satisfy the restless hunger for freedom.

This interpretation of freedom is monistic rather than pluralistic, emphasizing the convergence of religion and art. It is akin to Hegel's contention that life is a massive drive toward coherence and totality, and that the individual becomes more free in becoming more whole and less isolated. It is also akin to Spinoza's conception of the transition from human bondage to human freedom. According to Spinoza, God is free because he is the totality, and insofar as man shares in God's nature, he also is free—escaping from his separateness and isolation and participating in God's free and infinite being. He achieves freedom by uniting with other men and living as a whole man in harmony with a cosmic all-embracing whole. Hofstadter, more explicitly than Spinoza, interprets both religion and art as integral phases of the drive toward freedom.

So far as he speaks of the divergence between art and religion, it is to agree with Hegel that art with its predominantly sensory content cannot articulate the spiritual meaning of love and religious community:

> If you love another human being with true spiritual tenderness, then you find that there really is no way in which you can adequately express this love in a sensible gesture or action. No external medium is expressive enough to carry the whole meaning. The earth can never be heaven.

Despite the inadequacy of sensuous form to express the wealth of spiritual content, art and religion are closely allied. If Hofstadter is correct in maintaining this thesis, the fact should be evident in the treatment of themes common to both spheres. Among these none is more basic than alienation and its overcoming, to which we shall now turn.

A Common Theme of Art and Religion

In the little span between birth and death, each of us experiences the entrapment of being confined within his own skin and limited by his individual ego. Each of us feels small and insignificant and powerless before the vast indifference and immensity of nature. Each is curbed and hemmed in by the massive force of human culture, its laws, its taboos, its conventions. Especially in moments of crisis, every man, like a shipwrecked Robinson Crusoe, wants to escape from the little island of his own selfhood.

From the earliest times, this condition of solitariness has been felt as a deprivation: "Single is each man born into the world," laments an ancient text, "single he dies, and his body lies like a fallen tree upon the earth." [12] The existentialist philosophers have described this condition as "alienation"—the very opposite of feeling at home in the world. It is the condition of rootlessness and estrangement, the absence of personal warmth and sympathetic contact, the sense that the whole world is depersonalized and that one's self is a soulless automaton. It is the condition suffered by Kierkegaard when he noted in his diary: "I was the life of the party tonight; I came home and wanted to shoot myself." It is depicted in Albert Camus' *The Stranger,* Franz Kafka's *The Trial,* and much of the poetry of T. S. Eliot. It is the state of mind epitomized by the Shropshire Lad in A. E. Housman's poems:

> *I, a stranger and afraid*
> *In a world I never made.*

This estrangement from the world is experienced as also an estrangement from one's own self and from every other man. It is a soulsickness deeply based upon the nature of human existence—a dread

[12] From the legend of Manu, the first man in Sanskrit mythology.

and anxiety and inner loneliness bound up with the conditions of human individuality, of separation and finitude. In its most aggravated form, it is a profound sense of guilt and despair—the "absurdity" which Sartre has depicted, "the sickness unto death" of which Kierkegaard wrote, the "nihilism" which Nietzsche loathed but could not escape, the disintegration—physical, moral, intellectual—of the characters in Samuel Beckett's novels and plays. It is referred to in religious language by such terms as original sin, the fall of man, the separation from God, the dark night of the soul.

Religion is, in large measure, the inward struggle to pierce through and overcome this condition. It is the attempt to bridge the chasm between the self and the not-self, to attain an emotional integration and harmony of the individual with the world around him. In its more positive aspects, it is the projection and sublimation of love as a healing and cleansing power. John Macmurray has said that the function of religion is the "extension of family unity of affection to wider groups." [13] This characterization is suggestive but too narrow. The sense of communion is nourished by all the "I-Thou" relations of life —the unison of love, the bond of friendship, the spirit of neighborliness, or any other close and affectionate tie. In many of its moods, religion hallows and sanctifies this sense of oneness and projects it far beyond its immediate circle. Hence it is natural for religion to use the language of intimate human relations: to speak of love, fellowship, brotherhood, communion, the fatherhood of God. Although the facts of alienation and its overcoming could be expressed in prosaic psychological terms, it is characteristic of religion to speak of filial estrangement and reconciliation and to feel that this metaphorical language is peculiarly expressive of the nature of things.

The negative and the positive stages of religious experience— alienation and its overcoming—are equally reflected in the following quotation from the sixteenth-century Spanish mystic Saint John of the Cross:

> For truly [in the dark night] the soul feels the shadow of death and the groans and tortures of Hell, as if she saw them bodily before her, for Hell to her consists in feeling herself forsaken of God, and chastised and flung aside, and that He is outraged and wrathful. All this she suffers now; and, furthermore, she is overcome by a direful terror that it is for ever. And she is haunted by this same sense of being forsaken and despised of all created people and things, particularly of her friends. She feels within

13 John Macmurray, *Religious Experience* (New Haven, Conn.: Yale University Press, 1936), p. 70.

herself a profound void and utter dearth of the three kinds of wealth which are ordered for her enjoyment, which are: temporal, physical, and spiritual. . . . To this is added that she cannot owing to the solitude and desolation this night produces in her, find comfort or support in any teaching or any spiritual master. . . . For the soul can do little in this condition of terror until in this purgation the spirit is softened, humbled, and purified, and becomes so refined, simple, and rarefied, as to be enabled to become one with the spirit of God, according to the degree of union of love His mercy vouchsafes to concede. . . . And then all her former fear falls away, and she knows clearly that she is free, and sings with joy to see herself in such serene and tranquil peace.[14]

These two stages—alienation and reconciliation—can be traced in innumerable works of religious literature, such as John Bunyan's *Grace Abounding to the Chief of Sinners,* Leo Tolstoy's *Autobiography,* and T. S. Eliot's *Four Quartets.* Even traditional Christian texts can be made to fit this pattern. When interpreted symbolically, the Incarnation and Atonement represent an end to the alienation between man and God. In the words of *First Corinthians* (XV:22): "For as in Adam all die, even so in Christ shall all be made alive." God becomes incarnate as man, and man by redemption becomes the child of God—so the gulf which separates them is closed. The general idea of Christ the Redeemer, as Jung has pointed out, is one version of a worldwide and pre-Christian theme. The god-man redeemer appears, for example, in the Osiris-Horus myth of ancient Egypt and in the legends of Talmuz, Orpheus, and Baldur. But so old is this archetypal motif that nobody knows when and where it originated. [15]

Final triumph may occur in art too, as in the hymn of joy in Beethoven's *Ninth Symphony* or the ecstatic vision that concludes Dante's *Divine Comedy.* But the theme of alienation often occurs without the reconciling note of redemption. In the works of a painter such as Edvard Munch or a sculptor such as Germaine Richier, there is nothing to soften the images of terror and estrangement. The hero of Goethe's first novel, Werther, is the very embodiment of alienation, and his life ends in suicide. The characters Clov and Hamm in Samuel Beckett's *Endgame* not only reach the lowest point of dehumanization but can find no glimmer of hope, no rescue, no salvation.

[14] *The Dark Night of the Soul,* Gabriela Cunninghame Graham, ed. (London: Watkins, 1922). Abbreviated by Victor Gollancz, *From Darkness to Light* (New York: Harper & Brothers, 1956), pp. 28, 38.

[15] See Carl G. Jung et al., *Man and His Symbols* (Garden City, N.Y.: Doubleday & Company, Inc., 1965), pp. 73, 79, 108.

The alienation of Shakespeare's tragic figures, Macbeth, Hamlet, and Lear, is absolute and inescapable. Macbeth cries out:

> All is but toys; renown and grace is dead:
> The wine of life is drawn, and the mere lees
> Is left this vault to brag of.

And he goes to his death in the conviction that "life is a tale told by an idiot." The "sick souls" described by William James in *The Varieties of Religious Experience* resemble these doomed men, but like Job they finally achieve a kind of rebirth and transfiguration. Not so in the world's tragedies, from *Antigone* to *Death of a Salesman*. In art more than religion, mankind faces up to "the poignant, bracing bitterness of whatever is the truth."

If we think not simply of what a tragedy depicts but of its effect upon the audience, there may be a kind of triumph in the "bracing bitterness" of the spectacle. Nietzsche contended that the spectator experiences a supreme thrill from witnessing the most terrible aspects of existence and crying *Yea* to it all. Eugene O'Neill, perhaps the greatest American writer of tragedies, expressed this conviction in an interview reported in the *Philadelphia Public Ledger* (January 22, 1922):

> Sure I'll write about happiness if I can happen to meet up with that luxury, and find it sufficiently dramatic and in harmony with any deep rhythm in life. But happiness is a word. What does it mean? Exaltation; an intensified feeling of the significant worth of man's being and becoming? Well, if it means that—and not a mere smirking content with one's lot—I know there is more of it in one real tragedy than in all the happy-ending plays ever written. It's mere present-day judgment to think of tragedy as unhappy! The Greeks and the Elizabethans knew better. They felt the tremendous lift of it. It roused them spiritually to a deeper understanding of life. Through it they found release from the petty considerations of everyday existence. They saw their lives ennobled by it. . . . I don't love life because it's pretty. Prettiness is only clothes deep. I am a truer lover than that. I love it naked. There is beauty to me even in its ugliness.

This way of looking at life and art may appear to be antireligious, but it is religious in the wide, inclusive sense. As Nietzsche realized in connecting tragic ecstasy with the god Dionysius, it is one of the religious ways of coming to terms with the universe.

In religious experience, according to Hofstadter, alienation is overcome by "Being-with-other-as-with-own." We agree that this theme is basic in the religious life of mankind. In tragic art the same theme

is fundamental, but the note of redemption is frequently missing. Moreover, the art of tragedy is only one of many forms of artistic expression. Art is more various than religion in its motivation and subject matter.

The Divergence of Art and Religion

In Part One, we interpreted value in terms of the subject-object polarity. The subjective component in aesthetic value exhibits both an attentional and an elaborative aspect. Attention is aesthetic when it does not fly away from the object to referential meanings. It is a rapt and intransitive fascination with the object for its own sake. The elaborative aspect likewise centers on the object itself. It is an imaginative enrichment of the intrinsic perceptual worth of the object. Seeing-as or listening-as, characterized by Wittgenstein, and empathic and projective imagination, characterized by Coleridge and Keats and others, are means to this enrichment. Both the attentional and the elaborative aspects focus upon the object as the direct and immediate carrier of value. If there are references beyond, as in representational or symbolic art, they are so thoroughly incorporated in the object, so utterly at one with its form and qualities, that they add depth without distracting from its presentational immediacy. It is of the very essence of art, as Hegel said, that the spiritual content and the sensuous form be integrally fused. The transcendent is there only through its sensuous presentness.

In contrast, the religious interest is transitive. It looks *through* the immediate object to the sacred reality beyond. If the immediate object is so fascinating that attention focuses upon it without transcendent reference, the effect is to contribute to the religious sin of idolatry or to abandon the religious attitude altogether. Whereas the aesthetic interest shies away from the ineffable, the religious interest turns in that very direction. God is hidden or mysterious, and if men refer to him, they speak in riddles. Every image of God falls short of the mark. Theologians rely upon abstractions such as "Being" or "Ultimate Reality" or "the Transcendent" to point toward the unfathomable. Religion makes great use of analogies, else it would be wholly inarticulate, but its true meaning is the unspeakable.

Art is wider in range than religion. Although pure aesthetic interest is simply fascination with immediate qualities, the aesthetic interest when less pure takes on coloration from other interests. It then requires an erotic, cognitive, moral, religious, economic, or political tinge. If we include all these borrowed nuances, the subjective ele-

ment in art is almost infinitely various, being not only the aesthetic interest in its purity but also the whole vast gamut of interests that are susceptible to artistic incorporation.[16] Similarly, the objective component in aesthetic value is very wide in range. It is concrete and individuated, sensuous or imagistic—or, at least, vivid enough to arrest attention and to make us interested in it for its own sake—but otherwise there are no restrictions such as confinement to a sacred subject matter.

In religious experience, the subjective and objective components are not so unlimited in scope. The subjective element is not just any interest but a particular kind—the sense of the holy, sacred, mystical, or numinous —call it what you will. The objects, real or fanciful, toward which the sentiment is directed are felt to be mysterious, precious, and fundamental; in the words of Paul Tillich, they are matters of "ultimate concern." Among most people, primitive and non-primitive, they have been conceived as supernatural or at least supernormal, although for a Blake or a Whitman, the sacred object may be a blade of grass or a grain of sand. Mystics feel that whatever is deep and mysterious in the object—whether this object be a god or a wildflower—is akin to what is deepest and most mysterious within themselves. Here the dualism of subject and object is transcended, and in this sense, mystical experience is akin to the aesthetic. But art, we repeat, is wider in scope than religion: it may be sacred or profane, religious or irreligious or nonreligious, depending upon the nature of the value that is being embodied in the work of art.

Some pious or puritanical thinkers have denied the religious relevance of artistic imagery even when it is devoted to sacred themes. In the attempt to purify religion of idolatry, the Islamic and ancient Jewish religions prohibited graven and painted images, thus greatly constricting the range of their religious art. Modern rationalists would scale religion down to abstract conceptions and moralistic practices, or they demand that religious groups unite on some eclectic, washed-out formula that tries to sum up the common truth in all faiths. But without its particularistic elements and concrete images, religion is too disembodied and colorless to excite much devotion, or even to deserve the name "religion." Seeking to arouse, to stimulate, to inspire, religious art appeals to man's feeling through the rich colors of fresco, oil paint, or stained glass; through the exalted musical har-

16 The resulting diversity may justify Wittgenstein's contention that there is only a "family resemblance"—a complicated network of similarities that overlap and criss-cross—among the innumerable instances of art or the aesthetic. But it is *impure* art or aesthetic value that is so diverse as to conform to his analogy with games. See also Melvin Rader, *A Modern Book of Esthetics*, 4th ed. (New York: Holt, Rinehart and Winston, Inc., 1973), "Postscript: Esthetic Theory."

monies of the cantata or the mass; through the stately proportions of a Greek temple or the aspiring arches and buttresses of a Gothic cathedral; through the austere stone gods of Egypt or the attenuated spiritual figures of El Greco; through the story of Job, the parables of Jesus, the legends of Buddha, the whimsy and lyricism of Lao Tze. Symbolic imagery and poetic metaphor have always been the language of religious thought, and no set of abstractions is a satisfactory or possible substitute.

There are some earnest idealists, such as Plato and Tolstoy, who would forbid, if they could, all art that does not contribute to the religious and moral ideals which they have in mind. Tolstoy took the extreme stand he did partly because he appreciated so vividly the power of art to mold human character. The ideal of human brotherhood to which he wished to dedicate art is the more moving because, in his own life, he tried with such pathetic conviction to abide by it. But the narrowness of his criterion of artistic subject matter is intolerable: on the basis of this standard he would ban most of the great art masterpieces of the past as too secular or nonmoral or immoral. A standard that would exclude the plays of Shakespeare, the music of Mozart, or the painting of Renoir is absurd. Likewise Plato, with his lofty disdain for "those material things which can be seen and handled, eaten, drunken and lusted after," was not averse to censoring or banning the artistic masterpieces of Greece. In both instances we have the case of a "lost leader," for Plato and Tolstoy were artists of very rare distinction.

Art and religion may reinforce one another, but each has its own virtue and identity. Not all good art is religious, nor is all religious art good. For art to be excellent as art, it must meet the standards of *artistic* and not religious merit. For example, the medium chosen should be appropriate, and its expressive values should be effectively utilized. The sensuous and material qualities of the work of art—such as sounds, colors, shapes, and textures—should be employed with a keen appreciation of their unique qualities and expressive powers. All representational details or symbolic meanings should contribute to a well-knit and articulate whole. The style should be sincere, original, and suitable to the content; and the form should harmonize all the constituents into an all-embracing unity. Religious subject matter, however well-intentioned, cannot redeem a work of art that is defective in aesthetic respects.

Just as art has its intrinsic standards, so does religion. It can be good or bad, wise or foolish, profound or superficial, enlightened or superstitious, and no artistry can redeem cheap or shallow religious attitudes. Whitehead has said: "Religion is force of belief cleansing

the inward parts. For this reason the primary religious virtue is sincerity, a penetrating sincerity." [17] Religion must be deeply and sincerely felt if it is to inspire great art. During many centuries it has stirred the human imagination with extraordinary depth and force, but there have been many failures—religious works, or artistic works, with a religious content—that are insincere, didactic, superficial, woozy, or sugary-sweet. The decadence of religion, or the hypocrisy of inauthentic religious attitudes, becomes only more apparent when it is exhibited in art.

Art, to sum up, has its own wide and autonomous province that overlaps but does not coincide with religion. Art is art, and it is not morals or science or religion or any other sphere of culture. Its standards of artistic excellence are its own, and its subject matter is as wide as human thought and experience. The realms of society and nature and fantasy are open to the artist, and there he may wander free to select and idealize and portray what he will. Wherever feeling and thought can be put into "a form of flesh and blood," the artist will find his materials and do his work of transfiguration.

The Role of Art in the Critique of Religion

The exposure of religion's failures and corruptions is one of the recurrent themes of literature. We shall quote two examples from poetry. The first, taken from *The Prelude,* portrays a preacher that the youthful Wordsworth heard during a sojourn in London. The vanity and unction of the curate are caustically delineated:

> *There have I seen a comely bachelor,*
> *Fresh from a toilette of two hours, ascend*
> *His rostrum, with seraphic glance look up,*
> *And, in a tone elaborately low*
> *Beginning, lead his voice through many a maze*
> *A minuet course; and, winding up his mouth,*
> *From time to time, into an orifice*
> *Most delicate, a lurking eyelet, small,*
> *And only not invisible, again*
> *Open it out, diffusing thence a smile*
> *Of rapt irradiation, exquisite.*[18]

This is amusing as well as caustic, but there is a more sardonic humor in *Holy Willie's Prayer* by Robert Burns. The poem satirizes not only

17 Alfred North Whitehead, *Religion in the Making* (New York: The Macmillan Company, 1926, and London: Cambridge University Press), p. 15.
18 William Wordsworth, *Prelude,* Book VII, lines 551–61.

the cruelty and unconscious hypocrisy of Calvinist Willie but the malign myth that has shaped his character—the myth that God, without respect to individual merit, has elected to save the few and damn the multitude. Never doubting that he is one of God's elect, Willie unconsciously exposes his vindictiveness and conceit:

> *O Thou, wha in the Heavens dost dwell,*
> *Wha, as it pleases best thysel',*
> *Sends ane to heaven and ten to hell,*
> *A' for thy glory,*
> *And no for ony guid or ill*
> *They've done afore thee!*
>
> *I bless and praise thy matchless might,*
> *When thousands thou has left in night,*
> *That I am here afore thy sight,*
> *For gifts an' grace,*
> *A burnin' an' a shining light*
> *To a' this place.*

Holy Willie regards his own sins as forgiven, while he calls upon God to curse and damn the sins of others:

> *Thy strong right hand, Lord, make it bare*
> *Upo' their heads;*
> *Lord, weigh it down, and dinna spare.*

Willie ends his prayer by imploring God to bless him with both "grace and gear," regarding worldly goods as the proof and outward sign of grace.

The remarkable frescoes at Dartmouth College by the Mexican muralist J. C. Orozco depict both corrupt and regenerate religion. The hideous rites of the ancient Indian religions—Aztec and Mayan and Toltec—are represented by priests wearing grotesque ceremonial masks and ripping out the bowels of their sacrificial victim before the immense stone figure of their god. A later panel depicts the coming of the blue-eyed white god Quetzalcoatl—like Prometheus, a friend and teacher of mankind. He stands alone and imperious amid writhing serpents, while the gods of sacrifice and war hover in the background. The next panel shows the flowering of Indian civilization, its arts, and its productive labor. Then, in a sharp reversal, the white god is represented as departing on a raft of plumed serpents, having finally met with contempt and defeat. In the next scene Cortez stands forth in battle array amid the flames and carnage of war, while a priest hugs a black cross by his side. Moving on to the modern world, several frescoes depict the sacrifices to the "gods" of mechanization and war. Finally there is the figure of the risen Christ, brandishing the axe

with which he has chopped down the false cross and pillars of the temple while he gazes ahead into a future yet to be built. The series of frescoes is a powerful symbolization of religion as both the scourge and hope of mankind.

Most artists refuse to gloss over life's tragedies. By vocation they deal with the concrete rather than the abstract, and they cannot, by any device of purified abstraction, blink evil out of sight. In nightmares and other imaginative visions, as well as in sober perceptions, evil is as real as the good. Hence tragedy, stark and brutal, has been a frequent theme of the arts. The reaction of the poets to the problem of evil may be as pessimistic as that of Leopardi or James Thompson or A. E. Housman:

> Ay, look: high heaven and earth ail from the prime foundations;
> All thoughts to rive the heart are here, and all are vain:
> Horror and scorn and hate and fear and indignation—
> Oh why did I awake? when shall I sleep again? [19]

The poet's response to evil may take the form of a frontal attack upon theism, as in this fragment from the lost *Bellerophon* of Euripedes:

> Dares any say that there are Gods in Heaven?
> Nay, there are none, none!—save for the fool
> That still must cling to tales of ancient time.
> Think for yourselves—I do not ask ye take
> My word on trust. I say men tyrannous,
> With tongues that break all oaths, and robbers' hands,
> Fill earth with massacre and sacks of cities;
> And, though they do it, prosper more than those
> Whose days are spent in peace and piety;
> I know of little cities, fearing God,
> That yet must bow to wicked greater states,
> Crushed by brute weight of spears. [20]

For us who have lived in this tragic century, the words of Euripedes stab deep. The catastrophes of a nation, a generation, a civilization, when combined with the threat of even worse catastrophes, are a major cause of religious unrest and doubt.

No one has challenged religious optimism more savagely than

[19] A. E. Housman, *A Shropshire Lad* (New York: John Lane Company, 1917), p. 74.

[20] *Greek Drama for the Common Reader*, ed. and trans. F. L. Lucas (London: Chatto and Windus Ltd, 1954, and New York: The Viking Press, Inc.), Fragment 286, p. 348. By permission of Chatto and Windus Ltd and the Executors of the late F. L. Lucas.

Francisco de Goya. Only a Voltaire in *Candide* could match in words the scenes Goya depicted in his etchings of war:

> Here, old men dazed with blows watched the dying agonies of their murdered wives who clutched their children to their bleeding breasts; there, disembowelled girls who had been made to satisfy the natural appetites of heroes gasped their last sighs; others, half-burned, begged to be put to death. Brains were scattered on the ground among dismembered arms and legs.[21]

The works of Goya's old age are more than indictments of war or human folly—they are screams of protest against whatever gods may be. His painting of Saturn devouring his own children is a nightmare vision of terror at the heart of life.

Another cause of religious doubt has been the spread of scientific agnosticism. Not only are most religious doctrines unverifiable by scientific method, but they are incongruous with the universe as depicted by science. Hence, in a scientific age, it has become increasingly difficult to believe in traditional Christian doctrines—that man was made in the image of God, that God became incarnate in the flesh of man, that Christ's death on the cross was a vicarious atonement for human sins, that God, personally concerned with man's salvation, answers prayers, that human beings will be punished or rewarded in a life after death. All of these anthropocentric doctrines are difficult to reconcile with the modern scientific conception of the cosmos, in which our whole stupendous Milky Way is only a minor galaxy among hundreds of millions. It would be more compatible with science to conclude that the existence and well-being or ill-being of man upon earth are, in relation to the universe as a whole, a very tiny incident. Even religious doctrines less traditional than Christianity, so far as they rest upon the conviction of a harmony between ourselves and the universe at large, have become more and more problematic. Rejecting the "great illusion" that the universe is kindly and purposeful, skepticism has struck at the very foundations of most religious beliefs.

Modern technology has created an urbanized and mechanized society in which secularism has become the predominant way of life. God, the old problem-solver, in consequence, has simply been evapporating from human consciousness. Of course the debate goes on: "God *is* dead—God is *not* dead." One may react to this debate with a leap of faith, such as that of Pascal in the seventeenth century, Kierkegaard in the nineteenth, and Niebuhr and Barth in the twen-

[21] Voltaire, *Candide* (New York: The Literary Guild, Random House, 1929), p. 14.

tieth. Or one may revert to the old religious apologetics and find them adequate. Or one may sham belief in order to be respectable. But more and more people are honestly confessing that the old foundations are falling to pieces. This mood of disillusionment has become the theme of much art and literature. One thinks of such poems as "Dover Beach" by Matthew Arnold, "The City of Dreadful Night" by James Thompson, "In Memoriam" by Alfred Lord Tennyson, "The Waste Land" by T. S. Eliot, and "Sunday Morning" by Wallace Stevens. In fiction, one thinks of such recent novels as Golding's *Lord of the Flies,* Sartre's *Nausea,* and Camus' *The Stranger.* Even when, as in the case of Tennyson and Eliot, religious faith is ultimately affirmed, the writer leaves us with the chilling sense that the faith is precarious.

Religion and Poetry

In *Kerygma and Myth,* the German theologian Rudolf Bultmann sketches the mythology presupposed by the New Testament. "The world is viewed as a three-storied structure, with the earth in the center, the heaven above, and the underworld beneath. Heaven is the abode of God and of celestial beings—the angels. The underworld is hell, the place of torment." In between these two spheres is the earth—"the scene of the supernatural activity of God and his angels on the one hand, and of Satan and his daemons on the other." The earth is in bondage to the powers of the nether region, but it hastens toward its end. Aware that the apocalypse is approaching, God sent his Son, a pre-existent divine Being, to die the death of a sinner on the Cross and thus to make atonement for the sins of men. "Death, the consequence of Adam's sin, is abolished, and the daemonic forces are deprived of their power." The risen Christ, exalted to the right hand of God in heaven, will return again soon to complete the work of redemption, and all who truly belong to Christ's Church are assured of salvation. [22]

Believing that the mythical view of the world is obsolete, Bultmann proposes to "de-mythologize" the New Testament by an "existentialist" reinterpretation. His critics have pointed out that his existentialist version is scarcely less mythological than the original, the mythology being altered and reduced but not eliminated. Similar criticism can be directed against Martin Heidegger and Paul Tillich so

[22] See Rudolf Bultmann, in H. W. Bartsch, ed., *Kerygma and Myth* (London: Society for the Publication of Christian Knowledge, 1953).

far as they seek to invest such high abstractions as Being or the Ultimate with sacred meaning. The danger is that vague grandiosities may be substituted for poetic superstitions. "In such a spectral form religious illusion does not cease to be illusion," remarks Santayana of such modernizations. "Mythology cannot become science by being reduced in bulk, but it may cease, as a mythology, to be worth having." [23]

Santayana has said that "religion is poetry believed in," and Collingwood has declared that "the holy is the beautiful asserted as real." Ernst Cassirer, writing on the basis of a vast erudition, has concluded: "In the whole course of its history religion remains indissolubly connected and penetrated with mythical elements." [24] If these characterizations of religion are, in principle, correct, the proposal to save religion by expunging its poetic or mythical elements is radically mistaken. Religion cannot shed its imaginative content without forsaking its essence. Shorn of its poetry, "religion" is no longer religion—it is turned into some sort of moralistic homily or abstract metaphysics. The better expedient is to recognize that it is, in its very nature, a mythical expression of human values and insights. Time, exposing its imaginative fabric, makes a clean sweep of all the fictitious objectivities of religious belief—all the fantasies about heaven and hell, about Gilgamesh and Valhalla and Olympus, about Isis, Apollo, Yahweh, and all other ancient and modern gods. Orthodox Christians make an exception for their own supernaturalistic creed and accept it with literal belief, but non-Christians, approaching it with cool detachment, wonder how so wild a fiction could take root in a reasonable mind. As long as these fictions are recognized as imaginative, they do no harm—they are accepted as the changing poetic expressions of the ancient spiritual wisdom of the race. Although they may finally vanish like the apparitions of a dream, the values and realities which they unconsciously symbolize and the art which embodies this symbolism need not perish.

Sir Philip Sidney, in his *Apologie for Poetrie,* said of poetry that it "nothing affirmeth and therefore never lieth." This suggests an answer to the skeptics—not to affirm the *literal* truth of religion or religious art but to interpret its symbolism with poetic freedom and nonliteralness. This is the way a sympathetic mind tends to approach religions other than its own. When a cultivated Westerner reads the scriptures of Oriental religions—Hinduism, Buddhism, Taoism, and Confucianism—he is not tempted to attach to them literal belief.

[23] George Santayana, *Interpretations of Poetry and Religion* (New York: Charles Scribner's Sons, 1900, and London: Constable and Company Ltd), p. viii.
[24] *An Essay on Man* (New Haven: Yale University Press, 1944), p. 87.

He retains his sense of humor, his sense of porportion, his ability to distinguish between fact and fancy, his humility before the mysteries of existence, his imaginative freedom and ideality. There is consequently no compromise with his intelligence—the experience is enriching without being stupefying. Religion is interpreted as poetry with profound spiritual meaning but not literal truth.

This kind of approach to the religions of China is not difficult, because there is little dogma and much poetic lore in the Chinese classics. We know nothing in Western religion to match the whimsical skepticism of this Taoist text:

> Once upon a time, I, Chuang Tze, dreamt I was a butterfly, fluttering hither and thither, to all intents and purposes a butterfly. I was conscious only of following my fancies as a butterfly, and was unconscious of my individuality as a man. Suddenly, I awaked, and there I lay, myself again. Now I do not know whether I was then a man dreaming I was a butterfly, or whether I am now a butterfly dreaming I am a man.[25]

Nothing, it would appear, in Judeo-Christian or Islamic scriptures, corresponds to the open-mindedness attributed to Confucius: "There were four things from which the Master was entirely free. He had no foregone conclusions, no arbitrary pre-determinations, no obstinacy, and no egoism." [26] The spontaneous blending of beauty and holiness in the Chinese scriptures—Confucian, Taoist, and Zen-Buddhist alike—contrasts sharply with the intense moralistic tone of so much of the Bible. For example, in one passage of the *Analects,* Confucius asks four gentlemen what each would like to accomplish if opportunity should permit. The first wishes to teach the people "the rules of righteous conduct." The second wishes to make the people prosperous. The third, more modestly, wishes to dress and act with propriety in the service of a prince or sovereign.

> Last of all, the Master asked Tsang Hsi, "Tien, what are your wishes?" Tien, pausing as he was playing on his lute, while it was yet twanging, laid the instrument aside, and rose. "My wishes," he said, "are different from the cherished purposes of these three gentlemen." "What harm is there in that?" said the Master; "do you also, as well as they, speak out your wishes." Tien then said, "In this, the last month of spring, with the dress of the season all complete, along with five or six young men who have assumed the cap, and six or seven boys, I would wash in the I, enjoy

25 From *The Works of Chuang Tze,* in Robert O. Ballou, ed., *The Bible of the World* (New York: The Viking Press, Inc., 1939), pp. 512–13.
26 *Analects* of Confucius, in ibid., p. 405.

the breeze among the rain altars, and return home singing." The Master heaved a sigh and said, "I give my approval to Tien." [27]

Here there is none of the madness of putting human beings at the center of the universe, or pitting spirit against flesh, man against nature, or righteousness against aesthetic enjoyment. Neither Confucius nor Lao Tze would ever have joined in the admonition of Saint Augustine: "Go not out of doors. In the inner man dwells truth." [28] For them, as for the ancient Greeks, holiness was akin to loveliness, and they sought to harmonize beauty in the inner life with beauty in the outer world.

In the great religions of India, there is almost as little tendency toward dogma as in the religions of China. Hinduism is an "open" religion without grand inquisitors, indexes and excommunications, or threats of hellfire. Convinced that ultimate reality is ineffable, devout Hindus have taken it for granted that religious truth appears under many guises—that it is symbolical and poetic, not historical and literal. There are many gods in the Hindu pantheon, but they are no more than the imaginative shadowing forth of an all-compassing, all-penetrating Spirit. "How many gods are there?" asks an interlocutor in one of the *Upanishads*. "Three and three hundred, three and three thousand," is the answer. The question is pressed again and again, "How many gods are there really?" The answers, following one after another, are, "Thirty three, six, three, two, one and a half, one." "Who are these three and three hundred, three and three thousand?" asks the questioner. "They are only the various powers," is the reply. [29] This kind of tentativeness lends itself to artistic expression.

Gautama, the Buddha, inherited from his Hindu forebears the aversion to dogma and respect for other religions. He dismissed many theological questions as unanswerable, "tending not toward edification." Thus set aside were theories "that the world is eternal, that the world is not eternal, that the world is finite, that the world is infinite, that the soul is one thing and the body another, that the saint exists after death, that the saint does not exist after death." [30] In both original doctrine and certain later forms, the belief in supernatural beings is very tentative or absent. Although Buddhism became a missionary religion, it never drew up a canonical list of theological beliefs, it never

27 Ibid., pp. 408–9.
28 Quoted by Charles Singer, *A Short History of Science to the Nineteenth Century* (Oxford at the Clarendon Press, 1941), pp. 124–25.
29 Robert O. Ballou, *The Bible of the World*, p. 54.
30 Henry Clarke Warren, trans., *Buddhism in Translations* (Cambridge, Mass.: Harvard University Press, 1922), p. 122.

sought out and exterminated heretics, it never tried to frighten dis-
believers into conformity.

Gautama taught that life is full of suffering; that this suffering
is caused by self-centeredness; that self-centeredness is an intellectual
and moral error; that the error can and should be abandoned; that
the consequence of its abandonment is a blessed state called Nirvana
—negatively, the extinction of selfish craving, and positively, a deep
and abiding peace. In addition, stories and legends and innumerable
artistic symbolizations have given a poetic and pictorial rendering to
the original core. Without this vivid presentation Buddhism might be
termed a philosophical and moral doctrine and a way of life rather
than a religion.

The aesthetic element is very apparent in the religious classics
of India. The Vedas, oldest of the Hindu scriptures, express a poetic
naturalism like that of the Greeks and the Chinese. One of the hymns,
for example, is addressed to "Aranyi, the woods goddess," who is
praised as "the forest queen, sweet-scented, redolent of balm, the mother
of all sylvan things." [31] Another hymn, hailing "heaven and earth and
air," is akin to Traherne's nature-mysticism:

> Mine eye is sun and my breath is wind, air is my soul
> and earth my body. . . .
> Be ye my powerful keepers, watch and guard me, ye
> mistresses of life and life's creators! Dwell ye
> within me, and forbear to harm me.[32]

The *Upanishads* and the *Bhagavad-Gita* are pervaded by a more aus-
tere and philosophical mysticism but not to the neglect of natural
beauty. "Behold the universe in the glory of God: and all that lives
and moves on earth," reads one of the *Upanishads*. Its invocation to
the sun reminds one of the Zoroastrian scriptures: "O life-giving sun,
offspring of the lord of creation, solitary seer of heaven! Spread thy
light and withdraw thy blinding splendor that I may behold thy ra-
diant form: that Spirit far away within thee is my inmost Spirit." [33]
In the *Bhagavad-Gita* the Blessed Lord is not a god far off and tran-
scendent but immanent and all-encompassing.

> I am the sapidity of waters, O sun of Kunti, I the radiance in
> moon and sun; the word of power in all the Vedas, sound in ether,
> and virility in men; the pure fragrance of earths and the brilli-
> ance in fire am I. . . .[34]

31 Ballou, *Bible of the World*, p. 23.
32 Ibid., p. 26.
33 Ibid., p. 76.
34 Ibid., p. 93.

Modern Hindus, such as Sri Ramakrishna and Rabindranath Tagore, have expressed themselves in similar metaphors. "Wherever there is a bit of color, a note of song, a grace of form," writes Tagore, "there comes the call for our love—a love that is both aesthetic and religious." [35]

The aesthetic content of Indian religions was elaborated in temple architecture, in ritual, music, and dance, in poem and painting and sculpture. Hinduism was the richest source of Indian art, but it also reached a high peak of artistic expression at Anghor Vat in Cambodia, Borobudur in Java, and elsewhere in Southeast Asia. While almost dying out in its homeland, Buddhism became firmly established in Ceylon, Tibet, China, and Japan; and wherever it took root and flourished it stimulated an efflorescence of the arts. Likewise in the case of the native Chinese religions, Confucianism and Taoism and Zen inspired many generations of artists.

It is relatively easy to see that these religions of the Far East are, in the words of Santayana, "an imaginative echo of things natural and moral." To perceive that this is true of Judaism and Christianity is more difficult for Westerners, although it may seem obvious to outsiders. The Old Testament contains the archetypal myths of Genesis, the idyllic story of Ruth, the unconscious folk humor and dreamlike symbolism of the Book of Jonah, the tormented questioning and grave eloquence of the Book of Job, the richly varied devotionalism of the Psalms, the lyrical sensualism of the Song of Solomon, the brooding disillusionment of Ecclesiastes, the exalted visions of the Prophets. In the New Testament, the life and death of Jesus have a dramatic force that has deeply gripped the human imagination. Every reader has his favorite passages in the New Testament, ranging from striking parables and the Sermon on the Mount to the majestic cadences of Paul's First Epistle to the Corinthians and the strange visions of the Apocalypse. Even if the King James Bible is read simply "as literature," it remains one of the greatest books in the world.

We may seem to have reduced religion to a kind of poetry, but we do not wish to deny that there are additional elements in its makeup. In the first place, religion adds *belief* to poetry. Art, purely as art, is nonassertive: it ignores the distinction between reality and unreality. As long as our criterion is purely artistic, it makes no difference whether Troy was real or imaginary, whether Usna and Helen, or Menelaus, Ulysses, and Achilles once walked the earth, whether the gods that hovered in the background were actual. Such "truth" as art may convey is fidelity to values and not to bare facts, and this truth

[35] *Sadhana* (New York: The Macmillan Company, 1913), p. 115.

is embedded in feeling and imagery and not asserted in propositional form. Religion, in contrast, *is* assertive, and when theology makes explicit what in religion is implicit, it does not belie the nature of religion. Intrinsic to that nature are assertions, for example, that there is a God, or that the soul is immortal.

In the second place, religion adds to poetry *some kind of valuational commitment.* This is implied by the nature of the religious attitude, which has been described by many authorities—anthropologists, sociologists, psychologists, and philosophers—as the sense of the holy or sacred, or, in its intenser form, worship. John Oman has declared: "If we are to have one mark of religion, it could only be the sacred . . . valuation. . . . Everything that is sacred is in the sphere of religion, and everything in the sphere of religion is sacred." [36] On this point there is a surprising amount of agreement among authorities of the most diverse persuasion—Emile Durkheim, R. R. Marrett, M. E. Crawley, John Macmurray, Julian Huxley, Ernst Cassirer, to name but a few. To experience something as holy or sacred is to go beyond the bare contemplative attitude: there is more than awareness or vision, there is a hallowing and consecration. This is the reason that religion is a way of life: the transmutation of one's being in the service of ideal ends felt to be rooted in the nature of things. Art is concerned with values, as this book seeks to make clear, but they are values realized in creation or in vision and contemplation and not in *acts* of worship or religious morality. Because religion involves *belief* and *active commitment,* aestheticism is no substitute for religiousness—"the religion of art" is a contradiction in terms.

The Symbol and the Truth Symbolized

According to *The New English Dictionary,* a symbol is "something that stands for, represents, or denotes something else." Salt as a symbol of friendship (being, according to Sir Thomas Browne, incorruptible) is cited as a seventeenth-century example. A religious symbol, like salt in this example, refers beyond itself to something supposedly objective. For example, the cross is a symbol of the crucifixion, including all that Christ's death means in Christian lore. It may be large or small, embellished or unembellished, made of stone or wood or metal, mounted on a building or hung about one's neck on a chain. Whatever its characteristics, it serves as the crucifixion symbol. To this extent, what is symbolized is indepen-

[36] *The Natural and the Supernatural* (London: Macmillan & Company, 1931), p. 69. Reprinted by permission of Cambridge University Press.

dent of how it is symbolized. In art the very opposite is the case: what is expressed is not independent of how it is expressed. Take any fine poem you please and try to paraphrase it. The paraphrase is only a scarecrow of the original meaning—the poetic magic, the feeling-import, the vivid value has evaporated. In the case of a painting or a piece of music, the meaning is even less detachable.

If religious meanings are to be genuinely aesthetic, they must function as an integral part of the work. In Rembrandt's etching of "The Three Crosses," for example, the crosses with their tragic symbolism combine with all the other details, such as the dramatic use of light and shade, to express the deep solemnity of the total scene. Even a single cross, such as the cross of Godefroid de Huy in the British Museum, may be impressive as a work of art. It is more than an index or pointer to something absent—it is so beautifully embellished with enamel and precious stones that it is intrinsically fascinating to contemplate. If, on the contrary, religious symbolism pulls us away from the aesthetic surface and substitutes external reference for intrinsic beauty and signification, it is a corrupting influence in art.

As the definition of symbol that we have cited makes clear, there is a distinction between the symbol and the thing symbolized. For example, the American flag is distinct from the nation that it symbolizes, although the fervor that a patriot feels toward the latter may attach to the former. But among primitive and naive devotees, there is a tendency not to distinguish between a religious symbol and the sacred reality that it symbolizes. As Collingwood says, it is characteristic of religious thought that "the truth and its symbolic vehicle are fused together, the importance really attaching to the truth is transferred to the symbol, the outward act or image or formula, instead of trying to get behind it, slough it off and reach the truth that it conveys." [37] This tendency to reify the symbol, even though idolatrous when carried to extremes, is the source of much religious art. When a symbolic artifact is cherished as spiritual truth, it is more likely to be wrought with the loving care of an artistic craftsman.

Although the interpretation of the symbol by a "true believer" may be naive, modern scholars are less prone than their predecessors in the period of the Enlightenment to regard myth and fable and poetic symbolism as bare superstition. They recognize that a myth may be a "true story" in the sense that it is exemplary and significant. When allowance is made for imaginative formulation, the legends of Oedipus, Prometheus, Faust, and even Jonah and the whale are heav-

[37] R. G. Collingwood, *Speculum Mentis* (Oxford at the Clarendon Press, 1924), p. 128.

ily weighted with meaning. Whether mythology is interpreted by Vico as a clue to the primitive history of thought, or by Freud as a clue to universal psychological processes, or by Santayana as a clue to valuational insights, it can no longer be dismissed as nonsense. In consequence of this more sympathetic approach, much of the religious literature of the world has taken on fresh vitality.

The value of the distinction between poetic symbol and object symbolized will be assessed differently by various types of men, such as the skeptic, the mystic, and the orthodox believer. The fundamentalist draws no clear line between the symbol and the "truth" symbolized, attaching as literal a belief to the one as to the other. As long as he can cling to his naive faith he faces no personal crisis of belief, but he can retain this naiveté only by isolating himself from the modern world. The orthodox God is dead for most educated people today, and not even the neo-orthodoxy of Barth or Niebuhr can resurrect Him. This change in the cultural climate lends itself to imaginative expression. For example, Arthur Koestler's novel, *The Age of Longing*, is a fictional interpretation of the death of the old God and the yearning for a new sense of the sacred. Much of the poetry and fiction of recent years depicts, in one manner or another, collapse of the old faith. Historically this has been one of the great human experiences, and it is not surprising that it has deeply stirred the artistic imagination, as in the poetry of Rilke or the novels of Hesse.

For a thoroughly disillusioned skeptic, the distinction between symbol and thing symbolized does not resolve doubt, because he rejects as fictitious both the symbol and its object. Walter Stace, in his essay "Man Against Myth," for example, recognized the mythical character of religious symbolism, but at the time he wrote this essay, he believed that what is thus symbolized is no less imaginary. Beneath all the poetry and myth there is the serious religious claim that the universe is a friendly habitation for man—and according to Stace, this underlying belief, as well as all the art and poetry that give it vivid expression, must be regarded as fictitious. On the basis of his interpretation of modern science, he asserted that "the world which surrounds us is nothing but an immense spiritual emptiness. It is a dead universe. We do not live in a universe that is on the side of our values. It is completely indifferent to them." With unflinching honesty, Stace concludes that we must face the truth, however bleak it may be. [38] Similarly, I. A. Richards, in his famous little book, *Science and Poetry* (rev. ed., 1935), contended that there is no reason to sup-

[38] Walter T. Stace, "Man Against Myth," *Atlantic Monthly*, September 1948. In later writing, Stace was inclined toward a mystical point of view.

pose that the universe has the spiritual qualities that religious poetry imputes to it. We should learn, he said, to dissociate poetry from belief, while cherishing its enlargement of our sensibilities.

The reaction of the skeptic is partly a matter of temperament. Someone with a dissimilar temperament might face the same facts in quite a different spirit—not with a shudder at the bleakness of the universe but with a reverent attachment to the sources of his being. Nature as revealed in direct experience is haunting in its beauty, as every spring and even the winter should make us aware. What lies behind all these appearances is largely a mystery, because we have no sure access to things except as we experience them. Even science can do little more than describe by a kind of conceptual shorthand the regularities in appearance. But if we are naturalists in our philosophy, we believe that all that we love, no less than all that we hate, has emerged from the ample womb of nature. Even if nature is not purposive, it has proved itself fit to produce purposive beings. Even if nature is not alive, it enables the development of fullness of life. No human being can know what exists in the infinitude of time and space, but there is little occasion for consternation or despair. Since the publication of A. I. Oparin's celebrated book, *The Origin of Life on the Earth* (rev. English ed., 1957), it appears that life may exist at many stations in the cosmos and not just on earth—a supposition that George Meredith expressed poetically in his "Meditation Under the Stars." But even if organisms are confined to our planet, we have reason to believe that something worthwhile can be made of life on the earth, and that men can find happiness in working toward this goal. A naturalistic interpretation of the universe is fully consonant with Santayana's cosmic piety:

> Why should we not look on the universe with piety? Is it not our substance? Are we made of other clay? All our possibilities lie from eternity hidden in its bosom. It is the dispenser of all our joys. We may address it without superstitious terrors; it is not wicked. It follows its own habits abstractly; it can be trusted to be true to its word. Society is not impossible between it and us, and since it is the source of all our energies, the home of all our happiness, shall we not cling to it and praise it, seeing that it vegetates so grandly and so sadly, and that it is not for us to blame it for what, doubtless, it never knew that it did? Where there is such infinite and laborious potency there is room for every hope.[39]

[39] George Santayana, *Reason in Religion* (New York: Charles Scribner's Sons, 1905, and London: Constable and Company Ltd), pp. 191–92.

The religion of natural piety is as susceptible of artistic expression as any other, as the eloquence of Santayana itself indicates.

Whether we call his attitude "religious" is partly a question of definition. In conventional thinking, religion is considered to be an expression of man's belief in a supernatural reality and of the feeling of dependence in some way upon it. However, if we agree with the statement of William James quoted earlier in this chapter, that "at bottom the whole concern of religion is with the manner of our acceptance of the universe," it will then include ways of ordering one's thought, emotion, and life which are usually considered to be nonreligious or even irreligious. It will include a naturalistic attitude—that is, an acceptance of the natural world and natural life as intelligible, if at all, without any appeal to a supernatural realm or being.

Everyone lives in the natural world, and everyone has in some way to decide about it. And this decision, whatever it be, may be called his religion. The natural world may be felt to be either satisfactory or unsatisfactory to our total intellectual and emotional demands. And whether satisfactory or unsatisfactory—that is, whether regarded optimistically or pessimistically—we may rest in it as, in any case, all there is, or through faith we may believe in a reality transcendental and superior to it. The belief in a supernatural reality is familiar both in institutionalized orthodoxies and in individual and purely private beliefs, and we need say no more about it. But the naturalistic belief, which gives rise to various emotional sets toward the total natural order which it accepts as final, requires a bit more explication. It may be an attitude of stoical resignation; or it may be one of untroubled and grateful enjoyment of what we have while we have it. Or it may be said with André Gide, impatient and ironical with those who would lure us from the good certainties of the present to the doubted blisses of the eternal,

> I shall have plenty of time to contemplate the immutable, since you assure me my soul is immortal. Give me leave to make haste and love what is so soon to disappear.[40]

Or it may be an attitude of profound consecration of man to man in the face of an indifferent if not positively inimical universe. This humanistic religion, a religion without God, as it has been described, is expressed by the philosopher Bertrand Russell in the question which points its own answer: "Shall our God exist and be evil or shall He be recognized as the creation of our own conscience?"[41]

40 *Travels in the Congo* (New York: Alfred A. Knopf, Inc., 1937), p. 16.
41 "A Free Man's Worship," in Bertrand Russell, *Mysticism and Logic* (New York: W. W. Norton and Company, 1929), p. 50.

Perhaps we should add as a defining characteristic of all attitudes of naturalism which we will call religious a certain deep sense of limitation in the best of human knowledge, a humility of ignorance. This meaning of the religious is illustrated by the statement of Einstein:

> The most beautiful thing we can experience is the mysterious side of life. It is the deep feeling which is at the cradle of all true art and science. In this sense, and only in this sense, I count myself among the most deeply religious people.[42]

So conceived, the religious may then be said to be the infinite realm of our ignorance. Toward it we know that we do not know; but if we are sober naturalists, we resort neither to supernatural myths and dogmas of faith to fill out our ignorance, nor to an intellectual arrogance which refuses to recognize it—which affirms that the little which we do know is all there is to know. But whatever the attitude, if it be an emotional set toward reality which determines in large part our "manner of acceptance of the universe" (William James), it may then be called religious.

We have been speaking of the religion of the naturalist, but the mystic believes that he has additional grounds for religious belief: he claims to have direct apprehension of a higher realm of being. There is no question that the mystic ecstasy does occur, whatever its basis, and that this experience is very compelling. Most mystics have suffered the pangs of alienation, and they find a cure in "the union with ultimate spiritual reality." This idea—that there is a God or soul of the universe in whose life the mystic participates directly—is perhaps the most daring that the human mind has ever conceived. Such an idea might seem ridiculous if it were not advanced by men of great spirituality and intellectual force. When a philosopher of the stature of Plotinus, or a poet of the genius of Dante, makes this claim, it gives us pause.

The mystic trance, simply as a psychological phenomenon, is enough to excite our wonder: time appears to stand still and the moment's perfection to be eternal. The experience, when judged by naturalistic standards, is illusory and ephemeral, but for the mystic it is profoundly revealing and leaves its indelible mark. The "eye" of the mystic is altered, and "the eye altering alters all." This transformation exercises no cognitive authority over the nonmystic, but he may be impressed by the height of the ecstasy and the profundity of its transforming power. When we contemplate such peak experiences, our ordi-

42 Albert Einstein, *Comment Je Vois le Monde* (Paris: E. Flammarion, 1934), p. 7. Quoted by F. David Martin, *Art and the Religious Experience* (Lewisburg: Bucknell University Press, 1972), p. 25.

nary consciousness appears as only one of a number of possible modes, and the quality of life appears to be alterable down to its very roots. Simply as a human experience, this lends itself to artistic expression, and it has frequently been so expressed, as in the many poems in the *Oxford Book of Mystical Verse*.

The mystic prizes the distinction between poetic symbol and object symbolized, because he holds that the truth is ineffable and can be communicated only through symbols. Hence it is characteristic of mystics either to remain silent or to speak in metaphors. For example, the following is a typically metaphorical statement of the mystic's doctrine of the identity of the human soul and the universal spirit:

> The intelligent, whose body is spirit, whose form is light, whose thoughts are true, whose nature is like ether, omnipresent and invisible, from whom all works, all desires, all sweet odors and tastes proceed; he who embraces all this, who never speaks and is never surprised, he is my self within the heart, smaller than a corn of rice, smaller than a corn of barley, smaller than a mustard seed, smaller than a canary seed or the kernel of a canary seed. He also is my self within the heart, greater than the earth, greater than the sky, greater than heaven, greater than all these worlds.[43]

In style this passage is far removed from the bare abstractions of theology. Whatever we may think of the paradoxes of mystical interpretation, we should recognize that the artistic expression of mysticism has greatly enriched the heritage of mankind.

This is especially true of the milder kind of mysticism, which might be called "positive" to distinguish it from the more extreme and negative kind. It is the kind that has inspired many of the poets, such as Lao Tze, Saint Francis, John Donne, and Walt Whitman. Although they share the mystical sense of unity—that all is one and one is all—this sense does not exclude the recognition of variety. In the famous *Lines* composed near Tintern Abbey, for example, Wordsworth spoke of an intense and joyous mood in which "we . . . become a living soul" and "see into the life of things." In this passage describing a near-mystical state, the unitary "life" does not negate "things" in the plural. Similarly, William Blake, an authentic mystic, insisted on the peculiar identity of particular things:

> . . . he who wishes to see a Vision, a perfect Whole,
> Must see it in its Minute Particulars.[44]

43 From the *Upanishads*, in Robert O. Ballou, *Bible of the World*, p. 60
44 "Jerusalem," in Geoffrey Keynes, ed., *Poetry and Prose of William Blake* (New York: Random House, Inc., 1927), p. 737.

Positive mysticism does not turn away from the vivid qualities of life and nature. Because of the mystical vision, the spectacle of nature is more precious rather than less.

But mysticism of a completely monistic type is antithetical to art. In the extreme trance, there is no distinction between self and object, both being merged and indistinguishable in a single all-enveloping throb of being. For example, Sankara, the great Hindu mystic, declared that such distinctions as knower and known disappear in the mystical experience. Ignorance ("Nescience") makes things appear individual and separate, but perfect knowledge reveals the absolute identity of all existence. "The distinction of objects known, knowers, acts of knowledge, and so forth," he said, "is fictitiously created by Nescience." [45] The world around us, he contended, has no real existence, and it appears to have objective existence only when we lack perfect knowledge. From this standpoint, the aesthetic enjoyment of nature and the artistic portrayal of individual things and qualities are ways of dabbling in illusion. But the less extreme mysticism of a Lao Tze or a Saint Francis, we repeat, is more likely to be a reinforcement of art and nature enjoyment than a deterrent.

It would be sad if disbelief in mysticism or the decline of the old religious beliefs should prevent men from appreciating the great religious art of the past. A person who is so "modern" that he is incapable of appreciating Donne's religious poetry, or Bach's *Jesu, Joy of Man's Desiring*, or El Greco's *Agony in the Garden*, has allowed his skeptical intellect to overwhelm his aesthetic sensibility. No one should have to be a Buddhist to appreciate a statue of Gautama, or a materialist to appreciate Lucretius, or a Roman Catholic to appreciate Michelangelo's *Pieta*. An essential part of the aesthetic attitude, when directed toward religious works of art, should be what Coleridge termed "a willing suspension of disbelief." The beholder should be able to transcend his doubts and convictions and enter wholeheartedly into diverse worlds of imagination, grasping the way things appear from perspectives other than his own. In the arts, there is nothing but loss in intolerance and exclusion.

The point that we wish to make in concluding this chapter is that the whole range of religious attitudes—mystical and nonmystical, naturalistic and supernaturalistic, skeptical and orthodox, optimistic and pessimistic—have found expression in powerful works of the artistic imagination. Throughout the centuries art and religion have been

[45] Sankara Acharya (c. 789–820 A.D.) in F. Max Müller, ed., *Sacred Books of the East* (London: Oxford University Press, 1890), 34:14–15.

closely intertwined—hence to understand the one it is necessary to understand the other. To comprehend the past of man as well as the present, we must open our minds to this wide range of artistic and religious symbolism. Different though they are, art and religion are alike in being profoundly concerned with human values. They are the most powerful reminders that man cannot live by bread alone.

Chapter 9

ART

AND MORALS

On the Ancient Quarrel between Art and Morals

From the time of Plato to the present, the question of the relation between art and morality has been one of the liveliest topics among artists, critics, and aestheticians. We can distinguish two extreme views: absolute moralism and aestheticism. The first holds that either directly or in final analysis all art is subject to moral judgment, that the aesthetic is a species of the morally good. The second holds that moral judgments are wholly irrelevant to art. Between these two extremes are various intermediate positions.

Absolute moralism maintains, in brief, that art is good as it is expressive of, and conducive to, virtuous character and right conduct, by precept, by example, or by a general ennobling influence effected by the quality of sheer beauty of form, which art possesses because of the ultimate identity of the beautiful and the good. A work of art on this view is always either directly an "image of the good"—that is, of the moral good, upon which we can pattern our character and conduct—or it is an expression in nonliteral ways of a goodness whose influence, though it points no direct or specific duty, lifts us generally to nobler being. Goodness and beauty, it is thought, are essentially

related, and each influences the other. "Good language and good harmony and grace and good rhythm," says Plato, "all depend upon a good nature, . . . a mind that is really well and nobly constituted in its moral character." [1] John Ruskin is a modern exponent of the moral view of art:

> The fact of either literature or painting being truly fine of their kind . . . is proof of their noble origin. . . . If there is indeed sterling value in the things done, it has come of sterling worth in the soul that did it. . . .[2]

Another traditional view of long standing maintains that a work of art, while being aesthetically excellent, may be morally objectionable, and that this very excellence of a work of bad moral content or suggestion may render it doubly unacceptable. For example, the *Wen Hui Pao,* Shanghai Communist paper, in denouncing nonconformist Chinese novels as morally and politically corrupt, said that "the fact that some of these works had artistic qualities made them all the more dangerous." [3] Plato similarly concludes, after discussing passages in Homer which describe death as fearful and Hades as terrible, that

> we must beg Homer and the other poets not to be angry if we strike out these and similar passages, not because they are unpoetical, or unattractive to the popular ear, but because the greater the poetical charm of them, the less are they meet for the ears of boys and men who are meant to be free, and who should fear slavery more than death.[4]

The argument is, briefly, that good poetry or good art may be bad morality, and even if good aesthetically it must then be rejected on total human grounds. This view, of course, contradicts the view that beauty and truth and moral rightness become one in the ultimate idea of the good, the latter being the position of Plato at other times and of other thinkers in the idealistic and mystical tradition.

In opposition to the moral interpretation of art, the "art for art's sake" view, or the pure-art view, presses to the extreme the principle that it is the business of art to be beautiful, and not to be morally good or to serve the morally good. It holds that all interest of art in morality, all application of art to moral conduct, all judgment of art by moral standard, and all attempt to ground or unite art and morality in common principle is fundamental error, destructive to both

[1] Plato, *Republic,* 400D (Davies and Vaughan translation).
[2] *The Relation of Art to Morals,* in G. W. Allen and H. H. Clark, eds., *Literary Criticism, Pope to Croce* (New York: American Book Company, 1941), p. 464.
[3] Reported in *The Far Eastern Economic Review,* January 29, 1970.
[4] Plato, *Republic,* 387B (Jowett's translation).

aesthetic creation and appreciation. It consequently does not admit as genuine art much didactic or otherwise morally directed writing and painting. And when by constraint of taste or by weight of opinion it allows the master works in which moral significance seems incontrovertible, it interprets these in terms of formal character and sheerly sensuous qualities. Shakespeare is thus praised for the sweetness of his numbers, the variety and richness of his imagery, and the "symphonic" splendors of his structures; Milton for the organ-toned grandeur of his blank verse; Holbein for the clarity of his linear relationships; and Leonardo da Vinci for his balanced groupings and fluid movements —all in neglect of Shakespeare's profound involvement with human ambition, jealousy, patience, courage, treachery, and faithfulness; of Milton's preoccupation with sin and salvation; of Holbein's concern with temptation and death; and Leonardo's depiction of unholy betrayal and divine suffering.

The theory of "pure art" can be traced back in its origins to very ancient doctrines. Despite his moralistic bent in the *Republic,* Plato spoke in the *Philebus* of the "pure pleasure" to be found in nonrepresentational designs. Aristotle similarly recognized the "proper pleasure" to be derived from the sensuous and formal appeal of art. He noted, in addition to the impulse to imitate, a natural instinct for harmony and rhythm; he remarked that the beholder of a picture, who does not happen to have seen the original, may still delight in the execution, the coloring, or some similar cause. [5] "Works of art," he declared in the *Nicomachean Ethics* (II, sec. 4), "have their merit in themselves so that it is enough if they are produced having a certain quality of their own." Likewise, St. Thomas Aquinas, in the *Summa Theologica,* said that beautiful things are those which please when simply beheld, and that beauty includes three conditions —*integrity,* due *proportion* or *harmony,* and *clarity* (including brightness of color). The implication in each of these statements is that aesthetic objects may be justified by the sheer joy of contemplating their sensuous or formal properties as distinct from their moral or cognitive values.

But aestheticism emerged in sharp contradiction to moral judgments only in modern times. Oscar Wilde, in his Preface to *The Picture of Dorian Gray,* declared: "No artist has ethical sympathies. An ethical sympathy in an artist is an unpardonable mannerism of style." More recently, J. E. Spingarn, a disciple of Croce, insisted that we

[5] Aristotle, *Poetics,* IV. For a discussion of Aristotle's theory of aesthetic pleasure, see S. H. Butcher, *Aristotle's Theory of Poetry and Fine Art* (London: Macmillan & Company, 1902), Chap. IV.

should no more judge an artist's work by moral standards than we should so test a mathematician's proof:

> To say that poetry is moral or immoral is as meaningless as to say that an equilateral triangle is moral and an isosceles triangle immoral. Surely we must realize the absurdity of testing anything by a standard which does not belong to it or a purpose for which it was not intended. Imagine these whiffs of conversation at a dinner table: "This cauliflower would be excellent if it had only been prepared in accordance with international law." "Do you know why my cook's pastry is so good? He has never told a lie or seduced a woman." [6]

In this passage, Spingarn was applying Croce's doctrine of the absolute autonomy of the aesthetic sphere. Art, argued Croce, must exclude every form of practical action, including those which aim at "goodness and righteousness." [7] But Spingarn, as we shall note later, goes farther than Croce in denying that moral character has anything to do with artistic creativity.

The theory of pure art is logically committed to some manner of formalism. On this view, art to be genuine or good must be conceived in terms of the aesthetic surface, qualitatively or structurally. Art is a matter of sensuous quality and design, not of meaning. Thus we are told by Clive Bell, one of the best-known exponents of the art for art's sake view, that "to appreciate a work of [visual] art we need bring with us nothing but a sense of form and color and a knowledge of three-dimensional space." [8] Except for the representation of three-dimensional space *as such*, "every other sort of representation is irrelevant." So, of course, is the "descriptive element" which is found in many great works of art.[9]

There have arisen in the various arts, especially in this century, many schools consciously directed to the achievement of formalistic art in one way and in some degree or another. Illustrations in art movements, in works of art, and in expressed doctrine are manifold. Mere mention of a few names, at once tolerably respectable and familiar, will suffice: Gertrude Stein in literature, Braque and Rothko in painting, or, to go back to the nineteenth century, Mallarmé in poetry, and Walter Pater in literary-philosophical statement. A much-quoted passage from Pater may stand as the article of faith for all:

6 "The Seven Arts and the Seven Confusions," in *Creative Criticism* (New York: Harcourt, Brace and Company, 1931), p. 217.

7 See Croce's article, "Aesthetics," *Encyclopaedia Brittanica* (1944), 1:265.

8 Clive Bell, *Art* (London: Chatto and Windus Ltd, 1914), p. 28.

9 Ibid.

. . . We are all under sentence of death but with a sort of indefinite reprieve. . . . we have an interval, and then our place knows us no more. Some spend this interval in listlessness, some in high passions, the wisest—at least among "the children of this world"— in art and song. For our one chance lies in expanding that interval, in getting as many pulsations as possible into the given time. . . . Of this wisdom, the poetic passion, the desire of beauty, the love of art for art's sake, has most; for art comes to you professing frankly to give nothing but highest quality to your moments as they pass, and simply for those moments' sake.[10]

Which of these two views concerning the relationship of art and morality, aestheticism or moralism, is right? Is art at bottom an expression of morality, or is it absolutely nonmoral? Our exposition of each suggests a fallacy of the extreme in both. And at the same time each seems to carry its measure of truth. Aestheticism, which is another name for the art for art's sake view, is too big and various to be sensibly and safely either derided or indiscriminately proclaimed. At its worst it leads to empty and weak escapism, and at its best to firm emphasis on the intrinsic value of art. A similar conclusion may be asserted about moralism in art. At its worst, moralism leads to narrow puritanism and dull literalism, at its best to a practice and understanding of art as mindful of its profound connections with life and of the rich human experience that is available as artistic material.

Interrelations of the Moral and Aesthetic Spheres

Both the aesthetic and the moral attitudes are directed toward values, and in this sense they are concerned with the normative rather than the merely factual or descriptive content of experience. But otherwise they differ. In the moral attitude there is orientation toward future action, and, even when focusing on the present, moral concern is preoccupied with what is ongoing and consequential, being aroused by danger or opportunity and other signals of the need for choice. Hence it never wholly escapes from practical exigencies, and is less appreciative of the present than apprehensive about the future. In the aesthetic attitude, on the other hand, there is absorbed contemplation of directly presented content for its own sake. The fret and burden of life are suspended, and attention is upon value qualities directly found and appreciated. The two attitudes are not wholly disparate or incompatible, yet they are distinguishable.

[10] Walter Pater, "Conclusion" to *Studies in the History of the Renaissance*, 1873, reprinted in Allen and Clark, *Literary Criticism, Pope to Croce*, pp. 529–30.

Although the moral (as one species of the practical) and the aesthetic are thus distinguishable, they are related in complex ways:

1. Artistic activity engages the whole man, including his moral nature.
2. As the expression of human values, art includes the moral in the wide scope of its expressive content.
3. When values are in competition and conflict, judgments of comparative goodness must be made, the aesthetic being admissible in due proportion to its worth.

The first and second points we shall discuss briefly, but the third point will need more elaboration.

1. *Art engages the whole man.* Although we recognize that art is art and distinguishable from non-art, we reject the contention of men like Spingarn that moral traits have little or no relation to artistic creativity. On this point Croce is wiser than his disciple. Recalling a metaphor of an Italian critic, Croce writes:

> De Sanctis, in refuting certain romantic anticipations of modern pure art, wrote that the bird sings for song's sake but in singing expresses all its life, all its being, every instinct and every need, its whole nature. So a man, if he is to sing, must be a man as well as an artist.[11]

More than most forms of human activity, art makes man whole, and man is whole when he engages in art. This is one reason that artists such as Michelangelo and Beethoven or even Flaubert, the would-be "aesthete," had to engage in massive struggles of their whole body and mind to bring their art to its peak. The moral characteristics of the artist are involved in this total engagement.

The question of the relevance of morals to artistic creation is posed by an essay of George Orwell. [12] He asks whether the moral perversions of Salvador Dali have any relevance to his art. Citing episodes of sadism and obscenity from *The Secret Life of Salvador Dali* (the painter's autobiography), he concludes that Dali "seems to have as good an outfit of perversions as anyone could wish for. . . . It is a book that stinks. If it were possible for a book to give a physical stink off its pages, this one would—a thought that might please Dali, who before wooing his future wife for the first time rubbed himself all over with an ointment made of goat's dung boiled up in fish glue." On the basis of the book and other evidence, Orwell declares:

11 Benedetto Croce, *My Philosophy* (London: George Allen and Unwin Ltd, 1949), p. 134.
12 "Benefit of Clergy: Some Notes on Salvador Dali," in *Dickens, Dali and Others* (New York: Reynal and Hitchcock, 1946). The following quotations from Orwell are from this essay.

What Dali has done and what he has imagined is debatable, but in his outlook, his character, the bedrock decency of a human being does not exist. He is as anti-social as a flea. . . . a diseased intelligence . . . a symptom of the world's illness.

At the same time, Orwell remarks that Dali "is a draughtsman of very exceptional gifts. . . . One ought to be able to hold in one's head simultaneously the two facts that Dali is a good draughtsman and a disgusting human being. The one does not invalidate or, in a sense, affect the other."

We agree with Orwell that Dali is a good draughtsman. He has a sure feeling for composition, and he possesses the imagination and technical virtuosity to transpose the strange fantasies of the unconcious into visual symbols. This is an impressive achievement. But the verdict is less clear when we consider the subject matter characteristic of much of Dali's work. There are many signs of sexual perversity and images of death and putrefaction. For example, in his "Mannequin Rotting in a Taxicab" (a kind of faked photograph) huge snails ("the edible kind") are crawling over the somewhat bloated face and breast of an apparently dead girl. One ought not to pretend, declared Orwell, that such pictures "are morally neutral. They are diseased and disgusting."

Orwell warns us against committing two fallacies:

1. To believe that "since 'Mannequin Rotting in a Taxicab' is a good composition (as it undoubtedly is), it cannot be a disgusting, degrading picture. . . ."

2. To believe that "because it is disgusting that it cannot be a good composition. . . ."

We agree with Orwell that the second belief is a fallacy, but the first belief is not so easy to classify.

When art draws materials from life, the life values it thus incorporates acquire a new nature and meaning independent of their sources. But the life values are not *wholly* annulled—they are abolished in their literal reality but preserved on an imaginative plane. The scheme of values that an artist holds, whether consciously or unconsciously, will determine to a large extent what he says in his work and how he says it. When Aeschylus or Praxiteles portrayed man as heroic, he was expressing his metaphysical view that man is important and capable of greatness. When Dali portrays life as vile, he is expressing an opposite ethics and metaphysics. This fact must enter into our understanding and estimate of him as a human being. But we must distinguish between a moral judgment of the *artist* and a

moral judgment of his *art*, because condemnation of the artist as a person does not automatically entail condemnation of his work. Judged by the standard of expressiveness, a painting by Dali may be a good picture aesthetically precisely because it is so vividly and hypnotically disgusting. Also its very expressiveness may redeem it morally, if it needs such redemption. When evil appears disgusting, as in this instance, it is more likely to repel rather than attract. Moreover, the attainment of intellectual and moral maturity requires knowledge of evil as well as good. As John Milton remarked in *Areopagitica*, "That which purifies us is trial, and trial is by what is contrary." We need to know and understand evil, and to know it imaginatively is the least dangerous way of knowing it. Although Dali's picture may be symptomatic of moral rot, it is unlikely that it will morally corrupt the spectator.

When we judge the *man* and not his work, his talent as an artist does not exempt him from moral censure. Here we agree with Orwell:

> What the defenders of Dali are claiming is a kind of *benefit of clergy*. The artist is to be exempt from the moral laws that are binding on ordinary people. . . . So long as you can paint well enough to pass the test, all shall be forgiven you.

Orwell, of course, rejects this "benefit of clergy" plea, and so do we. The theory of Wilde or Spingarn that there is an impassible gulf between art and morals—a theory that might be used to defend Dali as a human being—is a gross exaggeration.

The contention that there is no relation between the quality of the man and the quality of his work is denied by Henry James in his famous essay, "The Art of Fiction":

> There is one point at which the moral sense and the artistic sense lie very near together; that is in the light of the very obvious truth that the deepest quality of a work of art will always be the quality of the mind of the producer. In proportion as that intelligence is fine will the novel, the picture, the statue partake of the substance of beauty and truth. To be constituted of such elements is, to my vision, to have purpose enough.

We cite this quotation to indicate the subtlety of the question at issue. Despite what James says, we cannot assume that defects in the man are necessarily reflected by defects in his work. But neither can we assume that the work of art in no way reflects the artist. Cheapness or superficiality in the artist is likely to show up in the work.

Even nonprogrammatic music bears the mark of maturity or immaturity, which is not without relevance to considerations of moral value. As Leonard Meyer points out:

The differentia between art music and primitive music lies in speed of tendency gratification. The primitive seeks almost immediate gratification for his tendencies whether these be biological or musical. Nor can he tolerate uncertainty. And it is because distant departures from the certainty and repose of the tonic note and lengthy delays in gratification are insufferable to him that the tonal repertory of the primitive is limited, not because he can't think of other tones. It is not his mentality that is limited, it is his maturity. Note, by the way, that popular music can be distinguished from real jazz on ·the same basis. For . . . "pop" music . . . operates with such conventional cliches that gratification is almost immediate and uncertainty is minimized.[13]

The basic style of an individual artist or a culture, as Meyer contends, is thus influenced by "the willingness to bear uncertainty" and "to forego immediate, and perhaps lesser gratification, for the sake of future ultimate gratification." And this willingness is, in the broad sense, a moral trait.

2. *Art includes the moral in the wide scope of its expressive content.* Works of art, for example a novel such as Dostoevsky's *Crime and Punishment,* may embody a moral vision as an essential part of the work. Indeed, values of *any* kind—moral, religious, economic, scientific, and so on—may, under appropriate circumstances, be contemplated aesthetically. On this basis we have argued that art may express or embrace the full gamut of human values. It is not initially the *kind* of value that marks off the aesthetic; it is the mode of apprehension and the subtle transmutation that artistic expression involves. In the aesthetic experience, the value, whatever it be, is contemplated for its intrinsic quality as absorbing in itself. Nonaesthetic values are transformed into aesthetic values when contemplated in this way. For example, the moral purity of Desdemona or the villainy of Iago is interesting to contemplate, and this is sufficient to justify its incorporation in a work of art, where it is transmuted into the stuff of tragedy.

We need to distinguish between the stuff of art (neutral or human) and the product into which it is worked. Whether the predominant character or interest be finally moral or aesthetic is not determined by the stuff but by what is done with it, in creation or response. If it is used to draw moral conclusions or present moral arguments, then so far it is moral and not aesthetic. But if it is shown or told as interesting in itself, then it is aesthetic. Moral *material* is not

[13] Leonard B. Meyer, "Some Remarks on Value and Greatness in Music," in Monroe C. Beardsley and Herbert M. Schueller, eds., *Aesthetic Inquiry* (Belmont, Calif.: Dickenson Publishing Company, 1967), p. 267.

aesthetic value, but it may be good aesthetic material which, when artistically organized and presented, may produce high aesthetic value. The stuff, as we have said, may be *anything*—neutral material such as stone, sound, color, and shape, or human material such as scientific idea, religious passion, moral struggle, conviction, and conflict. But if a work of art is to be produced, what is done with this material, whatever it be, cannot be just anything—it must in treatment and response *be* aesthetic.

This distinction between original stuff and final product is illustrated by Charles Lamb's discussion of Restoration comedy. He noted that dramatists such as Congreve and Wycherley depict vain and worthless characters whose delinquencies, if they were actual, would be the despair of moralists. But these "profligates and strumpets" are not to be taken as real-life characters. "They are a world of themselves almost as much as fairyland. . . . The whole is a passing pageant, where we should sit as unconcerned at the issues, for life or death, as a battle of the frog and mice." The effect upon Elia (the imaginary author of the essay) is altogether liberating. "I come back to my cage and my restraint the fresher and more healthy for it. I wear my shackles more contentedly for having respired the breath of my imaginary freedom." Perhaps the main difference between the moralistic censor and the delighted theater-goer is in this matter of aesthetic liberation. The censor, unable to make the imaginative leap, sticks the characters and incidents in a moral world, where they have no real place; the theater-lover locates them in "a speculative scene of things, which has no reference whatever to the world that is." [14] If every member of the audience could be trusted to respond like Elia, there would be no sense whatever in a censorship of plays. Even though Lamb exaggerates the separation of art and life, there is a large measure of truth in what he says. We conclude that art expresses moral as well as other values, but in doing so it transmutes them into the stuff of art.

3. *Moral wisdom is required for the achievement of an inclusive and harmonious integration of interests including the aesthetic.* We have construed values as the objects of interests, and we have recognized that every interest is compelled to recognize other interests as partners or opponents in the enterprise of living. Given the brevity of our life span and the limitations of human energies and resources, it is obviously impossible to realize all the values of art, health, com-

[14] Charles Lamb, "On the Artificial Comedy of the Last Century," in *The Essays of Elia.* By "no reference" Lamb evidently means no practical reference. An imaginative world is being depicted.

fort, love, ambition, play, knowledge, religion, economic sufficiency, and other interests. Aesthetic and moral values are only part of the vast congeries of human values, and somehow a selection and integration must be made among all the rival and competing claims. Ethical wisdom consists in knowing what goods to sacrifice and what to pour into the final mixture.

Morality functions at two levels. First, there is the primary level where acts and states of mind are, in themselves, moral or immoral. For example, it is moral, with few exceptions, to tell the truth, immoral to lie. At this level moral and aesthetic values are equally primary, and neither kind is necessarily to be preferred to the other. Second, there is the secondary or meta level where diverse competing interests, *including the moral at the primary level,* are weighed against each other, some to be excluded or minimized, others to be included or stressed. The problem is to remove conflicts when possible, and to choose wisely when conflicts are inevitable and some values have to be sacrificed.

The decision as to which interests should be given priority will depend in large measure on one's general orientation toward life. It is possible to embrace an intolerant puritanism, such as that of Stephen Gosson, the censorious Elizabethan, who warned that the arts lead to a fatal decline "from piping to playing, from play to pleasure, from pleasure to sloth, from sloth to sleep, from sleep to sin, from sin to death, from death to the Devil." [15] Or one may embrace an ethics of joy and life affirmation such as the following declaration of Spinoza:

> Nothing but a gloomy and sad superstition forbids enjoyment. . . . To make use of things, therefore, and to delight in them as much as possible (provided we do not disgust ourselves with them, which is not delighting in them), is the part of a wise man. It is the part of a wise man, I say, to refresh and invigorate himself with moderate and pleasant eating and drinking, with sweet scents and the beauty of green plants, with ornament, with sports, with the theater, and with all things of this kind which one man can enjoy without hurting another.[16]

If aesthetic values are to be included in the good life, it must be because they occupy a defensible position in the scale of life's satisfactions.

Even Clive Bell, the formalist, was willing to concede that ethical valuations at this level are unavoidable. "Of course they are right

[15] *School of Abuse* (London: The Shakespeare Society, 1841), p. 14.
[16] Benedict Spinoza, *Ethics,* trans. W. Hale White and Amelia H. Stirling (London: Oxford University Press, 1930), pp. 217–18.

who insist," he said, "that the creation of art must be justified on ethical grounds; all human activities must be so justified." [17] Believing that aesthetic values are the best things that life has to offer, he contended that "civilized" people ought to strive, above all, to create and appreciate art. He spoke of "the austere and thrilling raptures of those who have climbed the cold, white peaks of art," and of "that infinitely sublime state of mind to which pure visual art transports me." [18] The potential value of any work of art, he concluded, lies in the fact that it can "at any moment become a means to a state of mind of superlative excellence." Like Walter Pater, he asserted that the aim of every cultivated man is the "richest and fullest life obtainable, a life which contains the maximum of vivid and exquisite experiences," and that among such experiences "aesthetic ecstasy" is supreme. [19]

In these judgments, Bell was reflecting the tone of the "Bloomsbury Circle." This was a group of writers and artists that included, in addition to Bell, such luminaries as Roger Fry, Duncan Grant, Lytton Strachey, Virginia Woolf, and John Maynard Keynes. The favorite philosopher of the Bloomsbury Circle was G. E. Moore, the author of *Principia Ethica,* whose intuitionist moral philosophy extolled love and a sense of beauty as the two supreme goods. Keynes has described the attitudes that the Bloomsbury group derived, at least in part, from Moore:

> Nothing mattered except states of mind, our own and other people's, of course, but chiefly our own. These states of mind were not associated with action or achievement or with consequences. They consisted in timeless passionate states of contemplation and communion, largely unattached to "before" and "after." . . .[20]

In a chapter on "Art and Ethics," Bell cited Moore's doctrines to support his conclusion that "there is no state of mind more excellent or more intense than the state of aesthetic contemplation. This being so, to seek any other moral justification for art, to seek in art a means to anything less than good states of mind, is an act of wrong-headedness to be committed only by a fool or a man of genius." [21] The object of aesthetic contemplation, as he defined it, is "Significant Form" —that is, the inner cohesion or structural perfection of the work. This means, in the case of visual art, the harmony of shapes and

17 *Art,* p. 106.
18 Ibid., pp. 31, 33.
19 See Clive Bell, *Civilization* (London: Chatto and Windus Ltd, 1928), esp. Chap. IV.
20 *Essays and Sketches in Biography* (New York: Meridian Books, 1956), p. 242.
21 *Art,* p. 114. (Bell mentions Tolstoy as an example of a wrong-headed genius.)

colors, of surfaces and volumes. Because Bell—not always consistently —excluded reference and representation, it remained somewhat nebulous in what sense this kind of "form" can be "significant."

One need turn only to D. H. Lawrence's remarks about painting to find a very different basis for aesthetic evaluation. The "cult" of form *per se* seemed to him a ridiculous outburst of ecstatic evangelism and the silliest kind of snobbery. It was altogether too anemic a cult to satisfy his demand that the full-bodied sensual man be expressed in art. With intense sarcasm he characterized the formalism of critics such as Bell and Fry:

> They had renounced the mammon of "subject" in pictures, they went whoring no more after the Babylon of painted "interest," nor did they hanker after the flesh-pots of artistic "representation." Oh, purify yourselves, ye who would know the aesthetic ecstasy and be lifted up to the "white peaks of artistic inspiration." Purify yourself of all base hankering for a tale that is told, and of all low lust for likenesses. Purify yourselves, and know the one supreme way, the way of Significant Form. I am the revelation and the way! . . . Lo, I am Form and I am Pure, behold, I am Pure Form.[22]

Believing that aesthetic purism has its roots in "a deep, evil hatred of the instinctive, intuitional, procreative body," Lawrence denounced "the Holy Ghost of Significant Form" as violative of his love ethics. He maintained that our civilization, in pitting the spirit as higher against the body as lower, "has almost destroyed the natural flow of common sympathy between men and men, and men and women." It was this "natural flow" that he wanted "to restore into life," [23] and he dedicated his art to this end. For he was convinced that "the essential function of art is moral. Not aesthetic, not decorative, not pastime and recreation. But moral." [24] One may disagree with his subordination of the aesthetic to the moral, and one may prefer Bell's aesthetic credo or some other alternative, but not without reference to ethical standards— at least if one means by "ethics" the theory of life's basic priorities.

To insist that art is unconnected with life or that aesthetic values exist in isolation from all other values is to fall into the same kind of fallacy as that of some of the classical economists:

22 *Phoenix* (New York: The Viking Press, Inc., 1936), pp. 565–66. (From an introduction to his paintings.)

23 In *Selected Essays* (Hammondsworth: Penguin Books, 1950) , pp. 100–101.

24 In "Whitman," in *Studies in Classic American Literature* (New York: Thomas Seltzer, 1923), p. 254.

These economists invented a human being who is motivated only by economic considerations, who will buy only in the cheapest possible market and sell only in the dearest, and they viewed this artificial construct quite seriously as typical of real persons.[25]

Likewise, the advocates of a pure science of aesthetics construct "an aesthetic man, who is not to be found even among the adherents of the slogan, art for art's sake. Works of art spring from the full powers of their creators and engage all the inner activities of those who enjoy them."[26] Just as classical economics is too narrow to fit the real world, so likewise is puristic aesthetics.

A work of art is a form that expresses and embodies human values. The form may be contemplated in abstraction from the values it expresses, and this abstracted form may give delight to the spectator. The Bell-Fry theory, like many later pronouncements, has been useful in calling attention to the great importance of the formal side of art. But form should not be interpreted as mere abstract design. It is the integration of *all* the constituents—presentational, representational, and connotational—which together in their felt qualities and internal coherence constitute the work. When so interpreted form has a richness of meaning that applies to all the arts and properly stands high in the scale of human values. Even so, it must be compared and integrated with other values and given no priority over competing values of equal or greater worth. Ultimately moral wisdom, operating at the meta level, must be in command.

The Form of the Good and of the Beautiful

In a characteristic passage, Plato asked whether there is an affinity between artistic and moral harmony:

> The artist disposes all things in order, and compels the one part to harmonize and accord with the other part, until he has constructed a regular and systematic whole . . . and what would you say of the soul? Will the good soul be that in which disorder is prevalent, or that in which there is harmony and order?[27]

In response to his own question, Plato maintained that the best life has the same formal structure as the well-wrought work of art. In

[25] Max Dessoir, *Aesthetics and Theory of Art* (Detroit: Wayne State University Press, 1970), p. 424.
[26] Ibid.
[27] *Gorgias,* 503E–504A (Jowett's translation).

words that he attributes to Protagoras: "The life of man in every part has need of harmony and rhythm." [28]

This belief has persisted through all the centuries down to the present. Rather than to quote some older advocate, such as Plotinus or Shaftesbury, we turn to the following lucid statement by a recent American philosopher:

> Now it is possible to prove that the fundamental principles underlying design in art: organic unity (pervasive expressiveness); the existence of one or more motifs or themes; the repetition or modulation of these; the subordination of some elements of the whole to others (hierarchy); balance; and the evolution of meaning, as in the plot of a story or the development of a melody, are principles of value everywhere; that all experience, when it achieves integral satisfaction, tends to possess the form of a work of art. As Plato divined, the form of the good and the form of the beautiful are the same. For experience, as a whole, is good, in so far as its elements, the sense impressions and the eventual meanings, conspire to some single end or value; when it is clarified and consolidated through stable habits or purposes, freely chosen and distinctive of itself, like the themes of a musical composition, and so possesses, like a work of genius, style; when these purposes appear and reappear, always the same, yet enriched by new applications; when, again, the opposing elements of human nature, of its night side, as well as its daylight side, receive a balanced satisfaction, so that the whole man is expressed; when there is subordination to the major interests, yet some value in the minor interests on their own account; when, finally, life has a career, definite in outline, yet providing opportunity for curiosity, suspense, climax, and adventure; a life so built is a good life. And it was inevitable that, constructed by man for his own delight, out of materials utterly plastic to his will, art should exemplify the form of that will when it is happy.[29]

Parker developed this theory of the formal identity of beauty and goodness in his book *The Analysis of Art* (1924).

An interesting expression of this view is to be found in W. Somerset Maugham's novel, *Of Human Bondage*. Philip, the principal character, suffered one frustration or disaster after another until he asked himself desperately what is the use of living at all. In this depressed state, he spent several hours in the British Museum, where his mood gradually changed. Remembering that his friend Cronshaw

[28] *Protagoras*, 326 (Jowett's translation).

[29] DeWitt H. Parker, "Wish Fulfillment and Imagination," *Proceedings of the Sixth International Congress of Philosophy*, September 13–17, 1926 (published 1927), pp. 439–40.

had given him a Persian rug of very beautiful design, it occurred to him that his own life, however meaningless otherwise, might be wrought into a comparable pattern. He decided that "out of the manifold events of his life, his deeds, his feelings, his thoughts, he might make a design, regular, elaborate, complicated, or beautiful." He would make his life into a work of art, and even unhappiness would be justified if it could add another motif to weave into the pattern.

This kind of moral aestheticism has at least a partial justification. Every man wishes that his life could be a kind of melody, harmonizing his manifold interests and resolving major discords. But evident as is the good of life composed in so musical a fashion, the analogy between goodness and formal beauty has its limitations. To Philip, regarding his life as a work of art, happiness seemed to matter as little as pain. "They came in, both of them, as all the other details came in, to the elaboration of the design." But in real life, no one can simply look upon suffering and enjoyment as if they were notes in a symphony, empty of all significance by themselves and depending for their value entirely upon their relations. A man can perhaps maintain this attitude when he is in the role of spectator, gazing upon the weal or woe of others from a detached standpoint, or imputing to himself a kind of histrionic existence, as if he were a character in a play. Then the intrinsic difference between joy and suffering is muted, and these states of mind can be valued equally as they fit together in some larger design. As long as a person maintains this attitude, he can transform real life into a spectacle and look at everything as if it were a musical motif or a theatrical device. From this perspective

All the world's a stage
And all the men and women merely players.[30]

But when pain is direct and stabs deep, a person can no longer maintain the stage or story view of life. There is an immediacy and intrinsicalness in his feelings that cannot be disregarded. Suffering is obnoxious, joy is delicious *in itself,* whether or not it is gathered up into some larger configuration. To think otherwise is as mistaken theoretically as it is impossible practically.

There is another reason why the analogy between real life and a work of art breaks down. The aesthetic object, relatively speaking, is a little world in itself, self-complete and isolated. As a web of internal relations, it absorbs and holds our attention within its charmed circle; hence, it can be valued as a pure design, individual and self-subsistent. But a person's life, hermetic though it may be, has no

[30] Shakespeare, *As You Like It*, Act II, Scene 7.

merely separate existence. Wordsworth's account of Lucy, who "dwelt among the untrodden ways," illustrates the point. The sequence of poems about Lucy has a completeness in itself, but *Lucy herself*, if we can imagine that she is a real person, has no such isolation and self-completeness. On the contrary, she is taken up into the life of nature and incorporated with it:

> The floating clouds their state shall lend
> To her; for her the willow bend;
> Nor shall she fail to see
> Even in the motions of the storm
> Grace that shall mould the maiden's form
> By silent sympathy.

When Lucy dies it is a profound loss and not simply the satisfying end of a story:

> . . . she is in her grave, and, oh,
> The difference to me.

However withdrawn from the throng, she was an object of love and sorrow to others, and must have loved in her turn. Hence we cannot judge the value of a life, as we may judge a symphony, simply in terms of its inner coherence and formal structure. It depends upon self-transcendence and mutuality and abundant interaction with one's environment.

Imagination and Sympathy

The link that is believed to unite art and morality is sometimes found in an asserted kinship between artistic imagination and moral sympathy. Shelley, in his *Defense of Poetry*, gives a classic statement of this view. He maintains that poetry (meaning art in general, and not just poetry in the narrow sense) is deeply moral, even when not occupied explicitly with moral matters, because the fundamental principle of morality and poetry is the same—the principle of imagination. "The great secret of morals is love," he argues—it is a "going out of one's own nature" in sympathetic identification with others. Now "imagination" is the means by which we do this:

> A man to be greatly good, must imagine intensely and comprehensively; he must put himself in the place of another and of many others; the pains and pleasures of his species must become his own. The great instrument of moral good is the imagination; and poetry administers to the effect by acting upon the cause. . . .

Poetry strengthens the faculty which is the organ of the moral nature of man.

Poetry or art strengthens the imagination by sharpening its delicacy and enlarging its range and thrust. This increase in sensitiveness is accomplished by art in the normal course of its operation—the work of art touches the heart by enkindling the imagination, and that is enough. [31]

Hardness of heart is a kind of moral paralysis, and, in its acuter forms, a terrible psychological disease. It belongs to the depersonalized world depicted in the novels of Kafka or Camus—a world in which everyone is cut off from his fellows. Sealed within himself, morally isolated and unfeeling, a person is no better than a machine. We would like to think that we are immune to this malady, but every man suffers from the curse of self-enclosure. He is confined to his own skin, sees with his own eyes, feels with his own feelings. He never *directly* experiences anyone's enjoyments and sufferings but his own. If there is anything that should be called "original sin," this is it—the egocentric predicament into which everyone is born. In addition to being self-centered, human beings are group-centered, beset by the collective biases of race, nation, class, and creed. Hard-heartedness and cruelty, in consequence, play the devil with their sense of justice.

We can escape from egocentricity and group bias by the power of imaginative projection, a going-out from our own nature in sympathy and lively perception. Through aesthetic experience, we are in touch with other people and things, knowing them appreciatively in their vivid and unique qualities. Art conveys the sense of a living presence rather than a dead set of abstractions—it is a way, to use a striking phrase of Hegel, of "being at home with oneself in the other." Cold reason is powerless to stir our conscience unless imagination and feeling come to its aid. Hence art, more than science, is the great cultural means of arousing our sympathies and removing our moral blind spots. It can help immensely to create that community of feeling without which there can be no deep and vital morality.

Huckleberry Finn provides an example of the moral effect of art. Twain's novel is a study of the conflict between sympathy and racial bias in pre-Civil War America. When Huck, reporting the day's news to Aunt Sally, is asked whether the explosion of a steamboat had hurt anyone, he replies, "No'm: killed a nigger." Aunt Sally responds, "Well, it's lucky because sometimes people do get hurt." But try as

31 See Shelley's statement in his Preface to *Prometheus Unbound:* "Didactic poetry is my abhorrence."

Huck does to maintain this white callousness, he cannot suppress his sympathy for Jim, the runaway slave. He is consequently torn between his duty to abide by the law and tell the truth and his duty to lie in order to save the black man from being captured. In the torment of moral conflict he cries out:

> It don't make no difference whether you do right or wrong, a person's conscience ain't got no sense and goes for him anyway. If I had a yaller dog and he had no more sense than my conscience I would poison him. It takes up more room than a person's insides and ain't no good nohow.

The reader of the novel reaches out in imagination to comprehend this moral dilemma; he sympathizes when Huck rejects his "yaller dog" conscience to cast his lot with Jim. As the white boy and the black man, on their raft, drift down the Mississippi River toward freedom, they are drawn closer and closer together, and the reader shares vicariously in the healing process.

Many other works of art have a similar moral effect, quickening our sympathies and broadening our horizons. This is obvious in the case of representational art, such as the plays of Arthur Miller, the paintings of Ben Shahn, or the sculpture of Ernst Barlach. Music, often cited as an exception, is frequently combined with words or actions, as in song or opera; even when standing alone, it possesses tertiary qualities, which may have a semi-moral tinge. In the Heilgesang of Beethoven's *A Minor Quartet,* for example, not a word is spoken, but we know that the music springs out of tragedy and struggle and unearthly peace. What John Milton, in *Aereopagitica,* said of literature can be said of any artistic masterpiece: it is "the precious life-blood of a master spirit, embalmed and treasured up on purpose to a life beyond life." As long as spirit can speak to spirit in this way, the self need not be shut up in the very private house of its separate identity. This self-transcendence is necessary if men are to live a moral life.

As C. I. Lewis has written, the moral imperative for each one of us is to govern his activities affecting other persons as he would if these social effects "were to be realized with the poignancy of the immediate—hence, in one's own person. The dictate is to respect other persons as the realities we representationally recognize them to be— as creatures whose gratifications and griefs have the same poignant factuality as our own. . . ." [32] This means that we should weigh the

[32] C. I. Lewis, *The Ground and Nature of the Right* (New York: Columbia University Press, 1955), p. 91.

absent or the alien in "the *full-size* of it," as large and lively as the incidents in our own life. We must turn the great floodlight of imagination upon the distant and unfamiliar, lighting them up as clearly as the things in our near perspective. The moral function of art is to arouse the imagination to this vividness of compassion.

We fail if imagination, like a spotlight, lights up some relevant features while leaving others in the dark. The spotlight effects of the more striking value can be the source of grave moral error. Shelley's argument needs to be qualified by the recognition that love and imagination can exhibit their own forms of bias. A biased act, understood in this broad way, is one in which the values that should determine choice are *not* seen steadily and comprehensively. We exhibit bias when the one-sided or fitful play of imagination distorts our moral judgment, or when we narrow our attention to aesthetic appearances while neglecting other relevant factors. An example of the latter is the state of mind of the lover who is so entranced by the physical beauty of his sweetheart that he is blind or indifferent to the defects of her mind and character. "When my love deceives me I believe her, though I know she lies."

Dreadful mistakes are sometimes made when men are misled by superficial aesthetic glitter, as so many Germans were misled by the fervid myths, the "heroic" gestures, the "dramatic" threats, the militaristic fanfare, the spectacular demonstrations of the Nazi regime. Hitler, like his brother-in-arms Mussolini, was excessively romanticized by showmen and press agents. No hero or matinee idol has ever been greeted by so many clicking heels, so many arms raised in salute, so many throats hoarse with shouting. All of this was cheap melodrama, as meretricious artistically as it was corrupt morally, but it illustrates how the imagination can be beguiled.

A less gross example of the beguiling effect of the imagination is supplied by Charles Lamb in *The Essays of Elia*. The Elian form of moral aestheticism accepts in principle everything, even the socially ugly and the privately sore, as possibly interesting—something with its own unique quality, which can be suffered or attacked, on the one hand, or savored and enjoyed, on the other. Elia makes this latter method count well in taking a retrospective view of himself. His past, even when unfortunate, is not a burden to drag sufferingly along into the present—neither is it to be forgotten. It is to be remembered and cherished with all its pain and disappointments. He reflects on New Year's Eve:

> I would scarce now have any of the untoward accidents of my life reversed. Methinks it should be better that I should have pined

away seven of my goldenest years, when I was a thrall to the fair hair, and fairer eyes, of Alice W——n, than that so passionate a love adventure should be lost. It was better that our family should have missed that legacy, which old Dorrell cheated us of than that I should have at this moment two thousand pounds *in banco,* and be without the idea of that specious old rogue.

With the same postulates and the same logic he argues to similar conclusions in "The Praise of Chimney-Sweepers" and "A Complaint on the Decay of Beggars in the Metropolis." Both chimney-sweeps and beggars are feelingly recognized as unfortunate victims of society, but at the same time they are prized as part of the aesthetic landscape. They are an interesting species, for whose loss we would be the poorer in immediate quality. Elia sets himself against reforming them out of existence. "I do not approve," he says in the Beggars essay,

> of this wholesale going to work, this impertinent crusado, or *bellum ad exterminationem,* proclaimed against the species. . . . The Mendicants of this great city were so many of her sights, her lions. I can no more spare them than I could the Cries of London. No corner of a street is complete without them.

Most of us would protest that this is the point where the aesthetic must give way somewhat tragically to the moral. Perhaps Elia needs to put his tastes in order. But so do some of us who "enjoy" slumming in the big cities. The person who relishes beggars or slums because they are "picturesque" has stopped short at the aesthetic surface of life.

The imagination, in relation to moral judgment, thus cuts in two directions. In such instances as Shelley had in mind, it increases our moral sympathy by a vivid grasp of suffering and an empathic identification with its victims. In such examples as Lamb mentions, it makes us more tolerant of suffering by fixing attention upon aesthetic features or appearances to the relative neglect of underlying misery. For a lively imagination like that of Goethe, even criminality can be regarded with imaginative sympathy. He remarked to Eckermann that he had never heard of a crime which, in his heart, he did not know himself capable of having committed.

An example of the elasticity of the aesthetic imagination is the fascination that the Marquis de Sade's cruelty and debauchery have exercised in cultivated circles. His linking of sexuality with vileness (ugliness, filth, bad odors) and cruelty (whipping his victims and being whipped) was combined with artistic genius in depicting these perversions. "The fact is that it is neither as author nor as sexual pervert that de Sade compels our attention," remarks Simone de Beauvoir:

"it is by virtue of the relationship which he created between these two aspects of himself." [33] Despite some redeeming features in his character, the conflict between morality and aestheticism in his writings is flagrant. We do not think his works should be burned, but neither do we think that they can be defended by Shelley's argument. Their moral value, rather, is that they make us sharply aware of the human problem.

> If ever we hope to transcend the separateness of individuals, we may do so only on condition that we are aware of its existence. . . . De Sade drained to the dregs the moment of selfishness, injustice and misery, and he insisted upon its truth. The supreme value of his testimony is the fact that it disturbs us. It forces us to reexamine thoroughly the basic problem which haunts our age in different forms: the true relation between man and man.[34]

As William Blake remarked, the devil must be given a form so that he may be cast out.

One of the prime requirements of morality is that we should see things as they really are. When Shelley extolled love and imagination as the basis of morals, his statement was unguarded—for imagination may be partial and love blind. Sympathy, when too excessive or one-sided, may result in unjust favoritism. Or imagination, focusing upon the qualitatively exciting aspects of life, may make us neglect the unexciting but morally crucial features. Hence sympathy and imagination need to be regulated by impartial, well-informed judgment. The moral life should bring into play all our faculties, not only imaginative sensitivity but knowledge, practical sagacity, and critical insight. Reason and sympathy, science and art, need to be combined in the full mobilization of our resources.

But in practice we may be forced to compromise. It is a shallow optimism to hope that our various interests can be perfectly harmonized. The conflict between art and morals may, to some extent, be ineradicable. As Henry Sidgwick remarks, the only reason Milton's Paradise is not intolerably dull "is because we know the Devil is on his way thither." Sidgwick notes, as does Plato, the antinomy of moral and aesthetic value, and fears that it can never be eliminated:

> Both art and morality have an ideal . . . but the ideals are not the same, and it is just where they most nearly coincide—in dealing with human life and character—that some conflict is apt to arise. Morality aims at eradicating and abolishing evil, especially moral evil, whereas the aesthetic contemplation of life recognizes

[33] *Must We Burn De Sade?* (London: Peter Nevill, 1953), p. 10.
[34] Ibid., p. 89.

it as an element necessary to vivid and full interest. . . . I do not think that this opposition can be altogether overcome. Its root lies deep in the nature of things as we are compelled to conceive it. . . .

It may be that the best we can do is to cherish alike aesthetic, moral, and cognitive values, alternating if we cannot harmonize them:

> And on the whole we must be content that science and art and morality are for the most part working on the same side. . . . Perhaps they will aid each other best if we abstain from trying to drill them into perfect conformity of movement, and allow them to fight independently in loose array.[35]

This is not to deny that a working harmony is best if it can be attained without sacrifice or repression.

For the wholeness of life, ethical wisdom requires that aesthetic satisfactions be included among the basic consummatory satisfactions. If by morals one means the practical wisdom that deals with the entire sweep of human values, then it must be admitted that morals have primacy over life as a whole. But in the ordinary and more limited meaning of morals, it is a mistake to subordinate the aesthetic to the moral or the moral to the aesthetic.

[35] Henry Sidgwick, "The Pursuit of Culture," *Practical Ethics* (London: Swan Sonnenschein, 1909), pp. 232–34.

Chapter 10

ART

AND HISTORY

The Question Posed

Having considered the relation between art and religion and between art and morality, we shall now turn from moral and religious concerns to the subject of knowledge. In this chapter, we shall deal with art and history, and in Chapter 11, with art and science. Both history and science would seem to fall within the cognitive sphere. But some historians and philosophers deny that the writing of history belongs primarily to the category of knowledge, regarding it more as an artistic than as a cognitive pursuit.

"History" can mean either the past actions of human beings or the narrative of such actions based upon inquiry and interpretation. Taking "history" in this second meaning, we find that art and history interpenetrate in several ways: (1) Art is always a part of the data of history. (2) Art is often an explicit vehicle of history. (3) Art is sometimes implicit history—a self-reflective commentary, as it were, on its own period. (4) Written history is sometimes a work of art. (5) Art and history are akin generically in that both basically rest on value (rather than merely factual) considerations.

The first three of these relationships, fairly understood, are gen-

erally accepted in theory and practice. They should not be matters
of serious dispute. But on the points that (4) history is sometimes
a work of art and (5) that art and history are akin, there is sharp
and understandable disagreement between those historical theorists who
speak of "the elevation of history to the position of science" [1] and
those who maintain that "history is, in its unchangeable essence, a
'tale,' " and that "the art of history remains always the art of narra-
tive." [2] The disagreement here is not factual; that is, not about what
history writing has variously been. Rather, it is normative, a disagree-
ment about what history writing "properly" is, whether it *should* be
a science or an art. On the view of history as science, history as art
is, of course, disallowed in conception and deprecated in practice. On
the view of history as art, it is, of course, approved in its very idea.

On the view of history as science, history as art is relegated to a
"so-called" status, while on the view of history as art, the idea of history
as science is regarded, in final analysis, as highly questionable. This is the
main issue that we wish to discuss.

It may seem unnecessary to take a stand with or against either
of these opposing positions on what history "really" is. One may see
the history of history as embracing both scientific and art premises
and practices. A current anthology, *The Varieties of History* (edited by
Fritz Stern) in its very title suggests this pluralistic approach to the idea
of history. But in pursuing and supporting the less controversial relation-
ships mentioned first in our list, the basic question concerning the
kinship between art and history (point 5 above) will recur, and we mean
to give it further attention in what follows.

The Artist as Historian

If history is an interpreted account of all that man significantly
does, then art is certainly part of what history has to deal with—in
other words, part of its data. According to any view, the art of a
period or a people is one of the important things about it or them.
An account of art must be included in any synthesis which history
offers. But, more than this, art is sometimes implicit history. Some
works of art are, to use the phrase of one writer, "crystalized his-
tory," [3] which can serve the historian in a later period not only as
a primary fact to be accounted for in his reconstruction of the period

[1] John Bagnell Bury, "History as a Science," in Fritz Stern, ed., *The Varieties of History* (Cleveland and New York: Meridian Books, 1956), p. 223.
[2] George Macaulay Trevelyan, "Cleo Rediscovered," in Fritz Stern, ibid., p. 234.
[3] Roger Fry, *Vision and Design* (New York: Brentano's 1924), p. 1.

of his study but also as a commentary of that period on itself. Art that can be so characterized is not the "pure" art of which Kant spoke—the art of sheer design without existential import—but rather the "dependent" art that includes a cognitive element. Such art is not only a part of the life of a period; it is also a reflexive history and a self-judgment, from which the later historian can learn. The point has been suggestively expressed in saying that "Homer is not only Homer. The *Iliad* and the *Odyssey* are vivid chapters in the history of the world." [4] That is to say, an enduring work of art holds interest not only as a presently enjoyable object but also as a record of its time, a record which can often be correlated with other records and which can sometimes help throw light upon the whole.

A work of art is always a social "document" or fact as well as an aesthetic object. "The conclusions reached by the art-historian can often provide an essential part of the evidence vital to the historian of events." [5] Sometimes, partly because of the accidents of time, but also because of the directness of its meaning and its closeness to the source, art is, indeed, the chief data of history, as it is clearly in the numerous lost cultures which have been recovered mainly or solely in archaeological remains. The art historian just quoted makes the further point: "Indeed, at certain phases of history, when there are no written records, the arts often afford practically the only source of evidence that we have on which to reconstruct a picture [of the time]." [6]

Art is clearly and intentionally a social document, and, in measurable part, an historical commentary when, as in John Steinbeck's novel *The Grapes of Wrath* or in Picasso's *Guernica,* it presents and takes a stand on social fact and problem, or when, as in John Steuart Curry's controversial murals in the Kansas State Capitol, it dramatizes the events and personages of a commonwealth. When art chooses actual events or real persons as its subject, it becomes a vehicle of history. It is then not only itself an event but also a report and an interpretation of events. Much art does deal with historical events and persons, and often with the intent of accurately reporting and seriously interpreting them. The artist then, be he poet or painter or dramatist, is an historian as well. Writing historians not infrequently use the interpretations of artists and poets to support their own. Sometimes, it seems, historical fiction in the drama, the novel, the poem,

[4] H. A. Scott-James, *The Making of Literature* (New York: Henry Holt and Company, 1928), p. 254.
[5] D. Talbot Rice, "The History of Art," in H. P. R. Finberg, ed., *Approaches to Art* (Toronto: University of Toronto Press, 1962), p. 173.
[6] Ibid., p. 161.

and the painting captures the spirit of a time, a place, or a man much better than does the plain, factual record. Examples of successful poetic or other artistic achievements in the historical mode are abundant in literature and painting. Shakespeare's chronicle plays, Scott's historical novels, Thomas Hardy's imaginative and philosophic rendering of the Napoleonic Wars in *The Dynasts,* and Byron's contemporary portraits in *Childe Harold* and other poems are familiarly of this kind.

Professional historians, though they may frequently disagree with the poet-historians, do not simply and always dismiss them as irrelevant to their factual inquiries or their interpretive disciplines. Thus, for example, the historian Pieter Geyl turns respectful and professional attention to Shakespeare's historical plays as responsible works in history. "Shakespeare," he writes, "awoke to literary consciousness at a time when the stage was much used in order to bring before the public the great events of English history. . . . All the crowded variety of a century of English history he attempted to view as a unity." [7] And when he disagrees with Shakespeare, his disagreement is as between one historian and another. Thus, in differing with Shakespeare's account of the incident of the traitors in *Henry V,* he writes against Shakespeare's interpretation of Henry's behavior, which the poet presented in the noble character of the King as "a pattern of royal justice," that "one cannot guard oneself against the suspicion of calculation, and the less so because the traitors have been touched off with too careless a brush; the poet is less than fair to them." [8] And what Professor Geyl seems to mean is not that Shakespeare in this instance is less than fair to the created characters in his play taken fictionally, but that he is not here reading historical fact fairly.

In pictorial art, examples of historically inspired works include, among countless others, not only such factually questionable paintings of a distant past as Poussin's "L'enlèvement des Sabines" and Thomas Couture's "Les Romans de la décadence" but also works based on close and careful research into historical fact of the artist's present and immediate past, such as Copley's "Charles I demanding the Surrender of the five impeached M.P.s" and the same artist's early American portraits. Of the latter it has been said that they are "treasured not only for their splendid pictorial qualities but also as the most graphic record of their time and place," and that they "are priceless documents in which the life of a whole society seems mirrored." [9]

[7] *Encounters in History* (Cleveland and New York: Meridian Books, 1961), p. 14. See the whole essay, "Shakespeare as a Historian: A Fragment."
 [8] Ibid., p. 23.
 [9] *Columbia Encyclopedia,* 2nd ed. (New York: Columbia University Press, 1959), p. 456.

Among other examples of historical art, the mural paintings of Rivera, Orozco, and Siqueiros depict the major figures and episodes of Mexican history from pre-Columbian times to the revolutionary upheavals of the twentieth century. For the illiterate Mexican masses, they have taken the place of books and classroom instruction in recreating the past and presenting themes of national concern.

The role of the artist as historian is clearly recognized in one art historian's reading of Goya in the following passage:

> [Goya's portraits] which secured him a position at the Spanish court, look superficially like State portraits in the vein of Vandyke or of Reynolds. But only superficially, for as soon as we scrutinize the faces of these grandees we feel that Goya seems to mock at their pretentious elegance. He looked at these men and women with a pitiless and searching eye, and revealed all their vanity and ugliness, their greed and emptiness. No Court Painter before or after has ever left such a record of his patrons.[10]

What we have in Goya, according to this understanding, is not only an artist whose works are aesthetically of high excellence but also a keenly critical observer and truthful reporter and interpreter of his time. The second role is, of course, also shown in the familiar Caprichos, a series of trenchant and grotesque social satires. Even more famous and equally significant for the present point are the terrible and terrifying views of war seen in Goya's series of etchings collectively called "The Disasters of War."

In such works as these, it seems clear, there is explicit intent on the part of the artist to picture and interpret the events of history, of his own time or of the past. And the artist is then also an historian working in an artistic mode. But even when the artist is not directly presenting or indirectly alluding to historical material, it is often the case that his works, in addition to being experienced aesthetically, are "read" historically. The historian may look at the painting or read the poem or novel and find reflections of larger historical directions in them, or he may find correlations between the art object and other manifestations of a cultural period such that the character of the whole culture is better understood. For example, an historian of the ancient world generalizes the Greek character as one defined by strict loyalty to the immediate, small, and intimate community, the city-state. Part of the supporting data for that interpretation consists of the never-ending struggles and wars between the various Greek city-states. But, says this scholar, "the individual character of the na-

10 E. H. Gombrich, *The Story of Art*, 11th ed. revised and enlarged (London: Phaidon Press Ltd, 1966), p. 365. Reprinted by permisison of the publisher.

tional genius," which made for local loyalty rather than national unity, "is seen with special clearness in the region of thought and art. . . ." [11] And among the many data which evidence this characteristic local rather than national self-definition, he cites the fact that "there are no two temples in Greece which are exactly alike." [12] The historian thus draws from an architectural (aesthetic) fact, support for a political and cultural generalization.

Another interesting example of reading history from art is the following, in which the character of the people of a past period is in part inferred from the known character of the plays which they went to see. The plays are Shakespeare's and the period is the Elizabethan. The writer observes: "People in throngs, of all classes and callings, gathered to see Shakespeare's plays." What were these people? he asks. The answer can in part be found in many independent historical sources. We have much information concerning them.

> They came in wherries, on horseback, and on foot, from Cheapside and White Chapel, Westminster and Newington, Clerkenwell and Shorditch, deserting for an interval their workbenches, their accounts. . . . their suits of law and their suits at court. . . . These people were shorter on the average than we, and the majority were not so well nourished; the women wore voluminous skirts, and most of the men wore high-crowned hats; they had heard some curious rumors about geography and science.[13]

All this we know from *outside* Shakespeare. But then, the writer goes on to say, we know also (inferentially) what these people were because we know what the plays of Shakespeare are; we know what they were because we know what, in this important instance, they liked or enjoyed. Thus he continues: "In most ways . . . they must have been remarkably like ourselves, for the plays that please us were written to please them." [14] And on the basis of this hypothesis he goes on to particularize the probable character and interests of the Elizabethan man.

Proceeding from such examples as these, we may summarize the presently noticed relationships between art and history in the following conclusions:

1. Works of art are historical events and must be taken into account in any comprehensive chronicle or historical synthesis of their time or period.

[11] M. Rostovtzeff, *A History of the Ancient World*, trans. J. D. Duff (Oxford at the Clarendon Press, 1926), 1:238.

[12] Ibid., p. 247.

[13] Alfred Harbage, *As They Liked It* (New York: The Macmillan Company, 1947), p. 3.

[14] Ibid.

2. Works of art are often, if not always, records, explicit or implicit, of the thought, feelings, and attitudes of a time concerning itself, and they are then self-reflective history as well as historical events. In significant measure, a period records or reveals its history in the art which it produces.

Art and Cultural History

Works of art, often if not always, correlate with or parallel other cultural manifestations of their time—political, social, and intellectual; and attention to its art with a view to noting such relationships can help clarify and give comprehensive understanding of the total life of a people and its period. Or, to put it another way, art and man's other activities stand for the purpose of historical understanding in reciprocal relations. To understand the art of a given period in any full sense, it is necessary to understand the other activities of that period; and to understand these activities, it is necessary to know and to understand its art. This, at least, is the fundamental postulate of what is called "cultural history," conceived as a single all-integrating and all-embracing cultural study of the life of a time. The larger lineaments of a period, which it is the special task of cultural history to trace, are, it is believed, marked by a concurrence of events in different areas of human concern, such as the political or social, on the one hand, and the aesthetic or artistic, on the other. Jacques Barzun, who maintains this thesis, offers a supporting and particularizing example. Citing Richard Lovelace's poem, "To Lucasta, Going to the Wars," he writes:

> Given the task of appreciating all that is wrapped up in a Cavalier lyric, one must know what a Cavalier was, how he looked, whence he drew his ideas of honor and to what wars he was going when he bade farewell to Lucasta. Immediately the historian is face to face with King Charles's head, the ritual of knighthood, Puritanism, and the origin of the fashion of men to wear long hair in curls. All this and more is necessary for an *historical* understanding of the unique cultural product from which we quote "I could not love thee, dear, so much [Loved I not honour more]." Conversely, the poem preserves an historical moment and can help us reconstruct the cultural, that is to say at once the factual and emotional, past.[15]

Art, being a value event, it is implied, must be about something —i.e., expressive of an attitude toward something—and the something is always a fact, real or imagined. If there is no fact, there is no

15 "Cultural History: A Synthesis," in Stern, *The Varieties of History*, p. 393.

value—i.e., no feeling, no attitude. If nothing is "wrapped up" in the poem or work of art, then it is hollow; it is all surface without substance, at least no speaking substance. Hollow poems and hollow art may, of course, be contrived, and they may be formally appealing or interesting, but they are not significant historical-aesthetic events in the way of being culturally communicative. But they will still be data of cultural history. Hollowness may, of course, be a feature of some cultural works or periods, but in that case the very absence of extra-aesthetic reference is a significant characteristic of the work or period. Art and art history then still remain a significant part of the total cultural history, even though the art may not literally represent actual events or express real life emotions.

The Historian as Artist

So far we have emphasized the contribution of art to history. Let us now turn the tables and consider the contribution of history to art. It is obvious that the craft of writing history requires something of the skills that produce a well-wrought work of art. The historian's function is to tell a true story and to tell it well. Excellence in the telling results in artistic quality, whether the telling is of fact or fiction. In the purely technical sense, history is an art.

Among those who recognize an artistic element in history, there are some who maintain that history is at bottom a value enterprise. The superstructure of history, it is said, may be scientific, but, in its presuppositions, history is grounded on and proceeds from nonscientific decisions and interests. For theorists of this type, history in the final analysis is art, and not basically science. The opposite view is that the artistic element in historical writing should always be subordinated to the scientific. History, it is insisted, is essentially a scientific enterprise devoted to the task of gathering and ordering facts and in formulating laws generalized from the facts. An attempt to compromise or mediate between these opposing views is sometimes made in urging that the total method of history as a recounting and interpretation of the past, "the factual and emotional past," is both a science and an art. History, it is said, is written by two methods: "One is intellectual and scientific, the other is intuitive and aesthetic. They do not conflict; they complement each other."

A. L. Rowse, the historian who states this view of the craft of writing history, amplifies the position in saying further:

> In the realm of historical method, there is a non-scientific element that is just as important [as the scientific]. There is the feeling

for the material such as any good craftsman must have for the medium he is working in, the potter for the clay, the mason for the stone, the needle-woman for the texture of her stuff. . . . One derives all sorts of unconscious aids from the practice of one's craft, as with poetry or gardening.[16]

Another historian, Charles A. Beard, makes a stronger point, but with special reference to the *stuff* as distinguished from the method of history. He writes:

> The events and personalities of history in their very nature involve ethical and aesthetic considerations. They are not mere events in physics and chemistry inviting neutrality on the part of the "observer." [17]

Professor Rowse, in a further statement in the work from which we have quoted, while recognizing and insisting that the historian's aim, like the scientist's, is truth, insists too that the historian's method of attaining his truth, in essential part, is by means of imagination, the same power which moves the poet, the novelist, the artist. He writes:

> The historian's business is, like the novelist's, to render life in its proper terms. . . . By sympathetic insight, imagination . . . history records for us life as it has been lived by man. Its essence therefore is in the concrete fact, the manifold variety of events and happenings that once took place in the real world. The historian's business is to narrate them, to re-create them. To do that he needs to be an artist. The process of historical re-creation is not essentially different from that of the poet or novelist, except that his imagination must be subordinated sleeplessly to truth.[18]

A major point of this theorist's position is that the idea of a purely scientific history is not only impossible in conception but, if realized, it would leave the total task of history unfinished or incomplete. Literary or aesthetic history is needed to complete it. And by this is not meant history of literature and history of art in the ordinary sense, but, rather, the use of literary and artistic method in the writing of history. Scientific history, insofar as it can be achieved at all, deals with the mass of men—institutions, collective events, and causal relationships. It does not get to the "concrete facts," the individual lives, the emotional past, the unpredictables of unique persons.

Another historian, George Macaulay Trevelyan, argues his agree-

16 A. L. Rowse, *The Use of History* (London: Hodder and Stoughton, 1946), p. 94. See Chap. 4, "History as Science and Art."
17 "Historical Relativism," in Stern, *The Varieties of History*, p. 324.
18 Rowse, *The Use of History*, pp. 111–12.

ment with this view concerning the claims for literary history as against scientific history, in saying:

> Even if cause and effect could be discovered with accuracy, they still would not be the most interesting part of human affairs. It is not man's evolution but his attainment that is the great lesson of the past and the highest theme of history. The deeds themselves are more interesting than their causes and effects, and are fortunately ascertainable with much greater precision. "Scientific" treatment of the evidence . . . can establish with reasonable certainty that such and such events occurred, that one man did this and another said that. . . . It is the business of the historian to generalise and to guess as to cause and effect, but he should do it modestly and not call it "science," and he should not regard it as his first duty, which is to tell the story.[19]

Scientific history, one might say further, gathers and presents the facts, the materials for complete history. But these facts must be interpreted and felt and ordered. This is the conjoint task of history as art and of art as history. If it is left to the historian and is not done by the historian, then every man must be his own historian. The facts do not relate themselves. They must be imaginatively understood or re-created as story and not merely seen as a series of neutral events.

There is a further point in the theory of history maintained in the works from which the immediately foregoing passages were quoted. As we noted at the beginning of this chapter, the term "history" has two meanings: (1) lived history, everything and anything that happens to mankind; and (2) written history, what is preserved in word or memory as having happened. The two are not the same. In the first place, they cannot be, because the vast number of lived events are too many ever to be told or to be contained in books in which they would be recorded or related. Everything that happens to human beings is history in the first sense, but only a very small part of what happens becomes history in the second sense. Furthermore, what becomes history in the second sense, is not merely a quantitatively small part of history in the first sense; it is, rather, a deliberately selected part of history in the first sense. "In most cases," writes Professor Beard, the historian "makes a partial selection or a partial reading of the partial record of the multitudinous events and personalities in the actuality with which he is dealing." [20]

The selections thus made are intended to be of history-worthy facts. But decisions on what are history-worthy facts are not made sci-

19 In Stern, *The Varieties of History*, p. 233.
20 Ibid., p. 324.

entifically, but in terms of what is in some particular historian's view or in reference to some particular nation's interest, "important." That is, basic decisions on what are history-worthy facts are made normatively. Before scientific history writing begins, the facts which are dealt with scientifically are chosen on nonscientific grounds. According to this view, flatly argued, for instance, by Becker,[21] the data to be interpreted are first created, then interpreted. Or, we could say, the story is conceived or plotted, and after that the facts are invented or modified to serve the predetermined story. This account is somewhat exaggerated, but it may serve to offset the equally exaggerated claim that written history is a purely objective and scientific discipline. It cannot be a strictly scientific matter even in the simplest form of historical record, that of the chronicle, for even a chronicle of events in a limited period must determine by subjective decision what events are to be selected as important or interesting enough to be chronicled. Again, there simply is not room or space enough for everything. And events do not choose or reject themselves. "Important" and "interesting" are value categories.

The historicity theory of history, the theory that history in the sense of written history is relative to changes of interests and biases in lived history, can be translated into the view that history is art, or, more moderately stated, that the two are generically akin. It is interesting to note that more than one literary writer has argued this kinship, in some cases anticipating the professional statements of historical relativists. Thus, for example, Walter Pater put it in these words:

> Your historian . . . with absolutely truthful intention, amid the multitude of facts presented to him must needs select, and in selecting asserts something of his own humor, something that comes not of the world without but of a vision within. So Gibbon moulds his unwieldy material to a preconceived view. Livy, Tacitus, Michelet, moving full of poignant sensibility amid the records of the past, each after his own sense, modifies—who can tell where and to what degree?—and becomes something else than a transcriber: each, as he thus modifies, passing into the domain of art proper. For just in proportion as the writer's aim, consciously or unconsciously, comes to be the transcribing, not of the world, nor of mere fact, but of his sense of it, he becomes an artist, his work fine art. . . .[22]

21 See Carl L. Becker, *Detachment and the Writing of History* (Ithaca, N.Y.: Cornell University Press, 1958).
22 *Appreciations, With an Essay on Style* (London: Macmillan & Company, 1924), pp. 9–10. (First edition, 1873.)

The French novelist, critic, and satirist, Anatole France, expresses a closely similar view. He writes:

Is there such a thing as impartial history? And what is history? The written representation of past events. But what is an event? Is it a fact of *any* sort? No! It is a notable fact. Now, how is the historian to discover whether a fact is notable or not? He decides this arbitrarily, according to his character and idiosyncrasy, at his own taste and fancy—in a word as an artist. For facts are not divided by any hard and fast line of nature into historical facts and non-historical. A fact is something of infinite complexity. Is the historian to present the facts in all their complexity? That is an impossibility. He will present them stripped of almost all of the individual peculiarities that constitute them facts— maimed, therefore, and mutilated, other than what they truly were. As to the mutual connexion of facts with one another, what can we say? . . .[23]

Something of the same disbelief in the notion that the facts of history or the characteristics of a civilization are clearly and simply there to be read in the same way by all competent and careful readers and interpreters of the past is also expressed in the succinct observation of Jacob Burckhardt that "to each eye, perhaps, the outlines of a given civilization present a different picture. . . ."[24] Suggestively, the view here that history, in fact and meaning, is in the eye of the observer and in the mind of the interpreter, is akin to the subjective aesthetic position that "beauty is in the eye of the beholder." Goethe, speaking through the mouth of his skeptical Faust and answering the pedant Wagner, who grandly aspires to measure "the scope and ways of thought in wise men of the past," puts this subjective view strongly:

> *My friend, the past to us is locked from sight,*
> *A book with seven seals. And what you call*
> *The spirit of an age that's gone*
> *At the bottom is your own, whereon*
> *That age's pale reflections fall.*[25]

The implication of these various quotations is that there is a basic kinship between art and history in a common ground of both

[23] *The Garden of Epicurus,* trans. Alfred Allinson (New York: Dodd, Mead and Company, 1922), pp. 123–24.

[24] *The Civilization of the Renaissance in Italy* (New York: Oxford University Press, n.d.), p. 1.

[25] *Goethe's Faust, Part One,* trans. Bertram Jessup (New York: Philosophical Library, 1958), Scene 1, p. 33.

in imagination conceived as a guiding or generating principle in the achievement of human values. "History studied as a liberal art . . . ," as Jacques Barzun has said, "is an artistic discipline, since it requires imagination under control. To teach or write history is thus an incitement to imagination." It is important as a help to "defeat the blind repetitiousness of both inanimate nature and human routine." [26]

Perhaps the most extreme version of the view that history is art is that of William Blake, who maintained simply and without qualification, and with derisive intent, that interpretative history is myth or poetry. It is bad myth and misleading poetry as foisting itself off as report of fact and statement of truth. Besides written histories, Blake holds, there are the historical data, the acts. But these are lived history and lose their factuality when "reported" or interpreted. Scientific history is a fraud or a self-deception. "Reasons and opinions concerning acts are not history. Acts themselves alone are history, and these are neither the exclusive property of Hume, Gibbon, nor Voltaire. . . ." [27]

In Blake, as in many other writers of the relativist persuasion concerning history, there is anticipation of or agreement with the insistence of modern existentialism on the sole reality of the individual person, the unique action, and the unrepeatable event. These always escape scientific and philosophic generalization. In spirit the unique fact, person, or deed can be embodied only in the work of art, which is also always unique.

In the doctrine of historical relativism one further possibility is logically arguable. If history lives only in imagination, it can be grasped only in a metaphor, or image, and on the relative view is grasped only in a succession of metaphors or images. It follows that a history of any given or supposed set of events is many, ever-new things. History is historical. But what, it may be asked, happens when no new metaphor is found to re-imagine these events in a way that makes them meaningful to present experience? The possibility is there and has itself been imagined. The answer is clear: a history then becomes nothing. A poet too has suggested this possibility in saying, "A world ends when its metaphor has died." [28]

26 "History as a Liberal Art," *Journal of the History of Ideas* (1945) 6:88.
27 Quoted by Mark Schorer in *William Blake: The Politics of Vision* (New York: Vintage Books, Random House, Inc., 1959), p. 90. There seems to be some confusion in Blake's mind between the two meanings of history—namely, history as acts and history as narrative.
28 Archibald MacLeish, "Hypocrite Auteur," *Collected Poems 1917–1952* (Boston: Houghton Mifflin Company, 1952), p. 173.

Art and History Allied but Distinguishable

Despite the exaggerated claims of some relativists, the historian is not free to invent fictitious characters and events. Noting this fact, Francis Bacon contrasted "true history" with the feigned history of epic or tragedy.

> The use of this FAINED HISTORIE hath beene to give some shadowe of satisfaction to the minde of Man in those points wherein the Nature of things doth denie it, the world being in proportion inferiour to the soule. . . . Therefore, because the Acts or Events of *true Historie* have not that Magnitude which satisfieth the minde of Man, *Poesie* faineth Acts and Events Greater and more Heroicall . . . And therefore it was ever thought to have some participation of divineness, because it doth raise and erect the Minde, by submitting the shewes of things to the desires of the Mind, whereas reason doth buckle and bowe the Mind unto the Nature of things.[29]

Bacon is pointing to a fundamental contrast between "Poesie" and history. In the words of Sir Philip Sidney, in his *Apology for Poetry,* Nature's "world is brazen, the poets only deliver a golden." Not so with sober historians. They avoid the falsification of facts. With scrupulous care in the formulation of hypotheses and the search for evidence, they find and collect documents or artifacts and then decipher and assess them. Next they carefully interpret what they have thus gathered, verifying and comparing and collating bits of evidence. Finally, they construct their "true" historical narratives. The technique of historical research is a sophisticated attempt to be accurate. Napoleon said that history is a fable agreed upon by the winning side, but this is to characterize "history" in quotation marks, "history" that passes for history but fails to be completely historical. While admitting that historical narratives are seldom completely objective and that there is much truth in Napoleon's jibe, we would still contend that the aim of a conscientious historian is different from that of a novelist.

Even if genuine history is a "reliving" of the past, the question remains: *How can one know that one is doing so?* To have a *seeming* experience of the past does not guarantee its historical authenticity. We cannot mount H. G. Wells's "time-machine" and travel back through the centuries to experience *directly* the murder of Becket.

R. G. Collingwood's answer to our question is that the historian must use a hypothetico-deductive method akin to that of a skilled detective in solving a murder mystery. Just how this can best be done

[29] *The Advancement of Learning,* II, xiii.

is subject to dispute. Collingwood thinks it can be accomplished by the use of specific perceptions and insights pertaining only to the special case in question. This contention is sharply rejected by positivists such as Karl Popper and C. G. Hempel, who believe that history, in verifying and explaining past events, must draw upon the *generalizing* sciences, such as physics, biology, psychology, and sociology.[30] Whether one agrees with Collingwood or the positivists, the fact remains that there must be a verification process of a hypothetico-deductive type. This necessity distinguishes history from the imaginative arts.

Some writers, denying this distinction, make the point that even fictitious art is not indifferent to historical criteria, because it obeys the laws of "verisimilitude." Croce replies, in his article on "aesthetics" in the 1944 edition of the *Encyclopaedia Britannica,* that "verisimilitude" is here "only a rather clumsy metaphor for the mutual coherence of images." In this sense, even a highly fanciful work, such as *Alice in Wonderland,* exhibits verisimilitude. Similarly, Collingwood remarks that the historian and the novelist are alike in constructing a coherent narrative but differ in their relation to objective fact:

> Each aims at making his picture a coherent whole, where every character and every situation is so bound up with the rest that the character in this situation cannot but act in this way, and we cannot imagine him acting otherwise. . . . As works of imagination, the historian's work and the novelist's do not differ. Where they do differ is that the historian's picture is meant to be true. The novelist has a single task only: to construct a coherent picture, one that makes sense. The historian has a double task; he has both to do this, and to construct a picture of things as they really were and of events as they really happened.[31]

Collingwood goes on to say that the necessity of writing a truthful narrative imposes upon the historian three rules of method, from which the novelist is free:

> First, his picture must be localized in space and time. The artist's need not; essentially, the things that he imagines are imagined as happening at no place and at no date. Of *Wuthering Heights* it has been well said that the scene is laid in Hell, though the place names are English. . . . Secondly, . . . purely imaginary worlds cannot clash and need not agree; each is a world to itself. But there

30 See William H. Dray, ed., *Philosophical Analysis and History,* esp. essays by Hempel, Donagan, and Mink (New York: Harper and Row, 1966).

31 R. G. Collingwood, *The Idea of History* (New York: Oxford University Press, 1946), pp. 245–46. By permission of The Clarendon Press, Oxford.

is only one historical world, and everything in it must stand in some relation [of consistency] to everything else. . . . Thirdly, and most important, the historian's picture stands in a peculiar relation to something called evidence. . . . What we mean by asking whether an historical statement is true is whether it can be justified by an appeal to evidence: for a truth unable to be so justified is to the historian a thing of no interest.[32]

These differences between verisimilitude in a novel and truth in a historical narrative are fundamental. The historian, like the novelist, must exercise imagination, but his function is to imagine the real and not the merely possible.

Writing history as if it were fiction has been labeled "the aesthetic fallacy." In a book on the fallacies of historians, David Hackett Fischer has declared:

The *aesthetic fallacy* selects beautiful facts, or facts that can be built into a beautiful story, rather than facts that are functional to the empirical problem at hand. It consists in an attempt to organize an empirical inquiry upon aesthetic criteria of significance, or conversely in an attempt to create an *objet d'art* by an empirical method.[33]

Fischer cites the practice of the Roman historian Livy, who "subordinated historical precision to the demands of character and plot." Livy is even "reputed to have said that he would have made Pompey win the battle of Pharsalia if the turn of the sentence had required it. This extraordinary statement is attributed to Livy by Lytton Strachey, who thought it a perfectly sensible idea." [34] Among modern historians, A. L. Rowse, Bernard De Voto, and Samuel Eliot Morrison are accused by Fischer of committing the aesthetic fallacy. Although not "deliberate falsifiers," they are inclined "to tell beautiful stories for the aesthetic intoxication of their readers."

By definition, fact and fiction are incompatible, and to confuse the two is fallacious. But this does not mean that the historian and the novelist have nothing in common. A novelist may incorporate known facts into his narrative, as did Tolstoy in *War and Peace,* Dickens in *A Tale of Two Cities,* Hemingway in *For Whom the Bell Tolls,* and Malraux in *Man's Fate* and *Man's Hope.* Conversely an historian such as Herodotus or Macaulay can be an excellent storyteller. No doubt a love of the dramatic can lead the historian astray;

32 Ibid., p. 246.

33 *Historians' Fallacies* (New York: Harper and Row, 1970), p. 87.

34 Ibid. See also Lytton Strachey, *Spectatorial Essays* (London: Chatto and Windus Ltd, 1964), p. 13.

but there is plenty of drama in real life faithfully portrayed. In the great historians, such as Thucydides, Gibbon, and Prescott, that skill has not been lacking. Fischer seems to forget that facts are infinite in number and that the historian cannot record everything. Because all facts are equally true, he must have some other criterion for selection besides truth. Why should not one of the criteria be what is intrinsically interesting? There need be no falsification to satisfy this criterion, for true stories may be highly dramatic and reveal fascinating traits of character. If, in addition, there is grace of style, the narrative will be aesthetically satisfying, and so much the better.

Another criterion for selection is one's vision of history. Man has two contradictory ways of looking at himself as an historical agent. One way is to see himself as a unique and free individual shaping his own individual destiny. To quote from Shakespeare: "It is not in our stars, dear Brutus, but in ourselves that we are underlings." This is the vision of Carlyle in his history of the French Revolution and Malraux in his novels of the civil wars of China and Spain. The other way is to see man *en masse,* a mere statistic or helpless atom in the gigantic flow of historical necessity. This denial of free will we also find in Shakespeare: "As flies to wanton boys, so we are to the gods. They plague us for their sport." Tolstoy so envisaged mankind in his panoramic vision of the battles of Borodino and Austerlitz and in his characterization of Napoleon, Field Marshal Kutuzov, and Czar Alexander. Similarly, Thomas Henry Buckle in his *History of Civilization in England* (1857) interpreted history in terms of statistical trends and the irreversible momentum of cause and effect. Both kinds of historical vision, libertarian or determinist, are the products of philosophical imagination and incapable of proof at the present stage of human knowledge. Whether the writer be an historian, a novelist, or a playwright, he cannot escape from this enigma. Here again is a vital link between art and history.

Although on other grounds we may still distinguish between history and art, they serve the same liberating function. In its daily round, the human spirit is fenced in by all sorts of environmental limitations and practical exigencies. Each of us is doomed to play a single role, or, at least, a very limited number of roles. But there is no limit to the elasticity of our imagination or the potential range of our passions. We can fancy ourselves kings or beggars, heroes or villains, saints or sinners. Both the artist and the historian tap this capacity for imaginative projection. As Wilhelm Dilthey wrote:

> For me, as for most people today, the possibility of living through religious experiences in my own person is narrowly circum-

scribed. But when I run through Luther's letters and writings, the accounts given by his contemporaries, the records of the religious conferences and councils and of his official activities, I live through a religious process of such eruptive power, of such energy, in which the stake is life or death, that it lies beyond the possibility of personal experience for a man of our day. But I can relive it. . . .[35]

Most of us will never fly to the moon; but by means of art and history, we can be transported to far distant times and places, more fascinating than any moonscape. Without this liberation, we would never be able to comprehend the boundless possibilities inherent in human life or even in ourselves, nor could we imaginatively realize our unfulfilled hopes.

Bertrand Russell has said: "There has been much argumentation . . . as to whether history is a science or an art. It should, I think, have been entirely obvious that it is both." [36] This conclusion, tame though it may be, is justified.

[35] In H. A. Hodges, *Wilhelm Dilthey: An Introduction* (London: Routledge & Kegan Paul Ltd, 1969), p. 123.

[36] Bertrand Russell, "History as an Art," in Robert E. Egner and Lester E. Denonn, eds., *The Basic Writings of Bertrand Russell* (New York: Simon and Schuster, 1967), p. 533.

Chapter 11

ART

AND SCIENCE

Truth in Science and Truth in Art

In our comments on fundamental human interests, we have placed stress on the interrelations of those interests. We have observed that, rightly understood, they do not constitute separable or optional ways of life; they are rather strands in a single texture which is life complete and whole.

We want now to indicate in some particulars how such interrelationships obtain, specifically, between art and science. Art, then, we postulate, is not an independent way of life which may be preferred to some other way of life, for example here, the scientific. It is rather one fundamental part of complete living. It is no rival to anything else. It cannot stand alone. There can be little if any art without science, without morality, or even without economics. Art alone becomes unreal—an ivory tower, and the soul dwelling in "The Palace of Art" becomes, as Tennyson expressed it,

A spot of dull stagnation, without light or power of movement . . .
A still salt pool, locked in with bars of sand,
Left on the shore.

Conversely, science alone affirms no value; morality alone becomes dogma; and economics alone becomes inhuman—becomes the "dismal science." The data of science, of morality, and of economics are all incomplete without consideration of art in fact and in value.

A great deal has been written about the relations between art and science. It has been widely and variously both contended and denied that science and art are cognate pursuits aiming at truth and differing only in their methods or in being concerned with different kinds or aspects of reality. On the positive side, we have, for instance, the summary words of Herbert Read, who writes:

> In the end I do not distinguish science and art, except as methods, and I believe that the opposition created between them in the past has been due to a limited view of both activities. Art is the representation, science the explanation—of the same reality.[1]

On the negative side, we have the declaration that science and art must be sharply distinguished, truth or knowledge applying to the former but not to the latter. "No object in any mode of art can be of any value in attaining new knowledge," declares Rudolf Carnap. "Whatever therefore we take from a work of art may offer emotional or formal pleasure but cannot offer intellectual meaning." [2] Less extreme, but allied to this position, is the contention that art (especially literature) may express truth, but it does so adventitiously or accidentally. Thus, says one writer who holds this view, the poem "contains truth when at all, by an aesthetic accident and not as a part of its poetic nature." [3]

An intermediate position is that science and art differ profoundly, but that each contributes in its own distinctive way to man's understanding of his world. They both have a place in the total cognitive enterprise. According to the British poet, C. Day Lewis, poetry deepens our insight into the qualitative domain of feeling and value, whereas science explores the quantitative domain of measurement and regularity. "The distinction between qualitative and quantitative," he declares, "defines the separate fields of science and poetry." [4] Answering in the affirmative, he asks:

> Is not the feel of a thing as real, as much a fact, as the thing felt? Is not the conveying of the quality or value of an experience, therefore, a contribution to knowledge no less useful than the

[1] *Education Through Art* (New York: Pantheon Books, Inc., 1943), p. 11.
[2] Quoted by Stephen D. Ross, *Literature and Philosophy* (New York: Appleton-Century-Crofts, 1969), p. 219.
[3] Sidney Zink, "Poetic Truth," *The Philosophical Review*, 54 (1945), 133.
[4] *The Poet's Way to Knowledge* (Cambridge at the University Press, 1957), p 16.

analysis of that experience in terms of physical fact and natural law? [5]

Likewise Stephen Pepper, speaking of art and science in general, argues that science provides a conceptual grasp of causal connections while art conveys the most vivid realization of felt qualities:

> Art . . . as well as science is a cultural institution. Both have important cultural values. Those of art are mainly consummatory, those of science instrumental. And both contribute enormously to human knowledge: that of art to the qualitative living experience of men, that of science to the conceptual control of man's environment. Human wisdom requires that they should never be widely separated from each other. Each needs the other for a balanced view of the world, and for balanced judgment in human policy and action. [6]

This view, that science and art are complementary rather than competitive and that each in its own way contributes to human insight, is the position that we wish to defend.

Without pursuing the basic theoretical questions of the ultimate relation or irrelation between art and science—a pursuit which would lead us into the mazy reaches and perhaps quags of metaphysics and twisty linguistic analysis—we will assume the plain common-sense understanding that science is not art and art is not science in ruling purpose or in governing method. Scientific discourse is not poetry, and an account of scientific discovery is not fiction. The two endeavors, we will agree, are different in aim and value. Science seeks truth to fact, art gives truth to *felt* fact and *felt* imaginary things. In science, we can say, man is observer—ideally, an instrument—intent on knowing what things are apart from human desires, wishes, hopes, fears. In art man is, in part, of the very substance of what he shows, tells, or imagines. In science it is palpably an absurdity to ask if an observation or an experiment was made from a certain attitude other than cognitive, an attitude fixed in a certain religious affiliation or political persuasion, for instance. There is, despite silly statements to the contrary, no Catholic mathematics, no Protestant physics, and no communist or capitalistic chemistry. The scientist, *qua* scientist is neutral on all human sentiments or affections, whether individual or institutionalized in church, political party, or social class. In art and poetry it is different. Religious or atheistic or naturalistic poetry is not absurd. Religiousness or atheism or naturalism are attitudes, feelings to-

5 Ibid., p. 5.
6 Stephen C. Pepper, *Concept and Quality* (La Salle, Ill.: Open Court Publishing Company, 1967), p. 619.

ward the world, its facts and events. In art *felt* quality is the fact; in science feeling is a corruptive irrelevance.

This basic difference has been discussed, with particular reference to the contrast between literature and science, by Dorothy Walsh, a philosopher who has devoted much thought to the subject. In *Literature and Knowledge,* Professor Walsh poses the question: What kind of knowledge, if any, does literary art afford? By "literary art" she refers to such productions as poems, novels, plays, and by "knowledge" she means not only verifiable descriptions but revelatory insights. This inclusive meaning of knowledge is implied in the common remark: "You don't really know what it is until you have experienced it." Walsh is quite willing to admit that a work of literary art, *as art,* is not a vehicle for an abstract claim, message, or thesis to be backed up by evidence and arguments. But she distinguishes between "knowing about" something in this discursive sense and knowing the concrete quality of an experience by "living through it." For example, one might say, "I know what it's like suddenly and unexpectedly to fall in love, because this is what happened to me." The revelatory character of such direct experience provides the clue for answering her question: What kind of knowledge does literary art afford? "The answer I propose," she says, "is that literary art, when functioning successfully as literary art, provides knowledge in the form of realization: the realization of what any thing might come to as a form of lived experience." [7]

She gratefully acknowledges her indebtedness to John Dewey's distinction between what is just experience and what is "an experience." There may be nothing that "stands out," nothing especially noteworthy, in experience, because it is what comes to us in every conscious moment of our lives. But there are experiences that have a peculiar lustre of their own, that impress us with their quality and distinction. Then we respond with a heightened awareness, with a sense of realization and disclosure, and we exclaim, "That really was an experience." The aesthetic factor, according to Dewey, is not something separate and superadded: it consists in those very features of an experience that make it outstanding. Art elicits and accentuates these features by creating objects, such as those characterized by highly expressive form, that are aesthetic to a superlative degree.

Although he distinguishes science and art, and rejects all cognitive theories of art as untenable in a literal sense, Dewey still takes seriously

[7] Dorothy Walsh, *Literature and Knowledge* (Middletown, Conn.: Wesleyan University Press, 1969), p. 136.

the sense of increase of understanding, of a deepened intelligibility on the part of objects of nature and man, resulting from aesthetic experience. . . . The sense of disclosure and of heightened intelligibility remains to be accounted for. . . . Tangled scenes of life are made more intelligible in aesthetic experience: not, however, as reflection and science render things more intelligible by reduction to conceptual form, but by presenting their meanings as the matter of a clarified, coherent, and intensified or "impassioned" experience.[8]

Science as conceptual and cognitive, and art as presentational and passional, are thus seen as complementary, each with its own kind of import. The total task of understanding and ordering is seen as a shared task of science and art.

Although accepting this theory of Dewey, Dorothy Walsh distinguishes between "life experience" and the "virtual experience" (borrowing the latter term from Susanne Langer) incarnated in a work of literary art. The "life experience" just happens, the "virtual experience" is made. When fashioned by a poet, novelist, or playwright, the virtual experience has a greatly enhanced power of disclosure. "Life experience, as actual experience, is idiosyncratic, fragmentary, and fleeting; only virtual experience, structured and articulated, lifted out of the temporal flux of ongoing happening, provides something that can be fully realized and shared." [9] Literary art, through its creation of virtual experience, thus provides an immense extension and elaboration of the kind of concrete insight that characterizes "an experience." When the virtual experience strikes us as authentic we call it "truth"; when it deepens our understanding of life we call it "knowledge." In using these terms, we should avoid any confusion with the "knowledge" and "truth" of scientific discourse.

One difference between the two kinds of truth is that the artistic is embodied in imaginative or fictional experience, whereas the scientific kind is straight-out factual assertion verified by empirical method. The author of a fictional work, unlike the writer of a scientific discourse, does not by first intention assert the propositions which it contains. He uses them fictionally. But is this all that he does? Does the fictional intent preclude a cognitive intent? Is a fictional work necessarily noncognitive? Many writers of novels and plays and poetry do not think so. They do believe that fiction can be used to present truth. Fiction and truth do not, to their minds, appear as con-

8 John Dewey, *Art as Experience* (New York: G. P. Putnam's Sons, 1934), pp. 288–90. Quoted by permission of G. P. Putnam's Sons.
9 Walsh, *Literature and Knowledge*, p. 139.

tradictories. Thus, for example, Bernard Shaw, in the preface to his
Major Barbara, writes:

> This play of mine, *Major Barbara,* is, I hope, both true and in-
> spired; but whoever says that it all happened, and that faith in
> it and understanding of it consist in believing that it is a record
> of an actual occurrence, is, to speak according to Scripture, a fool
> and a liar. . . .

What Shaw means, we suggest, is simply that fictional discourse does
not or need not say *these* named persons existed or that *these* de-
scribed events happened, but rather that *such* persons existed and that
such events took place, or may exist, or could happen. And in this
he is in disagreement with any literal-minded reader who would say,
for example, that the assertion that Barbara joined the Salvation Army
is false simply because no such being as Major Barbara ever existed.
Shaw would agree, of course, that there is no such *specific* person as
Major Barbara, but he would regard that as patently obvious. And
he emphatically would not agree that fictional statements, because they
have no specific existent referents, are obviously false. They can be
true precisely because *such* persons can or do exist—that is, human
beings of the *kind* represented or described in fiction. So understood,
fiction does by second intention function as cognitively meaningful dis-
course.

The imaginative dimension of art whereby it transcends literal
fact is a natural consequence of its value-expressive character. As we
have repeatedly insisted, artists see life and nature and possibility in
valuational perspective and embody in their works the vivid values
that they thus discover or create. Unlike the scientist who, in the
words of Francis Bacon, "buckles and bows his mind to the nature
of things," or unlike the philosopher who characterizes reality and value
in abstract terms, the artist creates "an imaginative world in which
X shows forth as bright, luminous, and desirable, and Y shows forth
as shadowed, as suspicious, as undesirable." [10] The qualities of aesthetic
objects are values and not "neutral" matters of fact—they are *felt* qual-
ities, not separable from the awareness and appreciation of them. Values
are frequently ideal and not real, created by the imagination, and
even when they are "real," in the sense of being characteristic of "lived
experience," they are relational properties of the subject-object situa-
tion. Especially in art, the object-felt-about and the feeling-about-the-
object are internally related, being inseparable and mutually deter-
minative. All this we have said before, but we repeat it for emphasis.

[10] Ibid., p. 131.

If the artist *qua* artist expresses interests and a sense of values, it may appear to be misleading to characterize art as a mode of knowledge. As value-expressive, art transcends the limits of the natural world, making "the loved earth more lovely," or portraying dreadful possibilities rather than actualities, as in Dante's hell. Art may even forswear representation entirely and revel in the qualities of pure abstract design. To dwell upon truth and knowledge literally interpreted as the essential elements in art is to commit "the factualist fallacy," the fallacy of reducing value to bare fact. Because of these considerations, a number of careful aestheticians, when speaking of the kind of significance that works of art exhibit, prefer such terms as "import," "meaning," "insight," or "expressiveness" rather than "knowledge" or "truth."

We can still maintain that works of art, especially works of a representational character, have a kind of concrete and "living" significance akin to *"an* experience" in Dewey's sense. Whether we call such virtual experience "knowledge," "import," or something else is less important than that we should be unmuddled in our thinking. It would be a mistake to suppose that art is "true" in the sense in which a scientific description is true. It would be as much a mistake to dismiss art as "emotive" and thereby to deny that it can deepen our insights. As Nelson Goodman said: "In aesthetic experience the *emotions function cognitively."* [11] The fact that the work of art is felt and imagined does not deprive it of significance. Possibilities explored by emotion and imagination may be as significant as actualities, and a world not proved but possible may be a thing of awful portent, so beautiful that it pierces the spirit unforgettably, or so tragic that it touches the very depths of life.

Alfred North Whitehead has remarked:

All that has any significance is the depth and validity of an experience out of which art comes; if it comes out of mere consciously clever ratiocination, it is foredoomed. [12]

Call it profundity or what you please, this "depth and validity" characterizes the music of Bach, the paintings of Rembrandt, the tragedies of Shakespeare, and the novels of Dostoevsky. It is not the same as discursive meaning—it can't be reduced to a formula or a paraphrase—and it is not subject to scientific verification. But of the peculiar

11 *Languages as Art* (Indianapolis and New York: Bobbs-Merrill Company, 1968), p. 248.
12 *Dialogues of Alfred North Whitehead, as Recorded by Lucien Price* (Boston: Little, Brown and Company, 1954), p. 70.

kind of utterance that is art, we can say what was said by Wittgenstein:

> If only you do not try to utter what is unutterable then *nothing* gets lost. But the unutterable will be—unutterably—*contained* in what has been uttered.[13]

How Science Contributes "Raw Materials" to Art

Science and art meet in various ways. Ultimately, the one world of science is also the one world of art. The availability to art of the whole world of fact and the whole range of experience, intellectual as well as emotional and sensuous, can hardly be questioned. The "aesthetic state" as a thing apart is a phantom.[14] The aesthetic experience rises from the real world made up of all kinds of other experiences, including basically scientific experience. The feelings, emotions, and attitudes which art expresses are directed in main part upon the facts and truths which science offers. And even the imaginations and constructions which art may seem to evolve independently are in the final analysis inescapably anchored in scientific fact and theory.

To cite an example, the innumerable poems on mutability, such as Shakespeare's sixty-fifth sonnet, beginning,

> *Since brass, nor stone, nor earth, nor boundless sea,*
> *But sad mortality o'er-sways their power . . .*

would lose their force—could not in fact be written or felt—if all-pervasive change as the order of nature were not established as scientific fact. The concept of mutability, reinforced by an early version of the atomic theory, prompted Lucretius' vision of all things arising from and returning to a material base:

> *Globed from the atoms falling slow or swift*
> *I see the suns, I see the systems lift*
> *Their forms; and even the systems and the suns*
> *Shall go back slowly to the eternal drift.*[15]

Likewise, in Shelley's poetry the mutability of things takes on the perspectives of a cosmic vision:

[13] Paul Engelmann, *Letters from Ludwig Wittgenstein* (Oxford: Basil Blackwell & Mott Ltd, 1967), p. 7.

[14] See I. A. Richards, "The Phantom Aesthetic State," in *Principles of Literary Criticism* (New York: Harcourt, Brace, and Company, 1924), Chap. 11.

[15] William Hurrell Mallock, *Lucretius on Life and Death, in the Metre of Omar Khayyam* (London: A. C. Black, 1900).

Worlds on worlds are rolling ever
From creation to decay,
Like the bubbles on a river
Sparkling, bursting, borne away.[16]

This theme of universal flux is only one among many ideas that science has imprinted upon the minds of poets and artists. As J. Arthur Thomson, distinguished Professor of Natural History at Aberdeen University, has said, "Science has enormous stores of what may be called the raw materials of Art." [17] The interest of art in scientific report of fact as constituting a significant part of experience is, then, one of the important relations between art and science. Both science and art are directed upon the same world. Science expresses our understanding of the world, art our feeling attitude toward it—toward it, in part, as reported and theorized by science.

In his Preface to the *Lyrical Ballads,* Wordsworth remarks on this kind of relation between science and poetic art:

The man of science seeks truth as a remote and unknown benefactor; he cherishes and loves it in his solitude: the poet, singing a song in which all human beings join with him, rejoices in the presence of truth as our visible friend and hourly companion. Poetry is the breath and spirit of all knowledge; it is the impassioned expression which is in the countenance of all science.

The reports and theories of science condition not only what the artist feels but also what he sees and creates. Science conditions not only intellectual experience, observationally and ideologically, but it also expands, directs, and modifies the sensory and perceptual forms and qualities of art, as well as its ideas. Again to quote Wordsworth:

If the labors of men of science should ever create any material revolution, direct or indirect, in our condition, and in the impressions which we habitually receive, the poet will sleep then no more than at present; he will be ready to follow the steps of the man of science, not only in those general indirect effects, but he will be at his side, carrying sensation into the midst of the objects of the science itself. The remotest discoveries of the chem-

16 "Chorus" from *Hellas.* See also Alfred North Whitehead, *Science and the Modern World* (New York: The Macmillan Company, 1926, and London: Cambridge University Press), pp. 122–25. Whitehead's contention that Shelley's knowledge of science was "part of the main structure of his mind, permeating his poetry through and through," has been elaborately documented by Carl H. Grabo in *A Newton Among Poets* (Chapel Hill: University of North Carolina Press, 1930).

17 *Introduction to Science* (New York: Henry Holt and Company, 1912), Chap. VI, "Science and Art," p. 192.

ist, the botanist, or mineralogist, will be as proper objects of the poet's art as any upon which it can be employed, if the time should ever come when these things shall be familiar to us, and the relations under which they are contemplated by the followers of these respective sciences shall be manifestly and palpably material to us as enjoying and suffering beings. If the time should ever come when what is now called science, thus familiarized to men, shall be ready to put on, as it were, a form of flesh and blood, the poet will lend his divine spirit to aid the transfiguration, and will welcome the being thus produced, as a dear and genuine inmate of the household of man.

Wordsworth is speaking in the future tense, but he could truly have spoken of the present effect of science upon poetry. He himself kept abreast of the science of his day, including the development of associationist and gestaltist concepts in psychology, and this knowledge had a marked influence upon his poetry. [18]

Likewise, his friend Coleridge attended Humphry Davy's lectures on science "to increase his stock of metaphor," but his poetry was not always consistent with scientific fact. The image in *The Ancient Mariner* of

> *The hornéd moon with one bright star*
> *Within the nether tip. . . .*

is false to both scientific fact and appearances. There could never be a star inside the tip of the crescent moon, because the invisible part of the full moon occupies this space. The question can be asked whether this inaccuracy is an *aesthetic* defect. We think it is if interpreted as sheer error. To sharpen the question, let us compare Coleridge's lines with Wordsworth's characterization of Lucy:

> *Fair as a star when only one*
> *Is shining in the sky.*

A multitude of stars seen against a pitch-black sky is intense and overpowering, but a single star in a twilight sky is tender, mild, and beautiful—in one word, "fair." The agreement of Wordsworth's lines with the facts of perception enhances their poetic power. On the other hand, the inaccuracy of Coleridge's lines—once the reader grasps it—detracts from the beauty.

Someone might reply that we accept a measure of "poetic license" even in ordinary speech. We do not complain of a poet, or even a postman, who says "the sun rises," and we should not com-

[18] See Melvin Rader, *Wordsworth: A Philosophical Approach* (Oxford at the Clarendon Press, 1967), esp. Chap. IV.

plain when Coleridge similarly engages in a little poetic license. This reply misses the point of our criticism. "The sun rises" is true to appearances, and everyone understands that appearance is being reported; whereas Coleridge's description of a star within the crescent moon's tip violates appearances just as much as it violates scientific fact. Because the invisible part of the moon occupies the space and blocks the view of any more distant object, it is impossible for the star either to appear or be within "the nether tip."

This departure from accuracy is a small defect in a poem that psychologically rings true. As C. Day Lewis has written:

> Coleridge's poem, through images of ocean travel, tells a story of guilt, retribution and expiation—a sequence of events no less actual than the sequence of events which produces coal gas. Any psychologist would agree, I think, that the mental events symbolized in the poem are true to observed facts of human behaviour. But the poem does not merely embody a complex of experiences; it *is* an experience: and thus the kind of knowing it offers is different from the knowledge we should get from a number of case-histories illustrating the same sequence of mental events.[19]

In terms of the revelatory power of "virtual experience," *The Ancient Mariner* is "true" and "authentic."

Even with respect to the apparent inaccuracy we have mentioned, it might be said in Coleridge's defense that the image of the star is merely the Ancient Mariner's hallucination characteristic of his disordered mind. The departure from scientific fact and normal appearance would then be true to psychological fact, because it would be expressive of the wild perspective of the character, just as the terrifying distortion in Edvard Munch's painting, "I Hear the Scream of Nature," is expressive of the near-crazy panic of the man on the bridge. For Munch, the expressionist, "Nature is not only what is visible to the eye—it also shows the inner images of the soul—the images on the back side of the eyes." [20]

The inaccuracies in the art of children and primitive people are often highly expressive in this manner. Joyce Cary, the Irish novelist, has written:

> A small girl of seven once asked me if I would like a drawing. I said yes. She asked, "What shall I draw?"
> "Anything you like."
> "Shall I draw you a swan?"

19 *The Poet's Way to Knowledge*, pp. 5–6.
20 Quoted by Herschel B. Chipp, *Theories of Modern Art* (Berkeley and Los Angeles: University of California Press, 1969), p. 114.

"Yes, a swan"; and the child sat down and drew for half an hour. I'd forgotten about the swan until she produced the most original swan I'd ever seen. It was a swimming swan, that is, a creature designed simply to swim. Its feet were enormous and very carefully finished, obviously from life. The whole structure of the feet was shown in heavy black lines. The child was used to seeing swans on a canal at the end of her garden and had taken particular notice of their feet. Below the water the swan was all power. But for body she gave it the faintest, lightest outline, neck and wings included in one round line shaped rather like a cloud—a perfect expression of the cloud-like movement of the swan on the surface.[21]

Here the distortion is the means to truth.

We must distinguish, as Aristotle did in the *Poetics,* between the inept distortion that is the result of ignorance and the expressive distortion that is, as in the example cited by Cary, the result of a subtle intuition. If the poet depicts the impossible, wrote Aristotle,

he is guilty of an error, but the error may be justified, if the end of the art be thereby attained. . . . If, however, the end might have been as well, or better, attained without violating the special rules of the poetic art, the error is not justified: for every kind of error should, if possible, be avoided. Again, does the error touch the essentials of the poetic art, or some accident of it? For example, not to know that a hind has horns is a less serious matter than to paint it inartisically.[22]

We agree with Aristotle that inexpressive and inadvertent error should, in general, be avoided, but that "error" may be justified "if the end of the art be thereby achieved" and the *artistic* "truth" enhanced. The poetic value or truth of a poem, for example, is not determined by the literal truth of the poem or any part of it. The poem may refer to factual matters, directly or obliquely, and its reports may be false, historically or scientifically, without being false poetically. The poem communicates or expresses a feeling about a fact or state of affairs, not the bare fact or state of affairs. It is the truth to felt qualities which the poem expresses, not scientific or historical accuracy.

An error in the sonnet of Keats "On First Looking into Chapman's Homer" is a case in point. One day in the autumn of 1816, Charles Cowden Clarke summoned his old school friend, John Keats, to explore a beautiful copy of Chapman's Homer. So excited were the two young

[21] *Art and Reality* (New York: Harper and Brothers, 1958, and London: Cambridge University Press).

[22] *Poetics*, 4th ed., trans. S. H. Butcher (London: Macmillan & Company, 1911), Sec. XXV.

men by this translation that they read favorite passages to one another throughout the night until dawn. Keats then walked home, his mind churning with the wonder and delight of his experience. He composed the sonnet during that long homeward walk, and all he had to do when he reached his destination was "to see that it looked right on paper." [23] The concluding lines, in this original version, read as follows:

> Then felt I like some watcher of the Skies
> When a new Planet swims into his ken;
> Or like stout Cortez, when with wond'ring eyes
> He star'd at the Pacific, and all his Men
> Look'd at each other with a wild surmise
> Silent upon a Peak in Darien.

In a later emendation Keats substituted "eagle eyes" in place of "wond'ring eyes," but he left the factual error uncorrected. The question is whether the reference to Cortez rather than Balboa detracts from the "truth" of the poem.

The experience of discovering Chapman's Homer pored itself into the sonnet form, and the feeling had to fit. Keats had to tell what it was like within the limits of that form, and the form had to be respected in all its particulars, the fourteen lines, the iambic metre, the rhyme scheme and all. These features had to be the means of communicating a tremendous experience, and if necessary, they must overrule mere factual accuracy. "Cortez" compared with "Balboa" is freighted with a far richer connotation of boldness and adventure. Keats had seen the striking picture of Cortez by Titian, and, according to Leigh Hunt in his *Recollections,* the poet's imagination had been deeply impressed by "Cortez's eagle-eyes" portrayed in the painting. All things considered, the name "Cortez" was more faithful than "Balboa" to the stirring experience Keats was seeking to communicate.

These considerations may alleviate but not entirely dispel the reader's uneasiness about the mention of Cortez. The autobiographical context, it can be argued, demands greater fidelity to fact. Keats tells us in the sonnet that his discovery of Chapman's Homer is comparable in its psychological impact to the discovery of the Pacific Ocean by a famous explorer. Given this context in which one actual occurrence is being compared with another, the poet has invoked *factual* terms of reference. He has entered into an implicit pledge to "tell a true story," and his failure to keep that pledge jars on the reader. It is the pledge and not the fact that binds him. In a different frame of reference, the pledge

23 See B. Ifor Evans, "Keats's Approach to the Chapman Sonnet," *Essays and Studies by Members of the English Association* (Oxford at the Clarendon Press, 1931), Vol. XVI.

to tell a true story would be absent or less pressing, and the question of truth, as a scientist or historian understands it, would not even occur to the reader. But even in instances in which a poet or artist has implicitly given a pledge to fact, the artistic excellence is not wholly measured by literal accuracy.[24]

One of the striking metaphors in Keats' sonnet is its reference to astronomical discovery:

> *Then felt I like some watcher of the Skies*
> *When a new Planet swims into his ken.*

These lines may have been suggested by Herschel's discovery of a new planet in 1781—an event that excited much comment and that was discussed in a book owned by Keats, John Bonnycastle's *Introduction to Astronomy.* The poet's reference to the discovery of a new planet, whether derived from Bonnycastle or not, illustrates the dependence of art upon scientific advancement. The world from which and to which the artist addresses himself is not an independent world of purely aesthetic fancy. It is rather the world as given by science—the world of scientific fact. Today it is the up-to-date world of science with its advanced scientific instruments, and not the superseded or restricted science of the past. For example, Henry Moore, the English sculptor, comments on the artist's interest in natural forms, including the patterns revealed by microscope and telescope:

> The observation of nature is part of an artist's life, it enlarges his form-knowledge, keeps him fresh and from working only by formula, and feeds inspiration. The human figure is what interests me most deeply, but I have found principles of form and rhythm from the study of natural objects such as pebbles, rocks, bones, trees, plants, etc. . . . There is in nature a limitless variety of shapes and rhythms (and the telescope and microscope have enlarged the field) from which the sculptor can enlarge his form-knowledge experience.[25]

In some art and with some artists, the expression or reflection of scientific fact and scientific theory is then a direct and explicit aim. Artists themselves give us explanations of the scientific import of their work, in terms of content, symbolism, and even in techniques employed. Thus a representative painter of our century, who sees himself "oriented

[24] See A. Boyce Gibson, *Muse and Thinker* (Baltimore: Penguin Books, 1972), pp. 85–86.

[25] "On Sculpture and Primitive Art," in Herbert Read, ed., *Unit One* (London: Cassell and Company, 1934).

toward science," sets forth the ideas and intentions which direct his art as follows:

> Twentieth-century art is of an explosive complexity which, though confusing to the onlooker, is well suited to this era of the atom. . . . It is truly a reflection of, and a comment on, the world we live in. . . . Many of the new techniques . . . have served the artist as method of stimulating the imagination, of probing the unconscious, the submerged depths of which science has recently revealed. . . . Science also offers us new materials from test tube and factory. . . . My symbolism is oriented toward science. . . . Nature's spectacles, the vast happenings in the sky, the stresses within the soul; these also demand expression . . . the use of material offered by science in both the physical and psychological realm. . . .[26]

Artists from Leonard da Vinci to the avant garde of our day have recognized the influence of science upon their artistic rendition of nature and reality. This influence may be subtle and even conjectural, as, for example, in the reflection by Alexander Calder's mobile sculpture of the modern conception of matter as a state of dynamic equilibrium, or in the influence of relativity physics upon the cubists, who like Einstein abandoned the tradition of a single viewpoint and combined the simultaneity of different perspectives. More obvious and incontestable is the influence of depth psychology, especially Freudian, upon surrealism in painting and the stream-of-consciousness technique in literature. Among the many thus affected have been Virginia Woolf, James Joyce, William Faulkner, Eugene O'Neill, the Dadaists, and the numerous Expressionists and Surrealists in writing and in painting.

Contemporary science has recovered the Greek and medieval sense of the importance of form, and the resultant outlook has had a pervasive influence upon the arts. The universe depicted by physical science has become radically different from the older physical notions of relatively discrete unchanging particles and external relations. This difference primarily involves the increased recognition of synthetic wholes and integral processes. The region, the context, the given totality, the space-time configuration, the emerging levels of organization have taken the place of the old rigid atoms, the empty featureless space, the mere positions without contextual reference. Similarly, in biology there has been an increasing emphasis upon integral part-whole relationships: the idea of the organism, in which the whole in a sense is prior to and determines its parts; the idea of the ecological community, in which organ-

26 Boris Margo, "My Theories and Techniques," *Magazine of Art*, 40 (1947), 272–73.

isms interdependently live and function; and the idea of emergent stages in evolution, in which there are real creative syntheses and not mere additive resultants. Apart from some mechanistic and reductionist movements, such as B. F. Skinner's behaviorism, there has been an increasing tendency among psychologists (represented by many besides the Gestalt school) to think in terms of organic wholes and structural relationships. Likewise in the social sciences there has been a general revolt against discrete individualism and a tendency to think in terms of structure and interdependence. For example, Ruth Benedict, A. R. Radcliffe-Brown, Robert K. Lowie, and Claude Lévi-Strauss have developed the structuralist or "pattern" approach in cultural anthropology.

The great emphasis upon form—especially abstract form—in the art of the twentieth century constitutes a kind of artistic revolution parallel to the formistic revolution of science. It illustrates the fact that the artist and the scientist live together in the same world of meaning, and that the scientist's interpretation of reality is bound to influence the arts. Herbert Read has commented on this rapprochement between art and science:

> The increasing significance given to *form* or *pattern* in various branches of science has suggested the possibility of a certain parallelism, if not identity, in the structures of natural phenomena and of authentic works of art. That the work of art has a formal structure of a rhythmical, even of a precisely geometrical kind, has for centuries been recognized by all but a few nihilists (the Dadaists, for example). That some at any rate of these structures or proportions—notably the Golden Section—have correspondences in nature has also been recognized for many years. The assumption, except on the part of a few mystics, was that nature, in these rare instances, was paying an unconscious tribute to art; or that the artist was unconsciously imitating nature. But now the revelation that perception itself is essentially a pattern-selecting and pattern-making function (a Gestalt formation); that pattern is inherent in the physical structure or in the functioning of the nervous system; that matter itself analyses into coherent patterns or arrangements of molecules; and the gradual realization that all these patterns are effective and ontologically significant by virtue of an organization of their parts which can only be characterized as *aesthetic*—all this development has brought works of art and natural phenomena on to an identical plane of enquiry. Aesthetics is no longer an isolated science of beauty; science can no longer neglect aesthetic factors.[27]

[27] From Herbert Read's Preface to Lancelot Law-Whyte, ed., *Aspects of Form: A Symposium on Form in Nature and Art* (Bloomington: Indiana University Press, 1966). (Copyrighted by Percy Lund Humphries & Co., Ltd, 1951.)

An example of this rapprochement between science and aesthetics is Susanne Langer's monumental study of the correspondence between artistic and natural form.[28]

The Scientific Investigation of Art

Just as the data of science are common objects of art interest, so the data of art are distinct matters of scientific interest. This is true if science can be understood broadly to mean all knowledge activity, including the social sciences and philosophy.

The role of science in its investigation of art will be clearer if we distinguish three levels of art-related activities: (1) the data-producing activities—that is, the creative, the appreciative, and the critical activities; (2) the scientific activities, which investigate the factual conditions and regularities of aesthetic production and response; and (3) the philosophical activities, which examine questions of relevance and interpretation of the data as produced and described in the first two activities.

The data-producing activities are not only those of the creative artists but also those of the appreciator, the critic, the teacher of art, and the art historian. Their activities are not a part of aesthetics but provide the data, the body of facts, with which scientific and philosophical aesthetics must deal. This kind of activity is primary and immediate, because it involves the direct making, enjoying, or judging of particular works of art. Scientific aesthetic investigations, the second level of activities, belong not to one science only, but to several—to psychology, sociology, physiology, and even physics and chemistry. For example, we may understand art more fully if we know something of the chemistry of pigments, the physics of music, the physiology of aesthetic perception, the psychology of aesthetic emotion, and the sociology of art movements and collective styles. Philosophical aesthetics, the third level, not only analyzes the presuppositions and conclusions of the first- and second-level activities, but raises also the question of how all these go together.

Natural science has less to contribute to aesthetics than do the social sciences and psychology. The reason is that art as an activity concerned with values falls outside the subject matter of the natural sciences but within the subject matter of the social sciences. Natural science is not directed upon valuing as such; ethics, aesthetics, psychology, and the social sciences are. It remains true, however, that values are data for investigation, description, and generalization, and in that respect data for science. The science of psychology, for example, has much interest in

28 See Susanne Langer, *Mind*, 2 vols. (Baltimore: The Johns Hopkins Press, 1967, 1972).

art activity, as the development of gestalt psychology and psychoanalysis shows.

The interest of physical science in art is admittedly less substantial. The chemical atom or mineral in an artist's pigment has, for instance, no more interest for chemistry than has a similar atom from any other source; and the data of astronomy are almost exclusively discovered in stellar space. The aesthetic excursion into stellar space such as is found, for example, in Van Gogh's "Starry Night" is of no significance to the astronomer. But even the physical sciences study some of the data of art, or can be of use to art historians or other investigators of the arts. The physicist is interested in sound as music, or at least in tone as distinguished from noise; and he is likewise interested in color, if not as it appears on pictorial surface, at least in such subtle discriminations that have application in works of art and aesthetic appreciation. Thus, Walter Sargent writes:

> The qualities that distinguish colors which we call crude from those which we consider beautiful, and that make some combinations of colors mutually consistent, have their basis, in part at least, in the laws of light and optics, and can be stated in terms of these laws as well as in those terms which express our aesthetic pleasure or lack of pleasure in them.[29]

The methods of the chemist may be of some use to the art historian, as in the carbon-dating of ancient artifacts or the chemical analysis of pigments (e.g., the egg pigments used by da Vinci). The scientist also searches for correlations between aesthetic fact and biological and physiological fact. There has evolved a "physiological aesthetics," or theory of art, which proposes the view that aesthetic delight is determined by the smooth and unfatigued operation of the relatively nonvital physiological functions. "The aesthetically beautiful," according to Grant Allen, "is that which affords the maximum of stimulation with the minimum of fatigue and waste." [30] This statement appears in an 1877 work, but Stephen Pepper, in a more recent book (1949), explains aesthetic likes and dislikes by the effects of habituation and fatigue.[31]

Biological interpretations of art are notable in Aristotle and in more modern times in the evolutionist theories of Darwin and Spencer. Aesthetic reactions are explained as an important factor in the survival

[29] *The Enjoyment and Use of Color* (New York: Charles Scribner's Sons, 1924), pp. 3–4.

[30] *Physiological Aesthetics* (New York: D. Appleton and Company, 1877), p. 39.
[31] Stephen C. Pepper, *Principles of Art Appreciation* (New York: Harcourt, Brace and Company, 1949), Chap. 2. There have been other studies in physiological aesthetics. See, for example, P. D. Trevor-Roper, "The Influence of Eye Disease on Pictorial Art," *Proceedings of the Royal Society of Medicine* (London), 52 (September 1959), 721–44.

of the species, especially as related to sexual attraction or mating be-
havior. For example, the brightly colored feathers of birds, it has been
thought, are aesthetically attractive and therefore biologically useful in
bringing the sexes together. Possession of bright and presumably attrac-
tive feathers is, of course, not an activity, but preening and display of
plumage, which is characteristic of some birds in mating behavior, have
been interpreted as biologically directed aesthetic activity. "When we
behold male birds elaborately displaying their plumes and splendid col-
ors before the females," wrote Darwin in the *Descent of Man* (1871),
". . . it is impossible to doubt that the females admire the beauty of
their male partners." He pointed out the parallelism between the col-
oration of birds and animals and the artificial ornamentation of the
human body.

The aesthetic meaning of bird and animal behavior is, of course,
speculative. These creatures cannot communicate their motivations. But
in human beings it is fairly arguable and confirmable that common con-
cern for aesthetic attractiveness between individuals does operate as a
basic motivation. The human being everywhere strives to enhance per-
sonal appearance in various ways—in dress, in use of ornament, in col-
oring the face, in hair styling, all aiming at achieving "physical fascina-
tion" (Curt Ducasse's phrase), which is an important factor in sexual
selection. Professor Ducasse devotes a chapter to "The Art of Personal
Beauty." [32]

Bird songs and bird dances have also been studied and have given
rise to similar biological interpretations. One writer, who reports the
findings as of popular interest, observes that

> When we speak of the birds as artists, the first thing we think of
> is their singing. The scientists tell us that when a bird sings, he
> has one chief aim in view: to establish a home. He is warning
> other male intruders out of his territory; often he is signaling to
> a possible mate, whom he has not yet encountered; and then, after
> he has found her and been mated, he is expressing himself to her,
> and charming her, just as he does by displaying his plumage and
> by stunt flying. . . .[33]

The German biologist Karl Groos maintained that the evolutionary
roots of both play and art are to be found in such subhuman "artistry." [34]
According to the theory of art as play, art is sometimes assigned

32 Curt J. Ducasse, *Art, the Critics, and You* (New York: The Library of Liberal
Arts, 1944), Chap. VII.
33 Gilbert Highet, "The Unconscious Artists," in *Talents and Geniuses* (New
York: Meridian Books, 1959), p. 44. Reprinted by permission of Oxford University Press.
34 See Karl Groos, *The Play of Animals* (New York: Appleton-Century, 1898) and
The Play of Man (New York: Appleton-Century, 1901).

a biological function and value. Art is then explained as a kind of play activity with the serious function of strengthening the faculties necessary for subsequent biological use. Current sociological theories of art which explain art as of value in forming or increasing the bonds of human fellowship likewise imply a value of art in terms of the survival of a species—the human race. In general, the biological interpretation of art maintains that aesthetic experience arises from no peculiar and idle faculty, but consists of the exercise of ordinary sensations, perceptions, and cognitions, which have all primarily biological functions, and which can ultimately be understood as serving biological values.

The physical and biological sciences have contributed much less than psychology and the social sciences to the knowledge of art. Among the innumerable examples that might be cited are the psychoanalytical interpretations of art by Freud and Jung, the development of the gestalt theory of expression by Rudolf Arnheim, the social history of art by Arnold Hauser, the study of evolution in the arts by Thomas Munro, and the interpretation of artistic symbols and languages by Nelson Goodman. Worthy of special mention is the contemporary movement called "structuralism." Among its leaders are Lévi-Strauss in anthropology, Jean Piaget in psychology, and Roman Jakobson in linguistics. Structuralism seeks to uncover the deep underlying structures in many different spheres. It interprets art as a structure in the larger structure of human culture, it relates art to the human propensity to organize its experience through symbolic signs, and it tries to unify the arts and sciences in an integrative and holistic way of looking at man and the cosmos. As a general movement sweeping across ordinary boundaries, it is exercising a profound influence on art and aesthetics.[35]

We have mentioned a few of the scientific approaches to art and aesthetic data, but we have scarcely scratched the surface of an immense field. It is impossible in our limited space to do more.

Method in Science and Art

Both art and science are products of the creative imagination and draw from the deep well of the unconscious mind. As we pointed out in Chapter 7, Archimedes' discovery of how to measure the specific density of gold is strikingly similar to Wang Li's discovery of how to

[35] For an introduction to structuralism with emphasis on its aesthetic relevance, see Annette Michelson, "Art and the Structuralist Perspective," in *On the Future of Art* (New York: The Viking Press, Inc., 1970) and Robert Scholes, *Structuralism in Literature* (New Haven: Yale University Press, 1974). Scholes' book contains an annotated bibliography.

paint Hua Mountain. There is also a striking similarity between Poincaré's account of his mathematical discoveries and Mozart's account of his musical creations, and between Kekule's narration of how he hit on the conception of the Benzine ring (an idea that revolutionized organic chemistry) and Coleridge's narration of how he composed "Kubla Khan." [36] In all these instances the "ideas" or "forms" gradually crystallized in the unconscious imagination before they erupted into consciousness. Numerous examples of this sort bear out Rosamund Harding's contention that all creative thinkers, artistic and scientific alike, are dreamers.[37]

Science and art are also alike in their work-a-day methods. The artist may be motivated in whole or good part by close observation and exact report of his subject and may proceed with a precision of method comparable to that of scientific investigation. Thus, it is said of Thomas Eakins, the nineteenth-century American naturalist in painting:

He was a unique combination of artistic and scientific qualities, in tune with the dominant intellectual trend of the period. Thorough training in medical college gave him an anatomical knowledge far beyond any contemporary's. His experiments in photographing human and animal locomotion, as early as the 1870's and 80's, anticipated the moving picture. A mathematician and a master of perspective, he constructed his early paintings as exactly as an architect, even to ripples of water, as one can see from the extraordinary perspective drawings. . . .[38]

It should be noticed, however, that the artist, when he is interested in scientifically accurate report, still differs from the scientist in one very important respect—namely, in being interested in representing accurately the *individual* rather than the class or type—representing or imagining or making the thing rather than the *kind* of thing. Thus, of Eakins again it is said, "His interest was above all on character, on the traits that made the individual different from any other person in the world. . . ." [39] Even when art expresses the universal, it never entirely omits this element of individuality. The artist makes us realize the poignancy of Bishop Joseph Butler's famous remark: "Everything is what it is and not another thing."

No matter how closely they may meet, science and art are never

36 See Brewster Ghiselin, ed., *The Creative Process* (Berkeley: University of California Press, 1952) and R. W. Gerard, "The Biological Basis of Imagination," *Scientific Monthly*, 62 (1946).
37 Rosamund E. M. Harding, *An Anatomy of Inspiration* (New York: Barnes & Noble, 1967).
38 Lloyd Goodrich, "Thomas Eakins Today," *Magazine of Art*, 37 (May 1944), 163.
39 Ibid., p. 165.

the same thing. Science, for example, in certain of its purposes may use the art of drawing in its rendering of visual form, as in detailed anatomical or botanical drawings. Art in its extreme imitative mode may seek to render exact copies of what it depicts to create an illusion of reality, as in trompe l'oeil painting. But if it is science, it is the form of the type of species that is pictured and to which attention is directed, not the particular individual who or which may have the form. A work of science in its primary purpose of knowledge is conceptual. A work of art in its primary purpose or productive intent is not conceptual, but sensory and perceptual or imagistic. The product of art is an artifact; the product of science is an hypothesis or theory. Science even in its applications or inventive uses, which do lead to the production of artifacts, is still different from art and its artifacts. Science so pursued provides directions or formulae which constitute plans or, when physically embodied, models for reproduction or practical goods in quantity. Its directions or formula tell what something is or how to produce it or deal with it. In contrast, art provides no practical instructions and no practical goods, no models for reproduction in quantity, except in such instances as duplicate prints of an etching, or phonograph records of a musical composition. A work of art is concerned not with quantity but with unique quality, and even when it is reproduced in quantity, as in the examples just cited, what is repeated is originally a particularized and unique creation. The repeatable particularity of a work of art is quite different from the abstract generality of science.

The contrast between art and science is evident when we consider the possibility of paraphrase. In art *what* is expressed is inseparable from *how* it is expressed. If a pianist-composer is asked what his composition means, the best answer he can give is to ask his questioner to listen carefully while he replays it. Even a poem or novel, though its medium is language, cannot be verbally paraphrased without serious impairment. The change would be less in the paraphrase of a novel, but there would still be impairment of artistic quality. It may be replied that poems and novels are often translated into a different language; but a good translation is not a paraphrase—it is a work of art in its own right, requiring a talent for words comparable to that of the original creator. The contrast with a scientific treatise is obvious. Whereas a work of art is a unique web of internally related qualities, the treatise is a semantic construct of separable words, each having a universal public denotation. Hence the import of a scientific paper can be stated in a number of ways without distorting its meaning.

Another way of formulating the difference between artistic and scientific method is to say that art "isolates" and science "connects." Hugo

Münsterberg illustrates this difference by his comparison of the ways in which the painter and the scientist depict the ocean:

That ocean yonder was my experience which I wanted to know in all its truth and reality. The scientist came and showed me the salt which was crystallized out of it, and the gases into which the galvanic current dissolved it, and the mathematical curves in which the drops were moving—most useful knowledge, indeed, for all my practical purposes—but in every one of his statements, that ocean itself with its waves and its surf and its radiant blueness had disappeared.

In contrast the painter directs our attention to the breaking wave in its unique and self-contained essence. Unlike the scientist, he does not peer behind the object into its causes or gaze beyond it at its consequences. He is not intent upon asking *why* or *whence* or *whither*— rather, he concentrates solely upon *what* the object is in its immediate felt qualities.

Let us only once give our whole attention to that one courageous, breezy wave, which thunders there against the rock; let us forget what there was and what there will be; let us live through one pulse-beat of experience in listening merely to that wave alone, seeing its foam alone, tasting its breeze alone—and in that one thrill we have grasped the thing itself as it really is in its fullest truth. The painter alone can succeed in holding that wave in its wonderful swing as it is; and what his brush tells us is not less true than the formula of the mathematician who calculated the movement of the wave and the formula of the chemist who separated the elements.[40]

That there is some contrast of the kind indicated by Münsterberg is undeniable, but the difference can easily be exaggerated.

To say that art "isolates" and science "connects" is likely to be misleading, because both science and art reveal the interrelatedness of things. Science traces the laws and causal connections that bind objects and events into an ordered cosmos, discerning the uniformities, configurations, and mathematical proportions that escape the eye of casual observation. Art creates expressive forms out of a multiplicity of qualities, revealing the interconnections among our feelings and perceptions. In spite of the diversity that can be discovered by analysis, a well-designed work of art is experienced as a unity, each part being "organi-

[40] *The Principles of Art Education* (New York: The Prang Educational Company, 1905). Selection reprinted in Melvin Rader, *A Modern Book of Esthetics*, 3rd ed. (New York: Holt, Rinehart and Winston, Inc., 1960).

cally" related to other parts and to the whole. The context gives every detail its point, its intensity, its expressiveness. Each detail exerts some modifying power over every other, and the unity of the whole permeates and controls all its constituents.

These relations are *internal* to the work of art in contrast to the *external* causal connections revealed by science. But the artist as well as the scientist may be aware of these wider relations. For example, the poet Francis Thompson has commented on the hidden and far-flung connections in nature:

> *All things by immortal power*
> *Near or far*
> *Hiddenly*
> *To each other linkéd are*
> *That thou canst not stir a flower*
> *Without troubling a star.*

More familiar are the lines of Blake:

> *To see a World in a Grain of Sand*
> *And a Heaven in a Wild Flower,*
> *Hold Infinity in the Palm of your hand*
> *And Eternity in an hour.*

Similar thoughts are expressed by other poets—for example, by Tennyson in "Little Flower in the Crannied Wall," Whitman in "Hub of the Universe," Bryant in "Chambered Nautilus," and Emerson in "Each and All."

Apart from such express comment, the poet may employ metaphors or symbols which, being based on analogy, are devices calling attention to the interrelatedness of things. The metaphysical foundation of symbolism and metaphor was indicated long ago by the Greek philosopher Anaxagoras when he said, "You can't cut the world apart with an axe. In everything there is a portion of everything." Aristotle, in the *Poetics*, claims that the mastery of metaphor is the surest mark of poetic genius, "since a good metaphor implies an intuitive perception of the similarity in dissimilars." The genius for metaphor is not essentially different from the insight of the great scientists, such as Newton's inspired realization that the falling of an apple is a member of the same genus of events as the circling of the planets. Hence we can bracket art and science together, as contrasted with the limited insight of common sense, because both disclose hidden but fundamental relations, science through causal connections, art by means of metaphors and symbols.

The metaphorical link may be between different sensory domains:

Heavy with bees, a sunny sound. (Keats)

Bare ruined choirs where late the sweet birds sang.

(Shakespeare)

Or it may be between the sensory and the supersensory, as in the image of the soul fleeing "the Hound of Heaven":

I fled Him, down the nights and down the days;
I fled Him, down the arches of the years;
I fled Him, down the labyrinthine ways
Of my own mind; and in the mist of tears
I hid from Him, and under running laughter.

(Francis Thompson)

Or it may lie in the interplay between life and death, between birth and spiritual rebirth:

The unborn body of life hidden within the body of this half death which we call life.

(D. H. Lawrence) [41]

Whatever be the nature of the linkage, the function of metaphor is to unify and integrate things that appear distinct and unrelated.

The relating of things on the basis of such hidden resemblances is involved not only in metaphor but in artistic symbolism. Consider man's linkage with the animal world, and the ways in which this linkage has been symbolized. In the Trois Frères cave in France, there is a Paleolithic cave painting of a dancing human being, adorned with antlers, a horse's head, and bear's claws. Thousands of years later the Folklorico Ballet of Mexico City, in a deer dance derived from the Yaqui Indians, has depicted a dancer with antlers, half-human and half-animal, stricken by hunters, and expiring in a tragic dance of breathtaking beauty. When the white men first invaded their territory, the Indian dancers of the Northwest Coast of the American continent, wearing costumes symbolizing wolves, bears, sea lions, ravens, eagles, or other birds and animals, danced in solemn rituals to the music of song and percussion instruments. Similar animal motifs appear in ancient Egypt and Greece, Ethiopia, East Coast Africa, and South America, and in the folk art of modern countries, such as the Japanese *No* drama.

It would not be easy to analyze the symbols involved in this linking of men and animals, and we do not have space to do so. Our examples, unanalyzed though they be, are sufficient to point to one of

[41] "Glad Ghosts," *Dial*, 81 (July 1926), 2.

the innumerable spheres of artistic symbolism. When we scrutinize Erwin Panofsky's studies in iconology, or the many interpretations of symbolism inspired by Carl Jung or Sir James Frazer, we begin to realize how many are the ways in which art has symbolized man's affiliation with other men and with plants and animals and all kinds of things. Through its employment of symbols and metaphors, art takes its place with science as a great unifying force.

Is Science Cumulative, Art Noncumulative?

It is often said that science accumulates and develops through the ages, while art is noncumulative and begins afresh with each artist. The large number of duplicate independent discoveries or inventions is a clear indication of maturation and ripening in scientific development. In these instances two or more persons respond at approximately the same time and in the same way to a common heritage. William F. Ogburn in *Social Change* lists 148 examples, including the following:

- Discovery of the planet Neptune. By Adams (1845) and Leverrier (1845).
- First measurement of the parallax of a star. By Bessel (1838), Struve (1838), and Henderson (1838).
- Calculus. By Newton (1671) and Leibnitz (1676).
- The Periodic Law. First arrangement of atoms in an ascending series. By De Chancourtois (1864), Newlands (1864), and Lothar Meyer (1864). Law of periodicity. By Lothar Meyer (1869) and Mendeleef (1869).
- Law of conservation of energy. By Mayer (1843), Joule (1847), Helmholz (1847), Colding (1847), and Thomson (1847).
- Theory of natural selection and variation. By Darwin (1858) and Wallace (1858).
- Theory of mutations. By Korschinsky (1899) and DeVries (1900).[42]

The explanation of these parallel independent discoveries is that science is sharable and cumulative. A scientific creation becomes almost "inevitable" when "the time is ripe." Scientists build upon the works of their predecessors, and old works of science become obsolete as new "inevitable" discoveries supersede them.

Artists, in contrast, produce a sequence of original creations, each of which stands relatively alone and steadfast. As Werner Heisenberg said when playing Beethoven's *Opus 111* to a group of fellow scientists:

[42] William Fielding Ogburn, *Social Change* (New York: The Viking Press, Inc., 1937), pp. 90–102. Copyright, 1922, by B. W. Huebsch, Inc.

If I had not lived, someone else would have discovered the Un-
certainty Principle: but if Beethoven had never existed, we should
not have had this great piece of music. That is the difference
between science and art.[43]

Heisenberg's Uncertainty Principle may eventually be superseded
by some more inclusive or exact principle, but an authentic artistic mas-
terpiece retains its vitality forever. Greek science has long been obsolete
and retains only an historical interest, but *Oedipus Rex* and the Elgin
Marbles are still of unique and surpassing beauty. For an artist today,
what was produced two or three thousand years ago may be as vital a
stimulus as the products of the immediate past. Henry Moore, for ex-
ample, has been inspired in his creative work by "Cycladic" sculpture
of the early Bronze Age. No scientist has been inspired by science half
as ancient.

That there is some contrast of this kind between art and science
is indisputable. How shall we explain it? One relevant factor is the con-
trast between scientific and artistic forms of expression. The language of
science exhibits a high degree of generality and uniformity in denota-
tion. Its words and symbols are standard in the sense of being a com-
mon unequivocal medium of communication among qualified scientists.
The "language" of art is just the opposite. It consists of particularized
signs and symbols expressing, in large measure, the unique intuitions and
personal perspectives of the artist. Kant appropriately characterized an
"aesthetic idea" as a representation of the imagination which induces
much thought, yet without the possibility of any concept being adequate
to it. It is an image or configuration that, in its concreteness and wealth
of connotation, lies beyond the limits of abstract thought.[44] In short, sci-
entific meaning can be pinned down in definite concepts, artistic mean-
ing cannot. Hence science is more transmissible from person to person
and from generation to generation than is art.

Also, scientific hypotheses are subject to well-recognized techniques
of verification, whereas art lacks accepted, reliable criteria of evaluation.
Science, with its precise verification procedures, can incorporate what-
ever is scientifically valid in past science and then progress to a higher
level of accuracy. Art, being more concerned with personal feelings and
unique qualities, cannot so readily incorporate or measurably surpass
previous achievements.

43 Quoted by Julian Huxley, "Ritual in Human Societies," in Donald R. Cutler,
ed., *The Religious Situation: 1968* (Boston: Beacon Press, 1968), p. 699.
44 See Immanuel Kant, *The Critique of Judgement,* trans. James Creed Meredith
(Oxford at the Clarendon Press, 1952), pp. 175–80, 210.

Thomas Munro, in *Evolution in the Arts* (1963), has argued that the kind of contrast that we have drawn is exaggerated. A close look at the development of art reveals that it too is cumulative:

> All mature artists have been influenced by the past and present works of art about them. . . . The connoisseur of music can detect much of Bach and Handel in Haydn and Mozart; much of all these in Beethoven, Chopin, and Brahms. To the connoisseur of painting there is much of Tintoretto and of late Byzantine painting in El Greco; there is much of Giorgione and Titian in Tintoretto; there is much of Giotto and Masaccio in Raphael and Leonardo. Traits of the Sung Chinese landscape tradition persist in later Chinese and Japanese landscape painting. Of course, something new is added, the style as a whole is different, but elements of past achievement remain.[45]

Citing many examples, Munro argues that artistic styles evolve and incorporate much that has preceded.

Similarly, a distinguished molecular geneticist, Gunther S. Stent, has questioned whether scientific creations are any less unique than artistic creations.[46] He thinks that "multiple discoveries," such as those listed by Ogburn, can be shown on detailed examination to be rarely, if ever, identical. In substantiation of his position he cites the research of sociologist Robert Merton, who has found some striking differences, for example, between the calculus of Newton and that of Leibnitz, or the theory of natural selection of Darwin and that of Wallace.[47] On the other hand, Stent thinks that artistic creations are not as unique as they are often thought to be. For example, Shakespeare's *Timon of Athens*, as a type of tragedy, has its roots in Aeschylus, Sophocles, and Euripedes. The story is derived from William Painter's collection of classic tales, *The Palace of Pleasure,* and Painter in turn used as his sources Plutarch and Lucian. Stent even goes so far as to suggest that, in content although not in wording, the play might have been written without Shakespeare. Even the deep insights into human emotions that distinguish the play might, so Stent believes, have been supplied by another dramatist.

This distinction between wording and content violates the artistic unity of content and form. As we have said, in art *what* is expressed is inseparable from *how* it is expressed. What we have in *Timon of Athens*, as well as in other works of art, is form-meaning or meaning-in-form,

[45] *Evolution in the Arts and Other Theories of Cultural History* (Cleveland: The Cleveland Museum of Art, 1963), p. 356.

[46] Gunther S. Stent, "Prematurity and Uniqueness in Scientific Discovery," *Scientific American,* 227 (December 1972), 84–93.

[47] See Robert K. Merton, *The Sociology of Science* (Chicago: University of Chicago Press, 1973).

and to separate the thought content from the formal elements—namely, the plot and poetic wording—is a false abstraction. Stent himself remarks that "the semantic content of an artistic work—a play, a cantata, or a painting—is critically dependent on the exact manner of its realization . . . ," and that to paraphrase a play without loss of artistic quality would amount to creation of a new work of art. He should also have recognized that the "deep insights" of Shakespeare's play cannot be abstracted without violating the artistic integrity of the work. Although he speaks as if the same insights were expressed by Shakespeare in a second and greater play, *King Lear*, they are *not* the same insights regarded artistically.

The most interesting aspect of Stent's article is his discussion of "prematurity." He points out that some of the greatest discoveries of science have been passed over with very little notice until a later generation of scientists finally recognized their crucial importance. Mendel, for example, discovered the fundamental laws of genetic inheritance in 1866, but it was not until 1900 that his great work was noticed and verified by biologists. Stent implies that the same kind of prematurity occurs in the history of art. It would not be difficult for the historian of art to supply examples. El Greco, Bach, Vermeer, Van Gogh, Blake, Melville—to mention only a few names—received very little recognition in their own lifetimes.

Stent interprets prematurity in terms of "structuralism." The "canonical knowledge" in a given science is a strong structural configuration that prompts work in the field and that resists intrusions. A new discovery cannot be appreciated until it can be made to fit into this structure, or until the structure can be so transformed that it is congruent with the discovery. If the discovery does not depart greatly from the canonical knowledge, the transformation may be minimal. But if the departure is great, the requisite transformation may amount to a scientific revolution, such as the transition from Ptolemaic to Copernican astronomy or from Newtonian to Einsteinian physics. Until the transformation occurs, a heterodox scientific discovery is premature and fails to receive the recognition that it deserves. Similar revolutions occur in the development of art, as in the transformation of Gothic architecture into Renaissance architecture or Neo-Classic poetry into Romantic poetry. When an artist such as Van Gogh is ahead of his age he is spurned by contemporary taste, and a considerable lapse of time may transpire before he is much appreciated. In contrast, Picasso's "Les Demoiselles D'Avignon," the first major cubist painting, did not have to wait so long for acceptance, because a revolutionary transformation in painting was already underway.

Today there is very little resistance to new forms of art, because

the revolution has gone so far that almost nothing appears shocking. "The avant garde is a phenomenon of the past," remarks James S. Ackerman, "because the entire army, and a good part of the civilian population, has moved up to join and surround it." [48] This demise points to a difference between art and science, since it suggests that standards of judgment in science, thanks to its precise verification techniques, are more exact and constant than the standards of validity in art.

To conclude, we agree with Munro and Stent that the contrast between the cumulative character of science and the noncumulative character of art can easily be exaggerated, but we think that very significant points of contrast remain.

The Satisfactions Afforded by Art and Science

The end value or satisfaction afforded by both science and art must not be overlooked. No one will question the intrinsic value of aesthetic experience, but too few realize that science is likewise intrinsically rewarding. Science in use is, following Francis Bacon, most commonly thought of as a practical discipline—that is, as the prime method for the conquest of nature for the practical good of man. Hence there is a tendency to confuse science with technology, and to regard both as problem-solving activities. Although pure science and technology are closely linked, they pursue different goals. The technologist employs tools and techniques to achieve a practical result, such as the building of a bridge, or the improvement of sanitation. The scientist uses observation and experiment to understand the objective world and its laws. The aim of technology is control; the aim of science is knowledge.

J. Robert Oppenheimer has spoken of the fascination of pure science in these memorable words:

> We . . . know how little of the deep new knowledge which has altered the face of the world, which has changed—and increasingly and ever more profoundly must change—man's views of the world, resulted from practical ends or an interest in exercising the power that knowledge gives. For most of us, in most of these moments when we were most free of corruption, it has been the beauty of the world of nature and the strange and compelling harmony of its order, that has sustained, inspirited and led us. [49]

[48] "The Demise of the Avant Garde," *Comparative Studies in Society and History*, 11 (October 1969), 379.

[49] *Science and the Common Understanding* (New York: Simon and Schuster, 1954), pp. 97–98.

This statement by an eminent scientist is similar to the following observation by an equally distinguished art critic:

> Perhaps the highest pleasure in art is identical with the highest pleasure in scientific theory. The emotion that accompanies the clear recognition of unity in a complex seems to be so similar in art and science that it is difficult not to suppose that they are psychologically the same. It is, as it were, the final stage of both processes.[50]

J. Brownowski, in a profound book on the nature of science, points out how fundamental is the impulse toward unity and coherence in science as well as in art. Einstein, for example, equated energy and mass in a single line,

$$E = mc^2$$

and by this equation he brought a marvellous new coherence into man's picture of the universe. Agreeing with Oppenheimer and Fry, Brownowski sees in such achievements the common bond between art and science:

> This is the constant urge of science as well as of the arts, to broaden the likeness for which we grope under the facts. When we discover the wider likeness, whether between space and time, or between the bacillus, the virus and the crystal, we enlarge the order in the universe; but more than this, we enlarge its unity. And it is the unity of nature, living and dead, for which our thought reaches. This is a far deeper conception than any assumption that nature must be uniform. We seek to find nature one, a coherent unity. This gives to scientists their sense of mission, and let us acknowledge it, of aesthetic fulfillment: that every research carries the sense of drawing together the threads of the world into a patterned web.[51]

Turning to the making or creating feature which is characteristic of both disciplines, there is again a similarity between art and science in terms of the function of creative imagination which is common to both. Neither science nor art, it may be said, accepts the world as given. Both are operations upon the world of fact, directed ultimately to new fact and value. Whether scientifically or artistically employed, imagination is an important operational mode. Science, following a vision, takes things apart and puts them together in new ways. Art does the same. Or, it

50 Roger Fry, *Vision and Design* (New York: Brentano's, 1924), p. 83.
51 *The Common Sense of Science* (Cambridge, Mass.: Harvard University Press, 1958), pp. 133–34.

may be said, both art and science imagine new possibilities in the world. In science, new invention is the product of seeing a novel relationship among materials that appeared to be nonrelated. The same is true of art. A new creation in art also involves seeing novel relationships—or seeing relationships for the first time, or with a new emphasis.

Art may be thought of as differing from science in that it characteristically goes beyond matter-of-factness into imagination and feeling. It presents us with an imaginative world either beyond fact or of fact imaginatively or fictionally ordered, and it does this with feeling and an invitation to feeling. Art elicits a sense of strangeness and stirs emotions of wonder and admiration. Science, it may be said by way of contrast, presents us with the world of fact, dispassionately and without emotional appeal.

But the contrast is by no means absolute. If not stranger than fiction, quiet painstaking truth is often as strange, and the mere reports and records and interpretations of science often of themselves, without intent to move emotionally, give rise to the very same sense of strangeness and wonder which characteristically come from designed works of imagination. That is to say, facts in the cold light of reason alone, if looked at closely enough, if penetratingly and broadly examined and contemplated rather than complacently and matter-of-factly accepted, turn out often to be strange, wonderful, and poetic. J. Arthur Thomson, in the work previously cited, marks what we may call "the aesthetic dimension" of science in an almost rhapsodic passage:

> The grandeur of the star-strewn sky, the mystery of the mountains, the sea eternally new, the way of the eagle in the air, the meanest flower that blows—somewhere, sometimes, somehow, every one confesses with emotion, "This is too wonderful for me." When we consider the abundance of power in the world, the immensities, the intricacy and vitality of everything, the wealth of sentient life, the order that persists amid incessant change, the vibrating web of interrelations, the thousand and one fitnesses, the evolutionary progress that is like "the unity of an onward advancing melody," and the beauty that is through and through, we are convinced that our wonder is reasonable.[52]

The following is an example of scientific statement which, while staying strictly within the limits of factual report and scientific interpretation of factual findings (hypothesis), does decidedly arouse the aesthetic imagination and an emotion or set of emotions other than simple emotional satisfaction felt in cognitive enlightenment. The example is from Darwin's *Origin of Species*. Darwin cites an "instance showing how

[52] *Introduction to Science*, p. 172.

plants and animals, most remote in the scale of nature, are bound together by a web of complex relations":

I shall hereafter have occasion to show that the exotic Lobelia fulgens, in this part of England, is never visited by insects, and consequently, from its peculiar structure, never can set a seed. Many of our orchidaceous plants absolutely require the visits of moths to remove their pollen-masses and thus to fertilise them. I find from experiments that humble-bees are almost indispensible to the fertilisation of the heartsease (Viola tricolor), for other bees do not visit this flower. I have also found that the visits of bees are necessary for the fertilisation of some kinds of clover: for instance, 20 heads of Dutch clover (Trifolium repens) yielded 2,290 seeds; but 20 other heads protected from bees produced not one. Again, 100 heads of red clover (T. pratense) produced 2,700 seeds, but the same number of protected heads produced not a single seed. Humble-bees alone visit red-clover, as other bees cannot reach the nectar. It has been suggested that moths may serve to fertilise the clovers; but I doubt this in the case of the red clover, from their weight being apparently not sufficient to depress the wing-petals. Hence we may infer as highly probable that if the whole genus of humble-bees became extinct or very rare in England, the heartsease and red-clover would become very rare, or wholly disappear. The number of humble-bees in any district depends in a great degree on the number of field-mice, which destroy their combs and nests; and Mr. H. Newman, who has long attended to the habits of humble-bees, believes that "more than two-thirds of them are thus destroyed all over England." Now the number of mice is largely dependent, as every one knows, on the number of cats; and Mr. Newman says, "Near villages and small towns I have found the nests of humble-bees more numerous than elsewhere, which I attribute to the number of cats that destroy the mice." Hence it is quite credible that the presence of a feline animal in large numbers in a district might determine, through the intervention first of mice and then of bees, the frequency of certain flowers in that district.[53]

Darwin's account is, of course, not science fiction, but scientific fact, a "true story"; but the sense of wonder which it evokes has probably been felt by every reader who is not wholly inured to a matter-of-fact attitude. The "story" as Darwin tells it is fascinating enough in itself, but an imaginative reader might even enlarge it on his own, and with good warrant. Darwin weaves into a captivating web the observed frequency of certain flowers in a given district, humble-bees, field-mice, and

53 Charles Darwin, On the Origin of Species (1859), Chap. III, "Struggle for Existence."

cats. He might well have widened his web of correlations in its outer reaches to include the number of spinsters in his studied district. Lonely spinsters, he might have noted, are the persons most likely to own feline animals as companions. And thus, he might have reasoned, decrease in occurrence of heartsease and red-clover in a certain area might be expected to correlate with the increase of old maids in the given countryside of a given village.

Darwin's intense preoccupation with science led to an atrophy of his taste for poetry, painting, and music. In his *Autobiography* (1876), he remarks on the change that occurred as he grew older:

> Up to the age of thirty, or beyond it, poetry of many kinds such as the works of Milton, Gray, Byron, Wordsworth, Coleridge, and Shelley, gave me great pleasure, and even as a schoolboy I took intense delight in Shakespeare. . . . I have also said that formerly pictures gave me considerable delight. But now for many years I cannot endure a line of poetry. . . . I have also almost lost my taste for pictures and music.

But perhaps Darwin's aesthetic delight in the order of nature was a viable substitute for these artistic sources of pleasure. Certainly his book, *The Origin of Species,* is an enduring monument to mankind's sense of the wonderful unity of nature. Aristotle remarked that philosophy begins with wonder. Art and science, each in its own way, appeal to this primordial sense of wonder, which is part of "the poetry of things."

"The poetry of earth is never dead," wrote Keats. We may add, the poetry of fact is inescapable if we have a heart to feel it as well as eyes to see and a mind to grasp it. If science is descriptively ample and penetrating and interpretively broad, then science without ceasing to be science acquires something of the essential nature of poetry—that is, it then has imaginative appeal and power to move. It is not strange that fact, if humanly taken, should appeal poetically; for in the last analysis there is no other source of poetry than fact. Poetic experience is not unreality. It is a way of taking fact or of facing fact and of ordering fact or imagining the possibility of fact. This is not to deny that art is the expression of values, for felt fact *is* a value. To say that the artist looks at the world fact-wise is to commit the fallacy of factualism, but to say that the artist looks at facts value-wise is true and not fallacious.

The Impact of Applied Science and Technology

We have maintained that science and art need not be in conflict. Different though they are, they inhabit the same world, draw upon similar creative talents, and contribute to imaginative enjoyment and cogni-

tive insight. But the relation between them is not always harmonious. The scientist, if too prone to generalize, may antagonize the artist by trying to "reduce" man to a mechanistic level. The Nobel laureate Jacques Monod, in his book *Chance and Necessity* (1970), declares that "living beings are chemical machines." B. F. Skinner, the foremost behavioral psychologist, characterizes the belief in human "freedom and dignity" as the vestige of a prescientific age. Such simplistic generalizations have gained widespread credence, and have provoked reactions of an opposite nature. Those who still believe in the mystery and uniqueness of life and in the importance and efficacy of values have tended to reject "scientism" and to seek solace in religion or imaginative release in art.

The split between "the two cultures," the scientific and the humanist, is most evident in the reaction against *applied* rather than *pure* science. From the time of William Blake until the present, the more rebellious or romantically inclined artists have thought of themselves as "outsiders," sharply opposed to a scientific-technological culture. In the twentieth century, there have been many who have expressed the paradox of man's alienation in a mechanized world of his own making. This is a predominant theme in Charlie Chaplin's movies, which portray the tragi-comic little tramp trying to survive in a world much too large, too bureaucratized, too indifferent, too mechanically complicated; in the sculpture of Rudolf Belling: strange, semi-abstract, machinelike forms, half-human and half-mechanical; in the paintings of Giorgio de Chirico or Fernand Leger: organic forms transposed into inorganic shapes and relations—the human and the nonhuman confounded; in the music of Arthur Honegger's *Pacific 231*, depicting the crude, raucous, overwhelming power embodied in a great locomotive; or in Paul Dukas' musical rendition of the old fable of the *Sorcerer's Apprentice*, symbolizing the tendency of tools and machinery to run amuck. It is a theme as well in the poems of T. S. Eliot, in which "hollow men, stuffed men" are buffeted about in the "wasteland" of industrial civilization; in Karel Capek's *R.U.R.*, Aldous Huxley's *Brave New World*, and George Orwell's *1984*—satirical fantasies in which men are treated not as ends in themselves but as things to manipulate; in Franz Kafka's strange fables, which represent the ruling powers as incomprehensible and heartless bureaucracies; in Albert Camus' novel, *The Stranger*, which depicts an unwitting "murderer" who has lost sympathetic contact with other human beings and is dealt with by the authorities without pity or understanding; and in Samuel Beckett's plays, *Waiting for Godot* and *Endgame*, whose characters are paralyzed by the icy emptiness of their "absurd" environment. The theme of human alienation in a technological environment has been recurrent in every art genre.

The common word for the thousands of techniques and inventions

made possible by the advance of science is "technology." By this term we mean expert knowledge—mainly scientific—put to practical use. Technology includes the totality of tools and techniques that men use to make and do things—not only hand tools and machines but intellectual tools, such as computer programming and system analysis. The technology of the old Industrial Revolution was largely based on craft and mechanical ingenuity, but the technology of today is based mainly on science. The crucial inventions of recent decades, such as the transistor, the laser, the computer, atomic fission and fusion, have flowed out of quantum mechanics, relativity physics, and other forms of advanced science.

Are art and technology necessarily uncongenial? It is not easy to answer the question. Coming to grips with technology can be a very ambiguous confrontation for both the ordinary citizen and the artist. We are informed that human life is becoming "one-dimensional"—a dehumanized function in a technical apparatus. Conversely, we are assured that technology is greatly widening our horizons and opportunities. Or, dramatically, we are told that the human race is confronted by a fateful choice, "one world or none," "Utopia or annihilation." Almost everyone is bewildered by these conflicting voices. For the artist or lover of the arts, the bewilderment is likely to be compounded, because contemporary art is as complex and indecipherable as contemporary technology. Can we ever understand what contemporary art is about, what modern technology is doing, and what is the relation between the two?

This much we can predict with confidence, that the future will be as unlike the present as the present is unlike the past. Scientists are now penetrating the heart of the atom and exploring the far reaches of the cosmos; they are engaged in the most fundamental discoveries; and just as basic discoveries led to profound technological changes in the past, so these new discoveries can be expected to produce like changes in the future. The study of molecules gave us chemistry, with its innumerable applications; the study of electricity and magnetism gave us the electrical industry, with its immense contribution to the power and convenience of living; the study of germs gave us germicidal medicine, with its great saving and prolongation of life. Now scientists are delving into the secrets of the micro-world—the inconceivably tiny world of the mesons, hyperons, and "anti-particles." At the other end of the scale, with the appearance of earth satellites and space rockets and the investigation of cosmic rays, there has been a radical new beginning in the study of the macro-world—the universe in all its vastness. The micro-world and the macro-world are in scale almost infinitely far apart, but their study is interrelated and promises a gigantic extension of human knowledge. Like the earlier discoveries of bacteria, magnetism, and mo-

lecular structure, this knowledge will bring technological changes of incalculable range and importance.

Whether the changes on the whole will be good or bad hangs in the balance. No one will deny that there have been some improvements in human affairs, but the triple threat of thermonuclear war, overpopulation, and ecological catastrophe is acute. Our headlong technological escalation is rapidly using up the fossil fuels and ores upon which continued productivity depends. Smog and water poisoning and rotting slums and urban sprawl are fouling the environment at an intolerable pace. Aesthetically this is perhaps the most serious threat of all—the sweetness of nature, the very face of the land, is being glutted with ugliness and pollution. There are also the psychological effects of technology: mechanization invades mind and character and muddies the human soul to its dye. The effect is to stifle the imaginative freedom and internal spontaneity out of which art springs.

The role of prophet in our ambivalent civilization is hazardous. As Karl Popper argued in *The Poverty of Historicism*, the discoveries of science and the inventions of technology, in their very novelty, cannot be anticipated in advance, and their side effects are seldom foreseeable. We are confronted, not by a predictable future, but by "the double aspect of things to come."

> Everyone sees a dark figure and a bright one simultaneously, both approaching at startling speed. You may try to cover up one of them so as to see only the other, but both are inexorably there. . . . It is especially this double sense of the future, actively desired and actively feared, that distinguishes the reality of our century from that of the last.[54]

The future of man—assuming that man *has* a future of much duration —will certainly be very different from his past, but what that future will be no one can say.

There has been no lack of gloomy forebodings. Although not given to dour predictions, William James at the beginning of this century warned that technology might culminate in the total destruction of our civilization, and that scientific-technological man may be like the child drowning in a bathtub because he has turned on the water without knowing how to turn it off. H. G. Wells, who began as an inveterate optimist, predicted in his final book the clean extinction of the human race. "There is no way out or round or through," he announced. "It

54 Elias Canetti, *Tagebuch* (Vienna: December 1965). Report on a symposium on "Our Century and Its Novel" under the auspices of the Austrian Society for Literature, quoted by Ernst Fischer, *Art Against Ideology* (London: Allen Lane, 1969), p. 42.

is the end." [55] John Masefield declared, "We have all things, save hope," catching the prevalent mood of our affluent society. "If you want a picture of the future," states a character in George Orwell's *1984*, "imagine a boot stamping on the human face—forever." Since the death of these writers, the gloom has deepened and spread.

History has now lent to the old, old question: What shall we do to be saved? a new, terrible urgency. Why has this come to pass? Our reply would run something like this. In the development of humanity, different functions reach maturity at different historical stages, the easier problems usually being solved before the more difficult. An atom or a molecule, elusive though it be, is more easily understood than the labyrinthine ways of the mind. Consequently physical technology, like a hare, has raced far ahead, while other human functions move tortoise-slow in the rear. We have split and harnessed the atom, we have hurtled our rockets to the far regions of space, we have invented the most cunning machines; but we haven't learned how to curb human aggression or how to be kind to our neighbors. Vast, impersonal, bureaucratic organizations, spearheaded by the technologies of communication and management, have developed with dramatic swiftness, while the values and institutions of the free community have in no way kept pace. Our "progress" has been swifter in the techniques of homicide than in the arts of peace. Cursed by the anachronisms of war and class, this century has been an age of hyperbolic crises: glut and starvation, revolutionary upheavals, totalitarian regimes, world wars, and the threat of nuclear Armageddon. Mankind will not be out of danger until art, the impulse to appreciate; religion, the impulse to commune; politics, the impulse to govern; and humanistic science, the impulse to understand human nature, reach a maturity comparable to that of physical science and technology.

Confronted by very distressing or uncertain prospects, aesthetic-minded dissenters may choose either of two goals. One goal is to revolt against our whole scientific-technological-industrial society and to try to create a new "counterculture" based on art and mysticism and "I-Thou" relations. An alternative goal is to seek a higher union of art, morals, science, and technology.

The first goal is favored by the more thoughtful members of the counterculture and the anarchistic radicals. It is illustrated in the manifesto pinned to the main entrance of the Sorbonne during the tumultous insurrection of May 1968:

[55] *Mind at the End of Its Tether* (New York: Didier, 1946), pp. 4, 15. Compare this judgment with the heady optimism of *The Discovery of the Future*, written by Wells in 1913.

The revolution which is beginning will call in question not only capitalist society but industrial society. The consumer's society must perish of a violent death. The society of alienation must disappear from history. We are inventing a new and original world. Imagination is seizing power.[56]

Theodore Roszak, who quotes this bold French manifesto, admits that the movement of dissident youth toward a counterculture is a rather bizarre patchwork, borrowing from depth psychology, Oriental religions, anarchist social theory, drug experimentation, and an aesthetics of rock bands, strobe lights, free-form dance, and "happenings." Although he is critical of some of these features, Roszak thinks that the movement is toward "a new culture in which the non-intellective capacities of the personality—those capacities that take fire from visionary splendor and the experience of human communion—become the arbiters of the good, the true, and the beautiful." Scientific and technological priorities must be swept aside in favor of "a new simplicity, a decelerating social pace, a vital leisure" and "the communal opening-up of man to man." "For, after all, science is not everything, and in fact, is not very much at all when it comes to creating a creditable way of life for ourselves," and it is better to side with "the non-intellective spontaneity of children and primitives, artists and lovers, those who can lose themselves gracefully in the splendor of the moment." [57]

To a certain extent, we agree with the goal of this counterculture —an ideal, let us remember, as old as the Romantic Movement in the early nineteenth century. Like Wordsworth, we think that in getting and spending we lay waste our powers. We desperately need more humane interests and values to replace the ruthless dynamism of an acquisitive and mechanized civilization. Modern men need not—they should not—regard Science, or its child Technology, as their savior. Science, taken alone, is nonmoral, and no amoral basis of civilization can suffice. Only when science and technology are employed with moral and aesthetic vision can they be regarded as making for a sound social order.

The old legend of Faust and his damnation is worth recalling. Faust sold his soul to the devil in order to gain knowledge, power, and riches. For a time it seemed to be a marvelous bargain, while the world's goods showered upon him. But as the end approached, Faust was seized with terror and tried to repent. It was too late, and he was carried off to hell kicking and screaming. The Faust story is symbolical

56 Edward Mortimer's news dispatch from Paris, in *The Times* (London), May 17, 1968.

57 *The Making of a Counter Culture* (Garden City, N.Y.: Doubleday & Company, Inc., 1969), pp. 50–51, 54, 68. See also Roszak, *Where the Wasteland Ends* (Garden City, N.Y.: Doubleday & Company, Inc., 1972).

of the fate that may await our civilization, hell-bent on getting power and riches at any price. We should repent and change our ways before it is too late.[58]

Nevertheless, we do not regard the making of a counterculture as a viable goal for America or the world. More sensible is the making of a well-balanced culture, not as counter to science and technology but as corrective and inclusive of them. Neither the "intellective" nor the "non-intellective capacities" should become the "arbiters" of human values. Rather, man in his wholeness and integrity should become the measure of values. In this sense we would approve the ancient saying of Protagoras, "Man is the measure of all things." As far as possible, the ugly effects of applied science and technology, such as environmental pollution, urban blight, and scientific warfare, must be eliminated; but it would be short-sighted, if not silly, to be "against" the wider horizons and increased potentialities of scientific-technological advancement. It is well to recall the past and its shortcomings. In former days most children died in infancy, and if they grew to maturity, they lived in abject poverty and dismal superstition. Now certain nations, such as the Scandinavian countries, have lowered enormously the death rate, all but eliminated dire poverty, and educated most of their adult population. These are great gains that can be spread to other lands including affluent America, where it is still too true that "wealth accumulates and men decay." Our aim should be to eradicate the evil effects of technology while conserving its constructive uses. It will require a *wise* technology to remove the effects of *unwise* technology. For example, the replacement of the internal combustion engine by a nonpolluting substitute is required to stop the pervasive fouling of the atmosphere.

It is impractical to reverse the historical process and create a non-technological culture, and it would be silly to try. After all, there is no real virtue in ignorance or impotence: far better is the combination of power and knowledge with goodness and beauty. The machine is the normal tool of modern civilization, a tool to be regarded as any other and made to serve, not to enslave and dehumanize. In any case there is no way back to the simplicity of a relatively pretechnological age: the growth of science and technology is too great to arrest. Men will not willingly give up the advantages of technological advancement: their very lives depend upon it. "Take away the energy distributing networks and industrial machinery from America, Russia, and all the world's industrialized countries," writes R. Buckminster Fuller, "and within six months more than two billion swiftly and painfully deteriorating people

58 See Anthony J. Wiener, "Faustian Progress," in Richard Kostelanetz, ed., *Beyond Left and Right* (New York: William Morrow and Company, 1968).

will starve to death." [59] That is a price that no one but a sadist would want to pay. Let us, therefore, press ahead with our scientific and technological resources toward a world without war, poverty, or disease. At the same time, let us greatly enhance the role of art as a counterbalance to technology. In its vividness and individuality and emotional spontaneity, art is strong in the very aspects in which a scientific-technological civilization is deficient.

Art as an Antidote to Mechanization

Is the ideal of a well-balanced civilization an impractical dream? A number of writers, such as Roderick Seidenberg and Jacques Ellul, have warned us that the demand for an ever-greater degree of integration is characteristic of a scientific-technological society and that this demand will ultimately prove fatal to the values of personal independence and aesthetic spontaneity. Man does not lack "within his rich and volatile nature elements presaging another destiny, loftier perhaps, more spiritual and humane," writes Seidenberg, but "the hope of retaining the machine while avoiding the consequent mechanization of society is wholly wishful and fallacious. For the logic of the machine, repeating always its fixed and predesigned patterns, is a mass logic; and collectivism . . . is inherent in its laws and implicit in its operations." [60] Similarly, Ellul, in a profoundly pessimistic book, contends that neither free individuals nor autonomous groups can long hold out against the mechanistic trend of technology.

> Technique requires predictability and, no less, exactness of prediction. It is necessary, then, that technique prevail over the human being. . . . Technique must reduce man to a technical animal, the king of the slaves of technique. Human caprice crumbles before this necessity; there can be no human autonomy in the face of technical autonomy.[61]

Ellul wishes to rebuild modern civilization on Christian rather than technological foundations, but it would appear from his analysis that men have become too enslaved to technology to make the rebuilding possible.

It may be instructive to contrast the profound pessimism of these authors with the older and more optimistic outlook of John Dewey. He

59 "Man With a Chronofile," in ibid., p. 45.
60 *Posthistoric Man* (Chapel Hill: University of North Carolina Press, 1950), pp. 229, 231–32.
61 *The Technological Society* (New York: Alfred A. Knopf, Inc., 1964), p. 138.

steadfastly contended that there is nothing final or fatal about the state of the world. If we develop the capacity to think both compassionately and scientifically about the problems of mankind, and if we employ the fecund means of technology in behalf of a significantly human life, we shall find a practical answer to the pessimism rife among us. We need a balance and integration of all fields of culture, supplementing the older physical technologies with emphasis upon the newer social and psychological technologies, and combining both kinds of technology with art, morals, political action, and a humanistic faith. Technology operates within a cultural context, its potentialities are both constructive and destructive, and it must be guided and controlled if its constructive development is greatly to outweigh and exceed its destructive tendency.

We are more inclined to agree with Dewey than with Seidenberg and Ellul. Science and technology, we believe, can be utilized with imagination and foresight, not as the tools of a managerial technocracy, but as the means to a liberated and creative life. To achieve this goal, artists must join with city planners and civic-minded leaders in bringing a new cleanliness, order, and comeliness into our urban environment. The artistic phase must enter much more pervasively into industry— with less emphasis upon mere volume of production and more emphasis upon fine workmanship and good design. Individuals and groups must limit the mass standardization so characteristic of the Coca-Cola-and-television dimension of our civilization and stress the imaginative life as a countervailing force to mechanization. There must be a decentralization of our society and a renewal of culture, putting humanity before machines and considerations of goodness and beauty ahead of profits.

The proper function of art is the presentation for imaginative acquaintance of the whole realm of values, negative as well as positive. The proper function of technology is by the application of science to maximize the positive values and to minimize the negative. The technologist should be grateful to the artist for the vivid display of the values that he seeks to control. The artist should be grateful to the technologist for implementing the values that he has envisaged. Art supplies the vision, technology the means. In a well-balanced society, they are mutually supporting and complementary.

We do not deny that the danger of technocratic enslavement is real. The massive forces of change seem to be moving toward an organizational gigantism and standardization that undermine the values of individuality. The depersonalization of existence is not only a threat but a constant reality. Even pure science, with its abstract categories, general laws, and classificatory schemas, tends to weaken or diminish

the concerete, lively intiuitions of aesthetic experience. The vivid eidetic imagery characteristic of children and primitive peoples tends to die out as civilized human beings grow up and become habituated to an abstract scientific-technological culture. Too often the fluid richness of immediate experience is sacrificed to a rigid order from which emotional spontaneity and meaningfulness have disappeared. To create and see things afresh is the concern of a tiny minority.

If the artist should succumb to these forces he will have lost his birthright. For it is his function to emphasize quality instead of quantity, creativity instead of conformity, spontaneity instead of routine, vividness instead of abstraction. His greatest gift to mankind, all the more precious in an age of science and technology, is to withstand the forces that make for a colorless uniformity, to keep the freshness of life from going stale. He must cling to the matchlessness of the individual, the loneliness of the visionary. Amid the hurry and tension of getting things done, the artist who stops and listens and seeks his own rhythm has the most to offer. "Why should we be in such desperate haste to succeed, and in such desperate enterprises," asks Henry Thoreau. "If a man does not keep pace with his companions, perhaps it is because he hears a different drummer. Let him step to the music which he hears, however measured or far away." [62] It is the artist in each one of us that hears that distant drummer.

62 Henry Thoreau, *Walden,* Conclusion.

Chapter 12

ART

AND ECONOMIC ACTIVITY

The Relevance of Economic Values to Art

We have maintained throughout this book that human values form a system in which each conditions and limits all the others. There is a line of thought, constantly and variously asserted or assumed, which runs contrary to this conclusion. According to it, there are certain basic values which are absolutely free and unconditional. Traditionally, these are the religious, the moral, the intellectual, and the aesthetic—the holy, the good, the true, and the beautiful. They are respectively affirmed as absolutes in such familiar doctrines as righteousness for righteousness' sake, the sacred uncontaminated by the profane, truth as eternal and absolute, and pure art—art for art's sake.

On this view, there are two kinds of value, "physical" and "spiritual." Piety, virtue, truth, and beauty are spiritual values and are not subject to the conditions and determinations of physical values like felt pleasures or bodily satisfactions. There is no psychology, or at least no physiological psychology, of piety; virtue does not have a price; and there is no occasional truth and no relative beauty.

It follows specifically, and for the theme of this chapter of particu-

lar interest, that there can be no economic determination of the spiritual values, including the aesthetic. The contrary position, which is here maintained, that all values are interrelated, is exhibited as holding between two values, the economic and the aesthetic, specifically as pursued and realized in art.

First of all, it is a commonplace to observe that, aside from the question of economic determination, art as product is an important economic good, subject like all commodities to the laws of supply and demand, and of distribution, trade, use, and investment. Even this commonplace economic character of art as product has sometimes been overlooked or minimized, if not actually denied. Samuel Butler, reacting against the nineteenth-century art-for-art's-sake school, which had as one of its implied tenets the belief that art exists in absolute freedom from all nonaesthetic determinations or intentions, emphasizes in his satirical novel *Erewhon* the point that art is a commodity, that it is merchandise, and that it behooves the artist to look to his market. "The artist," the Erewhonians contend, "is a dealer in pictures, and it is as important for him to learn how to adapt his ware to the market, and to know approximately what kind of picture will fetch how much, as it is for him to be able to paint the picture." The satirical exaggeration serves at least to offset the guileless supposition that the artist's calling is in some peculiar, perhaps divinely favored way, inviolate from the so-called economic taint which is allowed to operate in all other human affairs of production and use.

The argument against this supposition need not rest on a special theory of human life nor on satirical imagination; it is firmly and variously supported by the facts of art history. Though, on the surface at least, exceptions occur, it is not the case that the artist in history has normally or typically worked in disregard or contempt of the market in his time. The artist is normally in some degree a caterer, even if often a highly selective one with reference to his actual or envisioned patrons. Faith in his work is faith in its cash value. And aesthetic value, although not always practical, is also a utility and therefore an economic value.

Even though the artist has a complete aesthetic and professional integrity—a fact which need not be questioned—he will, if he needs to sell by finding a buyer or to earn a fee in fulfilling a commission, be likely to try in some way to find the line within his integrity that will please his patron or client. Sometimes he will make a conscious effort to please from the beginning, working differently than he would if he were absolutely free. The art historian Duret gives an example in the case of Renoir. Telling of the artist's extreme difficulty in his early career

in getting recognition, he recounts that in the face of acute economic
need, he did finally succeed in selling a picture, and that this sale by
good fortune brought him to make

> the acquaintance of two wealthy society people, M. and Mme.
> Berard. Without pretending to be connoisseurs, they had admired
> the charm of *La danseuse* [the painting sold], and commissioned
> Renoir to paint a portrait of their eldest daughter, Marthe. Anx-
> ious to avoid producing a startling effect [which had made his
> paintings so unpopular heretofore], Renoir selected a simple pose
> and a sober scheme of color. . . . The picture proved a great suc-
> cess, and the Berards were delighted with the grace with which
> he had invested their daughter. . . . He stayed with them at their
> house in town and in the country, and received orders to paint
> a large number of portraits. Renoir had been careful to paint his
> first portrait for the Berards in very sober tones, and two or three
> others were similarly treated. But as soon as his connection with
> the family was more firmly established [i.e., we may interpolate,
> as soon as his *name* was economically established], he allowed
> himself great liberty of composition and achieved the most daring
> effects of color.[1]

The practical recognition that, in the world as it is, aesthetic free-
dom cannot be claimed as inalienable but must be won by coming to
terms with the world, economically as well as otherwise, has been given
and acted upon by not a few artists other than Renoir, and in a similar
way—that is by giving up some aesthetic freedom in order to gain the
economic strength which can then be used to win greater aesthetic free-
dom. Thus we are told of Turner that "his success, in spite of his
originality and [aesthetic] audacity, was due to his ability to do the usual
and the academic thing supremely well when he chose to curb his imagi-
nation." [2] His willingness on needed occasion to do "the usual and aca-
demic" brought him early in life the recognition and the financial means
that enabled him to go his own way aesthetically and thus become
"a lone giant" in English painting of his day.

The case of Gainsborough is another recorded instance. "Gains-
borough loved the quiet countryside," and "he wanted to paint land-
scapes." But unfortunately he "could find but few buyers for his land-
scapes, and so most of his pictures [that is, landscapes] remained mere
sketches done for his own enjoyment," and he turned to the fulfillment

[1] Theodore Duret, *Manet and the French Impressionists*, trans. J. E. Crawford
Flitch (London: Grant Richards, 1912), pp. 177–78.
[2] Sheldon Cheney, *The Story of Modern Art* (New York: Viking Press, Inc.,
1941), p. 58.

of numerous commissions for portraits.[3] Both he and his celebrated contemporary Reynolds became great portrait painters because the market was for portraits—and, of course, because their talents could supply the market demand. Both, however, wanted by first preference to paint other things.

From another period and another place, the sixteenth century in Italy, still another example of how economic demand often makes a work of art what it actually is, is found in the story of Caravaggio and his "St. Matthew." Caravaggio, "a very bold and revolutionary painter" who wanted to paint what he felt and believed,

> was given the task of painting a picture of St. Matthew for the altar of a church in Rome. The saint was to be represented writing the gospel, and, to show that the gospels were the word of God, an angel was to be represented inspiring his writings. Caravaggio, who was a very imaginative and uncompromising young artist, thought hard about what it must have been like when an elderly, poor, working man, a simple publican, suddenly had to sit down to write a book. And so he painted a picture of St. Matthew with a bald head and bare, dusty feet, awkwardly gripping the huge volume, anxiously wrinkling his brow, under the unaccustomed strain of writing. By his side he painted a youthful angel, who seems just to have arrived from on high, and who gently guides the labourer's hand as a teacher may do to a child. When Caravaggio delivered this picture to the church where it was to be placed on the altar, people were scandalized at what they took to be lack of respect for the saint. The painting was not accepted, and Caravaggio had to try again. This time he took no chances. He kept strictly to the conventional ideas of what an angel and a saint should look like.[4]

In spite of his being, as this account asserts, an "uncompromising young artist," Caravaggio did, in this case at least, find the point of compromise within which he was willing to work. Bluntly, Caravaggio bowed to his market. And he made a sale. The second "St. Matthew" was accepted and placed as intended, and it stands today in the church of S. Luigi dei Francesi in Rome. And even though the original, then unsalable version is today considered to be the better, and ultimately found its market, too (hanging today in Kaiser-Friedrich Museum in Berlin), the story as it occurred loses none of its force or pertinence. Market values of masterpieces can and do. of course, change.

3 E. H. Gombrich, *The Story of Art*, 11th ed. revised and enlarged (London: Phaidon Press Ltd, 1966), pp. 352–53. Reprinted by permission of the publisher.
4 Ibid., p. 12.

But it does not remain merely for outside interpreters to discover and revealed economic motivations, which often perhaps unwittingly and without direct calculation determine or influence what the artist does. Artists themselves not infrequently are realistically and hard-headedly cognizant of the directions and limitations which economic demand places upon their striving for aesthetic achievement. And some artists at least are not reticent about speaking their honest recognition of the economic facts of life in their creative world. Some, and among them the greatest, have put their recognition and acceptance of the economic motive in print without any felt need for anonymity or confidential communication. Thus Albrecht Dürer in his *Outline of A General Treatise on Painting* (c. 1512), after declaring painting to be a useful art, lists six specific uses which it fundamentally serves. Among these the sixth and last but not least is, says Dürer, "that if you were poor you may by such art come into great wealth and riches." And, he declares further, "a wonderful artist should charge highly for his art . . . no money is too much for it." [5]

Although the mode of utterance in Dürer is different, his plain recognition that art is gainful enterprise, to be pursued as such without apology or pretense, is perhaps not too different from what we get from the raffish bluntness of the fictional Gulley Jimson in Joyce Cary's *The Horse's Mouth*. Jimson is speaking to the "professor," who is going to promote him in a career of fame and wealth and who at the moment is not getting along with it.

"I thought you and I were going into business together," said I, "to coin me cash."
"Is it possible," said the Professor, "to serve Mammon and Art at the same time?"
"It is," I said, "or there wouldn't be any art. Through cash to culture. That's the usual road . . . the history of civilization is written in a ledger." [6]

Though the character is here fictional, his words have a convincing ring that comes from fact—the fact that art is not exempt from the conditions of the real world, a world in which, among other things, everything not free in nature has an economic cost and a price. Real-life artists, if they are realists, like Dürer, know this too and sometimes see clearly and specifically how what they do or do not do is, within their talents, determined by economic realities. Thus Henry Moore, whose

[5] *Artists on Art*, compiled by Robert Goldwater and Marc Treves (New York: Pantheon Books, 1945), p. 81.
[6] Joyce Cary, *The Horse's Mouth* (New York: Harper & Brothers, 1944), pp. 150–51.

preferred aesthetic range is monumental, observes of himself that "if practical considerations allowed me (cost of material, of transport, etc.), I should like to work on large carvings more often than I do." [7]

Nothing in all this argues that the artist who gets along economically must lack artistic integrity, that for the sake of practical success he settles in his work for less than he is capable of. It means only that the artist who is undeluded knows that the economic is one of the conditions of his work; that the artistic pursuit is also a practical pursuit. The economic condition freely acknowledged and acted upon needs to be no more corrupting of artistic integrity than are the other conditions which also limit the always unattainable and empty ideal of absolute, that is, unconditioned, artistic freedom. And there are many other conditions—for example, the fixed size and shape of a particular wall to be frescoed, or the nature of the available material to be worked, or the character of a model or a subject that at some point, no matter how extreme, is incorrigible to artistic alteration. Every situation for artistic creation sets a problem to be solved, presents conditions which cannot be set aside—just as truly as it offers opportunities for free action. The economic is simply one among these many conditions. To acknowledge it and bend to it is in principle no more and no less "corrupting" than to acknowledge and bend to any other.

The major point of interest in these observations is not the obvious one that art-work is economic production, requiring expenditure of labor, and that consequently art as a product commands a price for its acquisition and enjoyment (even in "free" museums), but rather that the economic conditions of production contribute qualitatively to what is produced—as clearly in those cases, for example, in which we often get from Henry Moore small or moderate-sized pieces rather than large or monumental ones. For size itself, as Moore has made clear to himself, has its specific quality. And when in art an envisioned size changes under economic as well as any other compulsion, the whole idea, the whole work changes. "There is a right physical size for every idea," says Moore, and "actual physical size has an emotional meaning." [8] Similar correlations would follow for the same reasons with other determinations of what the artist can get into his hands to work with.

Not only do economic conditions in part determine the kind and quality of art the individual artist produces, but economic considerations as well often have a direct effect in determining the quality of a given kind of art that will be produced and that will survive. Bernard

[7] "Notes on Sculpture," in Myfanny Evans, *The Painter's Object* (London: Gerald Howe, 1937), p. 26.

[8] Ibid., pp. 24, 26.

Berenson, for example, points out that Romanesque architecture has survived mainly in poorer districts, and that old Romanesque buildings were rebuilt or new Gothic structures were erected in the more prosperous areas:

> Some historians will tell you that Romanesque art had its origin in districts where Romanesque buildings are still spread most thickly. More likely those places were too poor or, perhaps, too indifferent, to rebuild in Gothic or later styles. As a matter of fact, Romanesque lingered on in the less prosperous, more outlying parts of Ile-de-France, or in Poitou and the Vendée and in the more out of the way districts in Spain. In that country only a few great cathedrals were not rebuilt in the Gothic style. I cannot recall many entirely Romanesque cathedrals in Normandy, Picardy, Ile-de-France, or Burgundy. Many an abbey failed to be rebuilt in the Gothic style, which means that the monastic communities were no longer as wealthy as when, regardless of expense, they rebuilt Cluny, Vézelay, or St. Benoît-sur-Loire.[9]

The prosperity of ancient Athens, of Renaissance Florence, of Elizabethan London—to cite but a few examples—had much to do with the burst of creative activity in these times and places. Berenson rightly concludes from his observations about Romanesque architecture and other evidence that "the economic factor must never be forgotten." [10]

How Art Serves Economic Interests

The aesthetic serves the economic in many ways, age-old in practice but continued in the modern economy with increasing attention. Quintilian, the Roman rhetorician, remarked that music and work naturally go hand in hand:

> Indeed nature itself seems to have given music as a boon to men to lighten the strain of labor: even the rower in the galleys is cheered to effort by song. Nor is this function of music confined to cases where the efforts of a number are given union by the sound of some sweet voice that sets the tune, but even solitary workers find solace at their toil in artless song.[11]

9 *Aesthetics and History* (New York: Pantheon Books, 1948), pp. 232–33.

10 For further comment on the effects of economic demand and patronage on artistic production, see Edgar Wind, *Art and Anarchy* (New York: Random House, Inc., 1969), Chap. VI. On artists combining to protect their economic interests see Teddy Brunius, *Mutual Aid in the Arts from the Second Empire to Fin de Siècle* (Upssala: Almquist & Wicksell, 1972).

11 *The Institutio Oratoria of Quintilian* with an English translation by H. E. Butler (Cambridge, Mass.: Harvard University Press, 1920), 1:167.

Karl Bücher, in a fundamental discussion of the relation between work and music, concludes that "the peoples of ancient times considered song an indispensable accompaniment of hard labor." The rhythm of the song is adjusted to the rhythm of the productive process, and the verbal content reflects the emotion and meaning associated with the work. Each kind of work has its own music and poetry.[12]

Work dances and work songs are also cited by Yrjö Hirn as examples familiar among primitive peoples everywhere of aesthetic stimulation to the performance of needful but onerous or irksome labor. Artistic activities which accompany the actual performance of work, Hirn finds, serve in various ways the hard necessity of labor. It helps overcome the disinclination to work, it lightens the burden of it, and it renders coordination more effective in group tasks.

> From many parts of the world there may be quoted examples of savages who always raise a chant when compelled to overcome their natural laziness . . . working men everywhere stimulate themselves by special songs of exhortation. And when employed in prolonged and monotonous work they everywhere seem to know that toil may be relieved by song. . . . However fundamental and primordial the aesthetic function of the perception of rhythm may seem for the theorist, it is most probable that the development of this faculty has been chiefly furthered by its utilitarian advantages. . . . Any work which necessitates the cooperation of several workers must be executed with greater efficiency the more closely individuals follow a common rhythm. . . . Hence the development of canoe dances and boating songs, by help of which the movements of the rowers are adjusted according to common and fixed rhythms.[13]

Recognition of the aesthetic as reliever of the drudgery of hard work is found too in the following homely "prescription" contained in a receipt book which circulated widely among American farmers and householders in the nineteenth century:

> The Happy Farmer, How Does He Do His Work? Equally applicable to all labourers, and to everybody—
> *Whistle and hoe, sing as you go,*
> *Shorten the row, by the songs that you know.*[14]

This same principle is widely employed in modern industry, business, office, and school. Wise employers today give increasing attention

12 See *Arbeit und Rhythmus* (Leipzig and Berlin: B. G. Trübner, 1909).
13 Yrjö Hirn, *The Origins of Art* (London: Macmillan & Company, 1900), p. 18.
14 *Dr. Chase's Receipt Book.* A. W. Chase memorial edition (Detroit: F. B. Dickerson Co., 1903).

to the aesthetic as well as the physical comfort of their workers. Planned pleasantness of design and decoration in places of work, and even the display of purely fine art such as painting and sculpture in stores, banks, and in doctor's offices and other commercial and professional establishments, are no longer uncommon or curious. As an example, a group of Eastern business firms shares a collection of high-quality modern paintings, which are exhibited successively in the clerical and executive offices of the member firms. And no need for further justification of the experiment has been felt than the knowledge that people, employees and patrons, like it. The farmer with his radio on his tractor and the trucker with his at his side undoubtedly rest in the same sufficient reason. Frequently, however, more directly calculated means are used to stimulate or support economic effort. For example, during World War II, broadcasts of music in plant and shipyard were found to increase output and were then widely used to hasten the building of the economic sinews for waging war. In recent years, piped-in music has become big business. This new "utility" is provided in hospitals, medical offices, and a wide variety of business establishments, from airports to stores and offices. Even some dairy barns have been so serviced for greater contentment and increased production, of cows as well as milkers!

In the modern world of corporate enterprise there has been a growing relationship between business and the arts. "It has dawned on not a few business leaders that art pays." [15] Art pays in the sense that investment in works of art may be highly profitable. In the international market, the prices of many paintings and sculptures have soared to sensational heights, and shrewd investors have reaped handsome profits. Art pays in the sense that corporate support of the arts is good "public relations," and with tax-credit write-offs it may involve no very great outlay. From a business standpoint, it may be justified on the ground that it is impossible to increase profits without due attention to public expectations of company civic responsibilities. Art pays in the sense that good design makes commodities more attractive and hence more salable. For example, the excellent design of most Swedish industrial products, such as stainless steelware and other household furnishings, has contributed to their wide sale in export to other countries. Art pays in advertising that is aesthetically attractive. Some companies, such as the Container Corporation of America, have employed accomplished artists for advertising purposes. Finally, art pays in the sense that the higher echelon of employees need to be educated in the arts and the humanities:

[15] Richard Eells, *The Corporation and the Arts* (New York: The Macmillan Company, 1967), p. 289.

It is now established practice among leading companies to expose their promising junior executives to the arts and the social sciences as a normal part of in-company education and training. Engineering firms have found that it does not pay to overload their pools of potential managers with technicians innocent of the humanities. Companies often send their more promising men and women to the leading universities for balance, for communication with people in other disciplines and the outside world. They are exposed to the history of Greek civilization and comparative literature, for example. They become aware of the cultures of Asia and Africa, whereas in college they might have done well to glimpse some bits of the history of Western culture.[16]

One of the striking educational developments in recent years is the introduction of more courses in aesthetics, literature, the arts, and art history in schools of business administration and institutes of technology.

The Acquisitive Impulse and the Creative Impulse

To recognize the economic as one among many conditions of art production and consumption is not, as it might at first seem, to accept the doctrine that economic influences always prevail, or that there is invariably a harmony between economic and artistic interests. The interests of the artist as well as of the consumer are often in sharp contrast to the objectives of corporate enterprise. The pure artist is bent upon creativeness rather than acquisitiveness; original design rather than standardized and quantitative production; imaginative freedom and human breadth rather than technical specialization; the search for a common spiritual center rather than competition; the principle of form and harmony rather than the rush, din, and overstimulation of an industrialized milieu. The works of those artists who place themselves, either as commercial designers or purveyors of luxury and amusement, at the disposal of organized business are considered by their employers good enough to spark sales or to enhance leisure hours; but the stubbornly independent artists often appear to "practical men" no better than idle dreamers.

Especially in a profit economy, the economic factor may limit the quantity of good art available to the public. Makers of phonograph records, for example, will record only what is likely to make money.

As a result, there are perhaps forty recordings of Rimski-Korsakov's "Scheherezade," perhaps fifty recordings of "Carnival of Animals," but no recordings whatsoever of most of the 300 cantatas by Bach

[16] Ibid., p. 291.

or the 600 lieder by Schubert, or the twenty-seven concertos of Mozart, or the forty-one operas of Handel, or the 104 symphonies of Haydn.[17]

Even more restrictive are the standards of commercial television and motion pictures. When the Columbia Broadcasting System dropped its fine series of Shakespearean historical plays, "The Age of Kings," a company official explained that even the huge audience of five million was not big enough to justify a network broadcast run by advertisers for profit. Likewise, firms investing from two to fifteen million dollars in a motion picture will examine the script very carefully. In adapting a great book to the screen, they "will frequently vitiate its essential character because it doesn't jibe with their preconception of what the audience will accept." [18] Similarly, our factories pour forth a vast quantity of ugly junk simply because it will sell.

The profit system tends to become all-engulfing. Even such an apparently personal concern as aesthetic taste is subject to economic regimentation. Culture becomes an industry and tastemaking a business. As Russell Lynes has written:

> The making of taste in America is, in fact, a major industry. Is there any other place that you can think of where there are so many professionals telling so many nonprofessionals what their taste should be? Is there any country which has as many magazines as we have devoted to telling people how they should decorate their homes, clothe their bodies, and deport themselves in company? And so many newspaper columns full of hints about what is good taste and what is bad taste? In the last century and a quarter the purveying of taste in America has become big business, employing hundreds of thousands of people in editorial offices, in printing plants, in galleries and museums, in shops and consultants' offices. If the taste industry were to go out of business we would have a major depression, and there would be breadlines of tastemakers as far as the eye could see.[19]

As Lynes goes on to remark, "it is in the nature of our economic system not merely to meet demand but to create it," and the tastemakers work "through mass communications media and vast corporations to reach millions upon millions of people."

If we turn from public taste to artistic creation, the economic motive may have a similar distorting influence. The desire to make money,

[17] Henry Temianka, in Gifford Pinchot et al., *The Arts in a Democratic Society* (Santa Barbara, Calif.: Center for the Study of Democratic Institutions, 1966), pp. 24–25.

[18] Abbott Kaplan, in ibid., p. 26.

[19] Russell Lynes, *The Tastemakers* (New York: Harper & Row Publishers, 1954), p. 4.

as we have seen, need not impair the integrity of the artist, but it *may* do so. The fact that Walter Scott was a "best-seller"—perhaps the first author to have made a sensational record in this respect—helps to explain not only his prodigious output but the deterioration that critics detect in his later novels. "I thank God I can write ill enough for the present taste," he said in a letter to a friend (18 January 1809), and a recent critic has noted in the later narratives a "greater staginess in dialogue and scene-painting," and a "more shapeless and careless" form, which resulted, it appears, from catering to the popular market.[20] To cite another example, Beethoven wrote his artistically inferior composition, the "Battle of Victoria," for the sake of monetary gain:

> It was the one time he thought he could make money, and it is far and away the worst composition he ever wrote and the greatest success he ever had. At the Congress of Vienna in 1815 he had two works performed, the "Battle of Victoria," with guns and cannons and everything, and the Seventh Symphony. The symphony went completely unnoticed, but all the reigning monarchs called him to their boxes to congratulate him on the magnificent masterpiece he had written with malice aforethought and for the most commercial reasons.[21]

Beethoven's musical genius, fortunately, was too potent to be corrupted by worldly success.

The artistic impulse is strong, and if it finds little or no economic reward, it still may prevail. One thinks of the persistent creativity of Emily Dickinson, whose poetry was disdainfully rejected by the editor of *The Atlantic Monthly*, and none of whose poems saw publication or sale within her lifetime; or of painters such as Van Gogh or Henri Rousseau, destitute and utterly neglected by the art public, yet driven as if by some demon to create painting after painting; or Rembrandt, Hals, Ruysdael and Hobbema—poor, bankrupt, or starving, yet never flagging in their art. For such men, art was clearly not a livelihood—it was life itself. If Balzac and Mark Twain were money-mad, as some biographers have asserted, there has been a host of artists and writers who were not. For them, art is a necessity, wealth is not. They prefer plain living, even poverty, to an affluence bought at too great a price. The artist needs the support of the economic system—at least to the point of having enough leisure and a market for his work—but he needs to make art and not money the focus of his life.

Conflict between economic and aesthetic values is neither neces-

[20] Patrick Cuttwell, "Walter Scott," in Boris Ford, ed., *From Blake to Byron* (Baltimore: Penguin Books, 1957), p. 110.

[21] Henry Temianka, in *The Arts in a Democratic Society*, p. 24.

sary nor desirable, but there has been much conflict of this sort in the past and there still is in the present. If there were none we would not have the "voluntary poor"—the hippies and the Bohemians and the struggling young artists who would rather take the "vow of poverty" than to settle down to the "dismal claque" of business or industry. But we can imagine a world in which such people find their rightful place, in which human beings are no longer exhausted by labor, no longer frustrated and weighed down by cares and duties, in which machines do almost all the drudgery and the things they make are well-designed, and in which there are ample resources and leisure for the enjoyment of natural beauty and the cultivation of the arts. To what extent is it possible to bring this kind of world into existence?

Industrial Art

The economic conditions of production in the modern world have been drastically altered by the industrial-technological revolution of the nineteenth and twentieth centuries. Most economic goods are no longer produced by the individual artisan or the small workshop—they are mass-produced in factories and marketed by great corporations, or in a socialist economy, by the state. The aesthetic factor enters into the productive process by means of industrial design. We mean by "industrial design" the creation of a model or sketch for goods to be manufactured in quantity by mechanized processes. In contrast to handicraft, in which the form emerges in fashioning the individual object and no two objects are quite identical, industrial design creates a pattern or working model for the manufacture of objects of exactly the same kind.

For several reasons it is hard to see the industrial designer as an artist. The very fact that his design is mechanically reproduced in quantity robs it of the uniqueness that is usually considered a hallmark of art. More often than not, his plan is to use bulk materials to manufacture articles of common use rather than to employ the traditional media of the fine arts, such as a sculptor's terra cotta or a painter's pigments. He works as a specialist within a complex industrial organization, and he is often a member of a team of designers rather than an independent creator. Hence, there is a tendency to think of him as an "organization man" rather than as an artist.

Nonetheless, the development of industrial design has been the work of great innovators. Distinguished artists were on the faculty of the Bauhaus School, which contributed so much to modern design. One thinks of Breuer and Gropius, Moholy-Nagy, Mies van der Rohe, and Gyorgy Kepes, not to mention Klee, Kandinsky, Feininger, and Albers,

painters who indirectly contributed to design. Among the more notable American designers have been Charles Eames, Herbert Bayer, Raymond Loewy, Eero Saarinen, and Philip Johnson (the last two being famous architects as well as designers). These and other talented men have wrought a veritable revolution in the design of industrial products.

The principles of this revolution were derived from varied sources. As a designer of home furnishings and employer of craftsmen, William Morris (1834–1896) insisted that objects of common use should be dignified by good design. He contended that workmen should respect the intrinsic beauty of different materials, such as wood, glass, and metals, and that they should neither slavishly imitate the handicraft designs of the past nor compromise with the shoddy commerical standards of the present. Although he favored handicraft and distrusted industrial production, there were others who broke with the past and accepted the Machine Age in all its implications: its new materials, forms, techniques, interests, and values. Among these pioneers was the Parisian architect, Henri Labrouste (1801–1875), whose untraditional approach and bold employment of industrial materials such as cast iron are recalled in his statement: "Form must always be appropriate to function. . . . A logical and expressive decoration must derive from construction itself." [22] Likewise, the Belgian designer and theoretician Henri Van de Velde (1863–1957) denounced extraneous ornament and insisted on a "logic without compromise in the use of materials and a proud honesty in working methods." [23] Perhaps few designers would go so far as to adopt the slogan of Adolf Loos, "Ornament is a crime," but there has been a general recognition that industrial design tends to simplify forms in contrast to handicraft, which tends to vary and complicate them. As Lewis Mumford has said:

> Expression through the machine implies the recognition of relatively new aesthetic terms: precision, calculation, flawlessness, simplicity, economy. . . . The elegance of a mathematical equation, the inevitability of a series of physical inter-relations, the naked quality of the material itself, the tight logic of the whole—these are the ingredients that go into the design of machines: and they go equally into products that have been properly designed for machine production. [24]

In no other area of artistic production has there been a greater emphasis upon undisguised functionalism and formal clarity.

[22] Quoted in *Encyclopedia of World Art* (New York: McGraw-Hill Book Company, 1963), 3:98.

[23] Ibid., p. 99.

[24] *Technics and Civilization* (New York: Harcourt Brace Jovanovich, Inc., 1934, and London: Martin Secker and Warburg Ltd), p. 350.

Industrial art and democracy go hand in hand. The only possible way to achieve the mass production of useful objects of high quality is by sound industrial design. It is through this means, more than in any other way, that art in advanced technological societies comes into contact with the multitude. Hence the improvement of industrial design is the principal means of raising the level of popular taste. But the attempt to combine quantity and quality does impose problems. Because manufactured products are often turned out in enormous quantities, the public's overexposure to a design results in boredom. Designers may try to combat this danger by eccentricities in styling and by employing the vagaries of fashion. But the appeal of fashion is ephemeral, and stylistic eccentricity soon loses its charm. It is better to attain a purity of form that does not obtrude and call attention to itself—a form that we enjoy almost unconsciously. If a shape is lovely in its simplicity and grace, the effect of familiarity will be to breed not contempt but liking. The austere designs of the Scandinavian countries have won a worldwide acceptance because they wear well and do not tire the beholder.

Industrial resources and techniques are applied not only in the mass production of goods but in large-scale individual constructions, such as bridges, skyscrapers, grain elevators, and hydroelectric dams. The more gifted technicians of the nineteenth century demonstrated that utilitarian constructions, like the aqueducts built by the ancient Romans, could be aesthetically impressive. A number of great engineers—such as Telford in England, Eiffel in France, and the Roeblings in the United States—constructed bridges, steamships, viaducts, and towers far superior in aesthetic quality to most contemporary architecture. These structures exhibited the principles of the new machine aesthetics: form is determined by function; modern materials such as steel, glass, and concrete are used without camouflage; extraneous ornamentation is replaced by geometrical proportions suited to the nature of the material and the functions of the whole. Similar results were being achieved by toolmakers and mechanics. In Britain, Henry Maudslay and Sir Joseph Whitworth built machines that were clean, simple, and direct in design. Recent designers in the United States, such as Raymond Loewy, Buckminster Fuller, and Victor Gruen, have sustained and enriched this tradition of industrial art.

The rise of new styles in modern architecture is in great measure the result of the revolutionary impact of modern industrial techniques and materials. Some of the materials, such as magnesia alloys and plastics, have been fabricated by technology and were not available in past centuries. Other materials, such as steel and concrete and glass, have been available for a long time but have come into cheap and common

use only recently. With the vastly increased repertoire of media, and with new techniques such as cantilever and ferro-concrete construction, the best modern architects no longer perpetrate sodden imitations of medieval cathedrals or Greek temples. They have evolved new styles that fit modern materials and the functions and techniques of modern life.

An example of this kind of architecture is the work of Pier Luigi Nervi, an engineer by training and profession, who became Italy's most renowned creator of architectural forms. With amazing technical skill in concrete construction, he has created uninterrupted, gravity-defying spans and dramatic curvilinear structures. His cantilevered roofs reach effortlessly across immense expanses of space, as in the aircraft hangar at Orbetello (1938), with its span 300 feet long and 120 feet wide. Similar effects are achieved in the Municipal Stadium in Florence, the Sports Palace outside Rome, and the great Exhibition Hall in Turin. The ribs and supports of these massive structures, curving forward as they surge upward, are spectacular in their beauty. Most architects, with their more limited engineering "know-how," have been unable to achieve such virtuoso mastery of structural design.

The superb blending of the technical and aesthetic aspects of building has been characteristic of past architectural masterpieces. For example, the Gothic cathedral builders were the forerunners of modern architectural engineers, eliminating the heavy masonry of the Romans and substituting the thrust and counterthrust of slender ribs and flying buttresses. But these achievements of the past no longer conform to present needs and opportunities. Architects must keep in mind the increasing wealth of new materials and techniques provided by modern industry. Utilized with aesthetic sensitivity and technical mastery, these new resources provide great possibilities in architectural design.

The importance of industrial technology has received a new emphasis in other forms of contemporary art. Kinetic sculpture, electronic music, computer graphics, and strobe-light displays would be impossible without modern industrial techniques. In the "Art and Technology" exhibit at the Los Angeles County Museum of Art (May 11–August 29, 1971), for example, the use of laser beams, gas plasmas, and sequentially fired strobes were characteristic features. The purpose of the Senior Curator of the Museum, Maurice Tuchman, who conceived and directed the exhibition, was to "bring together the incredible resources and advanced technology of industry with the equally incredible imagination and talent of the best artists at work today." [25] The result was such aston-

[25] Maurice Tuchman, *A Report on the Art and Technology Program of the Los Angeles County Museum of Art* (Los Angeles County Museum of Art, 1971), p. 9.

ishing creations as Rockne Krebs' "Night Passage," which combines a blue-green laser beam knifing down from a thirty-one story building across the street from the museum, several beams pulsing up from the museum itself, and one jutting out for three and one-half miles into the sky. Another example was Boyd Mefferd's five hundred sequentially fired strobe lights encased behind translucent plexiglass walls. The retina of the beholder was bombarded with light so intense that colored after-images largely replaced ordinary vision, causing the room to explode in a phantasmagoria of colors. Apart from such ultra spectacular creations, the influence of industrial technology has been profound and pervasive.[26]

Among the new possibilities is a radical extension and democratization of art, making it available to the masses and not just to the few. We should welcome this possibility and guard against its misuse. If television, for example, can be freed from cheap commercial exploitation, it can have a great artistic future. Public television in England and to a lesser extent in the United States has achieved some notable triumphs, such as the serial dramatization of Tolstoy's *War and Peace* and the broadcasting of Sir Kenneth Clark's *Civilization* and *The Romantic Rebellion*. The movies—a popular art genre created by industrial technology—are not only impressive in their finest achievements but tantalizing in their promises. Many of the most beautiful things in the world can now be mass-produced or mass-reproduced, and the rigid distinction between a "high" and a "low" culture is obsolescent. The means for practicing art (as in amateur photography) or of enjoying art (as in listening to high-fidelity phonograph music) have been radically extended. But it will be necessary to guard against a cheapening and lowering of standards. We should avoid the crude reproduction of masterpieces, such as the innumerable cheap prints of Van Gogh's paintings, or their too-frequent repetition. Industrial technology makes reproduction so easy and inexpensive that the tendency is to repeat it to the point of minimal response or monotony. As Sean O'Casey has said, art should be "common in an *uncommon* way."[27]

The most popular proponent of the technological interpretation and extension of art is Marshall McLuhan, whose books have received great acclaim. He has described history as governed by the development

[26] For additional examples of collaboration between artists, technicians, and industry, see Rolf-Dieter Hermann, "Art, Technology, and Nietzsche," *Journal of Aesthetics and Art Criticism*, 32 (Fall 1973), 95–102; and for a comprehensive discussion of the influence of industrial technology on the art of sculpture, see Jack Burnham, *Beyond Modern Sculpture* (New York: George Braziller, Inc., 1968).
[27] "The Arts Among the Multitude," in James B. Hall and Barry Ulanov, eds., *Modern Culture and the Arts* (New York: McGraw-Hill Book Company, 1967), p. 21.

of various media of communication, each of which works a radical change upon the human environment and upon man's characteristic ways of thinking, feeling, and sensing. The invention of printing had this kind of revolutionizing effect, and the new media of communication are similarly revolutionizing the world. From this point of view, McLuhan strongly emphasizes the importance of the new mass media —film, radio, television, computers, and other electronic devices. "Today we're beginning to realize," he declares, "that the new media aren't just mechanical gimmicks for creating worlds of illusion, but new languages with new and unique powers of expression." [28] He thinks that artists in these media, as "experts in sensory awareness," are leaders in a worldwide transformation of human sensibility.

There is a kind of tonic stimulation in McLuhan's bold generalizations, but he goes too far when he says, for example, that "the effect of the movie form is not related to its program content," and that "the formative power of the media are the media themselves." [29] This is to imply that the essence of communication lies not in the truth or falsehood, the wisdom or folly, the beauty or ugliness of the subject matter, but rather in the technical characteristics of the medium of communication. His theory not only exaggerates the fact that the medium is highly important but also neglects the controlling influence of economic factors in determining how the medium is used. The cheapest kinds of pornography and melodrama in film production, for example, have been commercially very profitable and hence frequent.

Veblen on Conspicuous Waste

Just how controlling economic factors are is a matter of sharp dispute. Among "the wordly philosophers" who have tried to answer this question are the American Thorstein Veblen (1857–1929) and the German Karl Marx (1818–1883). Veblen's study of snobbery and social pretentiousness, *The Theory of the Leisure Class* (1899), has been judged one of the nine or ten books published near or subsequent to the turn of the century which have changed our thinking. Marx, of course, has been even more influential, especially in communist nations. We shall discuss these thinkers in turn, not so much to elucidate their theories as to shape our own opinions. Rather than to dwell on the ideas of John Kenneth Galbraith, who was influenced by Veblen, or George

28 Gerald Emanuel Stearn, ed., *McLuhan: Hot and Cold* (New York: New American Library, 1969), p. 121.

29 Marshal McLuhan, *Understanding Media* (New York: McGraw-Hill Book Company, 1964), pp. 18, 21.

Lukács, who was influenced by Marx, we prefer to go back to the original sources.

According to Veblen, human beings have a basic propensity to emulate the standards of taste of the dominant class and these standards are generally based upon an honorific display of wealth. The existence of a "leisure class" is a characteristic feature of modern capitalist industrial society, and the manifold and complex effort at "conspicuous waste" is the defining activity of the class. Veblen explained a great deal of what goes on in modern society in terms of this class and this activity.

Beauty and art figure in the theory in two ways: (1) as use beauty or economic beauty, and (2) as expense beauty or waste beauty. The first corresponds to the functional interpretation of art and beauty. Veblen declared:

> So far as the economic interest enters into the constitution of beauty, it enters as a suggestion or expression of adequacy to a purpose, a manifest and readily inferable subservience to the life process. This expression of economic serviceability in any object —what may be called the economic beauty of the object—is best served by neat and unambiguous suggestion of its office and its efficiency for the material ends of life.[30]

In the kind of society that Veblen is analyzing, a society with leisure-class standards, the simple-use beauty is largely rejected in favor of expense or cost beauty. That is, the cost or price of an object—or the amount of economic effort necessary to produce it—determines very largely its accepted aesthetic worth. On the ground of use, writes Veblen,

> the simple and unadorned article is aesthetically the best. But since the pecuniary canon of reputability rejects the inexpensive in articles . . . our craving for beautiful things must be sought by way of compromise. . . . Hence it comes that most objects alleged to be beautiful, and doing duty as such, show considerable ingenuity of design and are calculated to puzzle the beholder . . . at the same time that they give evidence of the expenditure of labor in excess of what would give them their fullest efficiency for their ostensible economic end.[31]

To illustrate cost beauty, Veblen compared the gloss on a pair of shoes with the shine of a threadbare coat, and, similarly, a handwrought silver spoon with a machine-made spoon of "base" metal. He noted, in the case of each comparison, that the former connotes an honorific expendi-

[30] *The Theory of the Leisure Class* (New York: Modern Library, 1934), pp. 151–52. Originally published in 1899.
[31] Ibid., p. 152.

ture and the latter a much less respectable economy. The chief purpose of jewelry and other personal ornaments, he remarked, "is to lend éclat to the person of their wearer by comparison with other persons who are compelled to do without." [32]

The operation of the factor of expense in determining the canon of beauty is observed again in the following provocative passage:

> By habitually identifying beauty with reputability, it comes about that a beautiful article which is not expensive is accounted not beautiful. In this way it has happened, for instance, that some beautiful flowers pass conventionally for offensive weeds; others that can be cultivated with relative ease are accepted and admired by the lower middle class, who can afford no more expensive luxuries of the kind; but these varieties are rejected as vulgar by those people who are better able to pay for expensive flowers and who are educated to a higher schedule of pecuniary beauty in the florist's products; while still other flowers, of no greater intrinsic beauty than these, are cultivated at great cost and call out much admiration from flower-lovers whose tastes have been matured under the critical guidance of a polite environment.[33]

For example, orchids are prized as flowers of rare beauty in the United States, where they are very expensive to grow, but are little regarded in Guatemala and some other Latin American countries, where they grow wild in great abundance.

We have cited only a few examples among many instances of honorific extravagance. In manners and comportment, dress and personal adornment, houses and household furnishings, "objects of art" and things of fashion, indeed in almost every expensive article of consumption, Veblen discovered the marks of pecuniary standards of taste. One must read his book at first hand to realize how caustic and far-ranging is his analysis.

We agree with Veblen that cost is frequently an important de facto element in aesthetic taste and artistic effect, and we rejoice in his exposure of "conspicuous waste" and snobbism. But, as Veblen himself recognized, this is not the whole story. Almost diametrically opposite to such cost connotations is the expression of economy and fitness. If we

32 Ibid., p. 130.
33 Ibid., p. 132. With reference to the mention of "weeds" in this quotation, compare Helen Gilkey, a botanical authority, on "What is a weed?": "No definition to date has improved upon the traditionally accepted one of 'a plant growing where it is not wanted.' It may be beautiful or ugly, native or introduced, valuable or valueless in itself; but if it crowds out commercial plants or ornamentals, poisons stock, chokes irrigation ditches, . . . etc., it is a weed." *Weeds of the Pacific Northwest* (Corvallis: Oregon State College Press, 1957), pp. v–vi. One might add, à la Veblen, if it can be raised with no cost or too inexpensively, it is a weed.

analyze the beauty of a locomotive, a ship, an automobile, a bridge, clear readable type, a comfortable-looking chair, or a kitchen utensil, what we value is not overweening decoration but the functional rightness of the design. There are also innumerable aesthetic connotations that have nothing to do with either cost or economy. Take, for example, the suggestion of health in sparkling eyes and a clear, vivid complexion. This has its aesthetic appeal whether we find it in a peasant girl or a lady of fashion.[34]

Thanks to the progressive conquest of scarcity, the historical situation has changed greatly since Veblen wrote *The Theory of the Leisure Class*. Most objects of daily use such as light globes and telephones, being standardized and mass-produced, are identical, whether in the homes of the rich or relatively poor. The "working man" may spend less time on the job than his "boss," and the salesgirl and the fine lady both wear nylons. The classics of literature are available as inexpensive paperbacks, and almost everyone can have masterpieces of music at his fingertips by turning a knob or flipping on a record. Under these circumstances, the very meaning of "high culture" and "leisure-class standards" tends to be lost. Especially in the United States, the well-to-do consider it vulgar to parade their affluence—for example, most of them dress casually when they go to the theater or the concert hall. Likewise, much of our architecture and industrial design, even when produced for rich consumers, has been stripped down to essentials. Although there is still a good deal of ostentatious snobbery (for instance, in the design of some American automobiles), the display of wealth is usually less overt than in the heyday of the old leisure class. The abstention from rococo ostentation and conspicuous waste may be itself a subtle form of snobbery, which serves to differentiate the "well-bred" person from the *nouveau riche*.

The economic determination of standards of consumption still continues on a great scale, even though it may take the guise of inverse exhibitionism. As we have already noted, tastemaking and culture promotion have become major industries, aiding and abetting the massive drive for the bigger and faster turnover required in a profit economy to avoid unmarketable surpluses. If Veblen were alive and writing today, he would surely press the question whether tastemaking as big business is a desirable way to cultivate aesthetic interests.

In our discussion of Veblen's doctrines, we have been speaking primarily of standards of consumption, but he finds the same kind of

[34] See George Santayana, *The Sense of Beauty* (New York: Charles Scribner's Sons, 1896), sec. 53, "Cost As An Element of Effect," and sec. 54, "The Expression of Economy and Fitness."

disparity between economy and waste in the productive process. All through his books runs the contrast between the acquisitive and creative impulses. He has much to say about "the instinct of workmanship," meaning by this "instinct" the hatred of waste and futility and the solicitude for quality. He found this propensity in both the old handcraft and the new industrial design. Opposed to the instinct of workmanship is the profit motive, which he thinks is wasteful of human values and thrives best in an economy of scarcity. In effect, he agrees with William Morris that an unregulated capitalist economy "is by its very nature destructive of art," for it "does not and cannot heed whether the matters it makes are worth making; it does not and cannot heed whether those who make them are degraded in their work; it heeds one thing and only one, namely what it calls making a profit." [35] Implicit in Veblen's whole argument is the contrast between those who perform a useful social function, be it artistic or technological, and those who fatten on waste and acquisitiveness. Like R. H. Tawney, in *The Acquisitive Society*, he looked forward to the establishment of a functional social order that would free the creative impulses of mankind.

Marx on the Economic Basis of Art

Karl Marx, like Veblen, included the aesthetic fact, or art, in the total account of economic activity. One of his best-known but least-understood doctrines is his theory of the economic foundation of art and all other phases of culture. Although the determination of art by economic causes is not mentioned in the *Communist Manifesto* (1848), it seems to be implied there in the statement "that man's ideas, views, and conceptions, in one word, man's consciousness, changes with every change in the conditions of his material existence." Similar remarks occur in *The German Ideology* (1845) and in other works. The statement that is generally considered the classic formulation of his theory appears in the Preface to *A Contribution to the Critique of Political Economy* (1859). The following is a key passage:

> The mode of production in material life determines the general character of the social, political and spiritual processes of life. It is not the consciousness of men that determines their existence, but, on the contrary, their social existence determines their consciousness. At a certain stage of their development, the material forces of production in society come in conflict with the existing relations of production, or—what is but a legal expression for the

35 William Morris, "Art and Socialism," in *The Collected Works of William Morris* (London: Longmans Green and Company, 1915), 23:205.

same thing—with the property relations within which they had been at work before. From forms of development of the forces of production these relations turn into their fetters. Then comes the period of social revolution. With the change of the economic foundation the entire immense superstructure is more or less rapidly transformed. In considering such transformations the distinction should always be made between the material transformation of the economic conditions of production . . . and the legal, political, religious, aesthetic or philosophical—in short ideological forms in which men become conscious of this conflict and fight it out. Just as our opinion of an individual is not based on what he thinks of himself, so can we not judge of such a period of transformation by its own consciousness; on the contrary, this consciousness must rather be explained from the contradictions of material life, from the existing conflict between the social forces of production and the relations of production.[36]

The standard interpretation of this passage is as follows: Society has an economic foundation upon which the culture and social institutions of the society—law, politics, religion, manners, science, art, and so on—are built. The character of the base determines, in the long run, the characteristics and development of the superstructure. The economic base has two parts: the material forces of production and the relations of production. The productive forces include the labor power, raw materials, tools, and techniques involved in the production of commodities. The relations of production are primarily the class structure and division of labor—for instance, the division between slave-owner and slave, feudal lord and serf, land-owner and tenant, factory-owner and employee—a division which, in turn, partly creates and partly rests upon the institutions of property. In the early stages of a social system, the two parts work together harmoniously: the relations of production facilitate the expansion of the productive forces. But sooner or later they get out of kilter, and the relations act as a fetter upon the forces. The cause of this conflict is the incongruous combination of fast and slow changes. The forces of production, especially technology, develop more rapidly than the relations of production, held back by vested interests. When the conflict becomes sufficiently acute, a revolutionary transformation occurs: the property relations and class structure are altered fundamentally so as to match the new productive forces. This change is accompanied by a clash of "ideologies," which are the reflections in thought of the schisms in the economic foundation

[36] Karl Marx, Preface to *A Contribution to the Critique of Political Economy* (Chicago: Charles H. Kerr & Company, 1904), pp. 11–12.

of life. Art, as ideological, shares in the "false consciousness" with which men rationalize and excuse their class interests.

In judging whether this exposition is correct and whether the theory is valid, we must ask certain questions: Does Marx mean that thought processes, including the aesthetic, are no more than the echoes of economic factors? Or is Marx saying that only a certain form of thought—ideology—is an echo, and that there are other forms of thought that are relatively independent and autonomous? Can we characterize the foundation without introducing something from the superstructure, such as science, law, or art? If we cannot, will we have to conclude that the base-superstructure metaphor is false or misleading?

Before answering these questions, we must distinguish two ways of interpreting Marx's theory. One way is the fundamentalist doctrine that the various strata in the social order—the economic system, the state with its laws, and the cultural spheres of art, science, religion, and morality—are all distinct and externally related factors, in which the "higher" are determined by the "lower." The economic system is the "base" that "determines" the political cultural "superstructure." This way of interpreting Marx is still common among both his critics and his "followers." A contrasting mode of interpretation insists on the interrelational and interactive character of all social and cultural levels. This interpretation recognizes the interaction between all levels, but notes that it is an interaction of unequal forces of which the economic forces are especially important and powerful.

A searching examination of Marx's writings confirms this nonreductionist interpretation. In the passages we have quoted from the *Communist Manifesto* and the Preface of 1859, Marx refers to "the conditions of . . . material existence," "the mode of production in material life," "the material forces of life," and "the material transformation of the economic conditions of production." What does Marx mean by "material"? Is it a synonym of "economic"? We think he had more in mind. He used the word "material" to designate the primary, fundamental conditions of human existence. These conditions include the biological constitution of the human being and the interaction between man and external nature. In the *Manuscripts* of 1844, Marx speaks of nature as man's "inorganic body," an extension of his species-being. He describes the unfolding of human productive powers as the humanization of nature and the naturalization of man. Nature is the material in which the labor of man is realized, out of which and through which he creates artifacts and recreates himself. Similarly, in *Capital* he declares:

> Labour is . . . a process in which both man and Nature participate, and in which man of his own accord starts, regulates, and

controls the material reactions between himself and Nature. . . .
By thus acting on the external world and changing it, he at the
same time changes his own nature. . . . Thus Nature becomes one
of the organs of his activity, one that he annexes to his own bod-
ily organs, adding stature to himself. . . .[37]

Regarded in this way, the material foundation of human productivity
is permeated with the biological heritage of man and his ecosphere; yet
it is also historical, for the human condition in its natural setting is
continually in process of historical development.

In addition, Marx refers in many passages to the influence of po-
litical and cultural factors on the economic system. He speaks, for ex-
ample, of the "legal expression" of the property relations in the pas-
sage we have quoted from the Preface. This legal aspect is not to be
lightly dismissed. We need only a little reflection to realize that there
can be no system of property without a body of laws or customs to de-
fine, and a state or other civic authority to enforce, property rights.
At the present time the fusion of economic and political factors charac-
terizes modern society, as John Kenneth Galbraith so realistically points
out in *The Industrial State.*

In the *Economic and Philosophical Manuscripts* (1844), Marx rec-
ognized that ideas, especially scientific, are an essential part of the pro-
ductive process:

Natural science has penetrated all the more *practically* into hu-
man life through industry. It has transformed human life and
prepared the emancipation of humanity, even though its imme-
diate effect was to accentuate the dehumanization of man. *Indus-
try* is the actual historical relation of nature, and thus of natural
science, to man.[38]

As Marx stated in his later years, not only science but all other human
activities influence the economic system:

All circumstances . . . which affect man, the subject of production,
have a greater or lesser influence upon all his functions and ac-
tivities, including his functions and activities as the creator of
material wealth, or commodities. In this sense, it can truly be
asserted that all human relations and functions, however and

[37] Karl Marx, *Capital* (Chicago: Charles H. Kerr & Company, 1906) , I:197–99.
See also Karl Marx and Friedrich Engels, *The German Ideology: Parts I and III* (New
York: International Publishers, 1939), p. 7.
[38] Karl Marx, *Early Writings*, trans. and ed. T. B. Bottomore (London: C. A.
Watts, 1963, and New York: McGraw-Hill Book Company, 1964), p. 163. Reprinted by
permission of Pitman Publishing and McGraw-Hill Book Company. The 1844 *Manu-
scripts* in Bottomore's translation in this volume will henceforth be designated as
E. P. M.

wherever they manifest themselves, influence material production and have a more or less determining effect upon it.[39]

Marx perceived that the productive process is far from a blind and mindless affair, and that art and all other cultural factors help to shape the economic system. In the *Manuscripts* of 1844 and scattered remarks elsewhere, he recognized a large aesthetic component in the productive process, remarking that man in distinction from animals "constructs in accordance with the laws of beauty." [40]

The fundamentalist may retort by pointing to passages in which Marx seems to espouse a pure economic determinism. We admit that he was at times inconsistent or overemphatic. Engels explains that he and Marx were sometimes guilty of polemical exaggerations, being so intent on refuting the Hegelian notion of the absolute dominance of ideas and spiritual processes that they overstated their own case.[41] These exaggerations should not obscure the fact that in less polemical passages Marx expressed a more moderate position. He realized that the productive process is less one-sidedly determinative and less sealed off from political and cultural influences than his unguarded statements might imply. But, despite all these qualifications, he never renounced his belief in the decisive importance of economic causes.

The economic mode of life limits what can be created. Hence the kind of mythological and primitive art of the past can never be revived. "Is Achilles possible side by side with powder and lead?" Marx asked. "Or is the *Iliad* at all compatible with the printing press and steam press?" [42] Although his answer was an emphatic "No," he did not believe that artistic development is directly bound and proportional to economic development. Progress in the one does not necessarily mean progress in the other. "It is well known," he said, "that certain periods of highest development in art stand in no direct connection with the general development of society, nor with the material basis and the skeleton structure of its organization." [43] Conversely, there may be retro-

39 Karl Marx, *Selected Writings in Sociology and Social Philosophy* edited by T. B. Bottomore and Maximilien Rubel. Texts translated by T. B. Bottomore (London: C. A. Watts, 1956, and New York: McGraw-Hill Book Company), p. 100. Reprinted by permission of Pitman Publishing and McGraw-Hill Book Company. Quoted from *Theories of Surplus Value,* manuscripts which Marx intended to use for a fourth volume of *Capital* and which were not published until the twentieth century. (English translation of *Theories of Surplus Value,* 1953.)

40 *E. P. M.,* p. 128.

41 Letter of Engels to Joseph Bloch, September 21–22, 1890, in Karl Marx and Friedrich Engels, *Basic Writings on Politics and Philosophy,* Lewis S. Feuer, ed. (Garden City, N.Y.: Doubleday & Company, Inc., 1959), pp. 399–400.

42 Karl Marx, *A Contribution to the Critique of Political Economy,* p. 311.

43 Ibid., pp. 309–10.

gression in the arts while there is advance in the economic order. The rapid economic progress of capitalism, for example, was inimical to many forms of art (especially the folk arts), intensifying the mechanization of life and stifling imagination and artistic craftsmanship. Rejecting the view that aesthetic value is purely relative to the economic system, Marx was too much a lover of the classics to think that their value disappeared along with the ancient slave economy. He pointed out that Greek art and poetry "still constitute with us a source of aesthetic enjoyment and in certain respects prevail as the standard and model beyond attainment." The social childhood of mankind with its artistic creations exerts "an eternal charm" even though it will never return.[44]

Aesthetic Alienation and Its Overcoming

Marx's doctrine of alienation is closely related to his theory of the relation between art and the economic system. He characterized alienation as the state of being estranged from something or somebody: there is a gulf between man as subject and the world or alter ego as object. Various aspects of alienation are implicit in this characterization. A person is lost to himself and stultified into a material thing: he is estranged from his human essence, from his fellow men, and from the natural world. Material forces (machines and money) take on "life" and tyrannize over human beings. These various phases of alienation are not separate—they are aspects of an all-encompassing rootlessness and estrangement. In consequence, the deepest human needs are in conflict with the actual human condition.

Alienation, as Marx describes it, is both a psychological illness and an historical stage. He wrote many impassioned pages denouncing the foul slums and dreary factories of the Industrial Revolution, the very acme of alienation. The workers in these industrial centers found nature crowded out and beauty absent; their minds and bodies were depersonalized and dehumanized. "Light, air, and the simplest *animal* cleanliness cease to be human needs," Marx wrote. "*Filth*, this corruption and putrefaction which runs in the sewers of civilization, becomes the element in which man lives." [45]

Alienation has been greatly intensified by the extreme division of labor, which results in the division of man himself—for example, a man

[44] Ibid., pp. 311–12. For an interesting discussion of this passage by a Marxist, see Max Raphael, *The Demands of Art* (Princeton, N.J.: Princeton University Press, 1968), pp. 185–87.
[45] *E. P. M.*, p. 170.

is no longer a man but a "hand." In the older craft industries, a watch, a suit of clothes or a fine piece of furniture was the individual product of a skilled craftsman. "Every workman had to be versed in a whole round of tasks, had to be able to make everything that was to be made with his tools." [46] But in a modern factory the workman does over and over again the same monotonous task, such as the adjustment of a spindle or the screwing of a bolt. These routines "mutilate the labourer into a fragment of a man, degrade him to the level of an appendage to a machine, destroy every remnant of charm in his work and turn it into a hated toil." [47] This is the complete antithesis of artistic creativity.

Even the professional artist suffers from the division of labor. For Marx, the authentic artist is not a specialist but a man in the round. He is "corporeal man, with his feet firmly planted on the ground, inhaling and exhaling all the powers of nature." He is also "a suffering being, and since he feels his suffering, a *passionate* being. Passion is man's faculties striving to attain their object." [48] As a sensuous and passionate being, the artist finds fulfillment in the objects of sense, the vivid life of aesthetic experience and artistic creation. In a higher type of civilization every man is an artist and every artist is a whole man. The Industrial Revolution has made this impossible for most persons, because the great majority of workers have been "robbed . . . of all life-content, have become abstract individuals," while the artist has become a specialist. The effect of the division of labor, Marx declared, has been "the exclusive concentration of artistic talent in certain individuals, and its consequent suppression in the broad masses of the people." [49]

The emphasis on money, characteristic of a capitalist society, also has an alienating effect. Money tends to reduce qualitative values to quantitative abstractions, such as dollars and cents. But this reduction is a mutilation, because human values in their integrity are irreducibly qualitative: love, courage, honor, for instance, has each its individualized quality as intuited in the concrete moment of life. This preeminently is true of aesthetic values, whose vivid, unique, and diverse characteristics are never reducible to a homogeneous monetary measure. In contrast, the values of the marketplace are abstract and quantitative. Hence the effect of a money economy is to deprive "the whole world, both the human world and nature, of their own proper value. Money is the alienated essence of man's work and existence: this essence dominates

[46] Karl Marx and Friedrich Engels, *The German Ideology*, p. 46.
[47] *Capital*, 1:708.
[48] *E. P. M.*, pp. 206, 208.
[49] *The German Ideology*, in Marx and Engels, *Gesamtausgabe* (Frankfurt-Berlin-Moscow: Marx-Engels-Lenin Institute, 1927 onwards), Abt. 1, Bd. 5, p. 373.

him and he worships it." In this sense alienation is by no means limited to the proletariat. The affluent man may be the most alienated of all. "Contempt for theory, for art, for history, and for man as an end in himself," declared Marx, "is the real, conscious standpoint and the virtue of the man of money." [50] Acquisitiveness becomes the very "soul" of the society, permeating all realms of social life and thought.

Criticism and Conclusion

We have discussed Marx at some length because his theory provides a convenient touchstone for the clarification of our own convictions. There is a great deal of truth in the Marxist theory of the economic and material conditioning of art, especially in its accurately interpreted version. Many of the facts on which the theory rests are too obvious to escape attention. Reference to social-economic factors is familiar in a great deal of Western art—in, for example, Millet's "Man with the Hoe," in Courbet's "The Stone Breakers," in Van Gogh's paintings of the Drenthe and Neumen period, in Daumier's caricatures of the bourgeoisie, in Diego Rivera's paintings of the enslavement and liberation of the peon, and in the works of countless other artists, including many who are not at all of the "social message" school. In literature it is the same. Much of it in all countries and in all times is directly concerned with social and economic fact. Goldsmith's "Deserted Village," most of Dickens' novels, Zola's *La Terre,* Shelley's "Masque of Anarchy," and the plays of Bertolt Brecht are random and obvious examples. In England there is in fact a long and unbroken literature of socioeconomic protest running from *Piers Ploughman* and the Medieval folk verse,

> *When Adam delved and Eve span*
> *Who was then the gentleman?*

through each succeeding century into the present. Indeed, a very great deal of literary and pictorial art, if not all, can among the various possible "readings" be validly "read" economically. Art may embody economic thought, bear the strong imprint of economic class, and serve or retard social amelioration.

Nevertheless, the extreme "Marxist" position, with its metaphor

[50] "On the Jewish Question," in *Early Writings,* p. 37. For additional texts on Marx's aesthetics see Lee Baxandall and Stefan Morawski, eds., *Marx and Engels on Literature and Art* (New York: International General, 1974), which includes a comprehensive introduction by Morawski, a useful bibliography, and an ample selection of writings by Marx and Engels.

of economic base and cultural superstructure, is misleading and belies, as we have seen, Marx's own deeper insight. If art and aesthetic experience are interpreted broadly, they belong to the material foundation as well as to the "superstructure." Aesthetic value is a thread, and by no means a minor thread, that may run through the whole fabric of life. Consider, for example, the way in which the aesthetic element was woven into almost every aspect of the older Chinese society:

> The universal presence of art, manifest in the commonest utensil, the humblest booth, the advertisements of the shops, the marvellous handwriting, the rhythm of movements always harmonious, measured and as it were governed by inaudible music, speaks of a civilization integral, complete, finished in every detail, a civilization without a single discordant note to break a harmony so perfect that it ends by dazing and crushing us.[51]

One may not agree that the harmony was so perfect, but one can scarcely deny the pervasiveness of art and aesthetic value in traditional Chinese civilization.

Likewise, in a number of primitive societies artistic and economic activity are so closely interwoven that it is artificial to separate them. We are reminded by such books as Hartley Burr Alexander's *The World's Rim* and Bronislaw Malinowski's *Coral Gardens and Their Magic* that the folk arts may be as basic and primordial as anything can be. Among the Pueblos, the Trobriand Islanders, the tribes of Nigeria, and many other primitive peoples, art is an inextricable part of sowing and reaping, hunting and fishing, the making of utensils and the provision of clothing and shelter. The aesthetic, the sacramental, and the economic are all one, and the very notion of art as a separate entity does not even exist.

Even if we consider only our Western industrial civilization, we must reject the fundamentalist version of the base-superstructure doctrine. The account by J. L. and Barbara Hammond of the Industrial Revolution will illustrate our point. These famous economic historians do not deny the exploitation and poverty that Marx finds so horrendous, but more clearly than Marx they point to the loss of the aesthetic values of premechanized England—the folksongs, the Maypole dances and village festivals, the love of fine craftsmanship, the enjoyment of fresh meadows and clear blue sky. In the crowded industrial cities of the Midlands all these enjoyments were absent: the slums were the foulest and the dreariest that mankind had ever seen:

[51] Emile Hovelaque, *China* (New York: E. P. Dutton & Co., Inc., 1919), p. 30.

For the new town was not a home where man could find beauty, happiness, leisure, learning, religion, the influences that civilize outlook and habit, but a bare and desolate place, without color, air, or laughter, where man, woman and child worked, ate, and slept.[52]

The Hammonds conclude that it was *aesthetic* bleakness and *spiritual* poverty, not merely the insufficiency of economic goods, that poisoned life down to its roots. With his theory of alienation, Marx himself bears witness to the same truth, but the reductionist interpretation of his base-superstructure metaphor belies it.

Even at the present time, when we visit the slums of Berlin, London, Mexico City, or New York, it is the ugliness that assaults us so unmercifully. To sort out and separate the aesthetic elements from the economic features of slum life is to violate the integrity of life. At the deepest levels we cannot make neat dichotomies, relegating the "aesthetic" to the superstructure and the "economic" to the base. This is not to deny that the ugliness of the slums is maintained and intensified by economic factors, or that this infection spreads far beyond our urban ghettoes. As George Bernard Shaw wrote, poverty is a most infectious plague:

> Such poverty as we have today in all our great cities degrades the poor, and infects with its degradation the whole neighborhood in which they live. And whatever can degrade a neighborhood can degrade a country and a continent and finally the whole civilized world, which is only a large neighborhood. . . . The old notion that people can "keep themselves to themselves" and not be touched by what is happening to their neighbors, or even to the people who live a hundred miles off, is a most dangerous mistake. . . . People will be able to keep themselves to themselves as much as they please when they have made an end to poverty; but until then they will not be able to shut out the sights and sounds and smells of poverty from their daily walks, nor to feel sure from day to day that its most violent and fatal evils will not reach them through their strongest police guards.[53]

Poverty is not simply an economic evil, but a highly infectious moral and aesthetic blight.

In order to correct the economic-determinist theory, all that needs to be kept in view is the fact that there are other basic social divisions

[52] J. L. Hammond and Barbara Hammond, *The Rise of Modern Industry* (New York: Harcourt, Brace and Company, 1926, London: Methuen & Co Ltd), p. 232. See also *The Black Age* and *The Town Labourer* by the same authors.

[53] *The Intelligent Woman's Guide to Socialism and Capitalism* (New York: William H. Wise & Company, 1931), pp. 47–48.

than the economic and, therefore, other sorts of unions in which men meet overlappingly and thus join in interests which art can equally reflect. The extreme economic theory of art is just another special case of a fallacy which fills in multitudinous forms the pages of the history of aesthetic thinking—namely, the fallacy of arguing that because some or much art is so-and-so, or in part so-and-so, all art is wholly and at all times so-and-so. The view that art has nothing to do with economic activity commits, in another form and in the opposite direction, the same fallacy. It argues that because in art economics is not everything, it is therefore nothing. The all-or-nothing fallacy must be rejected.

A Marxist of the nonreductionist persuasion would agree that the political and cultural spheres are interactive with the economic sphere. But he would still contend that, amid all the acting and interacting forces, the mode of production is, in the long run, by far the most important. If we understand "production" broadly, the doctrine seems to us correct. But the "material productive forces" and the "productive relations" must not be thought of as excluding scientific, political, and aesthetic elements. The scientific component in material productivity, especially in the present phase of history, is enormously potent, and it involves much more than mere economic factors. The political, too, has become so entangled and interpenetrative with the economic that it is more realistic to speak of "political economy," thus combining the two factors, than to speak of the economy alone. The aesthetic element, we must admit, has been too often pushed into the margin, but it often is, and it should be, an integral part of human productivity. As Herbert Marcuse, the neo-Marxist philosopher, has said, "sensitivity and sensi-bility, creative imagination and play" must become major forces of trans-formation, and "aesthetic needs and goals must from the beginning be present in the reconstruction of society, and not only at the end or the far future." [54]

An extreme economic interpretation of art is inadequate for pur-poses of evaluation and criticism no less than for purposes of descrip-tion. The marks of excellence in art—such as mastery of the medium, richness and expressiveness of sensory qualities, depth and clarity of meaning, originality of style, and organic unity of form—are not imme-diately economic in character. To say: "This work of art is bad because it is economically reactionary," or: "This work of art is good because it is economically progressive" is not to utter an aesthetic judgment. A work of art may be poor or excellent aesthetically whether it is work-ing-class, middle-class, or upper-class in its subject matter or origins.

[54] "Liberation from the Affluent Society," in David Cooper, ed., *To Free a Generation* (New York: Collier Books, 1969), p. 186.

This is a truth that Marx knew full well, but many of his followers have slighted it.

In discussing the alienating effects of money, Marx correctly argued that aesthetic values are irreducible to monetary terms. We can compare one work of art or one aesthetic experience with another; but we cannot justly assign numerical values, such as dollars and cents, except to indicate, more or less accurately, a scale of supply and demand. The greater economic value includes the lesser, as for example ten dollars contains among its numerical components a dollar, a half-dollar, a quarter, a dime, a cent; but a greater beauty does not numerically contain a lesser beauty. We may think that the ripple of golden heads of grain in a wind-swept field is more beautiful than the pattern traced by hoar-frost upon a window pane, or that Brueghel's *Hunters in the Snow* is more beautiful than Matisse's *Odalisque*. But it makes no sense at all to say that the more valuable aesthetic experience or work of art *contains* the less valuable one. If we try to reduce aesthetic values to a common monetary measure, we are violating the unique qualitative characters of the things compared. Aesthetic values, like the values of friendship or justice or holiness, remain opaque to numerical measure.

Marx sought, as an end to the alienating effects of money and industrial mechanization, the fulfillment of "man in all the plentitude of his being," declaring that "it is not only in thought but through *all* the senses that man is affirmed in the objective world." [55] This doctrine of alienation and its overcoming is aesthetic in tinge.

It is obvious that mankind has suffered from rootlessness and estrangement, and that mechanization has been, at least in many respects, injurious to the imaginative life. We agree with Marx that to overcome destructive alienation we should learn to live in symbiotic harmony with nature, and that sensory and aesthetic values must be given their due. The humanization of nature and the naturalization of man, each harmonized with the other, is a great and valid ideal.

To grasp Marx's ideal of the future we must turn to his characterization of man as creator. His fascination with the figure of Prometheus as portrayed by Aeschylus indicates his frame of mind. In the preface of his doctoral dissertation (1841) he wrote that "Prometheus is the foremost saint and martyr in the philosophical calendar," and his entire dissertation was pervaded by the spirit of Promethean humanism. Also, in the brief "Confession" that he wrote late in life for his daughter Laura, he listed Aeschylus as a "favorite poet" along with Shakespeare and Goethe. His son-in-law, Paul Lafargue, declared that

[55] *E. P. M.*, pp. 161, 162.

Marx "every year . . . read Aeschylus in the original." [56] The figure of Prometheus in the play by Aeschylus is the embodiment of estrangement and hopeful rebellion. He symbolizes the humanistic arts and sciences, seeking to displace the tyrannical rule of the gods by diffusing their powers among men. Thus he stands for a moral ideal of the deepest human significance—the rational control of the environment, both natural and social. In the play he explains:

> How from the silly creatures that [man] was
> I made him conscious and intelligent.

This transformation he accomplished as the great innovator:

> The inventor I, who many a shape did show
> Of science to mankind.

Hence he deserves the encomium of the Wanderer:

> Thou great utility of social man,
> His brightest light since history began,
> Prometheus, steadfast in your works revealed.[57]

We know from Marx's early writings that he interpreted this creative role in no narrow technological sense—that he believed passionately that man the toolmaker should be also man the artist.

But Marx also believed that mankind must suffer the pangs of alienation before it can achieve the wisdom and the will to emancipate itself. He regarded the long-suffering proletariat as the Promethean agent of this emancipation. Similarly, Aeschylus discovered that wisdom comes through prolonged suffering. His Prometheus, as the symbol of this truth, foreshadows a different sort of art than has been characteristic of the past. Toynbee has said:

> When we admire aesthetically the marvellous masonry and architecture of the Great Pyramid or the exquisite furniture and jewellery of Tut-ankh-Amen's tomb, there is a conflict in our hearts between our pride and pleasure in such triumphs of human art and our moral condemnation of the human price at which these triumphs have been bought: the hard labor unjustly imposed on the many to produce the fine flowers of civilization for the exclusive enjoyment of a few who reap where they have not sown. During these last five or six thousand years, the masters of the civilizations have robbed their slaves of their share in the

[56] Lafargue's reminiscences and Marx's "Confession" are reproduced in Erich Fromm, *Marx's Concept of Man* (New York: Frederick Ungar Publishing Co., 1961).
[57] *Prometheus Bound*, trans. E. A. Havelock, in *The Crucifixion of Intellectual Man* (Boston: Beacon Press, 1950), lines 443–44, 469–70, 613–15. Reprinted by permission of Professor E. A. Havelock.

fruits of society's corporate labors as cold-bloodedly as we rob our bees of their honey. The moral ugliness of the unjust act mars the aesthetic beauty of the artistic result.[58]

The promise of Prometheus is that the humanistic arts and sciences will flourish and that such injustice shall cease. We are in hearty agreement with the Promethean ideal.

Although we have reviewed the ideas of Veblen and Marx rather than the ideas of recent economists, we note that an increasing number have adopted a humanistic interpretation of the aims of political economy. John Maynard Keynes, the chief theoretician of welfare economics, maintained that the "money-motive" should be subordinated to "the arts of life." Predicting the changes that "our grandchildren" will see, he declared:

> The love of money as a possession—as distinguished from the love of money as a means to the enjoyments and realities of life —will be recognized for what it is, a somewhat disgusting morbidity, one of those semi-criminal, semi-pathological propensities which one hands over with a shudder to the specialists in mental disease.[59]

Keynes believed that in the long run mankind will solve its economic problem, and that the "permanent problem" will be the use of its leisure and resources "to live wisely and agreeably and well."

Advocating the vigorous support of "the aesthetic dimension," Kenneth Galbraith has called on both government and private agencies to recognize it "as a high public responsibility":

> What is done as an afterthought is rarely done well. Something better can be expected when a task is seen to be central, not marginal, to life. It is worth hoping that the educational and scientific estate, as it grows in power, will encourage and enforce more exacting aesthetic standards. . . . Far more than the test of production, which is far too easy, the test of aesthetic achievement is the one that, one day, the progressive community will apply.[60]

In *Economics and the Public Purpose* (1973), Galbraith reiterates his contention that the aesthetic quality of life suffers from the single-minded concentration on profits.

[58] Arnold J. Toynbee, *Civilization on Trial* (New York: Oxford University Press, 1948), p. 26.

[59] *Essays in Persuasion* (London: Rupert Hart-Davis, 1952), p. 369. First published in 1932.

[60] John Kenneth Galbraith, *The New Industrial State* (Boston: Houghton Mifflin Company, 1967, and London: André Deutsch Ltd), pp. 352–53. See also Galbraith's Introduction to a new edition of Veblen's *Theory of the Leisure Class* (Boston: Houghton Mifflin Company, 1973),

In a book typical of humanistic economics, Walter A. Weisskopf likewise repudiates the one-dimensional "ideal of an ever-increasing Gross National Product regardless of what it consists of and who gets what," and insists that the "multidimensionality" of human values be vigorously cultivated:

> There are human potentialities and needs which are not related to the procurement of goods and services and cannot be satisfied by producing and by buying and selling. Love, friendship, primary, warm, affectionate human relations; the experience of beauty, worship, the pursuit of truth and of the good, are of this nature.[61]

Other contemporary economists, such as Gunnar Myrdal, Robert Heilbroner, and Kenneth Boulding, are keenly aware of nonmaterial needs and sharply opposed to a planless, undirected economic growth.

This call for a multidimensional balance and humanistic reassessment of goals is central to the argument of this book. We believe that sanity and balance can best be achieved in a free and democratic society. It is to the consideration of "Art and Freedom" that we shall turn in the next chapter.

61 *Alienation and Economics* (New York: E. P. Dutton & Co., Inc., 1971), p. 188.

Chapter 13

ART

AND FREEDOM

The Relation of Freedom and Art

In one of the many books treating of the relation between art and society, this passage from the Funeral Oration of Pericles is quoted: "We have provided education and recreation for the spirit . . . beauty in our public buildings, which delight our hearts day by day and banish sadness . . . we love beauty without extravagance." The author comments that "in these words Pericles gave an extraordinary reason why men should gladly die for their country," and that "it is probably the only instance in history of a statesman urging his people to be patriotic because their state offered them aesthetic opportunities." [1] The spokesman for Athenian democracy, Pericles, attributed the virility of Athens largely to the cultural freedom enjoyed by its citizens.

It may be that these Periclean sentiments are still without downright parallel in explicit pronouncement from any modern leader of state. Art, or the freedom of art, is not mentioned, for example, in the

[1] W. R. Agard, *What Democracy Meant to the Greeks* (Chapel Hill: University of North Carolina Press, 1942), p. 102.

Atlantic Charter, which defined the aims of America and Great Britain in World War II, but we may believe it to be implicitly there. Indeed, we have warrant to read it into that document in the light of some earlier public words of the president of the United States himself. Franklin D. Roosevelt declared in a public address (on the occasion of the dedication of the Museum of Modern Art) that "the conditions for democracy and for art are one and the same," and that "what we call liberty in politics results in freedom in the arts." [2] These words are at least *close* to those of Pericles in calling upon the citizens of a democracy to bethink themselves of the place of art and its freedom in the way of life that they were called upon to defend.

More explicit than the Atlantic Charter is Article 27 of the Universal Declaration of Human Rights adopted on December 10, 1948, by the General Assembly of the United Nations:

1. Everyone has the right freely to participate in the cultural life of the community, to enjoy the arts and to share in scientific advancement and its benefits.

2. Everyone has the right to the protection of the moral and material interests resulting from any scientific, literary or artistic production of which he is the author.

Here is recognition of the right of all men to "enjoy the arts" and to share in the intellectual and artistic advancement of the community. Without this right "men cannot give the best of themselves as active members of the community because they are deprived of the means to fulfill themselves as human beings." [3] These statements formulate norms to which the conscience of mankind can repair, but they do not constitute binding laws or judicial precedents.

In contrast, the Constitution of the United States is the operative law of a sovereign state. The First Amendment, with its charter of free speech, has been interpreted by the Supreme Court as applicable to all forms of artistic expression. Similarly, the Welfare Clause in the Preamble has been construed in terms that include beauty and art. The Court has declared:

The concept of the public welfare is broad and inclusive. . . . The values which it represents are spiritual as well as physical, aesthetic as well as monetary. It is within the power of the legislature to determine that the community shall be beautiful as

[2] Quoted by Horace M. Kallen, *Art and Freedom* (New York: Duell, Sloan and Pearce, 1942), 2:905.

[3] *Human Rights: A Symposium Edited by UNESCO* (London: Allan Wingate, Ltd, 1949), p. 263.

well as healthy, spacious as well as clean, well-balanced as well as carefully patrolled.[4]

These broad concepts of freedom and welfare have thus been invested with the authority of constitutional law. In practice, alas, we lag far behind our judicial standards.

If we turn to the aestheticians, we find that a good many have asserted that there is a natural affinity between art and freedom, or art and democracy. This contention may be called the liberal or democratic theory of art. The theory, in modest form, says that art flourishes best in a free and democratic society, both in creation and appreciation; in extreme form, that art is impossible without political freedom, and, perhaps, freedom without it. We may mention, as an example of the modest doctrine, some of the essays of Herbert Read, such as "The Education of Free Men" or "The Grass Roots of Art." For the more extreme view, we may cite the two-volume work by the American philosopher, Horace M. Kallen—a work which presents the history of art and history of freedom as merely two sides of the same story. The creative artists, we are told in these volumes, are "the avatars of freedom." Only in democratic society does art really flower, and most especially it seems in British-American democratic society of science, machine industry, and "free enterprise." [5]

This view that a flourishing and excellent art is conditioned by *political* freedom, should be distinguished from the view that *aesthetic* freedom—freedom in the creation and appreciation of art—is essential to artistic health and vigor. In the history of aesthetic thinking, the necessity and the inviolability of freedom in art has, of course, been often and variously argued. Freedom of aesthetic conception and action has been affirmed as a necessary condition of art creation; spiritual freedom or liberation has been declared to be the ultimate fruit of art enjoyment; and beauty was found by the philosopher Kant to be a metaphysical warrant for our faith in the possibility of freedom in a world which does not, by philosophical proof or scientific argument, support it.[6] We shall examine the concept of aesthetic freedom in the next section of this chapter. What we have in Kallen's work, or in arguments to similar effect, is something different. It is the belief that art is in its drive and in its work of the same nature as liberal democ-

[4] *Berman v. Parker*, 348 U.S. 26, 32-33 (1954). Majority opinion written by Justice William O. Douglas.

[5] See Kallen, *Art and Freedom*, p. 924. In *Liberty, Laughter and Tears* (DeKalb: Northern Illinois University Press, 1968), Kallen reiterates his contention that liberty and art are closely linked, but he is more circumspect in elaborating his thesis.

[6] See Immanuel Kant, *The Critique of Judgement*, trans. James Creed Meredith (Oxford at the Clarendon Press, 1954), sec. 58.

racy. In our opinion, this position is historically baseless and logically incorrect.

Long ago—probably in the first century A.D.—the brilliant Greek critic known to us only as "Longinus" came to the conclusion that *political* freedom counts little toward the existence or nonexistence of great art. "In our time," Longinus has "one of the philosophers" observe, "there is a world-wide dearth of great literature." And then he has the philosopher ask, "Must we accept the belief that great men of letters reached their acme with democracy and perished with it? . . . In this age . . . ," the philosopher quoted by Longinus continues, "we never drink of the most beautiful and freely flowing fountain of literature, namely, freedom." "But I took him up and answered," writes Longinus. And his answer in summary was that not external tyranny, but the internal moral state of man, the lack of inner freedom, "shrivels up the spirit" which produces great work.[7] This answer is simplistic, because it does not take into account the possible interdependence of inner and outer freedom. But it does point to what is crucial for art—namely, the freedom of the creative spirit.

In this century, we find the question again: Does political-social freedom guarantee or favor the arts? A number of writers have answered that history does not show it. George Boas, himself an uncompromising liberal, reminds us that "one of the greatest artists of all time, Johann Sebastian Bach, had as his patrons such petty rulers as the Duke of Weimar and the Duke of Coethen, and was constantly badgered by the town councillors of Leipzig." "Are we," he asks, "to believe that his music would have been even greater had he lived under Rutherford B. Hayes in the United States of America?"[8] Another writer, Huntingdon Cairns, has remarked that "positive control of art . . . has existed since the remote past. Great art has been created under its dominance in ancient Egypt, in Athens of the fifth and fourth centuries, in Renaissance Italy, and in France from Fronde to Revolution."[9] The art historian Elie Faure, quoted in the same essay, has declared: "Tyranny does not necessarily prevent the blossoming of the poem. Liberty does not necessarily favor it."[10] Herbert J. Muller, the noted historian of culture, has concluded:

> The golden ages [of art] have not been uniformly ages of intellectual freedom, much less civil and political freedom. Great art

[7] Longinus, *On the Sublime*, sec. 44.

[8] "The Stake of Art in the Present Crisis," *Conference on Science, Philosophy and Religion*, Second Symposium (New York, 1942), p. 300.

[9] "Freedom of Expression in Literature," *Annals of the American Academy of Political and Social Science*, 200 (1938), 89.

[10] Ibid., p. 91.

has been produced under diverse conditions, commonly including despotism.[11]

Still another writer observes: "Many of the world's greatest monuments (the sculptures of ancient Egypt or the frescoes of Ajanta) were products of slave-labor. Yet despite stylistic dictation as well, they were conceived with a nobility that little of our 'free' art can approach." [12]

In *The Social History of Art,* Arnold Hauser confirms these judgments. "It is certainly correct," he remarks, "that art has produced many of its greatest creations under compulsion and dictation, and that it had to conform to the wishes of a ruthless despotism in the Ancient Orient and to the demands of a rigid authoritarian culture in the Middle Ages." [13] Hauser notes that even "classical Athens was not so uncompromisingly democratic . . . as might have been supposed. . . . Neither Tyrants nor people succeeded in breaking the power of the nobility. . . . Athens of the fifth century may seem democratic, in comparison with Oriental despotism, but when compared with modern democracies it looks like the citadel of aristocracy." [14] Similar remarks are made by Hauser about other times and places of great artistic attainment, such as Florence in the time of the Medicis, or London in the time of Queen Elizabeth. Although ardently democratic in his own political ideals, Hauser is aware that there is no simple correlation between art and democracy, or art and freedom.

We believe that these observations are sober and these conclusions are just. Art history does not support the view that a free society is a necessary condition for the realization of aesthetic value.

We turn to our second critical point, that to hold art to stand in necessary relation to nonaesthetic forms of freedom is logically incorrect. Analysis of the concept of art reveals in it no necessary connection with freedom in its social or political meanings. What is revealed as necessary is a special kind of freedom—namely, aesthetic freedom, and nothing more. The freedom that is necessary to art production is the freedom of the artist to express himself, but not to express himself in certain fixed ways on certain fixed questions. It is not, for example, the freedom to express approval of the political-social system which guarantees free economic enterprise, trial by jury, habeas corpus, popular election of governing officials, fair taxation, or equal rights before the law. The artist as such need not be a participant in such freedoms, nor an advocate of them. The only freedom logically contained in the concept of art is the freedom to express *some* idea and *some* feeling in an artistic manner, and to practice the techniques necessary to such expression. All sorts of

[11] *Issues of Freedom* (New York: Harper & Brothers, 1960), pp. 96–97.
[12] George L. K. Morris, "Art in Various Aspects," *Partisan Review*, 10 (1943), 453.
[13] *The Social History of Art* (New York: Random House, Inc., 1951), 4:258.
[14] Ibid., 1:81, 82–83.

other freedom may be severely restricted or entirely denied and artistic freedom remain. The artist can be commanded to his work, and find his freedom in the command. Or he can accept the order as *his* will, or he can even accept *obedience* to the order as his will. In each case good and great art may result. Acquaintance with the long and varied history of art patronage should make these facts amply clear.

Similarly, the freedom that is necessary for art appreciation is the freedom to behold and appreciate the work of art. This kind of freedom can exist under many different kinds of social order. For example, the citizens of London, both aristocrats and commoners, were free to enjoy the plays of Marlowe, Ben Jonson, and Shakespeare, despite the authoritarian rule of Elizabeth and James the First. Modern audiences on Broadway are no more free to appreciate the theater. A total despotism that would deny its subjects the right to create or appreciate works of art is fatal to aesthetic freedom—but a non-total despotism might allow its subjects more aesthetic liberty than a meddlesome democracy. A despot such as Cosimo or Lorenzo de Medici might even be a strong patron of the arts.

The denial that the concept of art implies a necessity of nonaesthetic freedoms does not, of course, mean that the values of these other freedoms are thereby questioned. Neither does it mean that they may not find valuable expression in art. Art and political freedom, or art and the general ideal of freedom, may be affirmed as two values and cherished together; but they may not be affirmed, logically and historically, as co-implicative values.

To lock art and freedom in a single concept is, in fact, not only arbitrary but also contradictory, and destructive of freedom. For in maintaining nonaesthetic freedom as necessary to art we must needs impose it as a duty upon art. In this way we succumb to an intolerable absolutism or tyranny of our own—intolerable to the broader ideal of freedom as such—or to "free art." Against honest art, whatever it be, there must be no charge of social guilt and no arbitrary demand of service—social, political, or commercial. In holding to our ideal of a free art in a free society, let us understand, then, that this ideal embraces conjunctives, freedom *and* art: two cardinal values which can without strain on either reason or fact command our deep and clear-minded devotion.

Forms of Inner Freedom

In the concluding section of Chapter 6, "Aesthetic Value in Fine Art," we touched upon the meaning of aesthetic freedom. We have said that art, in its unfettered state, is free to range over the whole gamut

of human values, expressing whatever it finds interesting and important. Within the immense scope of its free expression, it is one of the great liberating interests of mankind. We now wish to return to the consideration of aesthetic freedom, clarifying its meaning and stressing its great human significance.

First, let us make a few comments about freedom in general. To be free is to be human. Freedom is essential to man as man. Without it he is a thing, an automaton, a mere effect of causes outside him; with it he is in a significant degree his own cause. But the freedom we mean is not the mere absence of external, physical restraint or compulsion. From these man can never be entirely free. The necessities of the world can be either understood and accepted or be confused and vainly denied. To be human and free is to understand them and to accept them. The ways of understanding and accepting are forms of human freedom. Although they are no substitutes for social or political freedom, they are essential ways of being free. Among these ways are science, philosophy, morality, religion, and art. What they afford are what we call the highest goods—ultimate human values. All are hard-won attainments, not easy gifts; and all are final— goods in themselves, not merely means to something else. And all are internal freedoms—freedoms from self-bondage. It is in ourselves that we are so-and-so.

The attainment of intellectual freedom is to see things as in fact we find them to be, not demanding in self-will that they should conform to our liking or wishing. When we are intellectually free we want to know what things are, whether they be good, bad, or indifferent. What we care about intellectually is truth. Whether the truth is sweet or bitter, harsh or gentle, is strictly irrelevant. If the universe in truth means well, good; if it means ill, so be it. And if it means nothing, so be it too.

In religious freedom, distinguished from intellectual freedom, we rest in the humility of our ignorance. We know that we do not know, and we resort neither to supernatural myths and dogmas of faith to fill out our ignorance, nor to naturalistic arrogance which refuses to recognize faith—which affirms that the little that we do know is all there is to know. In honest ignorance—honest in recognizing that we do not know—we are free. We are slaves neither to childish superstitions nor to self-weening pretension.

In moral freedom we cleave to what is right, not to what is convenient, expedient, or practical. We do not ask for personal rewards, nor calculate the personal cost. In moral conviction we are free—even of the universe itself. Moral demands are self-demands, not just demands upon the world, nor demands from the world.

In aesthetic freedom, finally, we take as self-sufficient what the

world offers us in its rich sensuous and perceptual immediacy. We take
it as good to smell, to feel, to listen, to look, to savor and appreciate.
We take what we find as good experience in itself—we take it as ma-
terial for art. Art or aesthetic activity is simply creative listening, feel-
ing, seeing, and making. Art does not seek, does not yearn, does not
exhort, does not report, and does not argue. It makes, it creates, it
presents, it imagines. Art is free. We do it wrong, and ourselves too, if
we ask that it should profit, serve, inform, or argue.

Though aesthetic freedom, like other human freedoms, may occur
at all levels of human experience, it is at the level of what we call
"fine art" that its attainment is most nearly complete. This is so because
fine art, as we said in Chapter 6, is the kind of thing in which the
aesthetic quality is the defining character. A work of art may be *used*
in nonaesthetic ways, but these uses do not define it—do not constitute
its *aesthetic* value. A Maillol statuette, for example, may be used as a
doorstop or a paperweight; a painting or a piece of music may serve
to arouse patriotic sentiment or devotion; and a concert may be used
as an occasion for showing off ermine coats or for establishing one's
social or cultural status. Manet's "Absinthe Drinker" may convey the
idea of the moral and physical ruin that results from the abuse of
absinthe, Picasso's "Guernica" may depict the horrors of the Spanish
war, and Beethoven's Fifth may present us with a musical correlate of
meditations on fate and human destiny.

But none of these uses, whether mean and trivial or lofty and
ideal, defines art, nor constitutes its characteristic value. Art is free and
self-expressive. It is concerned in its way to present all that life in its
full qualitative immediacy is and can be. And its way is simply to ex-
press—not to explain, not to condemn, not to justify. In art the human
spirit is self-expressive—that is all and that is enough. Even when life
is grim, the effect of this expression is to liberate. Subjective and per-
sonal emotions become objective and impersonal; the painful element
is purged along with the subjectivity. Yrjö Hirn cites the example of
Goethe writing *The Sorrows of the Young Werther*:

> In his memoirs the old poet frankly and unreservedly describes
> how, when lacerated by the conflict between hypochondriac, sui-
> cidal thoughts and an ineradicable love of life and cheerfulness,
> he resorted to the old homely remedy of writing down his suffer-
> ings. He lays especial stress on his desire to give definite form and
> body to his vague feelings of distress. And as we read that after-
> wards, when the work lay finished before him, "bound in boards,
> as a picture in its frame, so as to prove the more convincingly its
> individual and concrete existence," he could feel "free and joyful,
> and entitled to a new life," we cannot but explain this renewed

courage to live as a result of the sensation of security and support which the beholding of external form affords.[15]

The reader shares in this liberation: evil, from which no one is immune, has been given a form, an outward embodiment and expression, so that it can be understood and removed to a "psychical distance." Art is man's way of driving out into the open the thing he has to dread and facing it without flinching:

> For to bear all naked truths,
> And to envisage circumstance, all calm,
> That is the top of sovereignty.[16]

Play and Aesthetic Freedom

In its holiday moods, art frees us *from* reality; in its sterner moments, it frees us *in* reality. It immerses us in life and stiffens our resistance. Because it has this serious side, we hesitate to identify it with play or entertainment. But men of genius, such as Kant and Schiller, have insisted that there is a deep affinity between art and play. Both aesthetic and playful activity tend to be highly imaginative, the "make-believe" of play being akin to the imaginative flight of art. Each has its aim in itself, and, in contrast with onerous work, is a voluntary activity. There is a freedom and spontaneity about play and art that are lacking in compulsory kinds of activity, such as those required by duty or material want.

Although there is an order or design in play and aesthetic activity as in most kinds of work, the order is the expression—not the repression—of impulse. A tennis or chess player abides by rules, but the rules of the game, unlike the laws of nature or the mores of society, are voluntarily accepted for the joy of the activity. Similarly, a dancer moves in time and in step, in harmony with the music and the movements of his partner, but this is exactly what he *wants* to do. An English figure dance, according to Schiller, is the perfect image of an intricate social harmony in which the freedom of each does not interfere with the freedom of others:

> I can think of no more fitting image for the ideal of social conduct than an English dance, composed of many complicated figures and perfectly executed. A spectator in the gallery sees

[15] *The Origins of Art* (New York: The Macmillan Company, 1900), pp. 104–5.
[16] John Keats, *Hyperion,* Book II, lines 203–5.

innumerable movements intersecting . . . yet never colliding. Everything is so ordered that the one has yielded his place when the other arrives; it is all so skillfully, and yet so artlessly, integrated into a form, that each seems to be following his own inclinations, yet without ever getting in the way of anybody else. It is the most perfectly appropriate symbol of the assertion of one's own freedom and regard for the freedom of others.[17]

Similar remarks can be made about a polyphonic chorus or a symphony in which the diverse voices or instrumental parts are gracefully combined. Social harmony no more requires that each individual play the same tune, or a simple tune, or an unwilling tune, than does orchestral harmony.

We have been speaking of social harmony, but according to Kant and Schiller, there is a similar free and spontaneous harmony within the individual mind. Kant maintained that the essence of aesthetic freedom is the harmonious interplay of the cognitive faculties. There is a happy harmony of the form of the object with our faculties of apprehension and a happy harmony of the faculties in their interplay. These faculties consist of the imagination, which supplies the manifold of images and perceptions, and the understanding, which unifies the manifold. In aesthetic experience, the two faculties harmonize spontaneously without the restriction of explicit concepts or extraneous interests or purposes. This joy and freedom of the human spirit is what Kant means by aesthetic play.

An even more far-reaching interpretation of aesthetic play can be found in Schiller's *Letters on the Aesthetic Education of Man*. Art, he maintains, reconciles the opposite sides of man's nature—the active and the receptive, the spontaneous and the orderly, the free and the lawful, the sensuous and the rational. The sensuous and formal drives *(Stofftrieb* and *Formtrieb)* are harmonized by the play drive *(Spieltrieb).*

The object of the sense-drive, expressed in a general concept, we call life, in the widest sense of this term: a concept designating all material being and all that is immediately present to the senses. The object of the form-drive, expressed in a general concept, we call form, both in the figurative and the literal sense of this term: a concept which includes all the formal qualities of things and all of the relations of these to our thinking faculties. The object of the play-drive, represented in a general schema,

[17] Friedrich Schiller, *On the Aesthetic Education of Man in a Series of Letters*, Elizabeth M. Wilkinson and L. A. Willoughby, eds. (Oxford at the Clarendon Press, 1967), p. 300. (Quoted by the editors from a letter by Schiller to C. G. Körner.) By permission of The Clarendon Press, Oxford.

may therefore be called living form: a concept serving to designate all the aesthetic qualities of phenomena and, in a word, what in the widest sense of the term we call beauty.[18]

In combining the vivid perception of sense with the orderliness of reason, the play drive fosters harmony both in the individual and society:

> All other forms of perception divide men, because they are founded exclusively either upon the sensuous or upon the spiritual part of his being; only the aesthetic mode of perception makes him whole, because both his natures must be in harmony if he is to achieve it.[19]

Hence Schiller declares that "man only plays when he is in the fullest sense of the word a human being, and he is only fully a human being when he plays." [20] The free man is the whole man. Aesthetic play, in contributing to wholeness, is the means to and the stuff of freedom.

Among recent critics of this concept of wholeness is Justus Buchler. The notion, he says, that poetry or art activates "the whole man sounds right and comes to nothing." The "whole man," according to an obvious interpretation, includes the evil and the superficial things in man. These, surely, are not what Schiller would wish to include. No more satisfactory is the idea of "a unique, overarching 'quality of wholeness in man,'" because it is unclear what this quality might be or how anyone could recognize it. According to a more likely interpretation, "the whole man" may mean "a simple essential wholeness, a unitary indivisible humanness." But here again the difficulty, declares Buchler, is that "no such idea has ever been made intelligible." [21] We think that "wholeness" in Schiller's sense—the concept of a well-rounded and well-integrated person—is not as unintelligible as Buchler's words might suggest. Most of us cherish the ideal of the health and happiness of the whole person, emerging in the harmonious cooperation of interrelated physical and mental activities. We want the comprehensive and harmonious realization of our potentialities, not intensity if it means schizophrenia, not intellectuality if it means emotional frigidity, not cultivation of the mind to the neglect of the body or the body to neglect of the mind. Schiller, in his ideal of the whole man, was appealing to a common human aspiration.

Perhaps the word "grace"—a word which applies to both animals and human beings—connotes the kind of wholeness and integration that

18 Ibid., p. 101 (Fifteenth Letter, paragraph 2).
19 Ibid., p. 215 (Twenty-seventh Letter, paragraph 10).
20 Ibid., p. 107 (Fifteenth Letter, paragraph 9).
21 *The Main of Light: On the Concept of Poetry* (New York, London, Toronto: Oxford University Press, 1974), pp. 12–13.

Schiller had in mind. Consider the grace of a race horse running in top form. The ripple of muscles is smooth; the hindquarters move in beautiful rhythm with the forequarters; every organ functions in harmony with every other. All this is changed when the horse has raced to the point of exhaustion. Then its gait is choppy, its movements unrhythmic, its limbs uncoordinated. It wobbles and staggers and may stumble and fall. All its grace has been lost in its inability to function. As with animals, so with human beings, grace is the sign of functional integration and fulfillment, and the loss of grace is the sign of disequilibrium and malfunctioning.

Consider as a second example ice-skating that has become "second nature." The mastery of skating is then so complete that it sinks down deep into the unconscious and seems almost instinctive. The burden of directive consciousness has been lifted from all the troublesome little details of skating—details that require so much attention when a person is learning to skate—and the mind-body is free to concentrate on perfecting the art as a whole. The skating of champions in Olympic Games, for example, is a paradigm of grace—sure and unfaltering and a joy to behold. Whenever an activity in common life attains this level of mastery, it shares the grace of integrated activity with the running of a race horse, or the making of an artistic masterpiece. A superb painter in his brush strokes or a fine orchestral director in gestures with his baton displays a similar grace of movement.

"Art," Gregory Bateson has said, "is a part of man's quest for grace," and "the problem of grace is fundamentally a matter of integration." In this quest, the artist experiences "ecstasy in partial success," and "rage and agony at failure." [22] In the highest reaches of art, grace is a very difficult accomplishment, but even its rare attainment indicates that integration is a possibility.

Schiller's concept of the free play and reconciliation of the diverse sides of human nature is akin to Bateson's concept of grace. At a higher level than ice-skating, grace is the attainment of psychic integration, "the reasons of the heart" being integrated with "the reasons of reason." This integration of reason and heart, law and impulse, conscious and unconscious levels of the psyche, is the quest of art and aesthetic education. It is also the deeper meaning of freedom. For Schiller is right in thinking that the free man is the whole and integrated man.

Basic to Schiller's doctrine of aesthetic freedom is his concept of "semblance" (Schein). Semblance is sheer appearance, recognized as such and enjoyed for its own sake. Imagination, according to Schiller,

22 "Style, Grace and Information in Primitive Art," *Steps to an Ecology of Mind* (New York: Ballantine Books, 1972), p. 129.

is the power to distinguish semblance from reality, to abide with it in contentment and without confusion, and to create an imaginary world —a realm of semblance—with its independent principles of form and construction. It adds a new spiritual dimension to freedom because it liberates the mind from practical purposes and the limits of actuality:

> *I dwell in Possibility,*
> *A fairer house than Prose,*
> *More numerous of windows,*
> *Superior of doors.*[23]

Unchained to the familiar world, the imagination explores the unbounded realms of possibility. "Interest in semblance," Schiller declares, "may be regarded as a genuine enlargement of humanity and a decisive step toward culture." [24]

For the society as a whole, this step cannot be taken without substantial changes in the work-a-day world. In a passage that reminds one of Marx or Ruskin, Schiller sharply criticizes the fragmentation and mechnical routines of industrial society:

> Everlastingly chained to a single fragment of the Whole, man himself develops into nothing but a fragment; everlastingly in his ear the monotonous sound of the wheel that he turns, he never develops the harmony of his being, and instead of putting the stamp of humanity upon his own nature, he becomes nothing more than the imprint of his occupation or his specialized knowledge.[25]

Only when the constraint of material need and the fragmentation of life are surmounted can men escape from this starved and dehumanized existence.

It is instructive to compare Schiller's theory with Kant's. Both would free art from its subservience to extraneous ends and secure for it an autonomy of its own. Both conceive of art in terms of "play"—not play in the limited sense of a pastime or game, but in the ample sense of a harmonious and uninhibited exercise of mental powers. But there are significant differences. Schiller is less the aesthetic purist, less willing to reduce "beauty" to sheer abstract design. Beauty of form is achieved, he contends, not by sundering art from its life-deriving and life-enriching significance, but in the triumph of artistic form over heteronomous materials.

[23] *The Complete Poems of Emily Dickinson,* ed. by T. H. Johnson. Copyright 1919, © 1957 by Mary L. Hampson. By permission of Little, Brown and Company.
[24] Schiller, *On the Aesthetic Education of Man,* p. 193. (Twenty-sixth Letter, paragraph 4).
[25] Ibid., p. 35 (Sixth Letter, paragraph 7).

Kant insists . . . that each beauty which stands under the concept of a purpose, is not a *pure* beauty; that therefore an arabesque, and things like that, . . . are purer than the highest beauty of the human form. I find his distinction of logical and aesthetic can be of great use, but it seems to me to be quite inadequate to the idea of beauty. For beauty shows with its greatest brilliance, just when it overcomes the logical character of its object, and how can it overcome where there is no resistance? [26]

As long as the content is transmuted and assimilated by the form, the richer the life values, the greater is the work of art. In conformity with this contextualist perspective, Schiller puts greater emphasis than does Kant on social and political implications, lamenting the constraints and fragmentations of our industrial society, and hailing aesthetic education as the means to an integral and nonrepressive civilization. He thus is the advocate of "the play theory of art" in the widest and noblest sense of "play."

We must distinguish between the theories of Schiller and Kant and the play theory in its narrower connotation. Writers such as Herbert Spencer and Konrad Lange have sought to identify art with play as ordinarily conceived. But art is more than a diversion or amusement. Impelled by strong inner needs, artists may work to the utmost limits of exhaustion; players ordinarily stop when they feel painfully fatigued. The products of art are of serious and lasting consequence; playthings, as their very name implies, are usually valued only as objects to play with. When children play at make-believe, globs of mud with embedded pebbles count perfectly as raisin pies, or an ordinary stick serves as a horse because the child can "ride" on it. In neither instance is skill required, nor is the stick or mud expressive. Their intrinsic nature matters little as long as they serve to hook up the children's fantasies. Skill, of course, is required to play the adult game of tennis or chess, but because the balls and rackets or chessmen are ready-made, there is no creation of an artifact. Almost all the arts have gone through stylistic revolutions in recent years, whereas baseball and tennis have changed little and chess not at all. Because of contrasts such as these, we must distinguish between art and play—they overlap but do not coincide. However, the proponents of the play theory in aesthetics—Schiller most of all—have rightly emphasized that art is a liberating kind of activity. More than any other form of culture, art transcends the ordinary dualisms and polarities that limit and frustrate us, and thus provides a kind of model or paradigm of the free life.

26 *Schillers Briefe*, F. Jonas, ed. (Stuttgart, Leipzig, 1896), 3:238, quoted by Michael Podro, *The Manifold in Perception* (London: Oxford at the Clarendon Press, 1972), p. 41.

Akin to aesthetic play is the creative use of leisure. With the rapid development of automation and technical efficiency, working hours can be reduced and wages increased. In technologically advanced countries, the worker will have far more leisure time, and if he learns what to do with it, he can refresh his spirit and broaden his horizons. In the past, leisure has been the prerogative of a small privileged class; but in the future, it can be within the reach of the common man. There will then be need to cultivate a way of life in accordance with the very different possibilities that have been unfolding. The humiliating idea that man is a working animal will no longer correspond to the facts of life. There will be far more opportunity for love and play and art, the enjoyment of wild nature, the pleasures of travel, the adventures of the mind, the cultivation of life in its sparkle and diversity.

One sign of the coming change is the growth of amateur arts and crafts. An increasing number of women are designing their clothes, decorating their homes, upholstering furniture, weaving textiles, making jewelry. Men, too, are building furniture, landscaping gardens, using small power tools for metal-work or home carpentry, and engaging in any number of hobbies. Both men and women pursue photography as an art, or buy or build high-fidelity phonographs and cultivate their love for music, or learn to play instruments and join chamber music groups, or mould pottery or paint or dance or explore the beauty of natural scenery. Some of these activities are merely the result of a desire to save money, but the more interesting pursuits are intended to enrich liesure and to escape from the constriction and humdrum of daily routines. They are among the ways of being free and self-expressive. Even though the standard of performance may not be high, it is more rewarding to "do it yourself" than always to be a spectator.

The Aesthetic Implications of Two Concepts of Freedom

There are two main concepts of social freedom—one negative, a bill of immunities, and the other positive, a schedule of resources and opportunities. According to the negative concept, freedom means that a man can do what he wants to do without interference. "A freeman," said Hobbes, "is he that . . . is not hindered to do what he hath a will to do." [27] Because Hobbes thought that human beings naturally prey upon one another, he believed that government must impose strong controls to avoid anarchy and preserve even a modicum of freedom. Locke, Jefferson, and Mill, more optimistic about human nature, opposed the overweening power of government or any other authoritarian body. They

[27] Thomas Hobbes, *Leviathan* (New York: E. P. Dutton, Everyman's Library, 1914), p. 110.

admitted that the freedom of some must be curtailed to secure the freedom of others, but they insisted upon a large preserve of "civil liberties" to be protected against invasion. Mill, in particular, warned against the danger of a tyranny of the majority, whether in the form of repressive laws or intolerant attitudes and behavior. He believed that experimentation is socially advantageous, and defended the right to be different and the right to be wrong.

Artists in Western Europe and America are largely free in this sense. All taboos are off: any style, any subject matter is now permissible. Herbert Read has declared:

> It is a considerable achievement . . . of modern art to have made the world . . . tolerant (intellectually, if not politically) of variety. Modern art has broken through the artificial boundaries and limitations which we owe to a biased view of the human personality. . . . There is not one type of art to which all types of men should conform, but as many types of art as there are types of men. . . .[28]

Read considers it a great victory that the arts in Western countries have been freed for almost unlimited experimentation.

There is much to justify his opinion, but the gain may not be as great as it appears. Perhaps the straining after originality is not so much a spontaneous act of freedom as a symptom of restlessness. Contemporary artists—particularly the *avant garde*—are ill at ease in our bureaucratized and mechanically rationalized civilization. They note the tendency toward the standardization of opinion, behavior, and production, and, as artists, they hate such regimentation. "Only artists," Nietzsche remarked, "hate this slovenly life in borrowed manners and loosely fitting opinions and unveil the secret . . . that every human being is a unique wonder." [29] Recoiling from a world increasingly dominated by huge impersonal organizations, artists strive to be different and independent.

Art thrives on individuality, but individuality is not the same as individualism. Taken alone and apart from community, individualism is based on the separation of man from man rather than on the connection of man with man. This kind of individualistic "freedom" often results in destructive alienation—the rootlessness and sense of futility of men isolated from one another. To constitute a viable whole, "the all-varied, all-permitting, all-free theorem of individuality" must be combined with "another half"—"the personal . . . attachment of man to

[28] *Education Through Art* (New York: Pantheon Books, Inc., 1958), pp. 27–28.
[29] Friedrich Nietzsche, *Schopenhauer as Educator,* in Walter Kaufmann, ed., *Existentialism from Dostoevsky to Sartre* (Cleveland: World Publishing Company, 1956), p. 101.

man." [30] But a word of caution is necessary: the social concept of freedom may be as exaggerated and one-sided as the extreme individualistic concept. The attainment of "togetherness" by the repression of individuality is not the solution we seek. What is needed is neither a revival of individualistic capitalism, which has had its own grievous faults, nor an extension of twentieth-century corporatism, but a new synthesis that will put personal relations at the focus of life, while utilizing, selectively, the immense creative potentialities of a technological and scientific age. The main basis of living for the artist, as for the ordinary citizen, should be neither isolated individualism nor anonymous collectivity, but the friendly meeting between man and man, each giving and responding from a center of inwardness.

The need for inward and not merely outward freedom is exemplified by such anti-Utopian novels as *Brave New World*. Are the characters· in Aldous Huxley's novel free or not? If by freedom we simply mean that a person is able to do what he wants to do, we would have to say that they are free. They do what they want. But their wants and desires have been "programmed" into them—hence they lack all inner self-determination, being the very opposite of the free and creative persons envisaged in Schiller's *Letters on the Aesthetic Education of Man*, or its modern analogue, Herbert Read's *Education Through Art*.[31] As long as wants and needs are artificially induced by propaganda, advertising techniques, or "operant conditioning," men are no more free than the denizens of the Brave New World, even though like Huxley's programmed men they get what they want. Their wants, being manipulated from without, do not reflect their uniqueness or autonomy as persons, nor do they reach down to the depths or up to the heights of their being.[32]

A good, temperate statement of the idea of positive freedom is to be found in the writings of Thomas Hill Green. The achievement of

[30] Walt Whitman, *Democratic Vistas* (New York: Liberal Arts Press, 1949). First published in 1871.

[31] See Herbert Read, *Education Through Art*, 3rd ed. (New York: Pantheon Books, Inc., 1958).

[32] Here we sharply disagree with B. F. Skinner, the advocate of "behavioral engineering." The main point in his controversial book, *Beyond Freedom and Dignity* (New York: Alfred A. Knopf, Inc., 1971), is that "pre-scientific notions," such as "freedom" and "dignity," hinder the design of a better social order along behaviorist lines. His discarding of "mentalistic explanations" and sole reliance on "operant conditioning" raises issues too far-reaching to be discussed in this book. At the cost of appearing dogmatic, however, we reject his assault on "autonomous man" and turn to others for a deeper and truer conception of freedom. For those who wish to pursue the question, see the debate between Carl Rogers and B. F. Skinner, "Some Issues Concerning the Control of Human Behavior: A Symposium," *Science*, 124, November 30, 1956. For a critique of *Beyond Freedom and Dignity*, see Noam Chomsky, "The Case Against B. F. Skinner," *The New York Review of Books*, Vol. 17, December 30, 1971.

freedom from the constraints of others, he maintained, may be a hollow achievement if not accompanied by the presence of resources and capacities which social action alone can provide. The following is a characteristic passage:

> We shall probably all agree that freedom, rightly understood, is the greatest of blessings. . . . But when we thus speak of freedom, we should consider carefully what we mean by it. We do not mean merely freedom from restraint or compulsion. We do not mean merely freedom to do as we like irrespectively of what it is that we like. We do not mean a freedom that can be enjoyed by one man or one set of men at the cost of a loss of freedom to others. When we speak of freedom as something to be so highly prized, we mean a positive power or capacity of doing or enjoying something worth doing or enjoying, and that, too, something that we do or enjoy in common with others. We mean by it a power which each man exercises through the help or security given him by his fellow-men, and which he in turn helps to secure for them.[33]

At the same time, Green rejected Rousseau's notion that citizens should be "forced to be free," stating "that there can be no freedom among men who act not willingly but under compulsion." Liberals in the twentieth century have moved away from individualistic liberalism toward this more social-minded liberalism.

The United Nations Declaration of Human Rights demands both kinds of freedom—the immunities and privacies in the older liberal tradition and the affirmative claims and powers of the newer agenda of freedom. It insists equally upon *civil liberties,* such as freedom of speech, assembly, worship, and association, and upon *human rights,* such as the right to a decent livelihood, education, protection of health, and freedom from racial and religious discrimination. Without both kinds of freedom, men are deprived of the means to effectuate their choices and to perfect themselves as human beings.

We have declared that great art may exist in an unfree society and to this judgment we still cling, but now we must supplement it with another insight. Without civil liberties and human rights, aesthetic freedom cannot be widely disseminated. In a nonfraternal and inequalitarian society, there may be a culture high in its vertical thrust into excellence, but it will remain insufferably narrow in its horizontal spread among the masses.

Comparison of the United States and Czarist Russia will help to make this fact clear. American democracy, with all its teeming millions

[33] "Liberal Legislation and Freedom of Contract" (Lecture), 1880.

of educated citizens, has rarely equaled the aesthetic heights of Czarist Russia. Pushkin in poetry, Dostoevsky and Tolstoy in fiction, Moussorg-sky and Tschaikowsky in music, Pavlova and Nijinsky in dancing, Chek-hov in play-writing, and Moscow Art Theater in dramatic produc-tion have probably equaled or excelled any comparable achievements in the United States. But only the few participated in this high culture, for the mass of the population was illiterate and starved. Although the United States still has a great deal to do in realizing its full democratic potential, it has spread artistic creation and aesthetic enjoyment over a much more vast circumference.

Perhaps the same could be said for the Soviet Union, in which a literate awareness of the arts is much more widespread than in old Czarist Russia. But freedom of artistic expression has been sadly de-ficient, especially under Stalin and even under Brezhnev. Lenin's rela-tively mild stewardship of the arts, during the most productive years of cultural creativeness in Soviet history, was followed by a repression of all art and literature that did not fit the categories of "socialist real-ism." [34] A considerable number of artists and writers have been officially attacked, and in extreme cases driven to suicide, sentenced to hard labor, or carried off to lunatic asylums. Solzhenitsyn, the Nobel Prize winner, is the most prominent victim. Torture and imprisonment are rampant in many countries, including the far right as well as the far left.[35]

The agenda of freedom demands both unfettered artistic expres-sion and grass-roots participation in the arts. Liberal democrats do not want art or aesthetic freedom for the few, any more than they want government support for the few, or economic well-being for the few. They think that human culture should be enriched in both a quantita-tive and a qualitative sense. To share the good things of life and to make the things shared just as good as possible—this is the legitimate goal of a democracy. Among the good things to be shared, none is more precious than art and freedom.

What is needed is, in some particulars at least, clear—we want at once to preserve the freedom of art and to make it more democratic and responsibly operative in our society. We want art to be free. We must suffer it then to be in the genuine sense aristocratic—to be experi-mental, difficult, and even abstruse, as science and professional skills are allowed to be experimental, difficult, and abstruse. Let us welcome rather than suspect art *of*—and even *for*—the few.

[34] See Herbert Marcuse, *Soviet Marxism* (New York: Columbia University Press, 1958), pp. 128–35.

[35] See Aleksandr I. Solzhenitsyn, *The Gulag Archipelago* (New York: Harper and Row, Publishers, 1974). For a survey of extreme repression in "sixty countries," see "The Geography of Disgrace," *Saturday Review World*, June 15, 1974, pp. 14–19.

At the same time, let us have also in fluid gradations, not in fixed and supercilious declensions, an art for all, a people's art. Let it be bound at its broadest and all-inclusive base in a firm tradition of respect for art as one of the primary concerns in all living—in the building of a courthouse or a corner store, as well as in the painting of a mural or the writing of a poem. Let it be a concern nourished in sound education, from beginning to end, so that we will no longer look on our town and city streets everywhere and see the marks of aesthetic illiteracy. Let us in education be at least as serious about art as we are about physical health, comfort, and economic well-being, or negatively about physical disease and economic poverty.

Let art education in schools and colleges consist not only in desultory development of art lessons and studio problems, but let it in good half consist of day-by-day study of the social aesthetic failure that meets us on the surface of every main street and side street of the land. Let us, in brief, have an aesthetic will. The rest will come.

Such a tradition of aesthetic will, developed through social-critical aesthetic education, as it implies a new determination to be really serious about art, implies also a new social definition of the artist. The artist must be integrated in his free society as he has not yet been. He must be taken functionally in his society with just as much seriousness as is the doctor, the dentist, or the banker. The historical alliance of art and privilege must be brought to an end.

We need not worry about the freedom of art and its responsibleness, nor about the freedom of the society (as far as it can be aesthetically affected) if art is given genuine opportunities for leadership in our effective social tradition. With these opportunities, art will be reasonably as healthy and outward as society itself. Without them it will be ingrown, and in that sense irresponsible. These beliefs, we are convinced, constitute what can be a sound liberal aesthetic tradition, sufficient for our ideal of freedom and art.

Our insistence on the positive dimension of freedom is in accord with Albert Hofstadter's characterization of freedom as "Being with other as with own"—a concept which we discussed in Chapter 8. According to Hofstadter, the drive to achieve the freedom of "ownness" is the fundamental impulse of human life. By means of his arts and sciences and techniques, man strives not only to deepen and refine his humanity, but to transform an indifferent nature and a recalcitrant society into a genuinely human world. When freedom is so conceived, the whole question of the relation of man to his natural and human environment becomes focal. To this sphere of thought we turn in our next and final chapter, "Art and the Environment."

Chapter 14

ART

AND THE ENVIRONMENT

The Timeliness of Environmental Aesthetics

Seldom are "new" ideas and movements entirely novel. As Allan Shields has remarked in the *Journal of Aesthetics* (Fall 1973), Ludwig Wittgenstein's "family resemblance" doctrine, which has provoked lively controversy among aestheticians, was anticipated by William James in Lecture II of *The Varieties of Religious Experience* (1902). Because James, in this passage, was thinking about the difficulty of defining religion, it might be thought that Morris Weitz was breaking new ground when he applied the family resemblance concept to the problem of defining art.[1] But Thomas Reid in his *Essays on the Intellectual Powers of Man* (1785) and Dugald Stewart in his *Philosophical Essays* (1810) stated the doctrine in explicit application to aesthetic definition.[2] Similar anticipations may be cited with respect to art styles and movements. As we mentioned in Chapter 2, Plato anticipated the nonobjective art

[1] See Morris Weitz, "The Role of Theory in Aesthetics," *Journal of Aesthetics and Art Criticism*, Vol. 15 (1956). Reprinted in Melvin Rader, *A Modern Book of Esthetics* (New York: Holt, Rinehart and Winston, Inc., 1973).

[2] See Harold Osborne, *Aesthetics and Art Theory* (New York: E. P. Dutton & Company, 1970), pp. 253–55.

of the twentieth century, extolling the "true pleasures" to be derived from an art of "straight lines and curves and the surfaces or solid forms produced out of these by lathes and rulers and squares."[3] Nearer our own time, Ludwig Tieck (1773–1853), in his novel *Franz Sternbald's Travels*, predicted an abstract art of pure colors. In one of his plays, the audience climbs on the stage and mingles with the actors, much as performers and audience intermingled in recent "happenings."

Why did not such ideas and practices exercise a greater influence when they were first introduced? The same sort of question was asked in Chapter 11 with reference to scientific developments. Although we must not slur over the differences between art and science, innovations in both areas tend to lie dormant until the social climate is favorable. In view of this fact, it is unrealistic to contend that art has little social relevance and no social roots, as Whistler does in his "Ten O'Clock Lecture" (1888). The master artist, said Whistler, "stands in no relation to the moment at which he occurs—a monument of isolation—hinting at sadness—having no part in the progress of his fellow-men." Almost as unrealistic is the remark of Karl Popper in his *Open Society and Its Enemies*: "Aesthetic problems (with the possible exception of architecture) are largely of a private character, but ethical problems concern men and their lives. To this extent, there is a fundamental difference between them."[4]

In making this remark, Popper was attacking the environmental aesthetics of Plato, who maintained that beauty and harmony in the environment foster harmony and beauty in the soul. Because the molding of the environment is the responsibility of statesmen, Plato considered statesmanship the art of arts—the art whose function is to harmonize and control all the other arts, and whose goal is to achieve goodness and beauty in the polis. As Popper remarks, politics is for Plato the "Royal Art" in a "literal sense of the word. It is an art of composition, like music, painting, or architecture. The Platonic politician composes cities, for beauty's sake."[5]

Sheared of its Platonic royalism, environmental aesthetics is "an idea whose time has come." We are living in a period when environmental issues, aesthetic as well as nonaesthetic, have become desperately important. The world's population—especially the urban population—is increasing at a prodigious rate, and mass starvation is already occurring in the "Third World." At the same time, technological escalation is rapidly diminishing the natural resources necessary for survival. Con-

3 *Philebus*, 51 B.
4 *The Open Society and Its Enemies* (Princeton, N.J.: Princeton University Press, 1950), p. 580.
5 Ibid., p. 162.

fronted by air and water pollution and fuel scarcity, the public must increasingly substitute rapid transit in place of private automobiles and in-city dwelling in place of suburban commuting. The nation must build new towns and rebuild old towns on a scale never before undertaken.

The importance of high aesthetic standards in this fresh construction should be obvious. Individuals can seek out and wait upon poetry, painting, and music, but architecture and the civic environment intercept their very steps, doing more to determine the aesthetic sense of a community than all other influences combined. The environment is the school in which ninety-nine out of every hundred people get their training in aesthetic taste. If the city is ugly, it is impossible to keep them sensitive to beauty. Its ugliness degrades their aesthetic sense and deadens the emotions that attend to it.

Does this mean that all the emphasis should be on environmental art and aesthetics? Not at all. We cannot wipe the slate clean and start afresh. How can men attain aesthetic harmony with their environment when they are constantly altering their surroundings? Because we must perforce combine the old and the new and the tidy and the untidy, even the best of urban design and ecological control will leave things a bit messy. Consequently we shall have to look beyond the environment for the paradigm examples of artistic excellence. In the masterpieces of painting, sculpture, music, and poetry, we have a presentation of what form is like when it is aesthetically memorable—which it seldom or never is without subtraction. It has been well said that life should imitate art and not vice versa. We should cherish works of art not only for their intrinsic worth but as beacons to guide us. To ride the whirlwind of change, we need to keep our aesthetic standards high and our sensitivities keen, and there is no better way to do this than through the understanding and appreciation of works of fine art.

But "art" means much more than fine art. When we speak of "art and the environment," we are referring not just to art of the studio but art of the home, the factory, the neighborhood, the civic surroundings, and nature cultivated by human hands. As William Morris said, "a house, a knife, a cup, a steam engine, or what not, anything . . . that is made by man and has form, must either be a work of art or destructive to art." [6] Art should include, he believed, "the shapes and colours of all household goods, nay, even the arrangement of the fields for tillage and pasture, the management of towns and of our highways of all kinds; in a word, . . . the aspect of all the externals of our life." [7] Or as a distinguished landscape architect, Ian McHarg, has said:

[6] "The Socialistic Ideal," *Collected Works* (London: Longmans, Green and Company, 1913), 23:255.

[7] William Morris, "Art Under Plutocracy," in ibid., p. 165.

Process and fitness (which is the criterion of process) are revealed in form; form contains meaning. The artifact, tool, room, street, building, town or city, garden or region, can be examined in terms of process, manifest in form, which may be unfit, fit, or most fitting. The last of these, when made by man, is art.[8]

If we think of art in this inclusive sense, it is clear that art, politics, economics, and technology share the greatest of tasks, the creation and remolding of the human environment. The beauty of nature must be conserved and enhanced, and the city must be shaped as a value-expressive artifact, not left to drift and accident.

Urban Design

New Towns

Most of our cities deserve the comment of Gertrude Stein when she was asked about her impression of Oakland, California.

"How do you like it there?"
"There," she replied, "there is no there, there." [9]

The planless sprawl and clutter and confusion of the modern metropolis have produced an almost uniform drabness, whether it be in string cities along ribbons of concrete, in dense slums and ghettoes, or even in tiresome "fashionable" districts. As John E. Burchard has said:

Ever since Babylon was rebuilt, the world has known some beautiful cities. A few are still beautiful—Venice, Rome, Paris, Peking, Isfahan. Some, though not many, North American cities have been graceful or charming, have had patches of beauty such as New York's sky line, New Orleans's Vieux Carré, San Francisco's Golden Gate. But seen close up and measured by world standards, none can be called beautiful.[10]

How different from the really memorable cities and towns of the old world! The little hill-town of San Gimignano, fifty-five kilometers southwest of Florence, is one of these unforgettable places. Originally a fourteenth-century town encircled by ramparts, it has kept its ancient appearance, the newer structures being built in a style and out of materials consonant with the old. One can stroll along the cobbled streets lined with ancient houses and palaces, or tarry in the town square

8 Ian L. McHarg, "Values, Process and Form," *The Fitness of Man's Environment* (New York: Harper & Row, Publishers, 1968), p. 209.

9 Quoted by Victor Gruen, "New Forms of Community," in Laurence B. Holland, ed., *Who Designs America?* (Garden City, N.Y.: Doubleday & Company, 1966), p. 188.

10 "Must Our Cities Be So Ugly?" *The Saturday Evening Post*, December 2, 1961, p. 54.

framed by seven towers and a cathedral. The Piazza della Cisterna is paved with bricks in a herringbone pattern, and in the center is a beautiful cisterm which gives the square its name. Everywhere one looks are stone towers, chapels, palaces, or more humble structures, aesthetically interesting within as well as without. There are handsome frescoes by Ghirlandaio and carved wooden figures by Jacopo della Quercia inside the Chapel of Santa Fina; there are paintings and statues by distinguished Sienese artists inside the Cathedral; and both there and in the Church of Santa Agostino there are magnificent frescoes by Genozzo Gozzoli, a master of fifteenth-century Florence. Even the shops with their pottery and other folk art, or the colorful stalls of fruits and vegetables, blend in with the total aesthetic effect. The town is built on a very high hill that overlooks the Tuscan landscape, where vineyards join cypress and pine and olive trees to adorn the steep rolling hillsides. Here and there are stacks of hay and human dwellings, with animals and peasants going about the fields. Nowhere else does life blend more harmoniously with the inanimate landscape. San Gimignano is a town of about 9,000 inhabitants, but there is more of aesthetic interest to see there than in most American cities of over a million. Although nostalgia for a "romantic" past may explain much of its charm, we doubt that any modern city, large or small, has so much unity and identity and pervasive beauty.

Small as it was, San Gimignano shared in the glory of Italian culture, drawing upon nearby Florence and Sienna for its art and technical mastery. An advanced stage of technology enabled the builders to rear its ramparts and its fourteen tall towers, some over one hundred feet high. But the battlements and towers were built at the command of princes, who vied with each other to erect the tallest structures, and the basis of the whole society was aristocratic. Modern art and technology are different and should have a far more democratic foundation.

One of the first to point the way was Ebenezer Howard, whose famous book, *To-morrow: A Peaceful Path to Real Reform*,[11] provided the theoretical basis for the design and construction of Letchworth and Welwyn. Among the fundamental principles embodied in these "Garden Cities" were the interblending of town and countryside; the escape from urban congestion by decentralization and dispersal; the limitation in the size of the city and the number of its inhabitants; the ownership of land and control of investment in the public interest; the establish-

[11] Published in 1898; rev. ed. entitled *Garden Cities of Tomorrow*, 1902; later ed. with introductions by F. J. Osborn and Lewis Mumford (London: Faber and Faber Ltd, 1946, 1960).

ment of a balanced and diversified economic basis; and the provision of a considerable variety of social and cultural opportunities. According to the original Garden Cities and Town Planning Association:

A Garden City is a Town designed for healthy living and industry; of a size that makes possible a full measure of social life but not larger; surrounded by a rural belt; the whole of the land being in public ownership or held in trust by the community.[12]

On the basis of these plans "a new kind of city would emerge, in a balanced, many-sided, interrelated, organic unit." [13]

Letchworth, the first of the Garden Cities, was built entirely with private funds raised partly by popular subscription. Howard and his associates in 1903 formed a cooperative developmental corporation, First Garden City Limited, which acquired a large area thirty-five miles north of London upon which to build. The corporation then advertised and attracted further investors, pointing out the advantage of acquiring open spaces and allotments while land was cheap. Because the site was wholly rural, all the necessary public services—roads, sewers, power, light, water, telephones, hospitals, schools—had to be planned and constructed. It was difficult to attract investors for so daring a venture, and financial difficulties slowed down the building of the town for decades. Despite these handicaps, a city strong in its industrial basis and beautiful in its landscaping was very gradually constructed. By the end of 1967, Letchworth had a population of over 28,000, with 170 manufacturing establishments and an abundance of homes, public buildings, neighborhood centers, and social amenities. Unfortunately its handsome gardens and green spaces far outshone its architecture, which was, for the most part, timid and traditional.

In 1919 and 1920, Howard and a younger group of associates embarked on a second experiment, the building of Welwyn Garden City. As in the case of the Letchworth venture, a large open tract of land was acquired, and a developmental corporation retained the freehold and leased the sites to individual builders, controlling design and use by appropriate covenants. The overall design was under the direction of Louis de Soissons, architect and town planner, who was in charge from the beginning of the construction in 1920 until his death forty-two years later. By the end of 1967, the population of Welwyn had climbed to approximately 42,000, and no substantial increase was planned. Thus, for the second time, a new type of industrial city—aesthetically pleasing and technically efficient—was constructed. Both cities,

12 Quoted by Frederick J. Osborn and Arnold Whittick, *The New Towns: The Answer to Megalopolis* (London: Leonard Hall, 1969), p. 35.
13 Ibid., p. 27. (Lewis Mumford's Introduction.)

especially Welwyn, became internationally famous as examples of urban design.

The Garden Cities were the prototypes of the "New Towns" which were built with governmental funding and direction after World War II. The first fourteen towns were started by the Labour Government of 1945 to 1950, and the policy was continued by the Conservative Government. More than thirty are in progress, and more are projected. As Lewis Mumford has written:

> The translation of [Howard's] principles into the realities of the new towns movement is one of the most encouraging manifestations of our age. In a period when automatic and irrational forces are driving mankind close to self-annihilation, the new towns are a victory for the rational, the human, the disciplined, and the purposeful: a proof that sound ideas are not condemned by massive human folly or institutional inertia to remain inoperative.[14]

Eight of the towns are located in open country twenty to thirty miles from London and the remainder are scattered throughout England, Scotland, and Wales. They have been built to relieve congestion in the larger cities so that these areas of overconcentration can be redeveloped, and to bring a fresh grouping of people together under more efficient economic conditions and in beautiful new surroundings. According to the original plan, each town was to be limited to no more than 60,000 population. In some instances, this size has been increased within planned limits.

A visitor to Welwyn Garden City, about twenty miles north of London, will be immediately struck by the great intersecting avenues, Parkway and Howardsgate, with their broad lawns and trees and formal gardens. On a fine summer day when the flowers are at their height, the view along the Parkway to the central fountain, with its high jets seen against trees and sky, is unforgettable. Much of the residential area is gently rolling or somewhat hilly, and is well-adapted to curving roads, dead-end streets, footpaths, and other interesting irregularities. There are trees and shrubbery along the roads; open spaces intermingling with houses and apartments; playing fields, woods, gardens, and golf courses; and girding the whole city an inviolable green belt. The different types of dwellings and public buildings, so placed that they can be seen three-dimensionally, afford interest and variety; yet comprehensive planning achieves a pervasive effect of unity and design. The industrial area, located centrally within walking distance for most employees, avoids the usual drabness of such districts, the factories being of distinctive archi-

14 Ibid.

tectural character. Near the Howardsgate and Parkway intersection is the main town center, consisting of shops, offices, public buildings, a college, and a studio-residence for artists in a spacious and well-designed layout. There are also neighborhood subcenters, where one can find such facilities as a branch library, a health clinic, a day nursery, a grocery store, and a pub. Although the architecture is largely traditional, Welwyn combines rural beauty and urban efficiency to an outstanding degree.

In the designing of Welwyn, the declared aim was to bring "the beauty and delight of the country" into the heart of the city. This aim distinguishes Welwyn from ancient cities such as San Gimignano. As Christopher Tunnard points out:

> . . . with only occasional exceptions, there is a hard and fast line between town and country until well into the sixteenth century . . . no attempt was made to bring natural forms into the city pattern except in the privacy of the garden.[15]

In San Gimignano, the buildings, erected right next to the narrow streets, cast a shadow across them, and even the few open spaces are paved with stones. But the town is small and the countryside easily accessible. Quite different is Welwyn, a larger urban complex, where the streets are edged with trees and flowers and much of the center is devoted to gardens and open green space.

In the general vicinity of Welwyn are a number of the New Towns —Hatfield, Stevenage, Harlow, and Hemel Hempstead—and others are scattered far and wide. The following are among their best features:

- The adherence to a comprehensive and attractive urban plan, avoiding an unlimited or haphazard expansion.
- The "respect" accorded to the terrain, including trees and plant life, streams and ponds, and other natural features.
- The provision of ample facilities for play and recreation.
- The establishment of town forums, art centers, hobby workshops, and other places for artistic and cultural activities.
- The intermingling of gardens and open spaces with homes and buildings, providing a visually satisfying relation between solids and voids, natural and human artifacts.
- The separation of vehicular traffic from pedestrian paths and malls, insulating the latter from noise and intrusion.
- The accenting of focal points by statues, fountains, pools, formal plantings, lighting effects, and other decorative devices.
- The location of residential districts and industrial sites near enough to

15 *The City of Man*, 2nd ed. (New York: Charles Scribner's Sons, 1970), p. 238.

each other to make possible close-to-home work and avoidance of traffic congestion.

• The insistence that a factory zone be as beautiful, well-designed, and pollution-free as any other part of the city.

• The linking-up with a national planning and fiscal policy to secure adequate funding, wise spacing of towns, and relief of congested areas in overgrown cities.

We do not mean that the New Towns have always realized these objectives or lived up to the ideals of their founders. But, on the whole, they have moved in that direction. The most recent plans, moreover, are better than the old. For example, "the plan for the New Town of Cumbernauld near Glasgow, Scotland, . . . represents an approach that, though similar to that of the New Towns around London, has profited much from their experience and is more principled and sophisticated." [16]

As in almost all experiments, the New Towns have their critics. Although more sympathetic than hostile, Lewis Mumford notes "the excessive spacing and neighborhood segregation of the first batch of British New Towns." After remarking that the architect and planner, Louis de Soissons, achieved greater charm and coherence in Welwyn than in Letchworth, Mumford continues:

> Yet, except for the admirable industrial zone, the emphasis was again on private functions and traditional forms and ample greenery, rather than on association and intercourse, on public functions, on focal meeting places and social intermixture, all of which call for the pedestrian scale and a more close-textured design.[17]

In correspondence with Frederick J. Osborn, an articulate leader of the New Towns movement, Mumford complained of "two defects, quite serious ones":

> First, the lack of variety in the layouts, the failure to see new possibilities in grouping; and second, the absurd wastage of space in acres of unnecessary streets, too wide for any probable or tolerable traffic, with the houses set too far back from the street—as if there were not any other way of ensuring privacy. I admit that the standardization is at a high level, but the fact is that it is waste-

[16] Victor Gruen, *The Heart of Our Cities* (New York: Simon and Schuster, 1964), p. 292. The tighter urbanization pattern in Cumbernauld goes far to meet Lewis Mumford's criticisms quoted immediately below.

[17] Lewis Mumford, *The Urban Prospect* (New York: Harcourt, Brace and World, 1968), p. 151.

ful and dull. . . . The overall density I certainly consider too low, and the various neighborhoods of the New Towns are too widely scattered to fulfill the social purposes of living together in an urban community.[18]

In a letter written almost ten years later (1964), Mumford commented that the New Town planners

> were taking steps to compensate for non-existent crowding when they should have been moving in just the opposite direction—to increase variety and sociability and to overcome the smug isolationism of suburban life, itself justified only by the foul congestion of the big city.[19]

William H. Whyte, with less sympathy than Mumford, has maintained that the New Towns policy of decentralization and dispersal goes too far, and E. A. Gutkind has argued that it does not go far enough.[20]

The force of these latter criticisms is blunted if we recognize the diversity of human preferences and the need to satisfy more than one kind of taste. Osborn and Whittick, in their authoritative book on the New Towns, remark: "The advantages of one kind of environment necessarily involve the loss of some of those of other kinds." As they point out, many people will prefer suburbia, despite too-long commuting; others will prefer the great city, despite overcrowding. Plenty of big cities will remain to satisfy these two metropolitan patterns of living. "But there are more, we believe, who prefer the middle way between concentration and diffusion offered by the moderate-sized, reasonably open, partly countryfied town, with a good but not exhaustive urban equipment." [21]

Ebenezer Howard had high hopes for his projects, but he realized that the building of New Towns was not a universal panacea. He considered the Garden City as a unit within a wider regional or even national plan. Believing that overcrowded cities had to be drastically altered, he remarked at the end of his book that "a simpler problem must first be solved. One small Garden City must be built as a working model and then a group of cities. . . . These tasks done, and done well, the reconstruction of London must inevitably follow." In his pro-

18 Michael Hughes, ed., *The Letters of Lewis Mumford and Frederick J. Osborn: A Transatlantic Dialogue* (New York: Praeger Publishers, 1972), p. 229. (Letter of September 23, 1954.)

19 Ibid., p. 363. (Letter of April 6, 1964.)

20 See William H. Whyte, *The Last Landscape* (Garden City, N.Y.: Doubleday & Company, 1968), pp. 224–43; and E. A. Gutkind, *The Twilight of Cities* (London: Macmillan & Company, 1962), pp. 124–26.

21 Osborn and Whittick, *The New Towns*, p. 144.

posal for "a group of cities," he called for linking together into a single organized system of ten or more of the New Towns, united by better transit and communication and forming an interdependent regional unit. He hoped in this way to avoid the overcrowding of a huge city while providing its expanded services, such as a large university, a diversified hospital, and a flourishing arts center. The Garden City, the town cluster, and the reconstructed metropolis were all visualized as parts of a comprehensive strategy. Looking far ahead, Howard envisaged the eventual abolition of slums and other ugly sores of the Industrial Revolution.

He sought to bring about these changes through a cooperative middle way between socialism and private enterprise. The essence of his proposal was that the municipality or cooperative agency should control the land and determine the overall design, but that individuals and private investors should carry on within these limits. In contrast, the American New Towns, such as Radburn in New Jersey and Columbia and Reston near Washington, D.C., have been initiated and developed largely by private enterprise. The role of the government in building New Towns has been considerably greater in the Scandinavian countries and Israel and almost total in the Communist areas. But there are signs of convergence toward a "mixed economy," with the socialist nations introducing more initiative and decentralization, and the capitalist countries utilizing various combinations of public and private enterprise.

We have described the British Garden City and New Town movement, not because we consider it the one and only way to build beautiful cities, but because of its importance and great influence. It established the precedent for a whole spate of urban experiments, such as Sunnyside Gardens in New York, Baldwin Hills Village in Los Angeles, Kitimat in British Columbia, Vallingby in the outskirts of Stockholm, and Chandigargh in India. Probably the finest example in the world of a New Town is Tapiola, built on rolling, forested hillsides sloping down to a bay outside Helsinki. These experiments cannot be considered a "solution"—that is too final a word—but they are rich in suggestions. They were built by "men who refused to be bound by the forms of the past; who saw that man could make his own forms, could create new cities and give millions the health and elementary decencies for a humane life." [22] Greater employment of such experiments can provide a less abstract and more creative basis for deciding on far-reaching civic designs. Gradually the weaknesses that time has disclosed will be

[22] Michael Hughes, *Letters of Lewis Mumford and Frederick J. Osborn*, p. ix.

corrected and the new image of the town will become clear. In England, more than in any other country, the New Towns have been key elements in planned decentralization on a national scale. Similar decentralization is drastically needed in other lands and not least in America.[23]

Old Cities

The rebuilding of old cities is a far more difficult task than the construction of new ones. Here in our huge cities the noise, smog, dirt, squalor, congestion, traffic jams, and planless or badly planned construction have heaped up ugliness beyond endurance. Lest we suppose that these conditions are worse than anything in the past, we need only read such nineteenth-century novels as Victor Hugo's *Hunchback of Notre Dame*, Zola's *The Dram Shop*, Dickens' *Hard Times*, and Henry James' *Princess Casamassima*.[24] What distinguishes the present mess from past degradation is that it is so unnecessary. It has been technologically possible for the past forty or fifty years to rebuild great cities in a far better way.

Many of the best features of the New Towns are adaptable to the metropolis, and additional policies can be devised to cope with urban decay. Slums should be opened up to sun and good air, ramshackle buildings cleared away when acceptable substitutes can be made available, and decent subsidized housing provided for the unfortunate at prices they can afford. Zoning regulations should be designed to prevent blight and to insure a pleasing variety. The sky and the streets should no longer be cluttered with smoke stacks, light poles, TV aerials, billboards, signs, and neon lights. Heavy traffic should be concentrated along separate arterials, and pedestrian walks and malls protected from odors, noise, dust, and litter. Work places should be attractively designed and located away from homes, but not so far away that they cannot be reached by foot or easy transit. The city should be a differentiated structure of fairly independent cells, with related activities concentrated in functional groupings, and these should be so spaced as to avoid overcrowding. Rapid public transportation should be combined with this

23 For a survey and evaluation of the British New Towns movement and parallel developments in Europe and the United States, see H. Wentworth Eldredge, ed., *Taming Megalopolis* (Garden City, N.Y.: Doubleday & Company, Inc., 1967), Vol. II, Chap. 18. James Bailey, ed., *New Towns in America*, published by the American Institute of Architects (New York: John Wiley & Sons, Inc., 1973) is an excellent survey of the American scene.

24 For the sharp criticism of American cities by such older writers as Emerson, Melville, Howells, and Dreiser, see Morton and Lucia White, *The Intellectual Versus the City* (Cambridge, Mass.: Harvard University Press, 1962).

planned decentralization to reduce individual-automobile traffic, with the resultant smog, jams, and ubiquitous parking lots. Natural landmarks, such as rivers, lakes, bays, beaches, and wooded hillsides, should be preserved in their native beauty and kept free from litter and pollution. Greenery should be an integrated part of the urban pattern, but not to the point of covering an excessive proportion of the total area. The units of human service and enjoyment, such as schools, libraries, theaters, and shopping centers, should be built according to exacting aesthetic standards. Their appearance inside and out should be clearly articulated and expressive of their functions. Amid all this fresh construction there should be a sense of historical continuity and the human uses of old familiar places. The best of the old should be preserved and combined with the new. At every stage the planning should be conceived concretely in terms of human values and not concocted as a drawing-board project, a bureaucratic operation, or a political boondoggle.

It is impossible, someone may say, to realize these goals: the metropolis has already taken shape and the difficulty and cost of drastically reshaping it would be prohibitive. There is some truth in this objection: we cannot start completely afresh, and the attempt to do so would be catastrophic. But the objection is less valid for newer cities and invalid for the planning of new communities. Even older cities are in constant change, and the change will be for the better if the ideal of a beautiful and humane city is kept in mind. Some of the old cities, such as Stockholm and Toronto, have wrought great improvements by the implementation of city planning.

"Make no little plans," said Daniel Burnham in 1907, "they have no magic to stir man's blood." This statement by the creator of the Chicago plan is easily misunderstood. As Victor Gruen has remarked, "great" does not necessarily mean "big."

> The plans that "stir men's blood" are the great plans, based on great ideas, on philosophical thought, on deep conviction. A great plan may or may not involve demolition or destruction; it may or may not be costly. . . . But a great plan will always be one which distinctively improves the human environment. . . .[25]

With the guidance of great plans and the investment and mobilization of resources comparable in scale to our expenditure in the Vietnam War or the rocket flights to the moon, we could make our towns and cities incomparably more livable and comely than they are now.

[25] *The Heart of Our Cities*, p. 167.

Composition versus Configuration

If the building of new towns and the rebuilding of old cities are to be successful, there must be a sound body of principles to guide the construction. The need is for some kind of common understanding among men and women as they go about the business of transforming their environment. We have reason to think that a new set of philosophical principles will be forthcoming. Our Western civilization is in a state of transition not only in its outer aspects but in its ethos and inner life. During the last several decades, the mentality that has prevailed for several centuries has been changing. This profound revolution has gradually accelerated and is now in full swing. Its effect is to transform men's basic assumptions, their first and last thoughts, their "sense of reality." As Alfred North Whitehead has said:

> In each age of the world distinguished by high activity there will be found at its culmination, and among the agencies leading to that culmination, some profound cosmological outlook, implicitly accepted, impressing its own type upon the current springs of action. . . . In each period there is a general form of the forms of thought, and like the air we breathe, such a form is so translucent, and so pervading, and so seemingly necessary, that only by extreme effort can we become aware of it.[26]

We shall now try to characterize some of these very fundamental principles. Our method will be to state the old deep-seated idea and then its opposite. The following pairs will be discussed: (1) composition versus configuration; (2) dominion over nature versus harmony with nature; and (3) quantitative expansion versus qualitative stabilization. Composition, dominion, and quantitative standards form a cluster of related ideas; and configuration, ecological harmony, and qualitative standards form a countercluster. From the perspective of environmental aesthetics, the second cluster is on the whole more salubrious than the first.

An example that fits Whitehead's characterization of a deeply ingrained idea is the notion that wholes are the mere additive sum of their parts. The "composition theory," as this notion has been called, was implicitly held by most scientists and philosophers and even by ordinary laymen in the seventeenth and eighteenth centuries and in a gradually diminishing degree down to our time.[27] The assumption is

[26] *Adventures of Ideas* (New York: The Macmillan Company, 1933, and London: Cambridge University Press), pp. 13–14.

[27] For an excellent discussion of the composition theory and its pervasive historical influence, see James Gibson, *Locke's Theory of Knowledge and Its Historical Relations* (London: Cambridge University Press, 1917).

that a physical body is the sum of discrete atoms, that a complex mental state is the sum of discrete "ideas," and that a social organization is the sum of discrete persons. Synthesis or configuration, it is said, adds nothing substantially new; the way to understand any whole is by analysis. Relations are regarded as extrinsic and inessential, the reality being the aggregated individuals. The composition theory fitted an age of individualism ("free enterprise") in which intimate communities were being weakened or dissolved by the rise and predominance of a competitive social order. It was natural for thinkers, in this milieu, to assume that the individual person or thing, and not the community or configuration, is real and fundamental. Few men were so conscious and critical as to question this implicit dogma.

The atomization of human relations left its mark on innumerable artists. The *avant garde* beat a retreat into a private Bohemianism, esotericism, and subjectivism. In the best of modern art and literature, there has been a consequent gain in subjective depth and refinement; perhaps no one, for example, has more deeply plumbed the unconscious mind than James Joyce or has more exquisitely explored the intricacies of the inner life than Marcel Proust. Parallel achievements can be traced in other arts than literature. But individualism and subjectivism have been pushed to the point of neuroticism and to the relative neglect of *inter*subjectivity. Although the independent and original person enriches society far more than the tame conformist, no conception of individuality or freedom is adequate which takes little account of the myriad social ties that unite every man to his fellows. We can override these ties only by stifling a basic part of the self. "Whoever walks a furlong without sympathy," declared Walt Whitman in the *Song of Myself*, "walks to his own funeral dressed in a shroud." Modern psychology and social science have refuted and largely repudiated the "island" theory of individuality and freedom, but the conception of society as a collection of unmitigated egoists still bedevils human relations. The emphasis on the detail rather than the structure, on the part rather than the whole, on the individual rather than the community undermines civic spirit and urban design. Architecturally it results in "a bewildering chaos of competing individual stunts, a disorderly riot of styles, materials, and color. It is a true symbol of disunity—in the figurative sense—of a disrupted and decayed community life." [28]

The composition theory, with its exaggeration of the discreteness of things and persons, is gradually being replaced by a very different interpretation of man and nature. As we pointed out in Chapter 11,

[28] Walter Gropius, *Rebuilding Our Communities* (Chicago: Paul Theobald, 1945), p. 16.

recent science and philosophy are interpreting the world in terms of process, form, interrelation, and evolving levels of integration rather than in terms of unchanging atomic isolates and self-enclosed egoists. Gradually these new ways of thinking are changing the ideas and attitudes of common men. This new mentality is much more congenial to the ideal of the human community than the old climate of opinion.

If we think in these terms, the problems of environmental aesthetics will take on quite a different aspect. Our approach will be broad and inclusive rather than narrow and fragmentary. We will agree with the statement of one of the great city designers, Patrick Geddes, in his plan for Colombo, Ceylon, in 1921, that "neither the most practical of engineers nor the most exquisite of aesthetes can plan for the city by himself alone, neither the best of physicians nor of pedagogues, neither the most spiritual nor the most matter-of-fact of its governing classes." As Asa Briggs, who quotes this remark, has said, the planning of cities "requires a combination of insights and a convergence of disciplines. Neither the combination nor the convergence is usually there." [29]

Because the task requires a vast mobilization of technological skills and resources, the natural assumption is that technical experts should determine its goals. But the experts, as an exclusive group, cannot and should not do so. They cannot because they are not powerful enough; they are not, and cannot be expected to be, dominant as a class. They are dependent upon those who control the purse strings and are necessarily the servants of the dominant ideologies. As Aldous Huxley and George Orwell remind us, moreover, the objectives of the experts may not be the humane and legitimate objectives of the community. Even when the experts are well-intentioned they may demand efficiency at too high a price in human rights and aesthetic values.

Far better than an expertocracy is the kind of vigorous democracy that brings experts and people together in lively communication. The experts should enlighten the people to enlarge their civic choices by revealing the great dangers and opportunities presented by technology. The people, in turn, should educate the experts to make clear the democratic ends that technology should serve. A cooperative design process with built-in feedbacks should embrace all participants in city building and all aspects of aesthetic attention. If this process of collaboration is not to yield squalid aesthetic results, both the experts and the people must be keenly appreciative of aesthetic values. Here is one reason that sound aesthetic education should be part of everybody's schooling.

Opposed to the composition theory is the ecological interpretation

29 "The Sense of Place," in *The Fitness of Man's Environment* (New York: Harper & Row, Publishers, 1968), p. 79.

of man and nature. The change to this mode of thinking has been accelerated by the ecological crisis. Until recent years the various forms of ecological devastation—the pollution of air and water, the destruction of forests and grasslands, the extinction of plant and animal species, and the pressure of the population explosion on the earth's diminishing resources—were the occasion of many homilies but few if any prophecies of fearful catastrophe. Then rather suddenly a great many persons became aware that the man-made disasters of ecological imbalance pose a dire threat to humankind. A number of authoritative books, such as Rachel Carson's *Silent Spring* (1962), Barry Commoner's *Science and Survival* (1967), Paul R. Ehrlich's *The Population Bomb* (1968), and Robert L. Heilbroner's *The Human Prospect* (1974), warned their readers that the human race, if it continues on its headlong reckless course, will stumble and fall and break its silly neck. The impact of these books was reinforced by the plain evidence of ecological devastation and scarcity.

Consequently, ecology—the science of the relationships between organisms and their environment—has become a focal public concern. The lesson of ecology is the interrelatedness of things in life and nature. The long passage that we quoted from Charles Darwin's *Origin of Species* in Chapter 11 illustrates this interdependence. Although the idea of the ecological web is even older than Darwin's book, the sense that human beings are caught up in the web has suddenly become acute. The consequent influence of ecology on environmental aesthetics is bound to be profound. Ecology forces men to think in terms of contexts and configurations, in terms of cityscape and landscape and the whole earth. It makes men realize how interdependent they are with one another and with the varied forms of plants and animals and inorganic existence. It impels them to repair the impoverished ghettoes, to restore the raped land, to cleanse the befouled waterways and the filthy air, and to cease the practices that have produced all this despoliation.

Dominion over Nature versus Harmony with Nature

The idea that man should subdue nature has profound roots in religion, scientific technology, and economic enterprise. It should not be surprising that the ecological creed in opposing this concept of dominion is meeting stubborn resistance.

Historian Lynn White, Jr. has traced the historical roots of our ecological crisis back to the Judeo-Christian belief in a supernatural God who created man in the divine image and endowed him with ab-

solute dominion over nature. It is illustrated in a familiar passage from
Genesis (1:26–28):

> And God said, Let us make man in our image, after our likeness:
> and let them have dominion over the fish of the sea, and over the
> fowl of the air, and over the cattle, and over all the earth, and
> over every creeping thing that creepeth upon the earth. So God
> created man in his own image, in the image of God created he
> him; male and female created he them. And God blessed them,
> and God said unto them, Be fruitful, and multiply, and replenish
> the earth, and subdue it: and have dominion over the fish of the
> sea, and over the fowl of the air, and over every living thing that
> moveth upon the earth.

This thread in the Judeo-Christian tradition has provided a strong re-
ligious basis for the economic exploitation of natural resources and the
development of scientific technology. It has supplied a religious sanc-
tion to the overpopulation that has now reached catastrophic propor-
tions. Although technology and individual enterprise were impeded by
the supernaturalism and communalism of the Middle Ages, God's com-
mand to "fill the earth and subdue it" was strongly proclaimed by John
Calvin and other Reformation theologians.[30] In the Orient, where re-
ligion took a very different form, technology did not thrive and capi-
talism did not develop until Japan imported Western ideas and ways.

The Renaissance may be viewed as an individualist reaction
against the communal world of the Middle Ages. The primary ties of
the face-to-face community gradually weakened and the individual be-
gan to assert his independence. Jacob Burckhardt, in trying to sum up
the essence of the Renaissance, said that man "became a spiritual *indi-
vidual*, and recognized himself as such." [31] The talents of the unique per-
son were no longer discounted; man was glorified, human genius was
exalted; truth, beauty, riches, and renown were conceived to be within
the reach of the daring individual. The proud and adventurous spirit
of the Renaissance rings forth in the words of Marlowe's Tamburlaine:

> *Our souls, whose faculties can comprehend*
> *The wondrous Architecture of the world,*
> *And measure every wandring planet's course,*
> *Still climbing after knowledge infinite,*
> *And always moving as the restless Spheres,*

30 See Max Weber, *The Protestant Ethic and the Spirit of Capitalism* (London:
George Allen & Unwin Ltd, 1930) and R. H. Tawney, *Religion and the Rise of
Capitalism* (New York: Harcourt, Brace & Company, 1926).

31 *The Civilization of the Renaissance in Italy* (London: George Allen & Unwin
Ltd, 1921), p. 129.

Wills us to wear ourselves and never rest,
Until we reach the ripest fruit of all,
That perfect bliss and sole felicity,
The sweet fruition of an earthly crown.

The upsurge of individualism brought a new vigor and freedom to human life, and it helped to usher in experimental science and "free enterprise." But the change had its seamier side. Human relations were often poisoned and nature despoiled by a fierce struggle for power and wealth.

The Biblical doctrine that man has dominion over the earth and all its creatures was reinforced by the scientific technology that began to flourish during the Renaissance. "Knowledge is power," declared Francis Bacon, epitomizing the creed of pragmatic science.

For the matter in hand is no mere felicity of speculation, but the real business and fortunes of the human race, and all power of operation. . . . And so those twin objects, human Knowledge and human Power, do really meet in one.[32]

The connection between the Baconian interpretation of science and the Biblical command to subdue nature is manifest in Bacon's insistence that "the mind may exercise over the nature of things the authority which properly belongs to it." It is therefore not surprising that "the refugee Protestant theologians from the continent espoused so immediately the Baconian account of science and worked to make it influential in England." [33] Modern scientific technology has followed the same lead, too often heedless that knowledge without wisdom and power without love are the bane of human history.

That the profit motive should rule in human affairs is the basic idea of capitalist industrialism. This idea, initially shocking to men of religion and morals, gradually gained ascendancy. It finally became so respectable that Edmund Burke in the late eighteenth century could refer to "the love of lucre" as "this natural, this reasonable, this powerful, this prolific principle." [34] It is the principle of capitalism, for as everybody knows, the object of business is to earn profits. So, despite moralistic declarations to the contrary, it has become the operating principle of our business civilization.

[32] "Plan" of *The Great Instauration* (1605) in *The Philosophical Works of Francis Bacon*, ed. John M. Robertson (London: George Routledge and Sons Ltd, 1905), p. 253.
[33] George Grant, "Technology and Empire," in Carl Mitcham and Robert Mackey, eds., *Philosophy and Technology* (New York: The Free Press, 1972), p. 189.
[34] *Third Letter on Regicide*, in *Works*, World Classics ed. (London: Oxford University Press, 1934), 6:270.

One very serious flaw in the principle is that it takes no account of spillover effects. As an economist, E. J. Mishan, has written:

If, say, in producing vacuum cleaners a manufacturer incidentally produces a great deal of smoke from his factory chimneys, proper social accounting would require him to determine the value not only of the "good" produced (vacuum cleaners), but the value also of the "bad" (the smoke damage). The value of the damage suffered by others constitutes a cost to society. Clearly, then, the value of his *joint* product—vacuum cleaners *plus* smoke damage—will be less than the value of the vacuum cleaners alone by the costs of the smoke damage inflicted on the public.[35]

These spillover effects are sometimes beneficial but more often not. They include the destruction of wildlife with pesticides, the contamination of the air with tons of floating pollutants, the poisoning of rivers and lakes and seas with chemical wastes, and the turning of grasslands into dust bowls. In our huge cities a lovely winter snowfall is soon blackened by soot, but this does not cost the owner of the belching smokestacks a penny. The landlord can prize a slum tenement as a sound investment, though it is an aesthetic and moral disgrace.

The creed that man should subdue nature is not without its measure of justification; but only folly and spiritual death results when we erect it as total and absolute. The opposite creed, that man should live in harmony with nature and his fellow man, also has its religious basis. There are various and contradictory elements in both the Old and the New Testaments—some supporting and some opposing man's dominion over nature. The Christian tradition, for example, has its St. Francis of Assisi, who communed with Brother Ant and Sister Fire and preached to the birds. The Christianity of Eric Gill, with its compassion, natural piety, and aesthetic tinge, is a modern expression of the Franciscan spirit.[36] In the Orient far more than in the Occident, the religion of harmony is to be found. According to the *Analects* of Confucius, it is harmony with Nature that is prized. Zen Buddhism and Taoism and some forms of Hinduism are no less celebrations of natural harmony.

Ian McHarg, professor of landscape architecture and urban planning at the University of Pennsylvania, has contended that the Japanese mastery of gardening and landscape architecture reflects this religious spirit.

35 *Technology and Growth: The Price We Pay* (New York: Praeger Publishers, Inc., 1970), p. 30. Copyright E. J. Mishan, 1969.
36 See Eric Gill, *Christianity and the Machine Age* (London: Sheldon Press, 1940).

Architecture, village and town building use natural materials directly with stirring power, but it is garden making that is the unequaled art form of this society. The garden is the metaphysical symbol of society in Tao, Shinto and Zen—man in nature.[37]

There is another great bridge to the art of landscape, McHarg tells us, and that is the English romantic tradition. In a poet such as Wordsworth or Shelley, in a painter such as Constable or Turner, there is a sense of nature's unity that is akin to Tao. This sense "transformed England from a poverty-stricken and raddled land to that beautiful landscape that still is visible today." [38] Britain, more than any other Western nation, rivals Japan in its passion for horticulture. The ubiquitous flowerboxes and colorful home gardens, the trees and green lawns and bountiful flowerbeds in countless parks and squares, make the British cities memorable. It is no accident that the "Garden City" appeared in England and not on the Continent.[39]

Design *in* nature and *with* nature, not design *apart from* nature or *against* nature, is a salutary aesthetic principle. A superb illustration of this principle is the "Family Group" by Henry Moore in a lovely landscape setting in Harlow New Town. Here a great sculptural portrayal of familial unity contributes to the larger unity of man and nature—the natural humanized and the human naturalized. Moore has said that this kind of setting is ideal for his statues. Herbert Read, in discussing Moore's sculpture, has remarked:

> We normally associate monumental sculpture with crowded cities, but if we watch the people passing *King Charles* in Trafalgar Square, or *Gattemalata* in Padua, how few glance up to the familiar figures. A great work of art, however, only yields its essence in an act of contemplation—of recognition in a park or garden: but attention is best induced when it stands dramatically isolated in a landscape.[40]

37 *Design With Nature* (New York: Doubleday & Company, Inc., 1969), p. 27.
38 Ibid., p. 29.
39 Our historical sketch of men's attitudes toward nature is necessarily abbreviated. For a much more detailed account, see John Passmore, *Man's Responsibility for Nature* (London: Gerald Duckworth & Company Ltd, 1974), Part One. Passmore contends: "The traditions of the West . . . are far richer, more diversified, more flexible than its critics allow" (p. 3). "The fact that the West has never been wholly committed to the view that man has no responsibility whatsoever for the maintenance and preservation of the world around him is important just because it means that there are 'seeds' in the Western tradition which the reformer can hope to bring to full flower" (p. 40).
40 *Henry Moore: Sculptures and Drawings Since 1948* (London: Lund Humphries Publishers Ltd, 1955), p. xii.

Moore's sculpture and Read's interpretation of it illustrate how the two arts, sculpture and landscaping, can complement and enrich one another. The continuity of building with site in modern architecture likewise illustrates the principle of harmony with nature. The residence designed by Frank Lloyd Wright at Bear Run near Pittsburgh is a superb example of adaptation to the natural setting. Wright projected cantilevered building slabs above a great stone shelf where a stream flowed and cascaded. The hovering slabs and horizontal structural lines of the residence harmonize with the massive stone shelf and its neighboring stone formations. Large window areas, facing out on the stone, the woods, and the water, can be opened and closed at will. The unity of inner and outer space and building and site is all-encompassing.

The adaptation of a city to its natural surroundings is illustrated by the development of a boulevard and park system in Seattle during the early years of this century. With its sweeping panoramas of Lake Washington and Puget Sound and the Cascade and Olympic Mountains, the young city was faced with harmonizing its man-made structures with its superlative natural setting. It constructed a great boulevard and park system designed by the Olmstead Brothers, landscape architects. Magnolia Boulevard bordered by evergreen twisted madrona trees and Queen Anne Boulevard high on a great hill command a superb view of Puget Sound and the soaring Olympic Mountains. At the southwestern edge of the city, Lincoln Park, sloping down from a high bluff to a beach on the Sound, has been mostly kept in its wild state. On the eastern side of the city, the Arboretum and Interlaken and Lake Washington Boulevards and Seward Park respect the natural topography and preserve the salal, Oregon grape, sword ferns, and the fir, pine, cedar, dogwood, and madrona trees native to the region. Semi-wild Woodland Park bordering Green Lake and beautifully landscaped Volunteer Park atop Capital Hill also enrich the city. From a lookout tower in Volunteer Park one can survey waterways and mountain peaks over a vast circumference.

Seattle, like almost every other American city, has not always been respectful of its natural setting. In the layout of streets according to the conventional grid pattern, the roads ran straight and the blocks were evenly rectangular whether on a slope or a flat expanse. In the Denny Regrade area, a large and beautiful hill was sluiced into Elliott Bay to expedite the spread of the central business district. Lake Union, in the heart of the city, was exploited by commercial and real estate speculation, and its natural beauty was largely hidden or destroyed by the shoreline clutter. Outlying suburban areas were allowed to spread rapidly with few parks or public beaches, and engineers were given too

much license to cut up the city and scar the landscape with viaduct and freeway construction. Recently these trends have been vigorously challenged, and Seattle is now exhibiting a renewed respect for its heritage of natural assets.[41]

We conclude that design in harmony with nature rather than design in disregard or violation of nature is an essential requirement for civic beauty. When that principle is violated, the results are aesthetically disastrous; when the principle is fulfilled, the comeliness of the environment is enhanced.

Quantitative Expansion versus Qualitative Stabilization

Such traditional ideas as man's dominion over nature or the discreteness of things ("composition") have been "so translucent, and so pervading, and so seemingly necessary" that men were scarcely aware of them until they were challenged by their opposites. Nevertheless, their predominance characterizes certain epochs of history. The ideas of quantity and quality, in contrast, appear to lack an historical dimension. According to Aristotle, Kant, and Hegel, not to mention other philosophers, they are timeless categories of human thought. But even these categories, indispensable though they be, are not entirely without historical reference. In certain periods of history there is a tendency to emphasize quantity and to de-emphasize quality and in other periods to reverse this emphasis.

The emphasis on quantity is characteristic of periods of material "progress" and rapid expansion. The "population explosion" that has attended the scientific-technological revolution is a case in point. The sheer number of lives rather than the quality of those lives has been uppermost in men's minds. Cities have vied with one another in boasting about the increase in their numbers, and states and countries have counted their gains by the scale of demographic expansion.

Stern facts are forcing a reappraisal. A rapidly expanding world population is demanding an improved standard of living, and this "revolution of rising expectations" clashes with the fact of dwindling natural resources. As the authors of an authoritative book on ecology conclude:

> Considering present technology and patterns of behavior our planet is grossly overpopulated now. The large absolute number

[41] For an illuminating account of the way the city of Seattle has coped with its environmental problems and adapted to its natural surroundings, see Victor Steinbrueck, *Seattle Cityscape* (Seattle: University of Washington Press, 1962) and *Seattle Cityscape #2* (Seattle: University of Washington Press, 1973). Steinbrueck's books are illustrated with many pen sketches.

375

of people and the rate of population growth are major hindrances to solving human problems. The limits of human capability to produce food by conventional means have very nearly been reached. Problems of supply and distribution already have resulted in roughly half of humanity being undernourished or malnourished. Some 10–20 million people are starving to death annually now.[42]

If population growth rates continue, the situation will rapidly deteriorate.

We have been speaking of the world, but even in affluent America wealth is ill-distributed. We shall not try to estimate the extent of hunger and poverty in the United States, but Michael Harrington in *The Other America* (1962) sketched a grim picture. The conditions have not substantially improved and in some respects have worsened since this disturbing book was written. The population of our cities has increased at a disproportionately high rate, and the rapid influx of poverty-stricken people has enormously swollen our slums. The ugliness of American cities is directly related to these facts.

The growth of megalopolis must not be mistaken for progress. The size and density of population centers or the accumulation of urban wealth is no sure index to quality. As Hans Blumenfeld has written:

Louder than the warnings of the decentralizers that "bigger is worse"—and more typically American—have been the "bigger and better" barkings of chambers of commerce and other spokesmen of the business class. What both groups have in common is the emphasis on quantity. What ultimately matters, however, is the quality of life in urban areas, be they large or small.[43]

Oversize is more likely to be a sign of decadence than undersize. It is hard to resist a shudder when one reads the prediction of Constantinos A. Doxiadis that "the total urban population in the future will be of the order of 28 billion people or almost thirty times the present one. This means that the average city of the world will be thirty times larger. . . ." [44] Our dwindling natural resources could not long sustain urban aggregations of these gargantuan proportions.

42 Paul R. Ehrlich and Anne H. Ehrlich, *Population, Resources, Environment* (San Francisco: W. H. Freeman and Company, 1970), p. 321. For a more optimistic view, see Wilfred Beckerman, *In Defense of Economic Growth* (London: Jonathan Cape Ltd, 1974).
43 "Criteria for Judging the Quality of the Urban Environment," in Louis K. Loewenstein, ed., *Urban Studies* (New York: The Free Press, 1971), p. 504.
44 "How To Build the City of the Future," in Richard Eells and Clarence Walton, eds., *Man in the City of the Future* (New York: The Macmillan Company, 1968), p. 177.

Those who mistake size for quality have not read the record of the rocks. In the fossil record, as H. G. Wells noted, it is "always the gigantic individuals who appear at the end of each chapter." [45] If this were not so, brontosaurus and the other gigantic reptiles might still be striding the earth. The record of history is almost as clear. Megalopolis —the overgrown city—appears at the *end* of the historical cycle, as Patrick Geddes and Lewis Mumford, Oswald Spengler, and Arnold J. Toynbee all agree.

Babylon, Alexandria, Rome, Byzantium, and other great cities perished from a kind of elephantiasis. If a similar fate overtakes megalopolis in the modern world—New York, for example, or London, Moscow, or Tokyo—it will drag down whole countries and continents: the great metropolitan centers are now too interdependent to perish one by one.

"The bigger the better" criterion is no more reliable when it is applied to the volume of productivity. In our chapter on "Art and Economic Activity" we noted that a number of economists have expressed dissatisfaction with this measure of economic "progress." The Gross National Product standard takes no account of the kind and quality of the goods and services produced. It does not consider whether the products are needed or not needed, whether they are well-made or ill-made, whether they are beautiful or ugly, whether they are instruments of peace or implements of war. It takes no account of the spillover effects that are deleterious to the environment. It is not a measure of justice and equity in the distribution of products. It is not a measure of freedom or a measure of health.

The fact that quantitative standards are now frequently criticized is perhaps an indication that the age of expansion is giving place to an age of stabilization. The nature of this change was prophesied more than a hundred years ago by John Stuart Mill in a chapter of his *Principles of Political Economy.* Recognizing the need of population equilibrium and the natural limits of industrial expansion, he looked forward to a period when the emphasis would be on the quality of life rather than the number of consumers or the quantity of goods:

> I cannot . . . regard the stationary state of capital and wealth with the unaffected aversion so generally manifested towards it by political economists of the old school. I am inclined to believe that it would be, on the whole, a very considerable improvement on our present condition. I confess I am not charmed by the ideal of life held out by those who think that the normal state of human beings is that of struggling to get on; that the trampling,

[45] *Mind at the End of Its Tether* (New York: Didier Publishers, 1946), p. 25.

crushing, elbowing, and treading on each other's heels which forms the existing type of social life, are the most desirable lot of human kind. . . . I know not why it should be a matter of congratulation that persons who are already richer than anyone needs to be, should have doubled their means of consuming things which give little or no pleasure except as representative of wealth. . . . What is economically needed is a better distribution, of which one indispensable means is a stricter restraint on population. . . . If the earth must lose that great portion of its pleasantness which it owes to things that the unlimited increase of wealth and population would extirpate from it, for the mere purpose of enabling it to support a larger population, I sincerely hope, for the sake of posterity, that they will consent to be stationary, long before necessity compels them to it. It is scarcely necessary to remark that a stationary condition of capital and population implies no stationary state of human improvement. There would be as much scope as ever for all kinds of mental culture, and moral and social progress; as much room for improving the Art of Living and much more likelihood of it being improved, when minds cease to be engrossed in the art of getting on.[46]

The lineaments of a possible future are implicit in Mill's remarks. Life enhancement will be preferred to life multiplication. There will be more in the way of personal services and less in the way of gadgets and commercial junk that no one needs. The public will be encouraged to buy products that involve the minimum environmental disruption. Waste will be largely replaced by conservation and recycling. The cherishing of nature's assets will be accounted morally good and their wanton destruction evil; but there will be no objection to the transformation of nature as long as it makes the world more fruitful, more beautiful, and more habitable. Human beings will be regarded as integral members of the ecosystem, not as outsiders or villainous intruders. They will delight in the sensuous qualities of the natural environment, in sights and sounds and odors, in tastes and touches. With this greater emphasis on the aesthetic side of life, the arts will flourish: sculpture and painting, dance, music, literature, architecture, and civic design will play a greater role in human affairs. Skill and fine craftsmanship, which have been so long sacrificed to the mass production of consumer goods, will revive and again flourish. Diversity will tend to replace uniformity, decentralization to replace overcrowding. Poverty will be extirpated wherever possible; wealth will be equitably distributed, and luxury confined to sensible limits. Science and technology will be prized as much

46 *Principles of Political Economy* (London: John W. Parker, 1857), Vol. II.

as ever, but they will be given new directions. Technology, for example, will seek pollution-free sources of energy.[47] The empirical data and methods of the human sciences will provide a firm basis in knowledge for environmental design.[48] The norm of human well-being will be nothing less than the cultivation and fulfillment of the deepest and widest interests. We have been sketching an ideal, and not hazarding a prophecy. Whether or not this ideal future will be realized, it represents an enlightened goal.

The recent Report of the National Policy Task Force of the American Institute of Architects points the way.[49] We shall mention only a few highlights. A national growth policy, the Report affirms, should be an expression of national values, especially the worth of the individual and his freedom. The policy has more to do with the quality of life than with numbers. Realism dictates that major attention should be paid to the older core cities, "more especially the condition of those trapped in poverty and the squalor of declining neighborhoods."

> Until we deal with the deep-seated factors in American life that give rise to such conditions, all growth in America is vulnerable, no matter how much concern and money are lavished on it, no matter how carefully it may be segregated from those neighborhoods where the contagion of decline is more evident.

The Report wisely insists that the building of new communities and the repair of old must go together, pointing out the folly of leveling slums before relocation room is made ready elsewhere. There will be need for major and even radical changes in credit and interest rates, in taxation policies, zoning and building codes, land use and acquisition, grants and subsidies.

Avoiding grandiose schemes of urban renewal, the Report proposes that the building block for civic reconstruction be "the neighborhood Growth Unit—500 to 3,000 dwellings, 2,000 to 10,000 persons—built either singly or in multiples which over time would be fitted together into larger satellite communities." The federal, state, and local

[47] For a detailed proposal by a group of faculty and students at the University of Massachusetts to the National Science Foundation for investigation of pollution-free sources of energy, see James Ridgeway, *The Last Play: The Struggle to Monopolize the World's Energy Resources* (New York: E. P. Dutton & Co., Inc., 1973), Part II, Chap. 7: "Future Fuels."

[48] See Constance Perrin, *With Man in Mind: An Interdisciplinary Prospectus for Environmental Design* (Cambridge, Mass.: The Massachusetts Institute of Technology Press, 1972).

[49] National Task Force of the American Institute of Architects, "A Plan for Urban Growth," in Bailey, *New Towns in America*, pp. 143–53.

governments would cooperate in planning and paying for the necessary infrastructure, such as transportation and utilities. This kind of community building is "a challenge to developers, planners, and architects to anticipate and give creative expression to the emerging life-styles of a richly diversified American people." Among the requirements are "a rich array of critical services, such as day care, health, and continuing education," and "a greater degree of privacy and security. The art will be to put all these together into a workable and livable community. The Growth Unit invites that art." There is also the "challenge to those committed to the integrity of the environment—to provide increments of growth that are less hostile to man and nature, that continuously reduce the pollution of land, air, and water, and that maintain open spaces and greenbelts for recreation and tranquility." Much is said about the mechanisms for realizing these policies.

Brief and inadequate though this summary be, it indicates something of the tenor of the Report. In the substitution of qualitative in place of quantitative standards, it represents an emphasis on value that has been the major theme of our entire book. Quality prized, as we indicated in our opening chapters, is the objective component in value. To make these qualities articulate and manifest in civic design is the prime requirement of environmental art.

Models and Mandates

We have been speaking of the profound changes that must occur if the comeliness of the environment is to be conserved and enhanced. These changes, we have said, include alterations in deeply ingrained ideas. The idea that relations are merely extrinsic, and that the individual person or thing is alone real and fundamental, is not a fit basis for environmental design. Without the sense of whole configurations and essential relations we cannot think and act in terms of cityscape and landscape and the ecological web of nature. Similarly, the idea that mankind should have dominion over nature, without check or restraint, is the source of irreparable damage to the environment. From an aesthetic as well as an ecological standpoint, the concept of design in symbiotic harmony with nature is far more salutary. Finally, the idea of quantitative expansion must increasingly yield to the idea of qualitative development. In the modern world we have witnessed a remarkable, even spectacular increase in quantity, more often than not at the expense of quality. Human welfare must be reckoned less in terms of growth of population, size of cities, volume of production, and exploita-

tion of resources and more in terms of self-realization, intensity of personal relations, fineness of artistic achievement, and other qualitative criteria.

Sober scientists have warned that our civilization will collapse unless priorities are drastically altered.[50] There are goals, such as world peace, control of technology, stabilization of population, elimination of hunger, and conservation of natural resources, that must be given the utmost priority to avoid world calamity. The problems of aesthetics might seem irrelevant in the face of this threat, but the fact is that art and aesthetics are caught up in a much wider context than is normally encountered. Without a moral and aesthetic transvaluation there cannot be the profound social alterations that are now imperative. The development and implementation of environmental aesthetics are a necessary part of this transformation.

We have spoken of the revolution in ideas—let us now consider how this revolution may be implemented and enforced. In Switzerland, the land of sparkling lakes and majestic mountain peaks, the need for aesthetic protection of the environment is widely accepted. To illustrate, let us see what has been happening in Vaud, a Swiss canton, where aesthetic regulation has been in force since 1941.

> Vaud is a French-speaking canton in southwestern Switzerland, bordered on the south by Lake Leman, along which are some of the best summer resorts and wine-growing areas of Switzerland, and stretching northwest through rolling farmland to the crests of the Jura mountains and Southeast into the high Alps. The seat of the cantonal government is Lausanne, a city with both ancient and modern sections, both industrial and residential areas, and a population of 136,600. The canton as a whole has an area of 1243 square miles, and a population of about a half million.[51]

Here in this varied and beautiful canton we may find a precedent and a model for aesthetic regulation elsewhere. Although the details of the aesthetic control by the cantonal government are too multifarious to be indicated, a few highlights can be mentioned.

The cantonal law regulating the aesthetic character of constructions includes the following provisions:

[50] See the following two reports by the Club of Rome, an international group of technicians and social scientists: Dennis L. Meadows et al., *The Limits of Growth* (New York: New American Library, 1972), and Mihaljo Mesarovic and Eduard Pestel, *Mankind at the Turning Point* (New York: E. P. Dutton & Co., Inc., 1974).

[51] Samuel Bufford, *Aesthetic Legislation in Vaud: A Swiss Cantonal Model Adaptable for American Use* (New York: Unpublished Manuscript, 1974), pp. 1–2. Mr. Bufford, a New York attorney, has made an intensive study of aesthetic legislation in Vaud.

Article 57. All constructions are forbidden which are likely to compromise the appearance or the character of a site, a neighborhood, an area or a street, or to harm the appearance of a building of historical, artistic or picturesque value. . . .

Article 58. The communal government must assure that constructions present a satisfactory architectural appearance, even in the case of factories and adjoining workshops, tanks, electrical transformers, gasometers, etc. . . .[52]

This statute applies only to constructions in the private domain; public construction is governed by other laws.

The enforcement of Article 57, which has been the main basis for litigation, has given rise to nearly a thousand cases in which aesthetic needs have been balanced against private property rights and other nonaesthetic considerations. In a typical case, the court refused to permit the erection of two tower apartment buildings because their height and mass would blemish the countryside and screen off a beautiful view. Similarly, the permit to build a high-rise hotel was rejected partly because the violent contrast between the massive building and the surrounding small chalets would be aesthetically shocking. Other cases, for example, have dealt with proposed industrial or commercial structures that would have damaged the view or the aesthetic character of the site.

The rationale for this type of regulation had been stated as early as 1919 by a Swiss parliamentary committee:

It is not permissible that a property owner, whether a single individual, a powerful corporation, or even a governmental branch, can compromise the appearance or the character of a site or a neighborhood with impunity. It is right to demand that the most modest houses, like buildings with the most pronounced industrial character, should present a satisfying architectural appearance. Beauty is not expensive; on the contrary, the buildings treated the most simply will often be the most beautiful; and such houses in our villages with restful and soft lines offer more satisfaction to the eye than the most luxurious villas. Furthermore, the question of money, to which, some people say, all other considerations should always yield, is usually not at issue; ugliness is created by routine, by indifference, by laziness of mind.[53]

There is a strong public consensus in favor of this justification for aesthetic control.

The enforcement of the aesthetic provisions of the Vaud building

52 Ibid., p. 12.
53 Ibid., pp. 15–16.

Art and Other Spheres of Value

code takes place at the stage of building-permit issuance. Once a permit is granted or refused after a public hearing, interested parties may challenge the decision before a court established to hear appeals of building-code cases. The five-member court normally consists of two architects, two attorneys, and one engineer. Possible complainants include neighboring property owners and environmental interest groups, but anyone with a legitimate interest, whether material or aesthetic, may be heard. In almost every decision on aesthetic grounds the court conducts an on-site inspection of the location in controversy. In addition it is free to consider the recommendations of an advisory commission on questions relevant to aesthetics. This commission consists of seven members, of whom usually two or more are attorneys and two or more are architects.

The success of the law is attested by the public acceptance of the court's decrees:

> The only hard evidence of general consensus in the aesthetic judgments enforced by the Vaud court lies in the fact that the citizens of the canton permit the program of regulation to continue as originally conceived, despite the fact that it has produced a large amount of litigation, by Swiss standards. This toll of litigation has assured that the enforcement of the aesthetic provisions has not gone on unnoticed: if the citizens were not happy with the results, they would have changed the law. But quite to the contrary, it appears that they are quite satisfied with the legislation, and there appears to be much more support for it today than there was when it was first enacted. . . . The Vaud aesthetic legislation has succeeded in establishing a sufficient measure of objectivity in the application of aesthetic standards to vitiate the objection that aesthetics is the domain of subjectivity, where all judgments are equally valid, and none is worthy of legal imposition.[54]

According to Samuel Bufford, whose study of aesthetic legislation in Vaud is the basis of our discussion, the major shortcoming of the law is that its invocation is dependent on the initiative of individual complainants. This could be remedied if a public commission were given the authority to institute legal action in the aesthetic interests of the canton. The commission of experts would be empowered to develop "a general land use plan, by reference to which it could decide where development is to be permitted and where prohibited."[55]

We have been speaking of aesthetic regulation in the single canton of Vaud, but the federal government of Switzerland has adopted legislation to protect the aesthetic character of the entire Swiss environ-

54 Ibid., pp. 75–76.
55 Ibid., p. 104.

ment. A constitutional amendment imposes on all the cantons the obligation to establish effective laws and procedures to assure environmental protection in respect to sign control ordinances, highway and building codes, and other relevant areas of regulation. New far-reaching federal legislation is in process of formulation.

Bufford concludes his study by discussing whether the Vaud model is adaptable for American use. He decides that it could be adapted with some modifications, suggesting that the legislation should be cast in the form of zoning regulation rather than in the form of a building code, and that an effective program of statewide aesthetic control would require the establishment of an enforcement commission. The feature of the Vaud legislation that permits interested individuals or groups to bring an action on their own should be retained. The judges, as in Vaud, should almost always make an on-site inspection before deciding a case. It should not be necessary in the United States to create a wholly new type of court to deal with environmental questions.

The need for aesthetic regulation has been increasingly recognized by American legislators and courts. In the preceding chapter we cited the opinion of the United States Supreme Court that "it is within the power of the legislature that the community should be beautiful as well as healthy, spacious as well as clean, well balanced as well as carefully patrolled. . . ." (*Berman v. Parker*, 1954). This judgment has been reflected in legislation. The Federal-Aid Highway Act of 1968 declares that it is "the national policy that special effort should be made to preserve the natural beauty of the countryside." The National Environment Policy Act of 1969—a landmark in environmental protection legislation—includes the following statement:

> In order to carry out the policy set forth in this Act, it is the continuing responsibility of the Federal Government to use all practicable means, consistent with other essential considerations of national policy, to improve and coordinate Federal plans, functions, programs, and resources to the end that the Nation may . . . assure all Americans . . . esthetically and culturally pleasing surroundings.

In the last decade or two there has been a decided increase in legislative and judicial attention to aesthetic considerations.[56] This development evidently reflects the growing public appreciation of aesthetic and cul-

56 See Proceedings of the American Bar Association National Institute, *Junkyards, Geraniums and Jurisprudence: Aesthetics and the Law* (Chicago: American Bar Association, 1967); the Publications of the Council on Environmental Quality, especially Fred Bosselman and David Collies, *The Quiet Revolution in Land Use Control* (Washington, D. C.: United States Government Printing Office, 1971); and "Beyond the Eye of the Beholder: Aesthetics and Objectivity," *Michigan Law Review*, 71 (1973), 1438–63 (no author listed).

tural values, the increasing awareness that natural aesthetic resources are being diminished, and the difficulty of ignoring ugliness as our cities become more polluted and congested. In consequence, governmental action at all levels—federal, state, and local—has sought to preserve and improve the aesthetic environment.

Some of the principal objectives have been the following:

- The preservation of open spaces for permanent public use, thereby helping to reduce blight and urban sprawl, and providing areas for recreation, conservation, and scenic enjoyment.

- The removal of slums and ghettoes in cities, and their replacement by open spaces or decent housing at a cost that the poor can afford.

- The cleaning-up, painting-up, and fixing-up of neighborhoods by improving rather than replacing the existing layout.

- The preservation of buildings and urban areas of architectural and historical worth, such as the Vieux Carré section (French Quarter) of New Orleans.

- The removal of billboards and junkyards adjacent to primary highways, and landscaping within the highway corridors.

- The protection of wilderness areas and fish and wildlife in danger of extinction.

- The reduction, or if possible the elimination, of air, water, and noise pollution.

- The search for clean energy from the sun, the wind, water power, geothermal sources, and new technology—energy that will make the environment more livable.

- The use of economic penalties such as fines to eliminate deleterious spillover effects, and of economic incentives such as tax breaks to encourage better environmental practices.

All of these measures will fall short of their objectives if there is not a vigilant public opinion to support them.

There are many instances in which the private citizen, acting alone or in concert with his neighbors, should take the initiative in promoting the aesthetic values of his environment. The delicate discriminations and the creative innovations are more likely to come from individuals than from legislative or administrative bodies. Even when the public agency acts in the community interest, the rights of individuals must be respected. The Fourteenth Amendment to the United States Constitution, for example, provides that no state shall deprive any person of property without due process of law—a provision that must be respected when the state exercises the power of eminent domain.

Because the fate of the environment is bound up with the fate of mankind, there must be changes of the most far-reaching kind both

for the good of man and the good of his surroundings. To abolish the hellish fury of scientific warfare, to achieve an equitable distribution of wealth and power, to curb the mounting pressure of population upon diminishing natural resources, to redirect the unlimited potentialities of science and technology, to create simple and fraternal life-styles to replace the competitive, materialistic values of our society— these are the very mandates of survival in the critical decades ahead. We do not prophesy either victory or defeat in these endeavors— prophecy is too risky a business—but there are substantial grounds for hope.

The pessimism rife among us is debilitating. As Norman Cousins has said:

> The main trouble with despair is that it is self-fulfilling. People who fear the worst tend to invite it. Heads that are down can't scan the horizon for new openings. Bursts of energy do not spring from a spirit of defeat. Ultimately, hopelessness leads to helplessness.[57]

The alternative to a numbing despair is the hope enkindled by the nature of man himself, man at his best, man in his most creative moments. The human will to survival is a very powerful force and the human capacity to create is the most inspiring lesson in history. We need to recapture the wonder expressed by the chorus in *Antigone:*

> *Many are the wonders of the world,*
> *And none so wonderful as Man. . . .*
> *Language withal he learnt,*
> *And Thought that as the wind is free,*
> *And aptitudes of civic life:*
> *Ill-lodged no more he lies,*
> *His roof the sky, the earth his bed,*
> *Screened now from piercing frost and pelting rain;*
> *All-fertile in resource, resourceless never*
> *Meets he the morrow; only death*
> *He wants the skill to shun:*
> *But many a fell disease the healer's art hath foiled.*[58]

In the ability to heal and transform, to love and understand, to create and contemplate beauty, lies the best hope for man. The cultivation of art and aesthetic value is a long step toward both personal fulfillment and a better world order.

[57] "Hope and Practical Realities," *Saturday Review World*, December 14, 1944, p. 4.

[58] Sophocles, *Antigone*, trans. Robert Whitelaw (Oxford: Oxford at the Clarendon Press, 1906). By permission of the Oxford University Press, Oxford.

Appendix

BOOKS
AND ILLUSTRATIONS

The Historical Development of Aesthetics

The following is a brief bibliographical guide to the history of Occidental aesthetics. For the art and aesthetics of the Orient see the comprehensive bibliography in Sherman E. Lee, *A History of Far Eastern Art* (Englewood Cliffs, N.J.: Prentice-Hall and New York: Harry N Abrams, n. d.).

Plato's ideas about beauty and art are scattered through the *Hippias Major, Republic, Ion, Symposium, Phaedrus, Philebus,* and *Laws.* Lane Cooper in his *Plato* (New York: Oxford University Press, 1938) has translated most of this material. Aristotle's *Rhetoric* and his remarks about aesthetic education in the *Politics* should not be overlooked. His *Poetics* must be read not only for its own sake but for its immense influence. Among the best commentaries on the *Poetics* are S. H. Butcher, *Aristotle's Theory of Poetry and Fine Art,* 4th ed. (New York: Dover, 1951) and F. L. Lucas, *Tragedy: Serious Drama in Relation to Aristotle's Poetics,* revised ed. (New York: Collier, 1962). The most famous Roman works are *Art of Poetry* by Horace, and *On the Sublime* by Longinus, but the student may also wish to delve into Plutarch's treatise on music, Pliny's remarks on the fine arts, Vitruvius' treatise on architecture, and Cicero's and Quin-

tilianus' discussions on rhetoric. The neo-Platonic interpretation is expressed in the sections on "Beauty" and "Intellectual Beauty" of the *Enneads* of Plotinus, translated by Stephen MacKenna (New York: Pantheon, 1956).

Selections from St. Augustine's *De Ordine* and *De Musica* may be found in Albert Hofstadter and Richard Kuhns, *Philosophies of Art and Beauty* (New York: Random House, 1964). The scattered remarks of St. Thomas Aquinas on art and beauty are quoted by Wladyslaw Tatarkiewicz in *History of Aesthetics* (New York: Humanities Press, 1971). This history is the best single source for medieval aesthetic theory.

An eloquent example of Renaissance aesthetics is Marsilio Ficino's *Commentary on Plato's Symposium* reproduced in Hofstadter and Kuhns, *Philosophies of Art and Beauty*. The spirit of Renaissance thought can also be gleaned from Leonardo Da Vinci, *Notebooks* and *A Treatise on Painting*, Cennino Cennini, *The Book of Art*, and Giorgio Vasari, *Lives of the Painters*. English thought is represented by Sir Philip Sidney, *An Apology for Poetry*, Francis Bacon, "Of Beauty" in his *Essays*, and Ben Jonson, *Timber, or Discoveries*. Later English neo-classicism is represented by John Dryden, *An Essay of Dramatic Poetry*. The French neo-classic theory of literature is stated in Pierre Corneille, *Discourse on the Three Unities*, and Nicolas Boileau, *Art of Poetry*.

The eighteenth century abounds in works of aesthetics and criticism. Among the notable English works were Lord Shaftesbury, *Characteristics;* David Hume, "Of Tragedy" and "Of the Standard of Taste" in *Essays;* Francis Hutcheson, *An Inquiry Concerning Beauty, Order, Harmony, Design;* Joseph Addison, *The Pleasures of the Imagination;* Edmund Burke, *A Philosophical Enquiry into the Origin of Our Ideas of the Sublime and the Beautiful;* Sir Joshua Reynolds, *Discourses* (on painting); Thomas Reid, *Essays on the Intellectual Powers* (Essay VIII); and Adam Smith, *Of the Nature of the Imitation Which Takes Place in What Are Called the Imitative Arts*. On the Continent appeared such important treatises as G. E. Lessing, *Laocoön,* Denis Diderot, "The Paradox of the Actor" in *Rameau's Nephew and Other Works,* and Giambattista Vico, *The New Science*. Most important of all was Immanuel Kant, *The Critique of Judgement*. For an excellent interpretation of this difficult book see Donald W. Crawford, *Kant's Aesthetic Theory* (Madison: University of Wisconsin Press, 1974). Another major work was Friedrich Schiller, *On the Aesthetic Education of Man*. By far the best English edition is the translation with introduction and commentary by Elizabeth M. Wilkinson and L. A. Willoughby (Oxford: Clarendon Press, 1967).

Among the English romantics William Hazlitt has provocative things to say about art, imagination, and aesthetic emotion. There is a good selection from his writings in W. J. Bate, *Criticism: The Major Texts* (New

York: Harcourt, Brace, 1952). Wordsworth's Prefaces, Coleridge's *Biographia Literaria* and other works, Shelley's "Defence of Poetry," and the letters of John Keats are full of insights. In the Victorian period, the moral and cultural interpretation of the arts found impassioned expression in the works of John Ruskin, especially *Lectures on Art, Stones of Venice,* and *Modern Painters.*

The aesthetics of German romanticism is represented by Friedrich Schelling, *System of Transcendental Idealism,* as well as by the two Schlegels, August and Friedrich, Jean Paul, Novalis (Friedrich von Hardenberg), and Friedrich Schleiermacher. Better known to modern readers are the interpretation of art and aesthetic experience in Arthur Schopenhauer, *The World as Will and Idea,* and G. W. F. Hegel, *The Philosophy of Fine Art.* For the Marxian theory, which is exerting a powerful influence on contemporary aesthetics, see Lee Baxandall and Stefan Morawski, *Karl Marx and Frederick Engles on Literature and Art* (New York: International General, 1974). The Introduction by Morawski and the bibliography are especially helpful.

The developments in England and Europe had their repercussions in America. Emerson's essay, "The Poet," is a representative expression of New England transcendentalism, a movement influenced by English romanticism and German idealism. The principles of functional art are eloquently expressed by Horatio Greenough in his *Form and Function* (Berkeley: University of California Press, 1957). The ideal of a vigorous popular culture is enunciated by Walt Whitman in his Preface to *Leaves of Grass* and *Democratic Vistas.* In contrast, a puristic and formal approach to aesthetics may be found in the essays of Edgar Allan Poe, especially "The Poetic Principle." Late in the nineteenth century appeared George Santayana's *The Sense of Beauty* (New York: Scribner's, 1896), a work of great insight and felicity of style.

During the latter part of the nineteenth century, the art for art's sake movement found expression in Oscar Wilde, *Intentions,* James McNeill Whistler, *Ten O'Clock Lectures,* and Walter Pater, Conclusion to *The Renaissance.* Similar ideas appeared in such French writers as Baudelaire, Gautier, and Mallarmé. In Germany, formalism characterized the musical aesthetics of Edmund Gurney and Eduard Hanslick and the theory of painting of Konrad Fiedler. But there was also a very strong protest against aesthetic purism in Eugene Véron's expressionist *Aesthetics,* William Morris' *Hopes and Fears for Art,* Friedrich Nietzsche's *Birth of Tragedy,* and Søren Kierkegaard's *Stages of Life's Way.* In Russia, the reaction against aesthetic purism is characteristic of Leo Tolstoy in *What is Art?* and George Plekhanov in *Art and Society.*

In the twentieth century such notable figures as Theodor Lipps, Sigmund Freud, Henri Bergson, Benedetto Croce, Edward Bullough,

George Santayana, and John Dewey have contributed to aesthetics. The linguistic analysis of Ludwig Wittgenstein, the structuralism of Claude Levi-Strauss, the existentialism of Martin Heidegger and Jean Paul Sartre, and the Marxism of Gyorgy Lukács and Herbert Marcuse are exercising a considerable influence.

Readings from many of the above sources may be found in such anthologies as:

ADAMS, HAZARD, *Critical Theory since Plato*. New York: Harcourt Brace Jovanovich, 1971.

ASCHENBRENNER, KARL, and ARNOLD ISENBERG, *Aesthetic Theories*. Englewood Cliffs, N.J.: Prentice-Hall, 1965.

HOFSTADTER, ALBERT, and RICHARD KUHNS, *Philosophies of Art and Beauty*. New York: Random House, 1964.

LIPMAN, MATTHEW, *Contemporary Aesthetics*. Boston: Allyn and Bacon, 1973.

NAHM, MILTON C., *Readings in the Philosophy of Art and Aesthetics*. Englewood Cliffs, N.J.: Prentice-Hall, Inc., 1975.

RADER, MELVIN, *A Modern Book of Esthetics*. New York: Holt, Rinehart and Winston, 1973.

TILLMAN, FRANK A., and STEVEN M. CAHN, *Philosophy of Art and Aesthetics from Plato to Wittgenstein*. New York: Harper & Row, 1969.

SESONSKE, ALEXANDER, *What Is Art? Aesthetic Theory from Plato to Tolstoy*. New York: Oxford University Press, 1965.

The following histories of aesthetics are recommended:

BEARDSLEY, MONROE C., *Aesthetics from Classical Greece to the Present*. New York: Macmillan, 1966.

GILBERT, KATHERINE E., and HELMUT KUHN, *A History of Esthetics* (2nd ed.) Bloomington: Indiana University Press, 1953.

OSBORNE, HAROLD, *Aesthetics and Art Theory: An Historical Introduction*. New York: Dutton, 1970.

TATARKIEWICZ, WLADYSLAW, *History of Aesthetics*, 3 vols. New York: Humanities Press, 1971–1974. Highly recommended.

A Selected List of Twentieth-Century Books in Aesthetics

It is impossible in limited space to list the many books and articles on aesthetics written in this century.

Allan Shields' *A Bibliography of Bibliographies in Aesthetics* (San Diego: San Diego State University Press, 1975) will enable the student to construct his own list to suit his dominant research interest. This admirable research and reference tool notes twelve outstanding bibliogra-

phies in various areas of aesthetics, and in addition covers such categories as general aesthetics, philosophy of art, aesthetic education, pyschology of aesthetic experience, and the aesthetics of music, literature, and other arts. Below is a selected list of books published in the twentieth century:

ABELL, WALTER, *Representation and Form*. New York: Scribner's, 1936.

ALDRICH, VIRGIL C., *Philosophy of Art*. Englewood Cliffs, N.J.: Prentice-Hall, 1963.

ALEXANDER, SAMUEL, *Beauty and Other Forms of Value*. London: Macmillan, 1933.

ARNHEIM, RUDOLF, *Art and Visual Perception*. Berkeley: University of California Press, 1954.

—————, *Toward a Psychology of Art*. Berkeley: University of California Press, 1972.

BEARDSLEY, MONROE C., *Aesthetics*. New York: Harcourt, Brace, 1958.

BELL, CLIVE, *Art*. New York: Stokes, 1914.

BERENSON, BERNARD, *Aesthetics and History*. New York: Pantheon, 1948.

BERGSON, HENRI, *Laughter: An Essay on the Meaning of the Comic*. New York: Macmillan, 1911.

BOAS, GEORGE, *The Heaven of Invention*. Baltimore: Johns Hopkins Press, 1963.

BOSANQUET, BERNARD, *Three Lectures on Aesthetics*. London: Macmillan, 1923.

BRANDON, S. G., *Man and God in Art and Ritual*. New York: Scribner's, 1975.

BULLOUGH, EDWARD, *Aesthetics*. Palo Alto: Stanford University Press, 1957.

CALLAGHAN, WILLIAM, et al., eds., *Aesthetics and the Theory of Criticism: Selected Essays of Arnold Isenberg*. Chicago: University of Chicago Press, 1973.

CAMPBELL, JOSEPH, *The Mythic Image*. Princeton, N.J.: Princeton University Press, 1974.

CARPENTER, RHYS, *The Esthetic Basis of Greek Art* (rev. ed.) Bloomington: Indiana University Press, 1959.

CARRITT, E. F., *What is Beauty?* Oxford: Clarendon Press, 1942.

CASSIRER, ERNST, *An Essay on Man*. New Haven: Yale University Press, 1944.

—————, *Language and Myth*. New York: Dover, 1946.

—————, *Philosophy of Symbolic Forms*, 3 vols. New Haven: Yale University Press, 1953, 1955, 1957.

CAUDWELL, CHRISTOPHER, *Illusion and Reality*. New York: International Publishers, 1949.

COLLINGWOOD, R. G., *The Principles of Art*. Oxford: Clarendon Press, 1938.

COOMARASWAMY, ANANDA, *The Transformation of Nature in Art*. Cambridge, Mass.: Harvard University Press, 1934.

CROCE, BENEDETTO, *Aesthetic as Science of Expression and General Linguistic* (2nd ed.) London: Macmillan, 1922.

—————, *The Essence of Aesthetics*. London: Heinemann, 1922.

De Lucio-Meyer, J. J., *Visual Aesthetics*. New York: Harper & Row, 1974.

Dessoir, Max, *Aesthetics and Theory of Art*. Detroit: Wayne State University Press, 1970.

Dewey, John, *Art as Experience*. New York: Minton, Balch, 1934.

Dickie, George, *Art and the Aesthetic*. Ithaca: Cornell University Press, 1974.

Ducasse, Curt J., *Art, the Critics, and You*. Indianapolis: Bobbs-Merrill, 1955.

————, *The Philosophy of Art* (2nd ed.) New York: Dover, 1966.

Dufrenne, Mikel, *The Phenomenology of Aesthetic Experience*. Evanston: Northwestern University Press, 1973.

Elton, William, ed., *Aesthetics and Language*. Oxford: Blackwell, 1954.

Fischer, Ernst, *The Necessity of Art: A Marxist Approach*. Baltimore: Penguin, 1964.

Freud, Sigmund, *The Standard Edition of the Complete Psychological Works of Sigmund Freud*, ed. by James Strachey. London: Hogarth, 1953–1954. See especially *Civilization and Its Discontents, Delusion and Dream, The Interpretation of Dreams, Leonardo da Vinci*, and *Wit and Its Relation to the Unconscious*.

Fry, Roger, *Vision and Design*. London: Chatto and Windus, 1920.

Gardner, Howard, *The Arts and Human Development*. New York: Wiley, 1973.

Gilson, Etienne, *Painting and Reality*. New York: Pantheon, 1957.

Gombrich, E. H., *Art and Illusion* (2nd ed.) New York: Pantheon, 1961.

————, *Meditations on a Hobby Horse and Other Essays in the Theory of Art*. New York: Phaidon, 1963.

Goodman, Nelson, *Languages of Art*. Indianapolis: Bobbs-Merrill, 1968.

Gotshalk, D. W., *Art and the Social Order* (2nd ed.) New York: Dover, 1962.

Greene, Theodore M., *The Arts and the Art of Criticism*. Princeton, N.J.: Princeton University Press, 1940.

Gregory, R. L., and E. H. Gombrich, eds., *Illusion in Nature and Art*. New York: Scribner's, 1974.

Harrell, Jean G., and Alina Wierzbianska, eds., *Aesthetics in Twentieth-Century Poland*. Lewisburg: Bucknell University Press, 1973.

Hartshorne, Charles, *The Philosophy and Psychology of Sensation*. Chicago: University of Chicago Press, 1934.

Hauser, Arnold, *The Philosophy of Art History*. New York: Knopf, 1959.

Heyl, Bernard C., *New Bearings in Esthetics and Art Criticism*. New Haven, Yale University Press, 1943.

Hofstadter, Albert, *Agony and Epitaph*. New York: Braziller, 1970.

————, *Truth and Art*. New York: Columbia University Press, 1965.

Hospers, John, *Meaning and Truth in the Arts*. Chapel Hill: University of North Carolina Press, 1946.

Ingarden, Roman, *The Cognition of the Literary Work of Art*. Evanston, Ill.: Northwestern University Press, 1973.

————, *The Literary Work of Art.* Evanston, Ill.: Northwestern University Press, 1973.

JAMESON, FREDRIC, *Marxism and Form.* Princeton, N.J.: Princeton University Press, 1972.

JUNG, CARL GUSTAV, *The Archetypes and the Collective Unconscious.* New York: Pantheon, 1959.

————, et al., *Man and His Symbols.* New York: Doubleday, 1968.

KAHLER, ERICH, *The Disintegration of Form in the Arts.* New York: Braziller, 1968.

KAVOLIS, VYTAUTUS, *Artistic Expression: A Sociological Analysis.* Ithaca: Cornell University Press, 1968.

KEPES, GYORGY, ed., *Arts of the Environment.* New York: Braziller, 1972.

LANG, BEREL, and FORREST WILLIAMS, eds., *Marxism and Art.* New York: McKay, 1972.

LANGER, SUSANNE K., *Feeling and Form.* New York: Scribner's, 1953.

————, *Mind: An Essay on Human Feeling,* 2 vols. Baltimore: Johns Hopkins Press, 1967, 1972.

————, *Philosophy in a New Key: A Study in the Symbolism of Reason, Rite, and Art.* Cambridge, Mass.: Harvard University Press, 1957.

————, *Problems of Art.* New York: Scribner's, 1957.

LANGFELD, HERBERT, *The Aesthetic Attitude.* New York: Harcourt, Brace, 1920.

LEE, HAROLD NEWTON, *Perception and Aesthetic Value.* Englewood Cliffs, N.J.: Prentice-Hall, 1938.

LEE, VERNON, *The Beautiful.* Cambridge, Eng.: Cambridge University Press, 1913.

LEWIS, CLARENCE IRVING, *An Analysis of Knowledge and Valuation.* LaSalle, Ill.: Open Court, 1946.

LOWENFELD, VICTOR, *The Nature of Creative Activity,* 3rd ed. New York: Harcourt, Brace, 1957.

LOWRY, BATES, *Visual Experience.* Englewood Cliffs, N.J.: Prentice-Hall, 1975.

LUKÁCS, GEORGE, *The Meaning of Contemporary Realism.* London: Merlin Press, 1963.

MALRAUX, ANDRÉ, *Voices of Silence.* New York: Doubleday, 1953.

MANDELBAUM, MAURICE, ed., *Art, Perception, and Reality.* Baltimore: Johns Hopkins Press, 1972.

MARGOLIS, JOSEPH, *The Language of Art and Art Criticism.* Detroit: Wayne State University Press, 1965.

MARITAIN, JACQUES, *Art and Scholasticism.* New York: Scribner's, 1930.

————, *Creative Intuition in Art and Poetry.* New York: Pantheon, 1953.

MAST, GERALD, and MARSHALL COHEN, *Film Theory and Criticism.* New York: Oxford University Press, 1974.

MERLEAU-PONTY, MAURICE, *The Phenomenology of Perception.* New York: Humanities Press, 1962.

MEYER, LEONARD, *Emotion and Meaning in Music.* Chicago: University of Chicago Press, 1956.

MORAWSKI, STEFAN, *Inquiries into the Fundamentals of Aesthetics.* Cambridge, Mass.: Massachusetts Institute of Technology Press, 1974.

MUMFORD, LEWIS, *Art and Technics.* New York: Columbia University Press, 1952.

MUNRO, THOMAS, *The Arts and Their Interrelations.* New York: Liberal Arts Press, 1949.

————, *Evolution in the Arts.* Cleveland: Press of Case Western Reserve University, 1965.

————, *Form and Style in the Arts.* Cleveland: Press of Case Western Reserve University, 1970.

————, *Towards Science in Aesthetics.* New York: Liberal Arts Press, 1956.

NAHM, MILTON C., *Aesthetic Experience and Its Presuppositions.* New York: Harper and Row, 1946.

————, *The Artist as Creator.* Baltimore: The Johns Hopkins University Press, 1956.

NEUTRA, RICHARD, *Survival Through Design.* New York: Oxford University Press, 1954.

ORTEGA, Y GASSET, JOSE, *The Dehumanization of Art.* Princeton, N.J.: Princeton University Press, 1948.

OSBORNE, HAROLD, ed., *Aesthetics.* London: Oxford University Press, 1972.

OSBORNE, HAROLD, *Aesthetics and Criticism.* London: Routledge, 1955.

————, *The Art of Appreciation.* New York: Oxford University Press, 1970.

PANOFSKY, ERWIN, *Meaning in the Visual Arts.* New York: Doubleday, 1955.

PARKER, DeWITT H., *The Analysis of Art.* New Haven: Yale University Press, 1924.

PEPPER, STEPHEN C., *Aesthetic Quality.* New York: Scribner's, 1938.

————, *The Basis of Criticism in the Arts.* Cambridge, Mass.: Harvard University Press, 1945.

————, *The Work of Art.* Bloomington: University of Indiana Press, 1955.

PRALL, D. W., *Aesthetic Judgment.* New York: Crowell, 1929.

PRATT, CARROLL, *The Meaning of Music.* New York: McGraw-Hill, 1931.

READ, HERBERT, *Art and Society.* London: Faber, 1937.

————, *Education Through Art* (3rd ed.) New York: Pantheon, 1958.

————, *The Forms of Things Unknown.* London: Faber, 1960.

————, *Icon and Idea: The Function of Art in the Development of Human Consciousness.* Cambridge, Mass.: Harvard University Press, 1965.

REID, LOUIS ARNAUD, *Meaning in the Arts.* New York: Humanities Press, 1969.

————, *A Study in Aesthetics.* New York: Macmillan, 1931.

ROSENTHAL, M. L., *Poetry and the Common Life.* New York: Oxford University Press, 1975.

SANTAYANA, GEORGE, *Interpretations of Poetry and Religion.* New York: Scribner's, 1927.

——, *Reason in Art.* New York: Scribner's, 1922.

SARTRE, JEAN-PAUL, *The Psychology of Imagination.* New York: Philosophical Library, 1948.

SCRUTON, ROGER, *Art and Imagination.* London: Methuen, 1974.

SIRCELLO, GUY, *Mind and Art.* Princeton, N.J.: Princeton University Press, 1972.

SOLOMON, MAYNARD, ed., *Marxism and Art: Essays Classic and Contemporary.* New York: Knopf, 1973.

SPARSHOTT, F. E., *The Structure of Aesthetics.* Toronto: University of Toronto Press, 1963.

STOKES, ADRIAN, *Painting and the Inner World.* London: Tavistock, 1963.

STOLNITZ, JEROME, *Aesthetics and the Philosophy of Art Criticism.* Boston: Houghton Mifflin, 1960.

TOMAS, VINCENT, ed., *Creativity in the Arts.* Englewood Cliffs, N.J.: Prentice-Hall, 1964.

TORMEY, ALAN, *The Concept of Expression.* Princeton, N.J.: Princeton University Press, 1971.

USHENKO, ANDREW P., *Dynamics of Art.* Bloomington: University of Indiana Press, 1953.

WALSH, DOROTHY, *Literature and Knowledge.* Middletown, Conn.: Wesleyan University Press, 1969.

WEITZ, MORRIS, *Philosophy of the Arts.* Cambridge, Mass.: Harvard University Press, 1950.

WELLEK, RENÉ, *Concepts of Criticism.* New Haven: Yale University Press, 1963.

WOLLHEIM, RICHARD, *Art and Its Objects.* New York: Harper and Row, 1968.

——, *On Art and the Mind.* Cambridge, Mass.: Harvard University Press, 1974.

WORRINGER, WILHELM, *Abstraction and Empathy.* New York: International University Press, 1953.

Reference Sources on Works of Art *

The student of aesthetics needs to be familiar with works of art, preferably original, but he must often depend on secondary sources, such as phonograph recordings and reproductions of paintings. Below is a list of reference sources dealing with the visual arts, music, and literature.

* The following list of reference sources has been compiled largely by Professor Gerard L. LeCoat of the University of Washington.

The books on the visual arts are full of color plates and other illustrations, and the musical scores and phonograph records provide a basis for appreciating and understanding the historical development of music. The anthologies of literature are standard works in the field.

In the Visual Arts:

BAZIN, GERMAINE, *The History of World Sculpture*. Greenwich, Conn.: New York Graphic Society, 1968.

DENIS, VALENTIN, and T. E. DE VRIES, *Picture History of World Art*, 2 vols. New York: Abrams, 1967.

ELSEN, ALBERT E., *Purposes of Art*. Holt, Rinehart and Winston, 1967.

Encyclopedia of World Art, 15 vols. New York: McGraw-Hill, 1959–1968.

FLEMING, WILLIAM, *Arts and Ideas*. New York: Holt, Rinehart and Winston, 1968.

GOMBRICH, ERNST H., *Art and Illusion*. New York: Pantheon, 1960.

——————, *The Story of Art*. New York: Phaidon, 1958.

HUYGHE, RENÉ, ed., *Larousse Encyclopedia of Art: Art and Mankind*. New York: Putnam, 1962, 1963, 1965. A series of three volumes beginning with prehistoric art.

JAFFE, HANS L. C., ed., *20,000 Years of World Painting*. New York: Abrams, 1967.

JANSON, HORST W., *Key Monuments of the History of Art*. New York: Abrams, 1959.

——————, *The History of Art*, rev. ed. New York: Abrams, 1969.

JUNG, CARL GUSTAV, and others, *Man and His Symbols*. New York: Doubleday, 1964.

LEE, SHERMAN E., *A History of Far Eastern Art*. Englewood Cliffs, N.J.: Prentice-Hall, and New York: Abrams, no date.

MILLON, HENRY A., *Key Monuments of the History of Architecture*. New York: Abrams, 1964.

SPENCER, HAROLD, ed., *Readings in Art History*. New York: Scribner's, 1969.

In Music:

a. s c o r e s

BURKHART, CHARLES, ed., *Anthology for Musical Analysis*. New York: Holt, Rinehart and Winston, 1964.

DAVISON, ARCHIBALD T., and WILLI APEL, eds., *Historical Anthology of Music*, 2 vols. Cambridge, Mass.: Harvard University Press, 1946, 1950.

HARDY, GORDON, and ARNOLD FISH, eds., *Music Literature*, 2 vols. New York: Dodd, Mead, 1962.

KAMIEN, ROGER, ed., *An Anthology for Listening*. New York: Norton, 1968.

PARRISH, CARL, ed., *Treasury of Early Music*. New York: Norton, 1958.

PARRISH, CARL, and JOHN OHL, eds., *Masterpieces of Music Before 1750*. New York: Norton, 1951.

b. phonograph records

ABRAHAM, GERARD, ed., *History of Music in Sound: Sound Companion to the Oxford History of Music*. RCA Victor. 23 records.

DAVISON, ARCHIBALD T., and WILLI APEL, eds., *Historical Anthology of Music*.

————, *History of European Music*. Orpheus Records. 6 records.

PARRISH, CARL, ed., *Treasury of Early Music*. Haydyn Society Records. 4 records.

PARRISH, CARL, and JOHN OHL, eds., *Masterpieces of Music Before 1750*. Haydyn Society Records. 3 records.

VALABREGA, CESARE, ed., *Storia Della Musica Italiana*. RCA Italiana. 40 records. Pleiades Records. 7 records.

In Literature:

ABRAMS, M. H., ed., *Anthology of English Literature*, 2 vols. New York: Norton, 1962.

GARDNER, HELEN, ed., *The New Oxford Book of English Verse 1250–1950*. Oxford: Clarendon Press, 1972.

HARRISON, G. B., ed., *Major British Writers*. New York: Harcourt, Brace, 1954.

KERMODE, FRANK, and JOHN HOLLANDER, eds., *The Oxford Anthology of English Literature*. New York: Oxford University Press, 1974.

MACK, MAYNARD, ed., *World Masterpieces*, 2 vols. New York: Norton, 1956.

QUILLER-COUCH, SIR ARTHUR, *The Oxford Book of English Verse 1250–1918*. Oxford: Clarendon Press, 1939.

INDEX

[Geographical names, titles of works of art, and names or topics mentioned only casually have been omitted.]